COWBOY BEBOP

MAKING THE NETFLIX SERIES

JEFF BOND WITH GENE KOZICKI

TITAN BOOKS

COWBOY BEBOP
MAKING THE NETFLIX SERIES

ISBN: 9781789097764

Published by
Titan Books
A division of Titan Publishing Group Ltd
144 Southwark St
London
SE1 0UP

www.titanbooks.com

First edition: June 2022
1 3 5 7 9 10 8 6 4 2

Cowboy Bebop © Netflix and Tomorrow Studios. Used with permission.

Did you enjoy this book? We love to hear from our readers.
Please e-mail us at: readerfeedback@titanemail.com or
write to Reader Feedback at the above address.

To receive advance information, news, competitions, and exclusive
offers online, please sign up for the Titan newsletter on our website:
www.titanbooks.com

No part of this publication may be reproduced, stored in a retrieval system, or transmitted, in any form or by any means without the prior written permission of the publisher, nor be otherwise circulated in any form of binding or cover other than that in which it is published and without a similar condition being imposed on the subsequent purchaser.

A CIP catalogue record for this title is available from the British Library.

Printed and bound in China.

Photography by Geoffrey Short, Kirsty Griffin, Nicola Dove and Kerry Brown.

CONTENTS

— **FOREWORD** 05 —

THE ULTIMATE BOUNTY 06

Welcome Back, Cowboy 07 The *Bebop* Feel 20

CHARACTERS 24

Spike Spiegel 25
Jet Black 30
Faye Valentine 36
Vicious 40
Julia 42

BEBOP SWEET RIDES 44

The *Bebop* 45
Inside the *Bebop* 54
Swordfish II 68

Faye's Burner Ship 84
The *Red Tail* 94
ISSP Ships 106

Space Freighter 108
Ecoterrorist Ship 112
Ecoterrorist Pollen Grenades 116

TOUR OF THE SOLAR SYSTEM 118

Astral Gate 119
The Colonies 128
Venus 134
Earth 138
Mars: Ana's Bar 140

Mars: Vicious' Penthouse 144
Mars: Virtual Reality Londes Center 146
Mars: Lefou Medical Facility 148
Pierre Le Fou 152
Mars: Tharsis City Fish Factory 154

Mars: Cathedral 156
Elders' Temple 160
New Tijuana and Other Colonies 162
Earthland 172

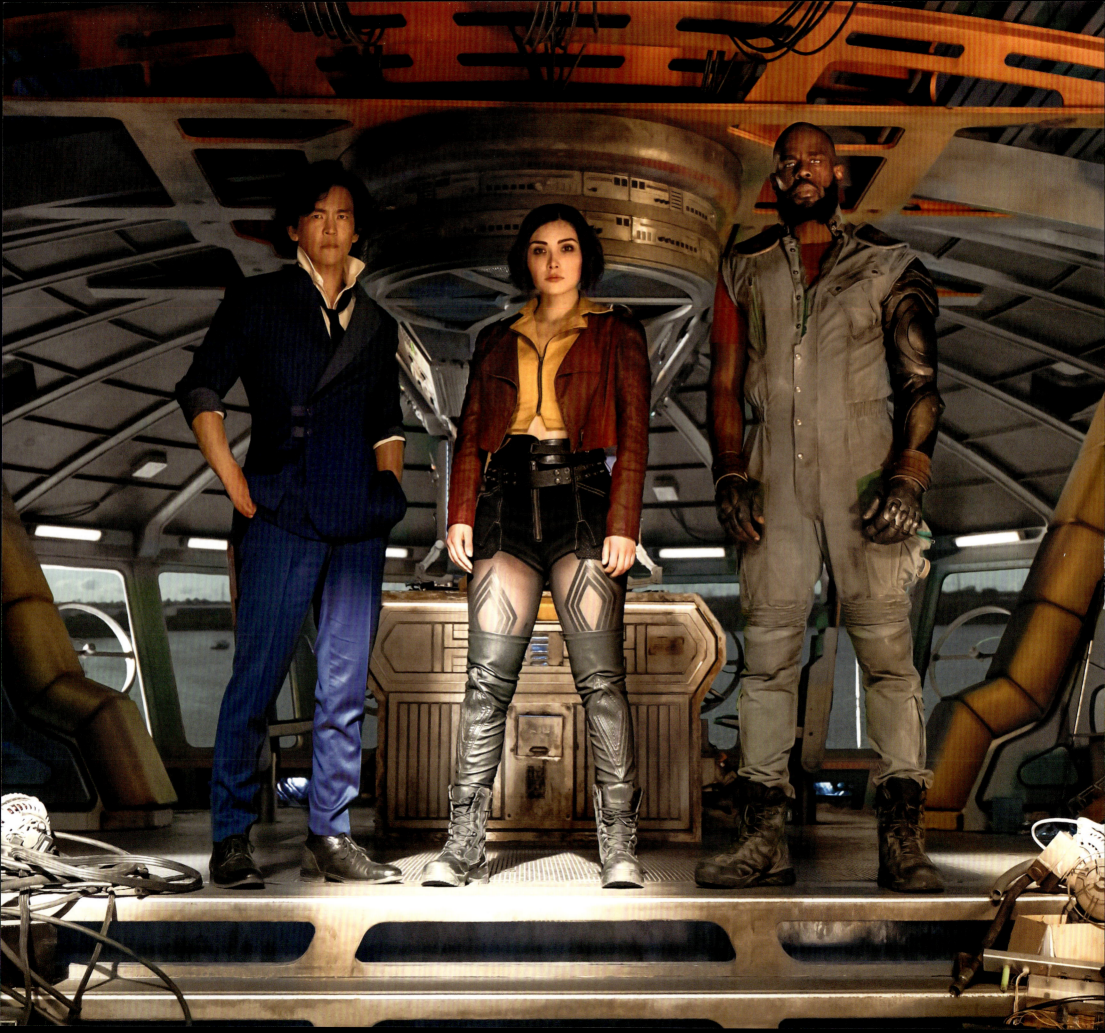

FOREWORD

It's a western.
No, it's a noir.
Or maybe it's a buddy cop show with its roots in 80s action movies.
But then there's that strong sci-fi helix twisting in its DNA.
Wait, it's a tone poem oozing with ennui.
Though that music, that delicious, delicious music.
It's an opera.
It's a *SPACE OPERA*!
I don't know… is it a space opera?

How can it be all those things and still be one thing?
What is that one definable thing?
A North Star by which to guide us.
All questions I asked myself when embarking on the journey of crafting the live-action telling of a culty anime from the late 1990s.

But over the course of this labor of love—
— Contemplating and adapting the characters and the worlds they inhabit, the tech that surrounds them, the bad guys they chase and are chased by, the fights they engage in... Every fine detail that exists in every fine frame—
— it became clear to me.
It's all of these things.
Rolled into a single unique jazzy piece of pulpy entertainment.
Because…
It's *Cowboy Bebop*!

André Nemec, showrunner

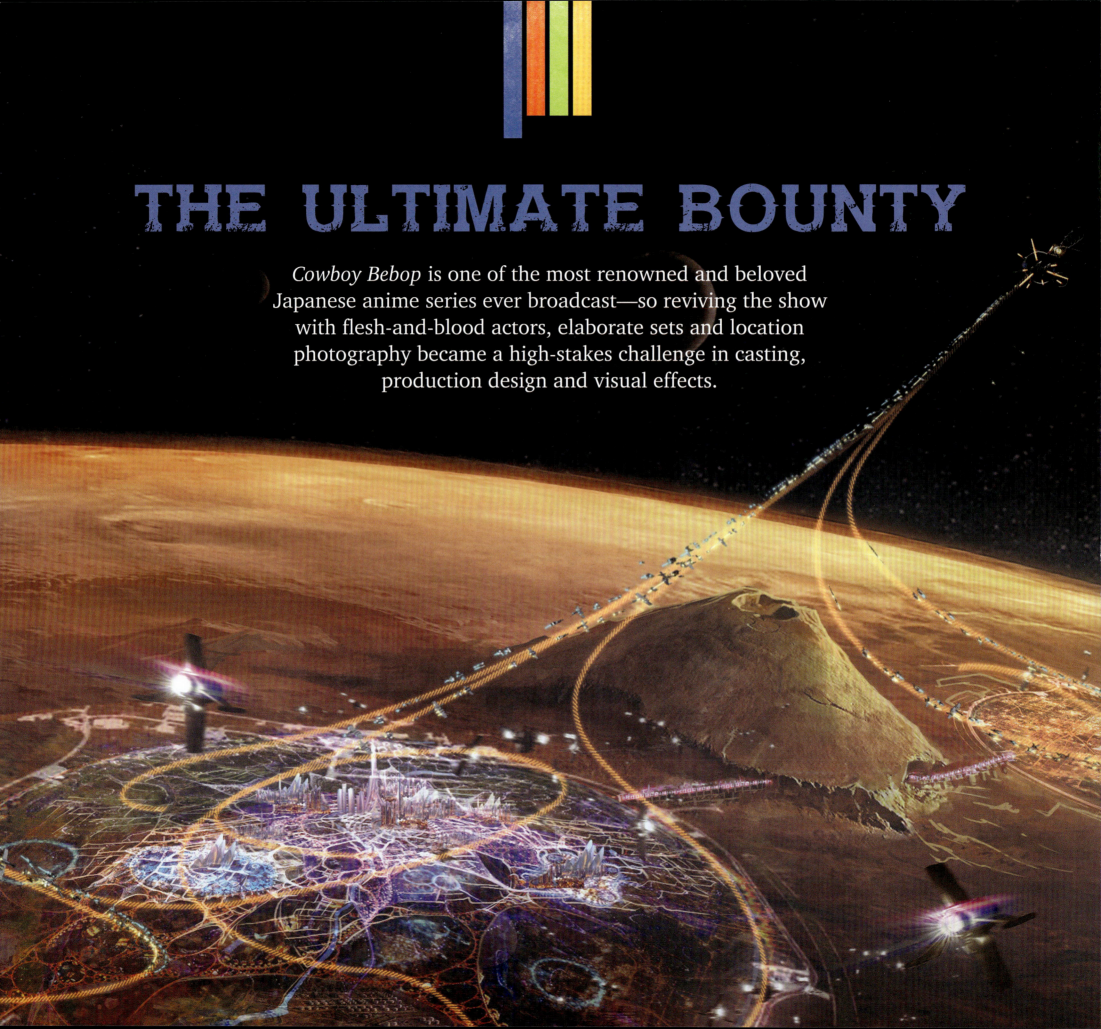

THE ULTIMATE BOUNTY

Cowboy Bebop is one of the most renowned and beloved Japanese anime series ever broadcast—so reviving the show with flesh-and-blood actors, elaborate sets and location photography became a high-stakes challenge in casting, production design and visual effects.

WELCOME BACK, COWBOY

It's been a couple of decades of Earth time since the original *Cowboy Bebop* anime scooped up awards and won over audiences in Japan and the United States. Set in 2071, the series, created by the Sunrise Inc animation studio, originally broadcast just half a dozen 'sessions' (riffing off its wild jazz-action title music by Yoko Kanno) as a number of its adult-themed stories proved too hardcore for Japanese television (the full set would air later in Japan and overseas).

In the show's speculative future the solar system has been colonized, and many of its planets and moons, including Mars, Venus, Ganymede and others, have been terraformed or populated with environmentally sealed urban centers, with fast travel to individual planets and colonies made possible by astral jump gates that propel spacecraft to near luminal speeds.

The only planet that doesn't benefit much from this interplanetary action is Earth—it fell victim to a gateway accident that has rendered most of the surface uninhabitable, leaving whatever population lucky enough to survive as refugees scattered throughout the colonies. The various colonies are a bit like the Wild West, with crime, drugs and violence rampant, and the Inter Solar System Police (ISSP) stretched thin enough in resources to resort to registering bounty hunters as contract workers, legally able to enforce arrest warrants and turn in criminals to the ISSP for rewards. These bounty hunter 'cowboys' form a vital part of the

▶ Faye in Ana's Bar.

▶▶ Episode 105 deals with Jet's days with the ISSP, and was the production's homage to film noir.

▼ Katerina's zipcraft, which she steals from a spaceport on New Tijuana, was based on a helicopter that could no longer fly. Concept designer Henry Fong added wings, jet engine exhausts, and intake grills to disguise the origins.

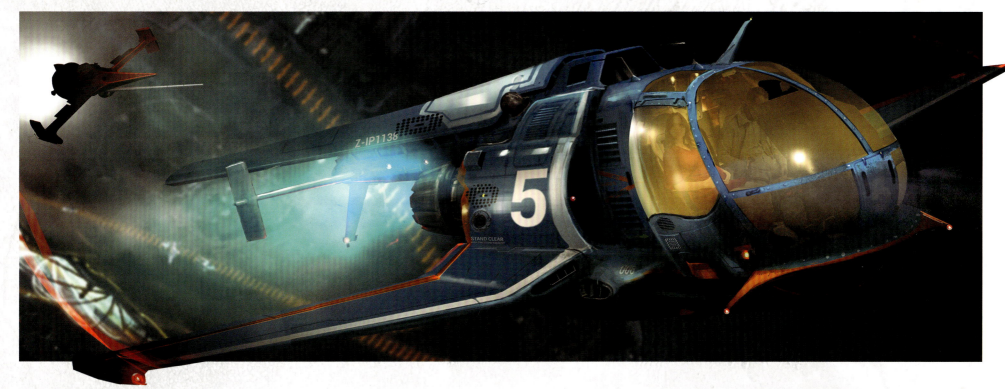

THE ULTIMATE BOUNTY

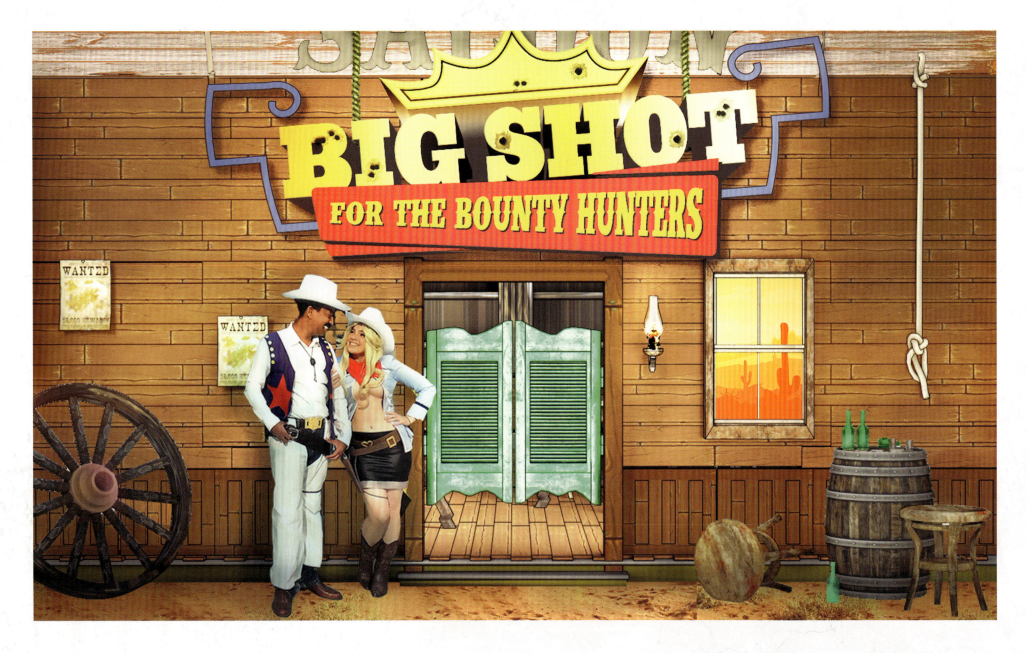

▲ The team wanted to make sure the *Big Shot* set maintained the janky, cheaply put together vibe of the anime.

▲▶ Whether set on a planet or in space, *Cowboy Bebop* was to have a rich color palette.

solar system's economy—and cause almost as much trouble as the criminals they pursue.

Laconic cowboy Spike Spiegel is running from his past in the Syndicate, a crime family where he once operated as a hit man called Fearless alongside an unpredictable fellow assassin named Vicious. Now he travels the solar system in the spaceship *Bebop* with jaded former ISSP officer Jet Black and (eventually) independent contractor Faye Valentine, a refugee from Earth whose stint in suspended animation has left her clueless about her own past.

With its sprawling science-fiction space-scapes, eye-catching spacecraft and hardware from mechanical designer Kimitoshi Yamane, comical 'Big Shot' video commercials advertising upcoming bounties and their enticing opportunity to earn a cargo hold full of woolongs—the solar system's prevailing currency—and vivid characters, the original *Cowboy Bebop* put tropes from westerns, Hong Kong action movies, film noir and cyberpunk in a blender, and created one of the most popular and iconic animes ever made, a gateway drug—just like a vial of Red-Eye—to the entire world of anime for viewers all over the globe.

So how do you translate that into flesh and blood? The idea occurred to executive producers Becky Clements and Marty Adelstein of Tomorrow Studios and studio vice president Nic Louie, who were searching for iconic properties and characters to draw in writers and other talent for the company's production slate.

Japanese anime seemed the perfect, unexplored territory for the kind of eye-grabbing programming Tomorrow Studios was looking to launch. "I've always been a really big anime fan," Louie says. "But I think anime has been looked down upon as something weird or niche—people that like anime in the past were almost embarrassed. It's so strange to me, especially when we're having

this moment with comic books in the mainstream post-Marvel and Kevin Feige. There's no reason why anime can't be the same thing. It's just another medium."

Anime and manga (Japanese comic books or graphic novels) first reached Western and US audiences in the 1960s with titles like *Speed Racer* and *Kimba the White Lion*. Since then, *Dragon Ball Z*, *Super Dimension Fortress Macross*, *Akira*, *Ghost in the Shell* and others have all found popularity, with a few making the transition into American live-action adaptations. But cultural and production challenges have kept many familiar anime titles from making a lasting impression on Western audiences.

That's where *Cowboy Bebop* stood out. The title alone spoke to Western sensibilities—there are few things more uniquely American than the Wild West and jazz. The show's powerful influences—from gangster crime sagas and film noir to Western shootouts, space monster stories and buddy cop movies—presented something that seemed already designed for American audiences. "*Cowboy Bebop* seemed like the best place to start and a dream project honestly," Louie says. "Because it has a lot of Western influences and a lot of Western themes in it. That makes it more translatable. It's a classic that everyone considers a gateway piece to the [anime] medium. That makes it also a great property for adaptation compared to an anime that tends to have more of the classic anime tropes."

"*Cowboy Bebop* was really my entry to anime, because my kids, growing up, watched it," says Adelstein.

For Becky Clements, the *Bebop* anime was unexplored territory. "Nic Louie said, 'What do you guys know about manga and anime?' And we're over 30, so, we know Batman and Superman," she says. Tomorrow Studios hired consultants to look at potential anime and manga subjects in Japan and Korea, turning up a number of possibilities for adaptation. "And so one day Nic walked up to me and said, 'What do you know about *Cowboy Bebop*?' And I said, 'Nothing. But that is the best title I've ever heard in my life.' And so I immediately pulled it up on my computer and started watching these episodes, and it's just perhaps the most perfect construction of a TV show that could exist."

For the Tomorrow Studios staff, *Cowboy Bebop* presented immediate potential for physical production because while its story spanned a fully colonized solar system with action in space and on other planets, the urban setting of most episodes involved recognizable environments—bars, restaurants, apartments, and city streets with automobiles and motorcycles not dissimilar to what we see outside our windows every day. "What attracted me to it and why it was a good entry point for me was because it lives in the near future," Adelstein says. "It doesn't live in a world that's completely foreign to me, that seems completely made up. It's grounded in a way that there's recognizable elements in that, and that just made it more appealing to me. Having 20% being a world you recognize I think helps to differentiate it from *Star Wars* or anything like that, that was totally foreign." And Adelstein notes that some of the technology intended as futuristic even in 1998 now comes across as commonplace. "I used to remember when I was a child, I'd watch *The Jetsons* and they'd have these phones that you could see people and talk to and I was like, 'Oh, my god, that'll never happen.' Now, three times a day I'm sitting here looking at a computer screen talking to people and seeing them."

Louie too says that the lived-in look of *Cowboy Bebop*'s future makes it more relatable. "It's not as shiny. You're not running through a very hardcore sci-fi environment."

▲ Executive producer Marty Adelstein.

◀ Left to right: Showrunner André Nemec; executive producer Becky Clements; executive producer/director Michael Katleman.

▶ Like the anime, the graphics team modified existing logos and brands to lend an air of familiarity to the show.

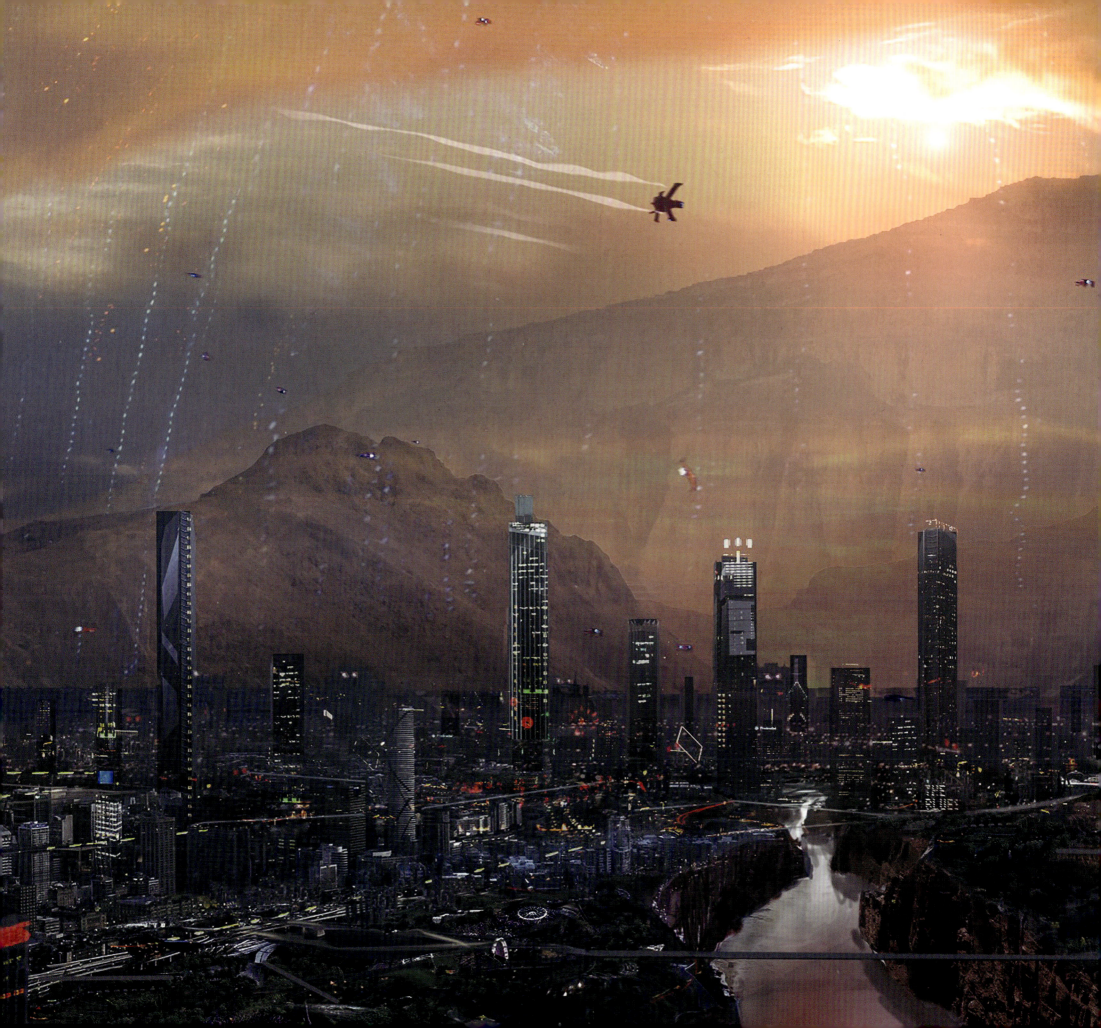

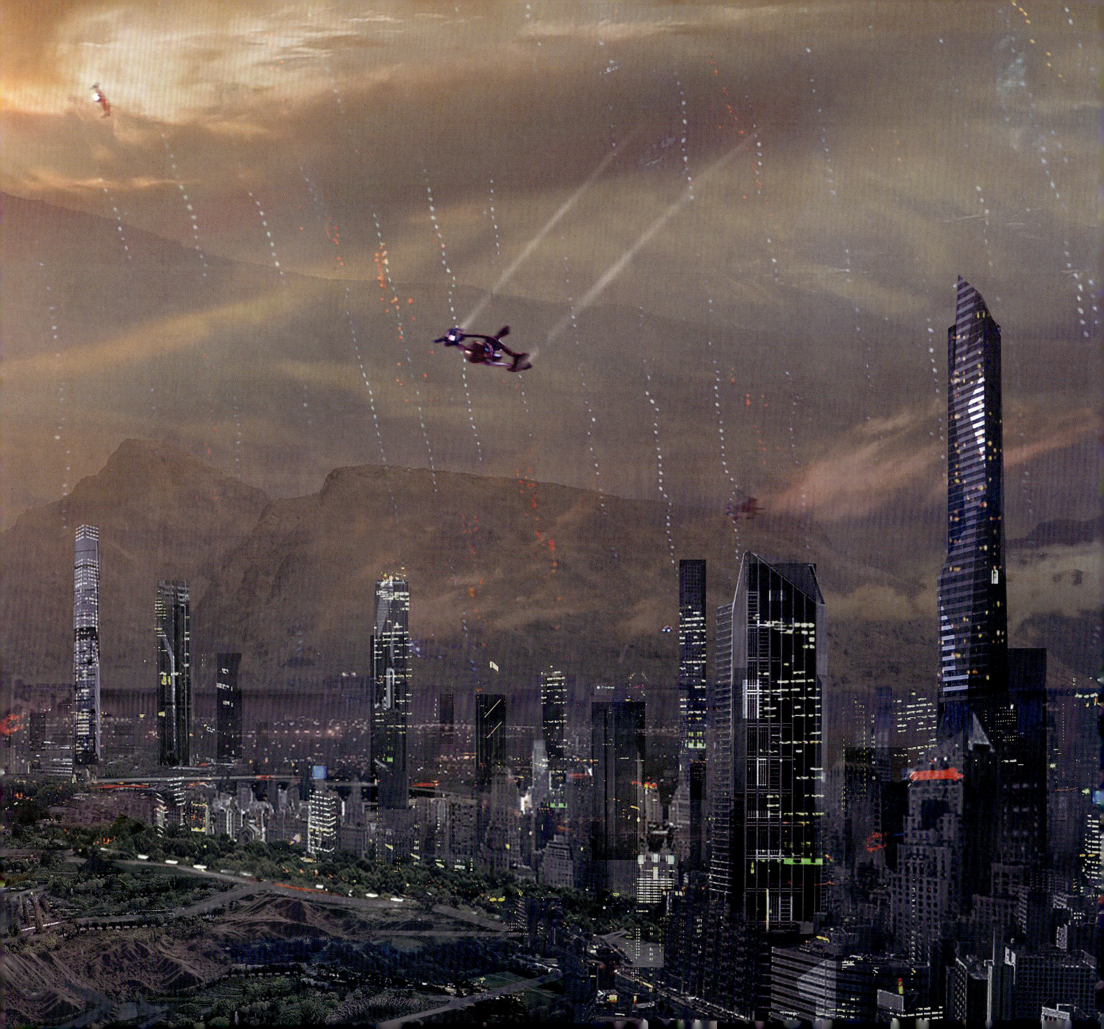

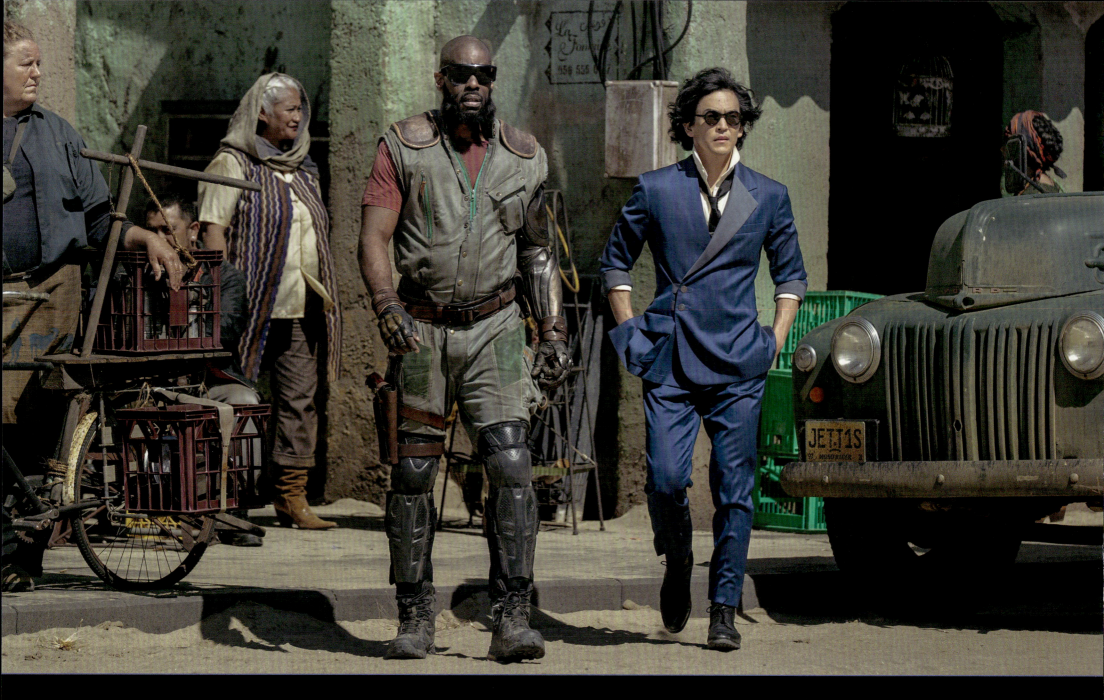

▲ Spike and Jet on the hunt for their next bounty.

▶ Spike meets Katerina for the first time.

▶▶ John Cho (left) and Mustafa Shakir share a lighter moment on set.

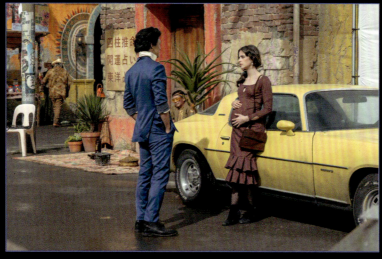

"It's producible for the most part," Clements adds. "Every episode you're on the same spaceships with the same people. You just have to decide who your antagonists are. So right away it was like, 'We have to do this live action.'"

Nic Louie points out that another aspect of *Cowboy Bebop* that makes it more relatable is the age and maturity of the characters. "From a character point of view, and looking at a lot of popular anime, *Cowboy Bebop* is different. A lot of the popular shows are often shonen and so tend to have that fiery, enthusiastic, teenaged protagonist that's often associated with that genre. And the thing I like, and why people recommend *Cowboy Bebop* as a gateway show, is because it's an older protagonist. It's a little bit more grounded in character and emotion and backstory."

The Tomorrow Studios trio took *Bebop* to Midnight Radio, a production company founded and run by seasoned writer-producers André Nemec, Jeff Pinkner, Josh Applebaum, and Scott Rosenberg. Nemec's first exposure to the anime had been years earlier, when he'd questioned his brother one day about the "funky, groovy" music playing in his car. It turned out to be Yoko Kanno's eclectic soundtrack from the anime series. Nemec's brother quickly made a detour to his house to introduce Nemec to the show. "I remember thinking, 'Wow, this show is a pretty snappy, pretty cool, kind of eclectic bit of anime poetry.' I was into it."

While he was up to speed on the series when the Tomorrow Studios crew pitched it, Nemec also knew enough to be a little intimidated. "*Bebop* is crazy," Nemec says. "And it's cool. It's terrifying because it is so beloved. But nothing better than being a little terrified when you start a job. And when you're in the middle of a job, I think that a little bit of that terror goes a long way to nurture the material. We began the process of figuring the show out; we brought in Chris Yost to write the pilot. Together, we worked on crafting the story and script details. And *Cowboy Bebop* was born."

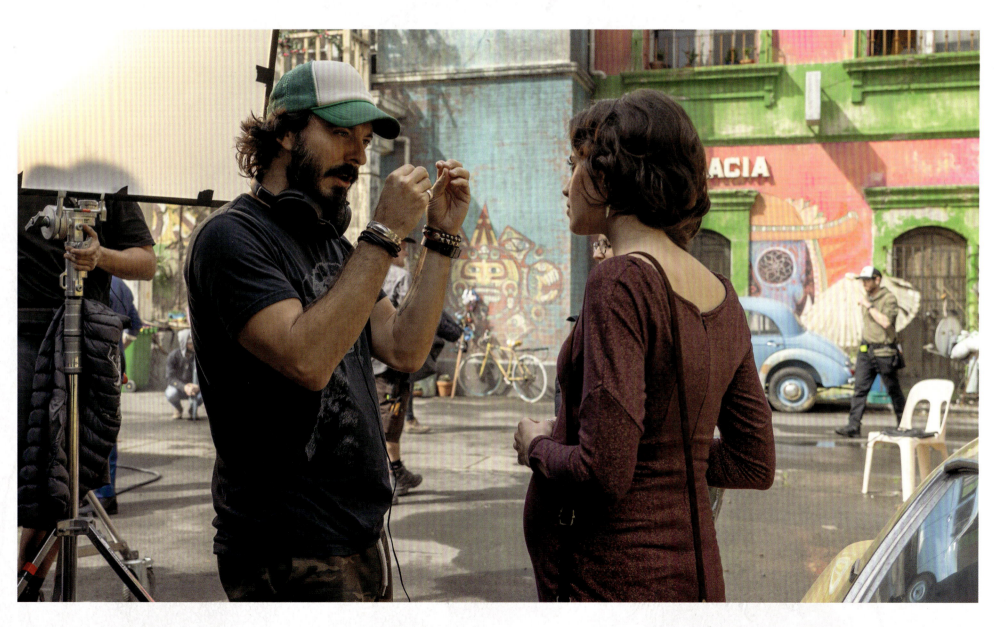

▼ Director Alex Garcia-Lopez lines up a shot with Katerina (Lydia Peckham).

THE ULTIMATE BOUNTY

◀ Filming a scene in Ana's Bar with actor Mason Alexander Park (Gren).

▼ On location setting up a shot for Earthland.

▶ Director Michael Katleman (with mask) prepares Daniella Pineda for a fight scene.

Original *Cowboy Bebop* creators Sunrise signed off on the idea. "The original creators of the anime granted us license to make our version of *Cowboy Bebop*," Nemec says. "We talked a little bit about inspirations, where things came from, what they were. They were very generous in letting us play freely in their sandbox. They were also very generous in sharing as much material as they had to share with us: piles and piles of original sketches and drawings, concept art that they had done when they created the anime. Variations on characters, planets, props and the such. How they made the choices that ended up in the anime. As well, we talked a lot about their inspirations. And for us that was hugely valuable because we like to say around here, 'If it ain't broke in the anime, we shouldn't try to fix it.'"

Nemec pushed the idea that they were not necessarily remaking the *Cowboy Bebop* from the 1990s. "We want to live in the spirit of *Cowboy Bebop*. So we asked ourselves: What was the spirit of the anime? The spirit of this character? The spirit of that ship? What was the spirit of this episode's story? And from that we drew inspiration. This is not my first adaptation of something, and I think it's important when you make an adaptation that you live in the material. You honor it. But you also need to craft a story that people haven't seen before so you can serve them a new meal. Inherently, that's a double-edged sword. Some people are thrilled to be getting

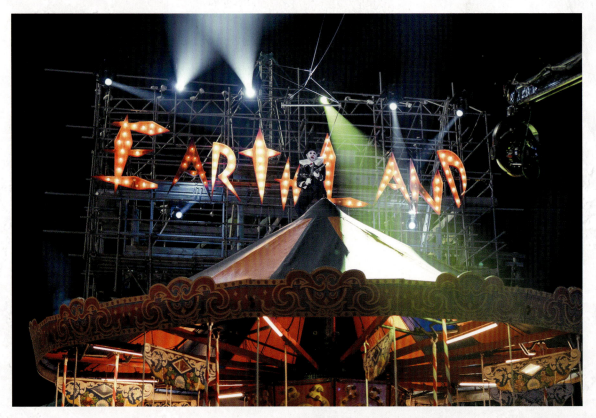

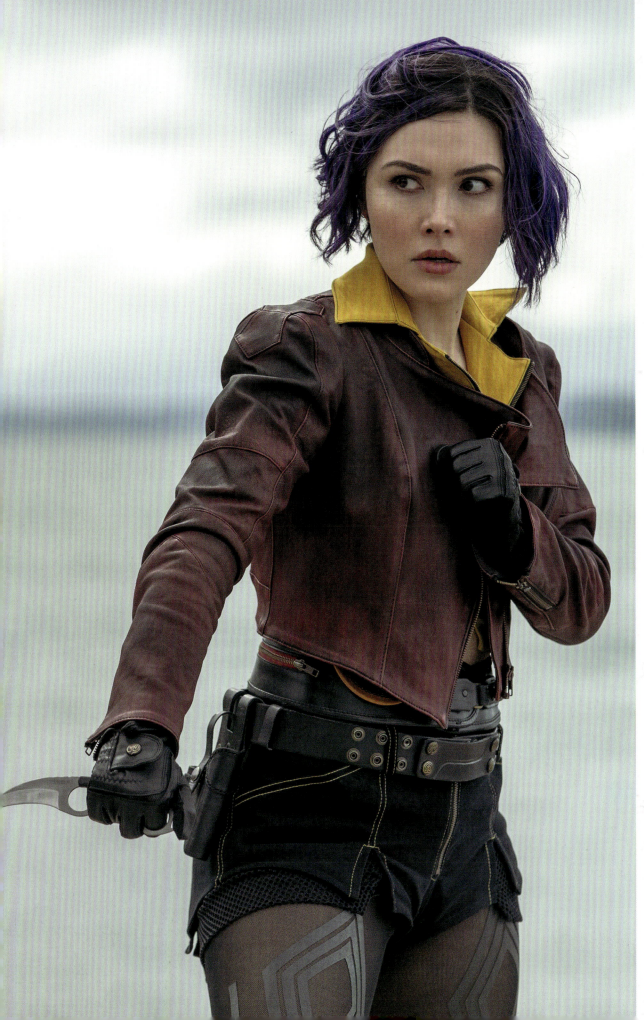

THE ULTIMATE BOUNTY

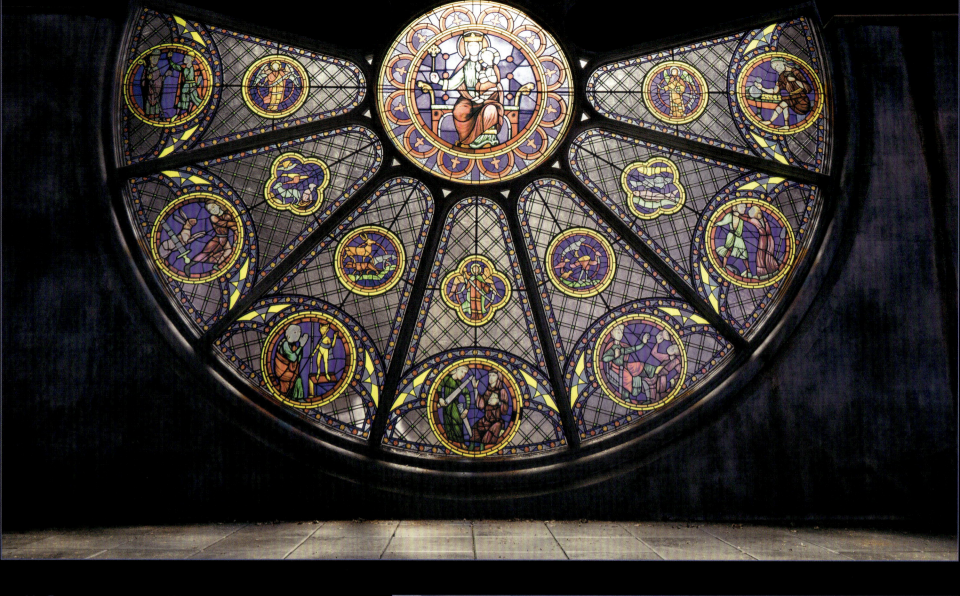

> "*COWBOY BEBOP* IS SO SPECIAL TO SO MANY PEOPLE, AND HAS BECOME THIS MASSIVE CULTURAL PHENOMENON."
>
> ALEX HASSELL (VICIOUS)

▲▶ The cathedral setting from the anime was painstakingly recreated for the live-action series.

new tastes. An expanded story. And some people will always be somewhat agitated by the treading on the hallowed ground of the story that came before. But I think that's okay—we are crafting a story that we love and that we are thrilled to be telling."

For Nemec the biggest challenge and driving idea was to broaden and deepen the story behind the anime and its characters, recognizing that animation brought a level of stylization that spoke for itself, while live action would require more in terms of dialogue and background to support it. "The truth is, you're never going to be able to cast real people to fill the roles of the exact characters from this anime. So we needed to fill them out in order to really know what we were looking for [in terms of casting them]. But once we did know what we were looking for, I can't say the casting process got easier. We met with and auditioned lots and lots of people. And it was a trip seeing the characters start to come to life through different actors' embodiments."

Adding to the background of Spike Spiegel, Jet Black and Faye Valentine also meant expanding on the characters of Spike's bitter enemy Vicious, and Julia, the fulcrum of their deadly love triangle. "Vicious is a real cipher in the anime, and Julia is mostly just an idea of a person," Nemec explains. "We felt it was important to detail out the characters in order to build out a season's worth of stories (sessions), many of which have an anthological component to them. Chasing bounties, and the 'life and times' of Spike Spiegel and Jet Black, etc. But there's also a strong serialized component. To address overall narrative themes. And to evolve the characters beyond the anime. Such as to explain why Spike and Vicious have this strong mutual animosity. This required expanding the canon."

With all the work and development, Nemec says he and his team had one mantra in mind. "One of the things that we say quite a bit around the offices and on set: 'This is *Cowboy Bebop*. This is kind of hallowed ground. It's a lot to tread on. So let's not fuck it up.'"

◄▼ Rehearsing a fight scene on the cathedral set.

▼ Ein was played by muliple corgis. The main one's real name is Harry.

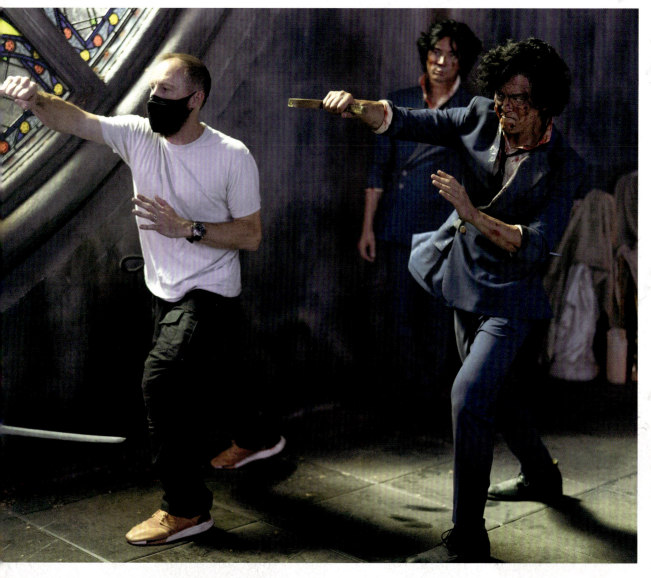

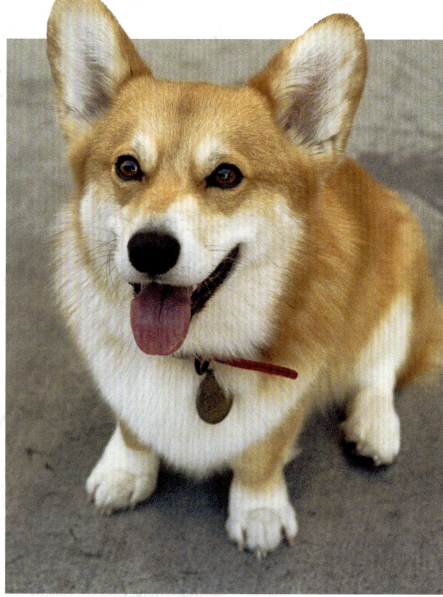

THE ULTIMATE BOUNTY 19

THE *BEBOP* FEEL

With writers Jeff Pinkner, Scott Rosenberg, Jennifer Johnson, Javier Grillo-Marxuach, Liz Sagal, Karl Taro Greenfeld, Vivian Lee, Sean Cummings, and Alexandra E. Hartman adapting storylines from the original anime, and Alex Garcia Lopez and Michael Katleman set to direct the first-season episodes, a team of talented artists gathered to develop the visual look of the live-action series, beginning with famed production designer Grant Major (of Peter Jackson's *King Kong* and *The Lord of the Rings* films) beginning the conceptualizing of the *Bebop* spaceship interiors and other elements before being succeeded by Gary Mackay of *Shadow in the Cloud*, who would complete oversight of the first season design after Major departed to work with director Jane Campion on a film project. Art directors on the show include Robert Key, Helen Strevens, Alistair Kay, Mike Becroft, Craig Wilson and Simon Hall, with set decoration by Anneke Botha and her crew.

From the beginning, capturing the eye-popping visual feel of the anime while balancing it with the reality of flesh-and-blood actors and practical sets became a major challenge. Jean-Philippe Gossart (of *The Witcher* and *Into the Badlands*), Dave Perkal (*Castle*, *The Vampire Diaries*), and Tom Burstyn collaborated as directors of photography. "Alex Garcia Lopez worked with [Jean-Philippe Gossart] on *The Witcher*, so the directors always have people that they pitch and then we find people," Becky Clements says, noting that incorporating some specific, stylistic elements of the anime's lighting and camera angles is part of the live-action show's marching orders. "It's very film noir, definitely all this Julia flashback stuff—a lot of the fights have a film noir look to them. And then the anime has some very interesting angles, so we tried to tip our hat to the extreme angles that they used where we could. I think we added on top of that a layer of entertainment value—we still call it the *Bebop* feel, which is

All the departments strove to give *Cowboy Bebop* its own distinct look.

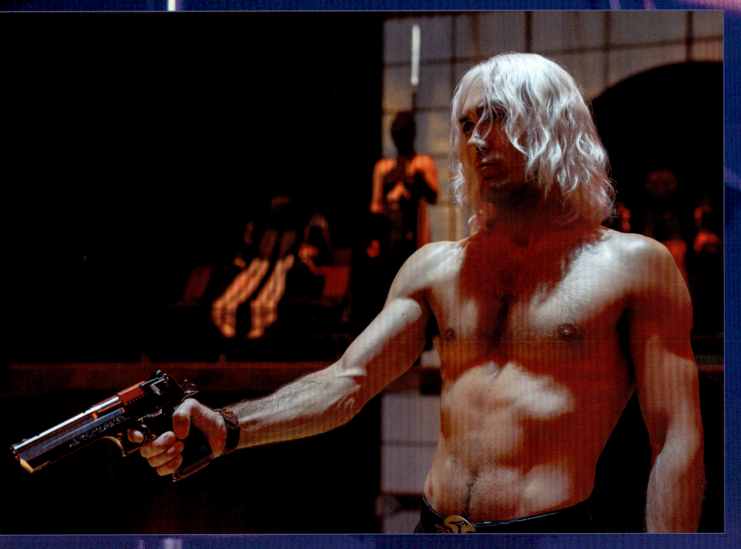

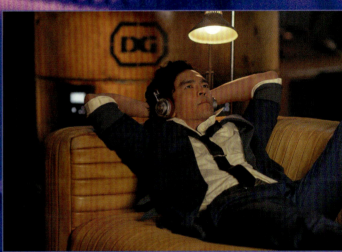

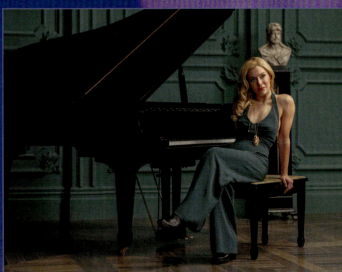

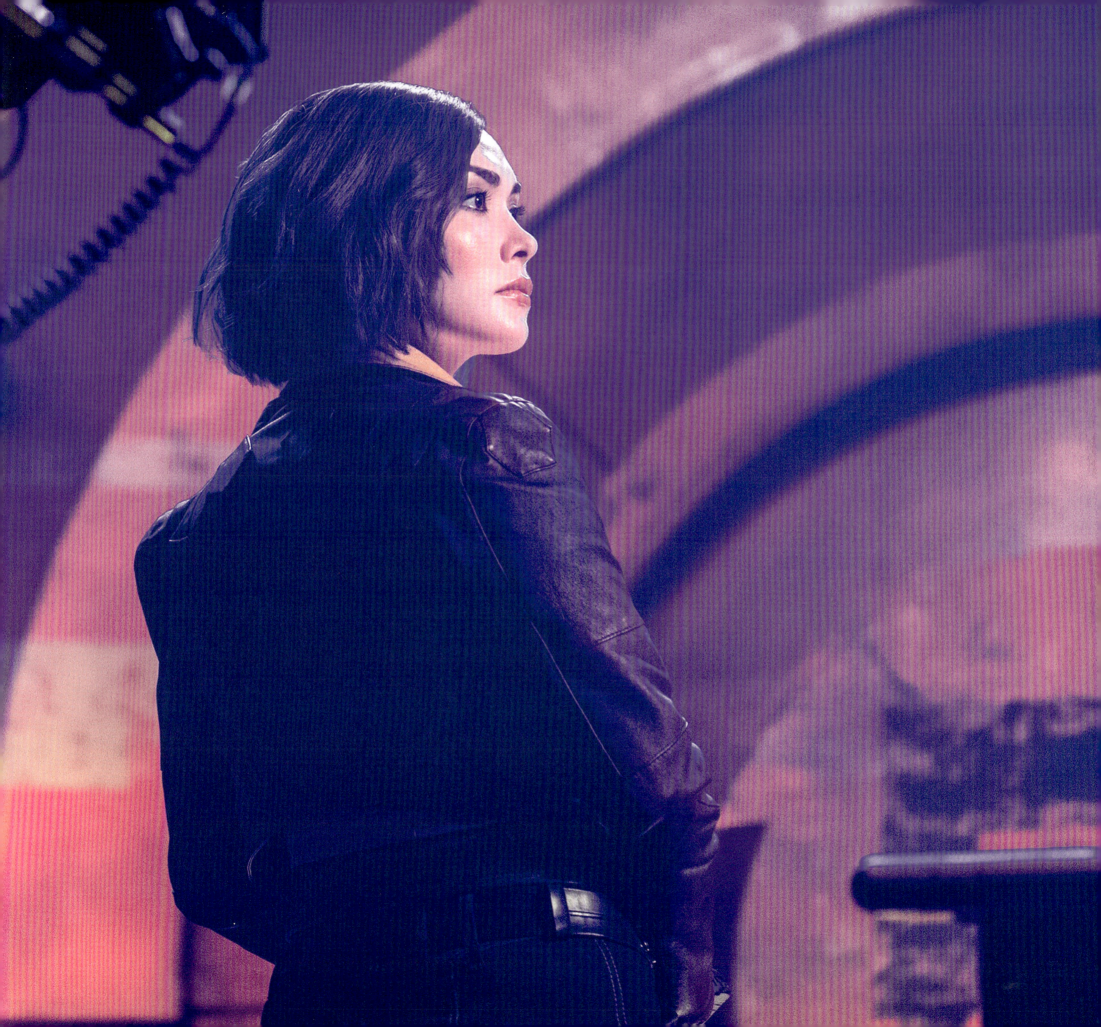

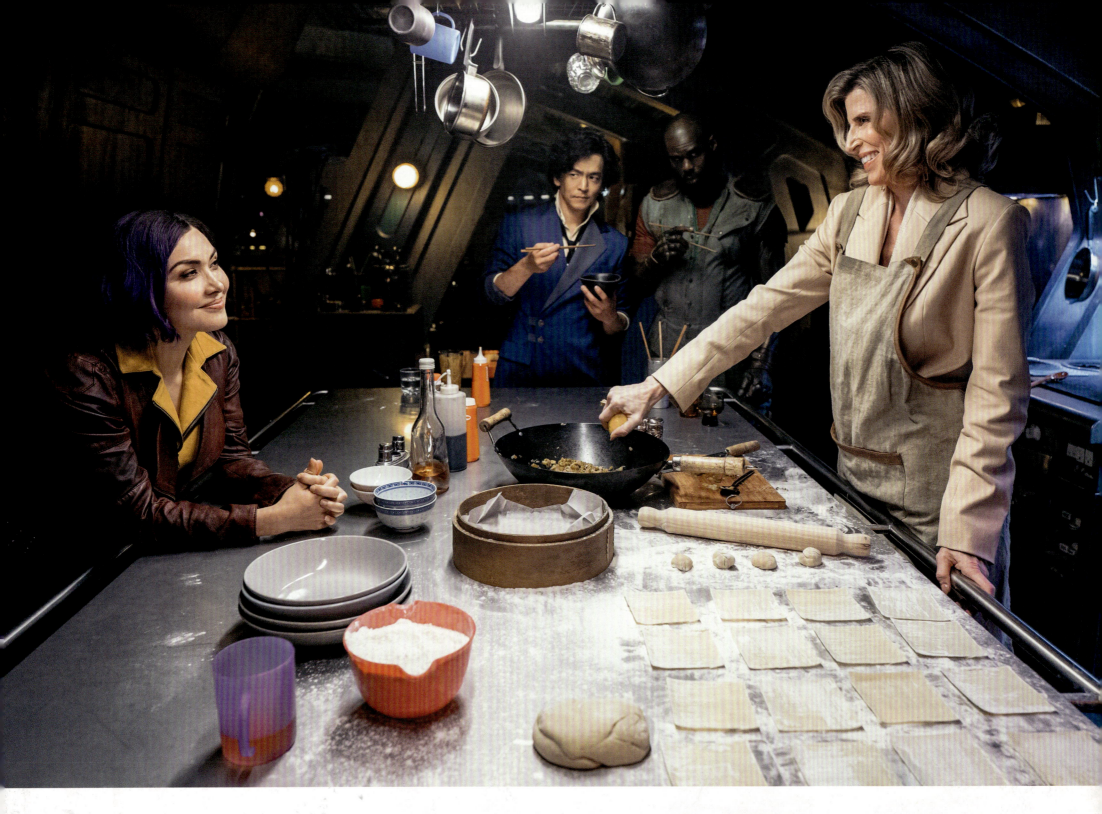

kind of poppy and energetic, with witty dialogue. It's like breaking out of that film noir vibe in those moments when Jet and Spike are giving each other a hard time or we're on the *Bebop* because then you add the music on top of it. It's its own tone. I don't know that you could ever call it truly film noir in the cinematography because you have a guy in a blue suit with a yellow shirt and [we have a woman with] purple blue hair. So that kind of gives it a little bit of a heightened feel."

Gary Mackay and the art team helped build the look of the show from the ground up and coordinated with visual-effects co-supervisors Victor Scalise and Greg McMurry and visual-effects co-producers Scott Ramsey and Gene Kozicki to work out the approach to the spacecraft exteriors, the look of the show's outer-space action, and even some of the science-fiction concepts behind the stories and the look of the show. "There's just months and months of set designing," Mackay says. "We've probably had four different

▲ Episode 107 introduces us to Whitney (Christine Dunford), the woman who might be Faye Valentine's mother.

▶▲ Shooting a shoot-out with the Syndicate.

▶ Concept art for a casino in space.

22 COWBOY BEBOP MAKING THE NETFLIX SERIES

set designers work on this simultaneously or at different times and do every panel and every moment of detail.

"We spent months designing these spaceships' interiors, and then we would hand them over to the VFX guys, and then work and develop from there and just keep the discussion going about size, scale, color, and texture. And then obviously they take all the LIDAR scans and everything off the inside and the outside of assets, so they are texturing with textures that we've done for real. I think we had probably at their peak six, maybe seven concept artists working at the same time. So that's the monthly art preparation leading in."

> "WE'VE PROBABLY HAD FOUR DIFFERENT SET DESIGNERS WORK ON THIS [SHOW] SIMULTANEOUSLY OR AT DIFFERENT TIMES."
>
> **GARY MACKAY, PRODUCTION DESIGNER**

CHARACTERS

Bringing iconic characters Spike Spiegel, Jet Black and Faye Valentine to life meant finding the right actors with the right mystique, costuming and accessorizing them to reflect the classic look of the original anime—and sometimes updating their look to match up with 20 years of social change.

SPIKE SPIEGEL

Cowboy Bebop's hero is sardonic Spike Spiegel. Born on Mars, he worked as an enforcer for the Syndicate, with that experience adding to his deadly skill set to make him a very efficient killer, with his own style of well-practiced martial arts. During his years in the Syndicate, Spike develops a complex friendship with another enforcer, Vicious, and eventually becomes embroiled not only in a love triangle with his fellow Syndicate killer but also in the problems the unpredictable Vicious begins to cause for the Syndicate, all leading to a fateful showdown that provides Spike with the opportunity to disappear and leave the Syndicate world behind.

Spike's familiarity with the Syndicate and his skill at fighting, killing and surviving proves to be the perfect groundwork for a career as a bounty hunter—a cowboy. And former ISSP officer Jet Black proves to be the perfect partner—as long as Spike can keep the secret of his criminal past from him. But the problem with being a cowboy is that the job can take you into all sorts of low places—like Syndicate territories where Spike might be recognized for his criminal past. Consequently, Spike is sometimes torn between going after a good bounty and keeping his ties to the Syndicate buried deep. Writing and casting *Cowboy Bebop*'s iconic hero proved to be one of the biggest challenges for the live-action series. "In the anime, the characters are drawn," says André Nemec. "Because of the nature of the anime being a little bit more poetic in its storytelling, and some of the characters being more archetypal in their rendering—things that were hinted at, but not necessarily concretized—we needed to build out deeper backstories for them. As an example, Spike Spiegel at his core is a cowboy, with a longing past and a broken heart.

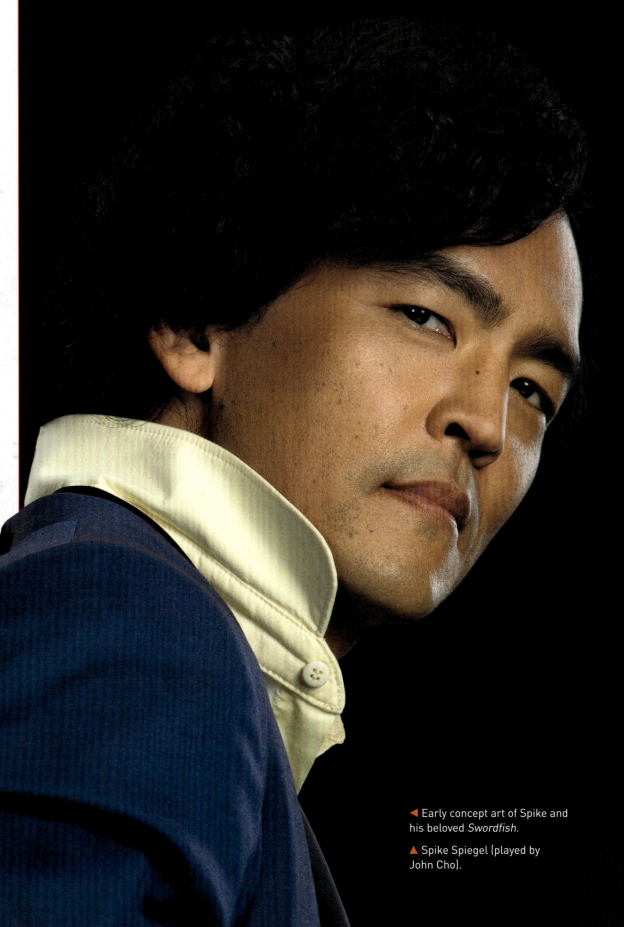

◀ Early concept art of Spike and his beloved *Swordfish*.

▲ Spike Spiegel (played by John Cho).

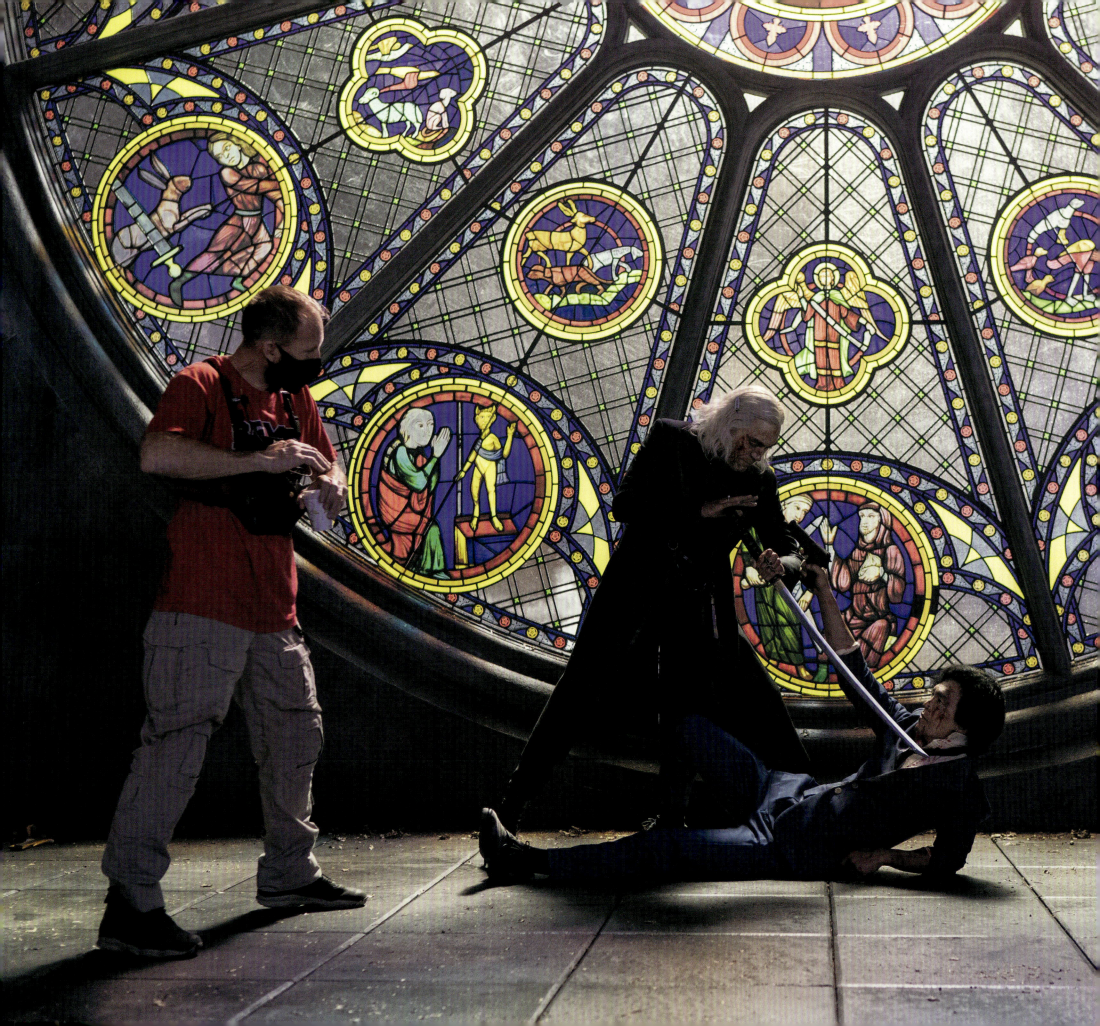

◀ Rehearsing the climactic fight between Spike and Vicious in the cathedral.

So while there is a tough, slick, iconic exterior to Spike Spiegel, there is an internal pain that drives him, and he covers that pain with his laconic presentation. But there needs to be a real person underneath that. So we ask, 'Who is he?', 'What is the history that feeds the internal pain?', and 'What is the story we want to tell about him?' And that real person we defined through a history that we were looking at and that we built for that character." John Cho, who had previous spaceflight experience playing Sulu in three *Star Trek* films, as well as a cult following from the comedic *Harold and Kumar* films, landed the part of Spike. "I was a big believer in John," Nemec says. "I knew John was a deep actor, with real talent. And a very funny streak in him. He's clever. He definitely delivers one-liners well. But more importantly, I felt like Spike Spiegel shouldn't be played by a comedian; we really needed to get an actor. We really needed to cast someone who could deliver both on the Spike from the anime [and] also on the Spike that we were writing. The cowboy with a broken heart."

"I very much identify with Spike Spiegel myself," Marty Adelstein says. "He's a guy who has a lot of moves that you don't necessarily know what his complete motivation is. And I always liked the way it was uncovered in the anime. If we're talking about Spike, John Cho was the best choice we could have ever found. He really has his personality down; even the way he talks is how I imagine Spike speaking, and he has that wink in his eye, which I've always been

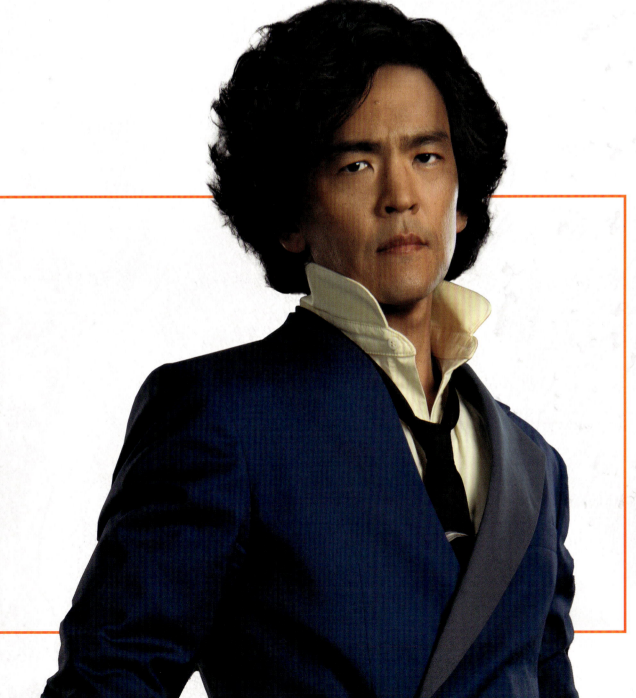

> "I LIKE SPIKE. I WANT HIM TO FIND LOVE AND HAPPINESS AND PROSPERITY."
>
> **JOHN CHO (SPIKE)**

CHARACTERS 27

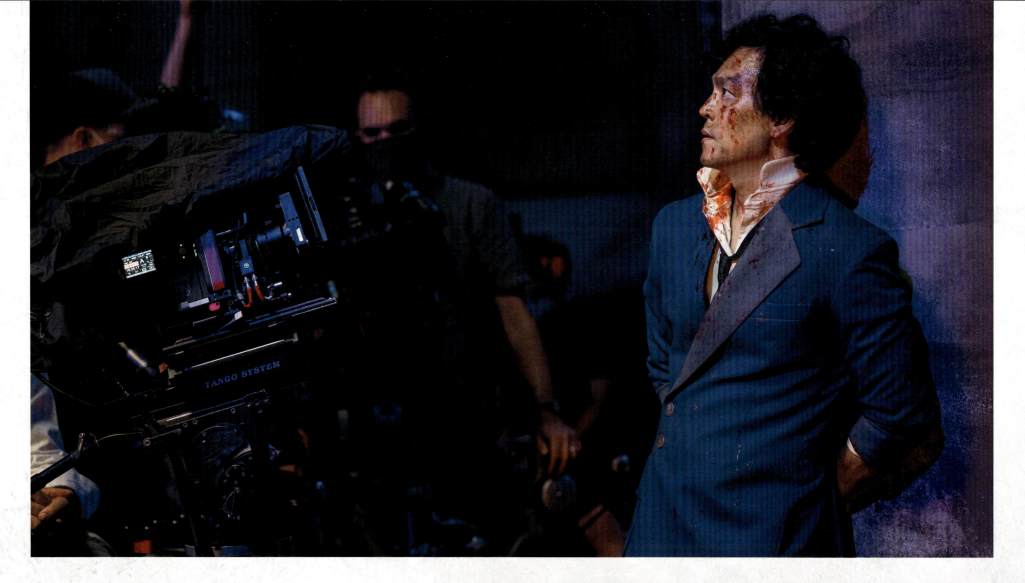

attracted to in the character."

"Spike had to be cool," Becky Clements adds. "The whole thing is cool, but Spike Spiegel in particular had to have an attitude and a presence that felt like the actor embodied it on a cellular level. And John Cho is super cool. There had to be a lot of confidence to the actor. It's a terrifying proposition to play a live-action version of an iconic character and also the physicality, being able to handle [action]—when he fights he makes it feel effortless. So there had to be [a] cool[ness] and competence to the actor, and John was that [when] we met with him. You could immediately feel him recognizing the scale and scope of the role from a physical level, but also the confidence to be able to try to take a run at pulling this character off that people are going to have a lot of opinions about."

Nemec says that both he and Cho acknowledged the "scary" challenge of taking on such an iconic character. "He took on the challenge, and he has been nothing but Spike Spiegel. I recently had a conversation with someone where they said to me, 'You know, for all the talk that we had a couple years ago about who would be Spike, I can't see any other person being Spike Spiegel but John Cho.' And that is as true as true gets."

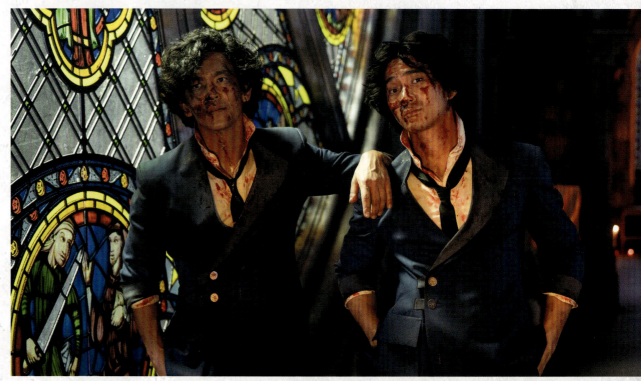

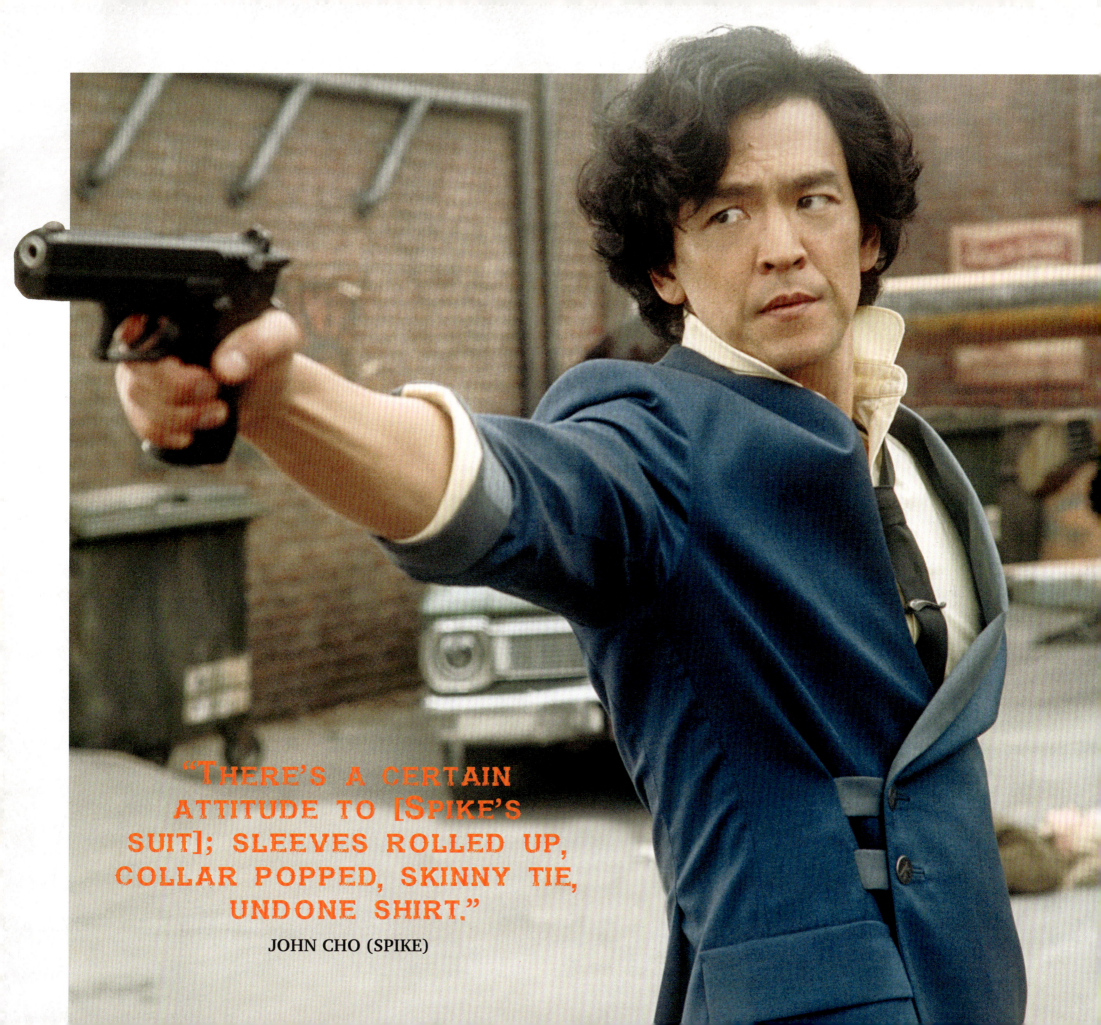

"THERE'S A CERTAIN ATTITUDE TO [SPIKE'S SUIT]; SLEEVES ROLLED UP, COLLAR POPPED, SKINNY TIE, UNDONE SHIRT."

JOHN CHO (SPIKE)

JET BLACK

Hulking Jet Black bears the scars of his former work for the Intra Solar System Police. He lost the use of his arm in the line of duty, necessitating its replacement with a mechanical arm and hand, and he was also shot in the face at one point. An eyepatch pad covers that scar, but a vertical slash is still visible on his cheekbone and forehead, giving Jet a piratical look that combines with his gruff, tough-talking manner to create a formidable presence. Jet left the ISSP under grim circumstances, framed and jailed—possibly by someone on the force—for a crime he didn't commit, making him a pariah to the ISSP and forcing him to pursue the only livelihood a man of his background can: as a bounty hunter.

Adding to the bitterness of his betrayal by someone in the ISSP, Jet's wife left him for the man that Jet suspects framed him, adding great difficulty to Jet's determination to reconcile with her and stay involved in the life of his young daughter Kimmie.

Contrasting with his rough-hewn appearance and crass language, Jet Black has a cultured side—the *Bebop* is Jet's ship, named because of Jet's love of jazz music, and the ex-ISSP officer also raises bonsai trees and cooks, all while maintaining the spacecraft and taking the practical side of his work a bit more seriously than Spike does.

While Spike Spiegel takes a more relaxed approach to his shipboard duties, Jet is a jack-of-all-trades who's frequently annoyed at the laid-back attitude of Spike and later of Faye Valentine when she

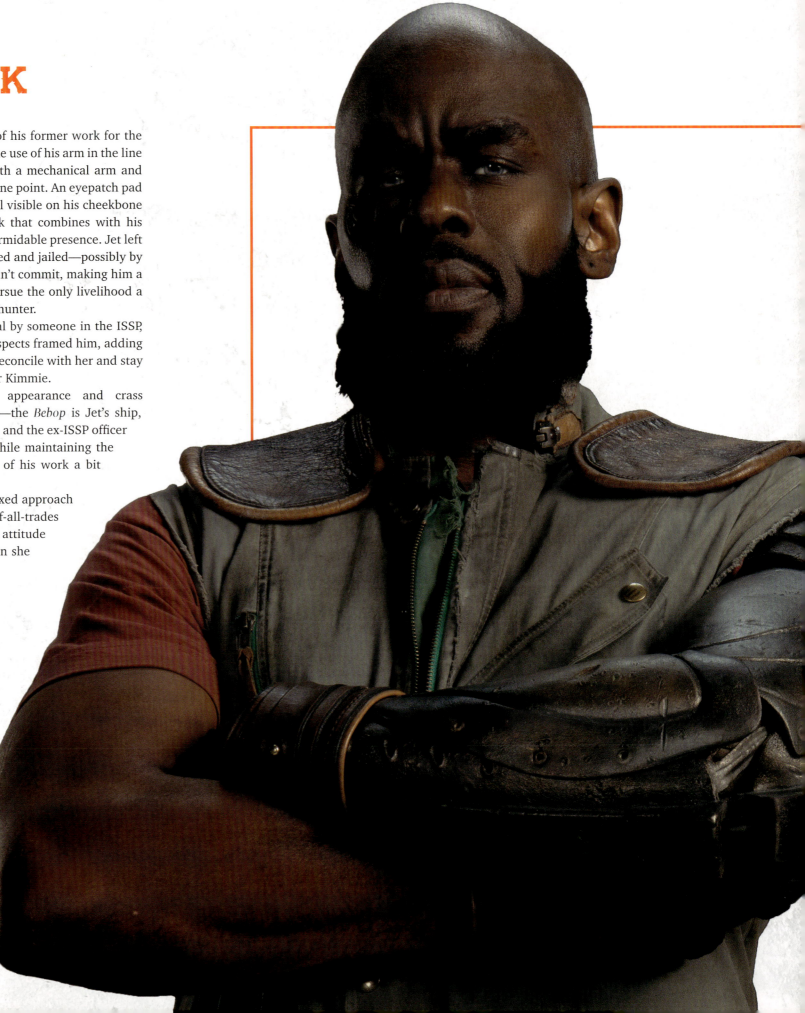

▶ Jet Black (played by Mustafa Shakir).

▶▶ Concept art for Jet's mechanical arm. Jet's arm would be a practical prop/wardrobe piece, not CGI.

becomes a regular presence on the *Bebop*. Jet is fiercely loyal to Spike and his trade, but he is completely unaware of Spike's criminal past, and Spike's struggle to stay one step ahead of the Syndicate and hide his connections to the crime gangs from Jet adds a level of tension and suspense to their relationship.

André Nemec says that the key to Jet Black was a mix of strength, a devotion to family, and a damaged past that has led him to becoming a cowboy and making a home for himself on the *Bebop*. "But he's also an optimist at heart, a man who, when losing a bounty at the end of any given day, takes it in and truly believes… 'We'll get the next one.'"

New York actor Mustafa Shakir landed the role. "Mustafa has this undeniable appreciation for life," Nemec says. "As a person, he has this true beauty inside him. To quote Mustafa, he's the guy who says, 'You know, I love love.' He's a strong guy with a heart full of jellybeans. He was the first actor we cast on the show, he set a standard for us in terms of the talent he brings."

The buddy cop relationship between Spike and Jet Black was one of the most appealing aspects of the *Cowboy Bebop* anime, and a vital element to recreate in the live-action series. "Obviously,

CHARACTERS 31

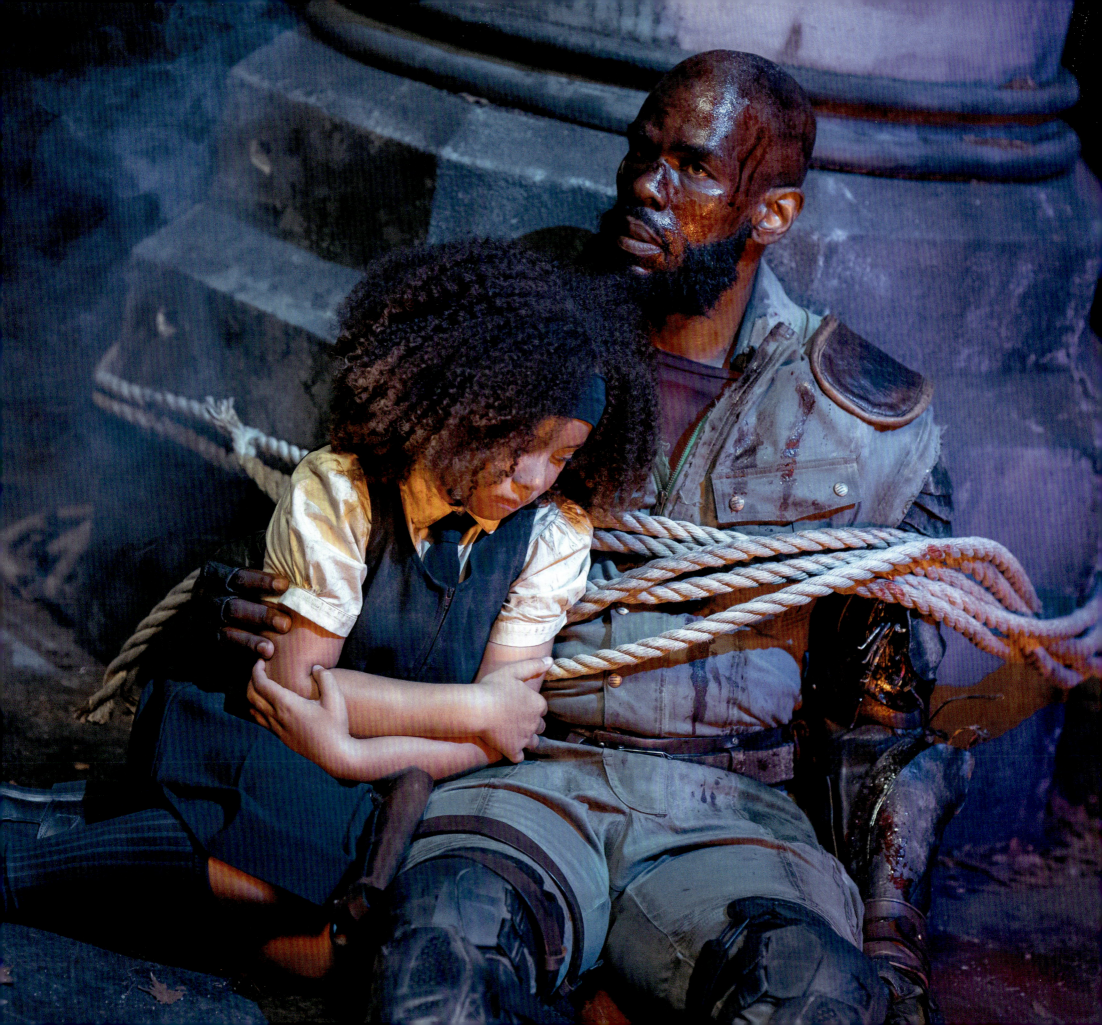

◀ Jet Black and his daughter Kimmie (played by Mollie Moriarty).
▼ Concept art for Jet's motorcycle.

whenever you're doing these, you want to stay as close as possible to the anime and add something special because the fans are so rabid about these characters, and the relationship between Jet and Spike was really what we wanted to capture more than anything," Marty Adelstein says.

"Jet has to have that almost 1950s, inflexible, fatigued, grumpy dad feeling to him, with a big soft heart at the center," Clements adds. "Mustafa has these beautiful eyes. And when you speak to him, he's a very gracious and open person. When we flew him out to read, you could feel both sides to the character of Jet Black, which is impatient and tired about life, but also has a lot of heartbreak and loss about how his life has turned out, and Mustafa just possesses both of them."

Adelstein agrees that Shakir brought the right combination of power and vulnerability to Jet. "It was funny because I've had it happen on a number of shows where you see a lot of people and the right guy walks in, and you realize you have the right guy. [Mustafa] was vulnerable. [Jet's] relationship with his daughter and what he goes through to get the doll and things like that just make him a very appealing, attractive character who has been screwed over by society at that point. He's a particularly great character. It seems like [he'd] be the heart of the show, and in some ways he really is the emotional heart."

> "I RELATE TO JET AND HIS DESIRE FOR HONESTY AND TO DO WHAT IS NECESSARY IN THE GIVEN MOMENT."
>
> — MUSTAFA SHAKIR (JET)

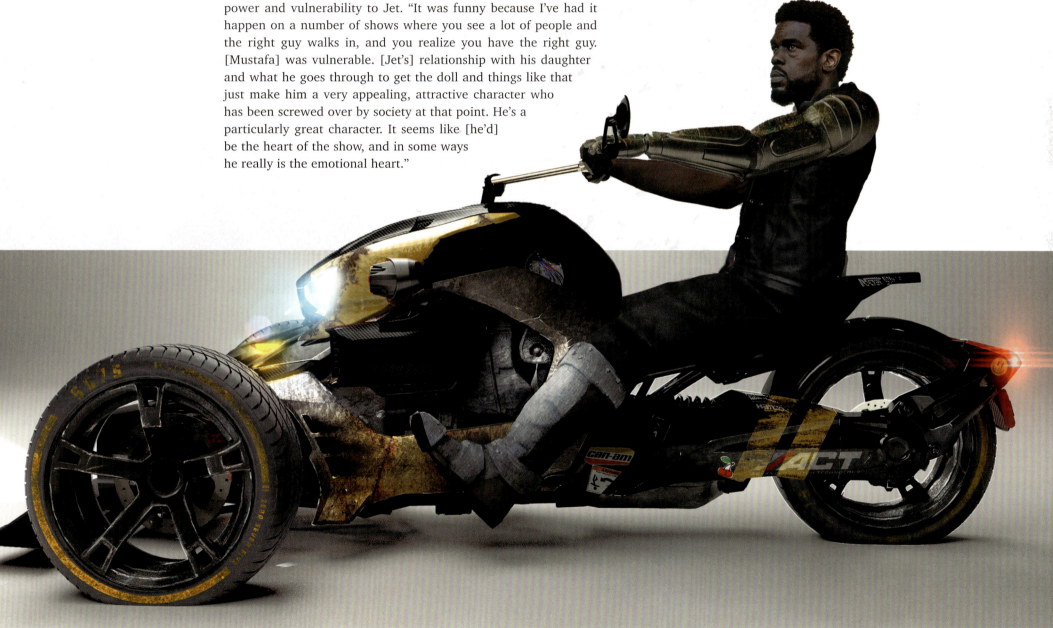

CHARACTERS 33

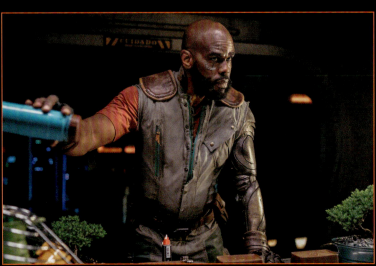

◄▲► Throughout the first season Jet feels feels like the galaxy is constantly against him, but he doggedly perseveres for the sake of his beloved daughter Kimmie.

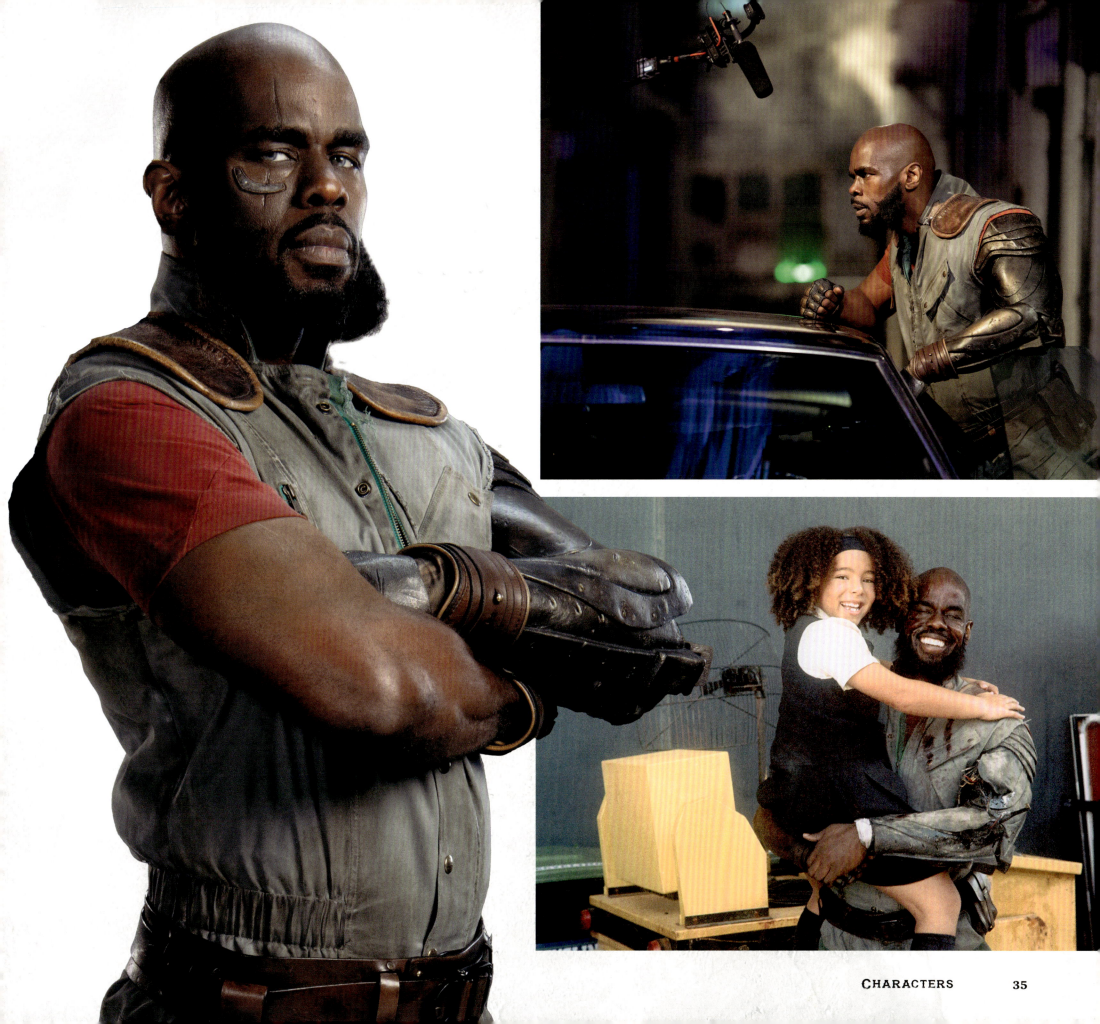

CHARACTERS 35

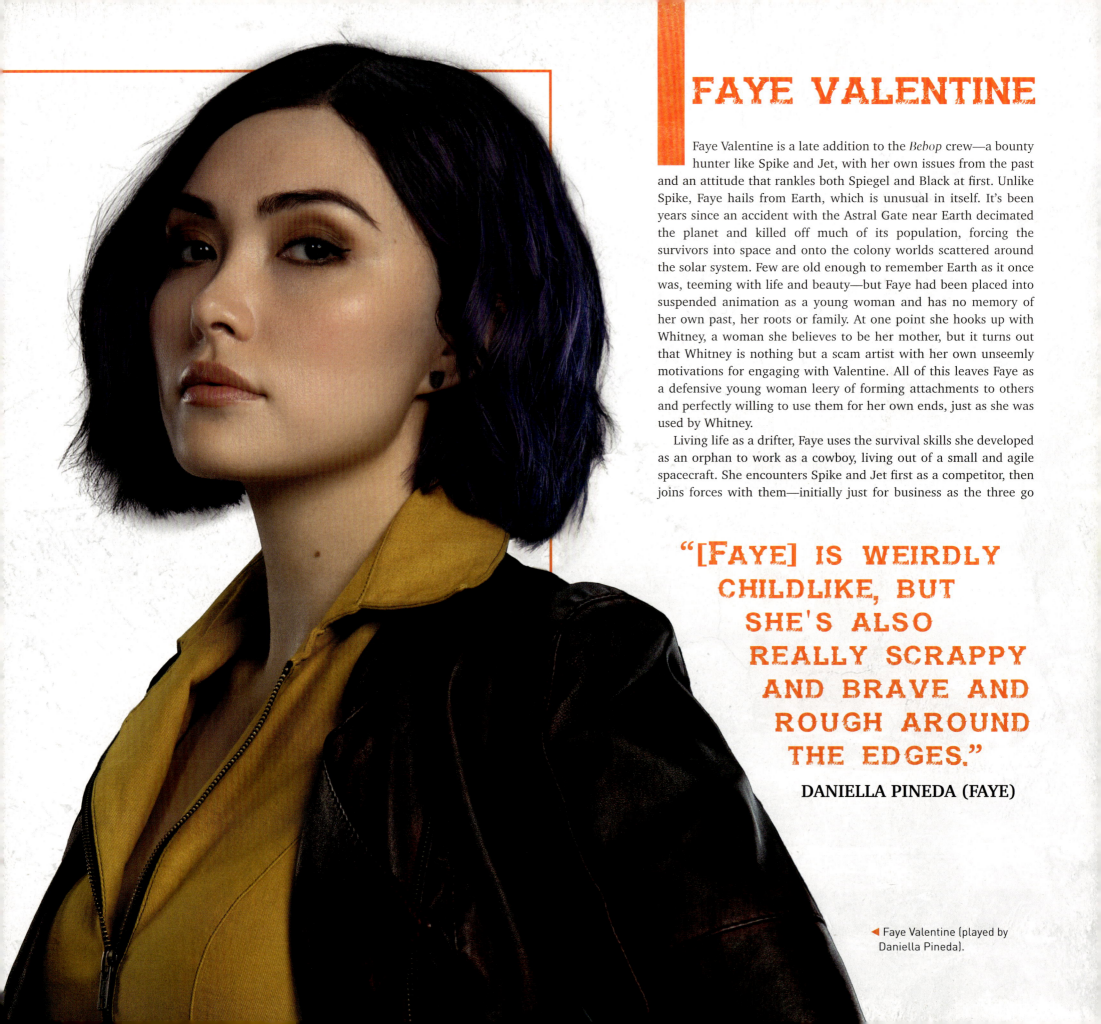

FAYE VALENTINE

Faye Valentine is a late addition to the *Bebop* crew—a bounty hunter like Spike and Jet, with her own issues from the past and an attitude that rankles both Spiegel and Black at first. Unlike Spike, Faye hails from Earth, which is unusual in itself. It's been years since an accident with the Astral Gate near Earth decimated the planet and killed off much of its population, forcing the survivors into space and onto the colony worlds scattered around the solar system. Few are old enough to remember Earth as it once was, teeming with life and beauty—but Faye had been placed into suspended animation as a young woman and has no memory of her own past, her roots or family. At one point she hooks up with Whitney, a woman she believes to be her mother, but it turns out that Whitney is nothing but a scam artist with her own unseemly motivations for engaging with Valentine. All of this leaves Faye as a defensive young woman leery of forming attachments to others and perfectly willing to use them for her own ends, just as she was used by Whitney.

Living life as a drifter, Faye uses the survival skills she developed as an orphan to work as a cowboy, living out of a small and agile spacecraft. She encounters Spike and Jet first as a competitor, then joins forces with them—initially just for business as the three go

> "[FAYE] IS WEIRDLY CHILDLIKE, BUT SHE'S ALSO REALLY SCRAPPY AND BRAVE AND ROUGH AROUND THE EDGES."
>
> DANIELLA PINEDA (FAYE)

◀ Faye Valentine (played by Daniella Pineda).

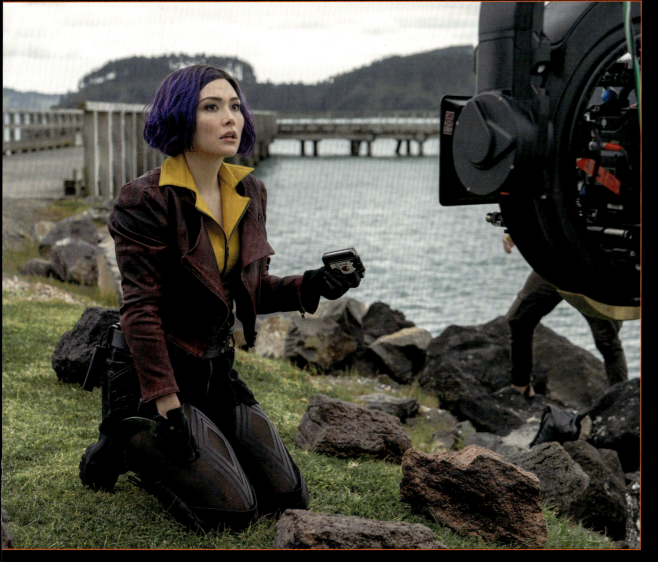

◀▲ Faye is on the hunt for clues to her past. She crosses paths with a woman, Whitney, who claims to be her mother (above).

after some of the same bounties, but eventually Faye's search for her own family ties causes her to find roots with Spike and Jet on the *Bebop*.

Along with Spike Spiegel's space fighter craft the *Swordfish II*, Faye Valentine might be the most iconic image associated with the original *Cowboy Bebop* anime. Wearing a distinctive—and quite abbreviated—yellow top and an equally immodest miniskirt, a yellow headband, thigh-high stockings and white high-heel boots, the anime Faye has the nubile look of a lot of female anime characters, but she also sports an intriguing, mysterious past and a personality that can easily go head-to-head with her fellow cowboys Spike and Jet.

In casting Daniela Pineda as Faye, the showrunners sought to capture the anime character's personality while updating her visual appeal to something a little more practical.

"Faye Valentine was an interesting character because the rendering of Faye in the anime is highly sexualized," André Nemec says. "It felt important to me and my partners that we take Faye Valentine and let the fact that she's a 'clever survivor' take lead. Clever, funny, smart, offbeat, sexy, strong. So you see, 'sexy' wasn't the only word we were leaning into. We looked at Faye's past, her cryo-sleep-induced amnesia, and used that as a jumping-off point—what kind of person survives that event? What kind of person is driven to find answers? And that became a strong point for us in terms of figuring out the character."

Actor, writer and comedian Daniella Pineda (of *Jurassic World: Fallen Kingdom*) provided the perfect mix of high energy and offbeat humor for the character. "Daniela has an ease and effervescence about her," Nemec says. "And she was able to embody that 'clever survivor' from day one. Slicing all of Faye's moments with charm and humour, a kick-ass-take-no-prisoners mindset, and real and deep emotion. And with that trifecta firing on all cylinders, there was no doubt Daniela is our Faye Valentine."

Nemec says that Faye Valentine serves as a "disrupter" who shakes up the easy relationship between Spike and Jet. "We had these two great bounty hunters in Spike Spiegel and Jet Black:

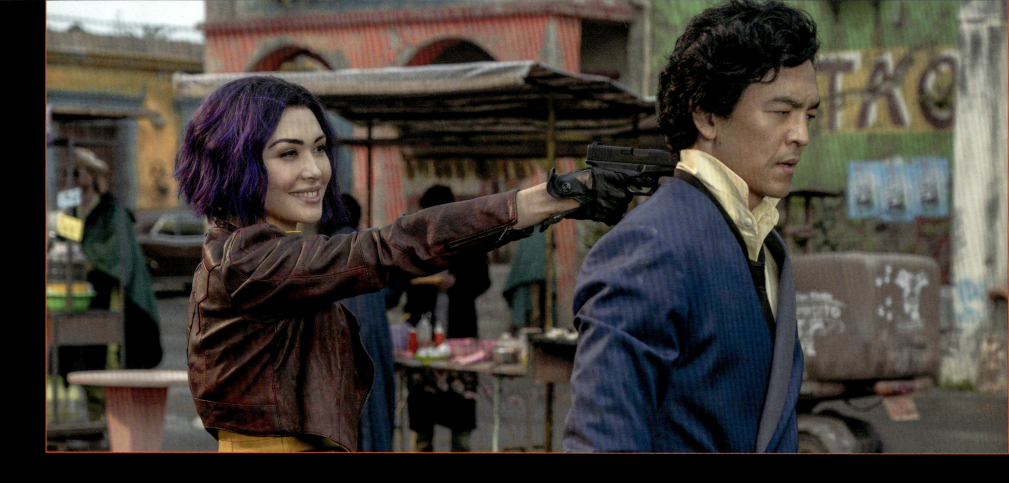

> "WHAT EXCITED ME MOST ABOUT PLAYING FAYE WAS THAT I KNEW I COULD BE ERRATIC AND HAVE FUN AND MAKE REALLY BIG CHOICES."
>
> **DANIELLA PINEDA (FAYE)**

unlikely partners, unlikely friends, two guys who are in a bromance like all of those great buddy cop movies. The addition of Faye Valentine serves—in an incredible way, through her energy—as a disrupter for the guys. A lovable kid sister. That's what Daniella brings in an incredible way through her ease, through her instinct as an actor, through her sense of humor."

Fans of the anime may also notice that Faye as portrayed by Daniela Pineda isn't dressed quite as outrageously as her anime counterpart. "One of our writers was talking about how we took a practical look at the costume," Nic Louie recalls. "In the real world no one can wear that costume."

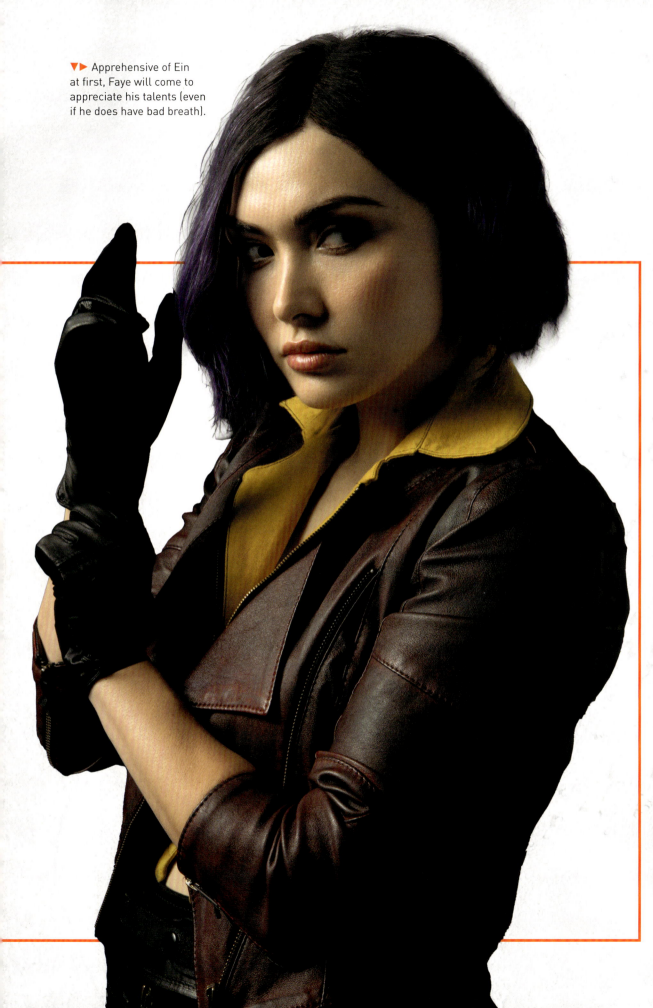

▼▶ Apprehensive of Ein at first, Faye will come to appreciate his talents (even if he does have bad breath).

"It was very simple—she can't beat the crap out of people in those short shorts, suspenders, and flimsy top, that just doesn't work," Becky Clements says. "You can't do anything in that costume but walk. Just simple things like that way of [thinking], 'We have to live in the laws of physics when we're doing this show.'"

Nic Louie says Faye's anime look is endemic to a great deal of Japanese animation, and therefore part of what viewers of a *Cowboy Bebop* show might expect, and the challenge is to reference that and modernize it for contemporary viewers. "I think that's why [sometimes anime] gets this bad rap, but there's tons of different anime out there. There's anime targeted towards young women. There's anime targeted for older women. There's children's anime. A lot of love was put into the show, we wanted it to definitely have moments where it is honoring the original costume, but we just tried to think of what is the practical use of it, and always take it back to the character while still having some of the color elements and some of the look of it. You can clearly see how it's a version of the costume. But definitely it had to be more practical, and it had to fit the character as she is in this show."

One other crucial crew member for the *Bebop* is Ein, the ship's adopted 'data dog', played in the series by a real Pembroke Welsh Corgi. While the anime never really explores Ein's 'data dog' designation, the live-action series finds some dramatic uses for the canine's data and communication capabilities.

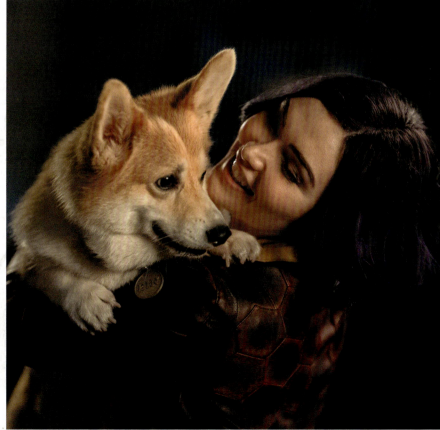

CHARACTERS 39

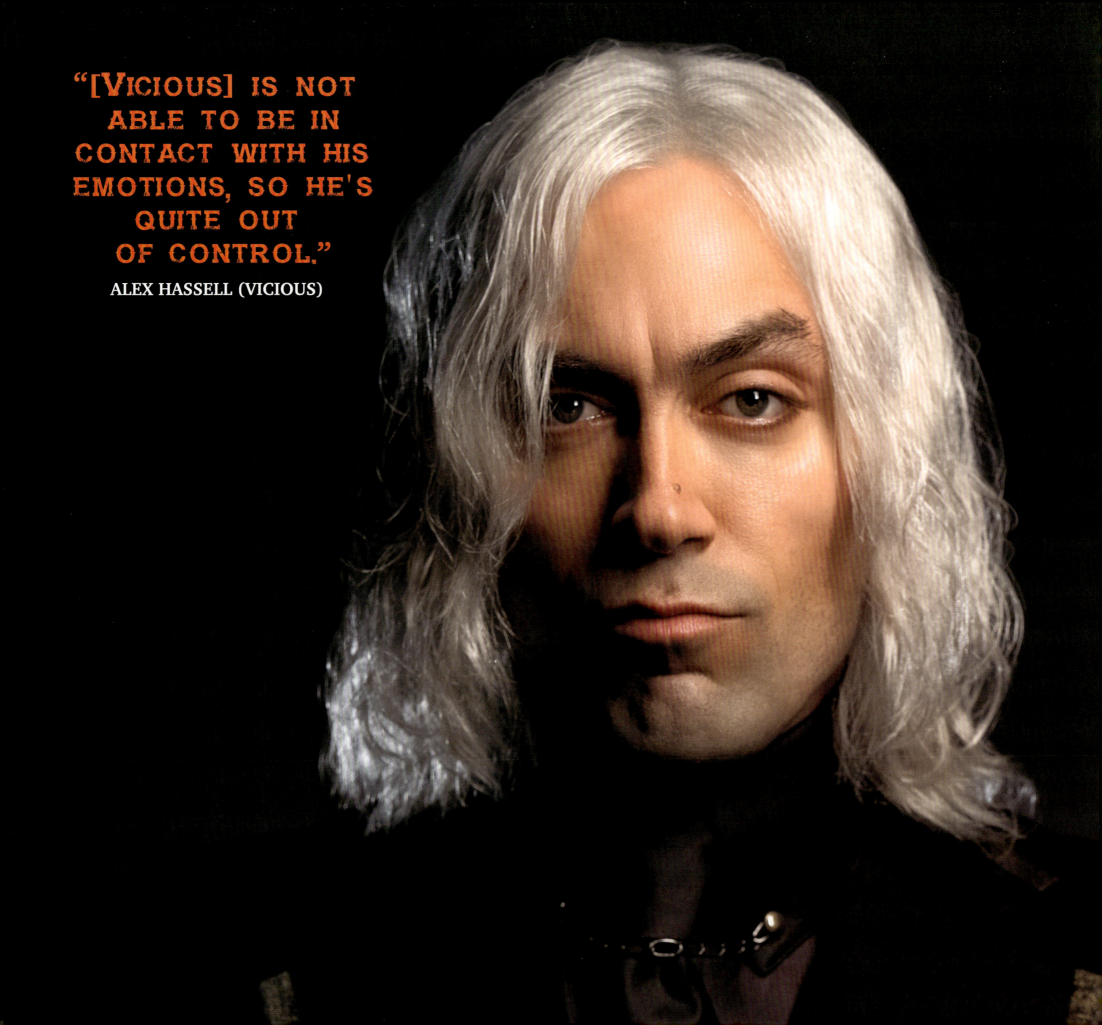

"[Vicious] is not able to be in contact with his emotions, so he's quite out of control."

ALEX HASSELL (VICIOUS)

VICIOUS

Vicious is Spike Spiegel's nemesis from his Syndicate past. When Spike was working as a Syndicate enforcer known as Fearless, he befriended another Syndicate killer in what would become a fateful and dangerous relationship that would ultimately drive Spike out of the world of crime, forcing him to change his identity and steer clear of the Syndicate as a matter of pure survival. The man known as Vicious was Spike's age, working at the same level in terms of rank within the organization, with a similar skill set and lethal ability—but Vicious was the son of one of the Syndicate elders. His father wanted Vicious to rise through the ranks through loyalty and experience, working his way toward becoming a Syndicate leader. But Vicious, angry and unpredictable, seeks a faster rise and feels that Syndicate leadership is owed him—and he's more than willing to break the rules and go against the elders to get what he wants.

"We crafted a story about a man who could never live up to the idea of who he should be," André Nemec says. "A man who was always running from the looming shadow of a father figure, of authority, of hierarchy, of all of these things. We knew that we wanted Vicious to be directly involved with the Syndicate. We knew that there was a strong story to tell about this bad guy. But we needed to humanize him. We needed to give him a deeper backstory, to properly ground the character. And we wanted to add Julia. We felt like she was a very important character that had only been hinted at in the anime."

British Shakespearean actor Alex Hassell won the role of Vicious. "Alex Hassell was a guy who really stuck in our minds as someone who was such a strong actor that we felt that there was almost nothing [he couldn't handle] in terms of the material. Also, it's crazy, and it's part of what I love about actors, but he's the nicest man in the world. You can't find a nicer man; his mama must've raised him right. But when he turns on the bad guy, he really turns on the bad guy."

"He's a sociopath," Adelstein says of Vicious. "There's a scene where [the Syndicate elders] tell him to kill Julia, and even though you believe that he loves her, he's gonna do it because he's been told to do it. And he wants to survive above all else. So everything is just props for him in the world. He's maniacal."

◀▼ Vicious (played by Alex Hassell).

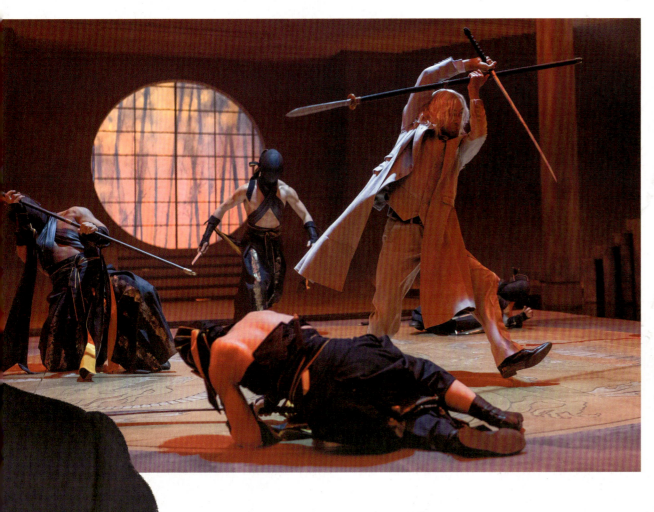

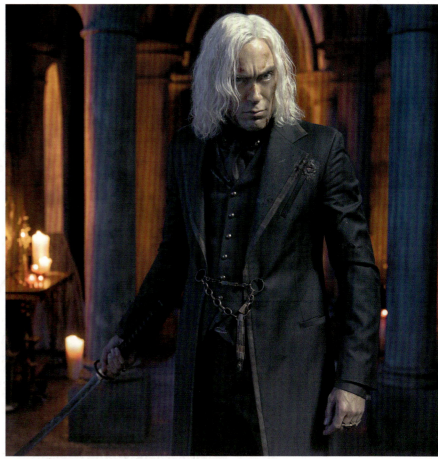

JULIA

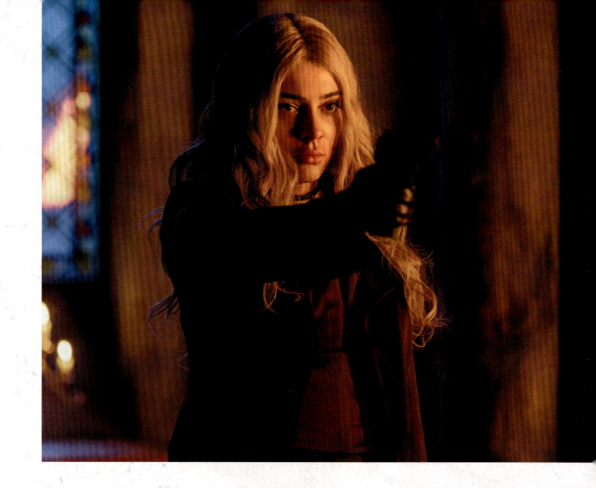

The fulcrum between Spike and Vicious is a lounge singer in Tharsis City on Mars, who Vicious becomes involved with while he is working with Fearless, and who eventually becomes involved in an affair with Fearless that causes him to change his identity and flee from the Syndicate to become Spike Spiegel. By the timeframe of the live-action series, Julia and Vicious are in a long-term relationship—but Julia is a kept woman haunted by regret about her new life and exploring her own potential avenues of escape. "We really wanted to build out [Julia] as our femme fatale of the season, as a way to utilize the noir genre of this show most effectively," Nemec says. "A key component of this was to craft Julia as our Helen of Troy. A woman who could launch a war between two men that would escalate to epic proportions."

Russian émigré Elena Satine plays Julia. "We auditioned a lot of people for the role of Julia, and Elena always stuck out," Nemec says. "Elena was a big, big fan of the anime, and was really intrigued by the idea of trying to capture the role of Julia. Elena really embodies that classic noir beauty. And she's quite a skilled actor. Casting her rounded out our top five actors in an exciting way."

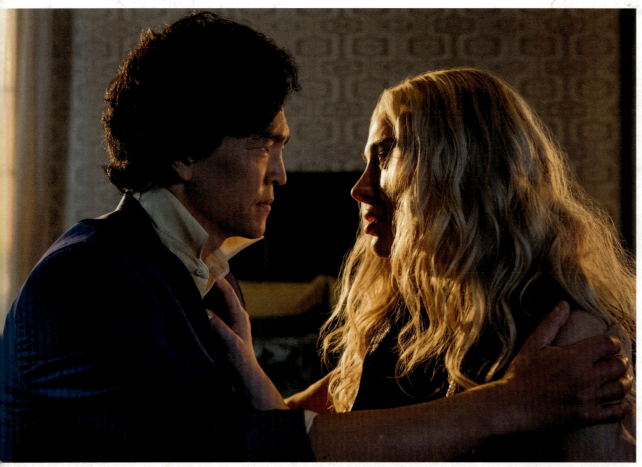

▲▶ Julia (played by Elena Satine).

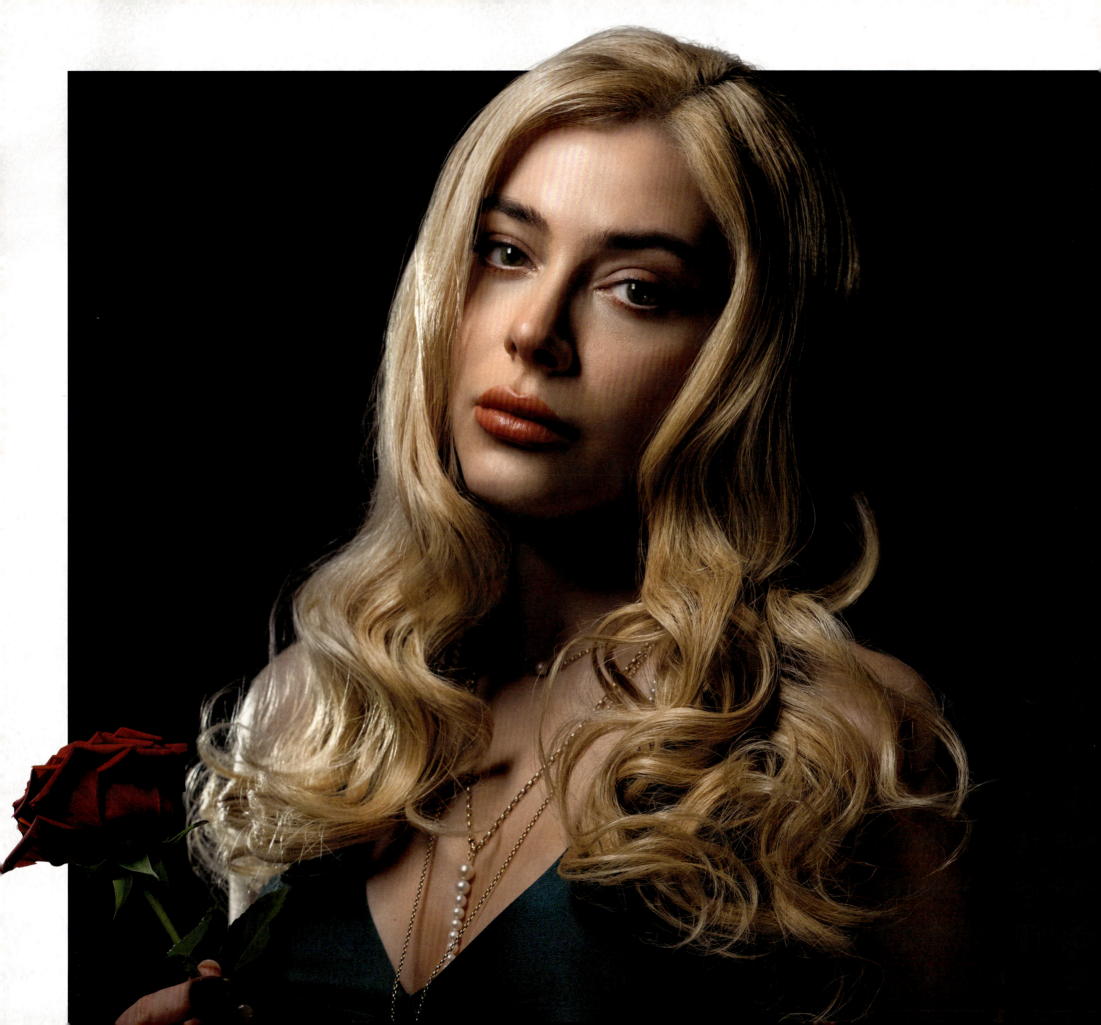

BEBOP SWEET RIDES

Recreating the home base *Bebop* as a spacehound bachelor pad, Spike's *Swordfish II* as a believable version of one of anime's most memorable vehicles—and finding a sneaky way to introduce Faye Valentine's *Red Tail*—meant finding a technological throughline for the *Bebop* universe.

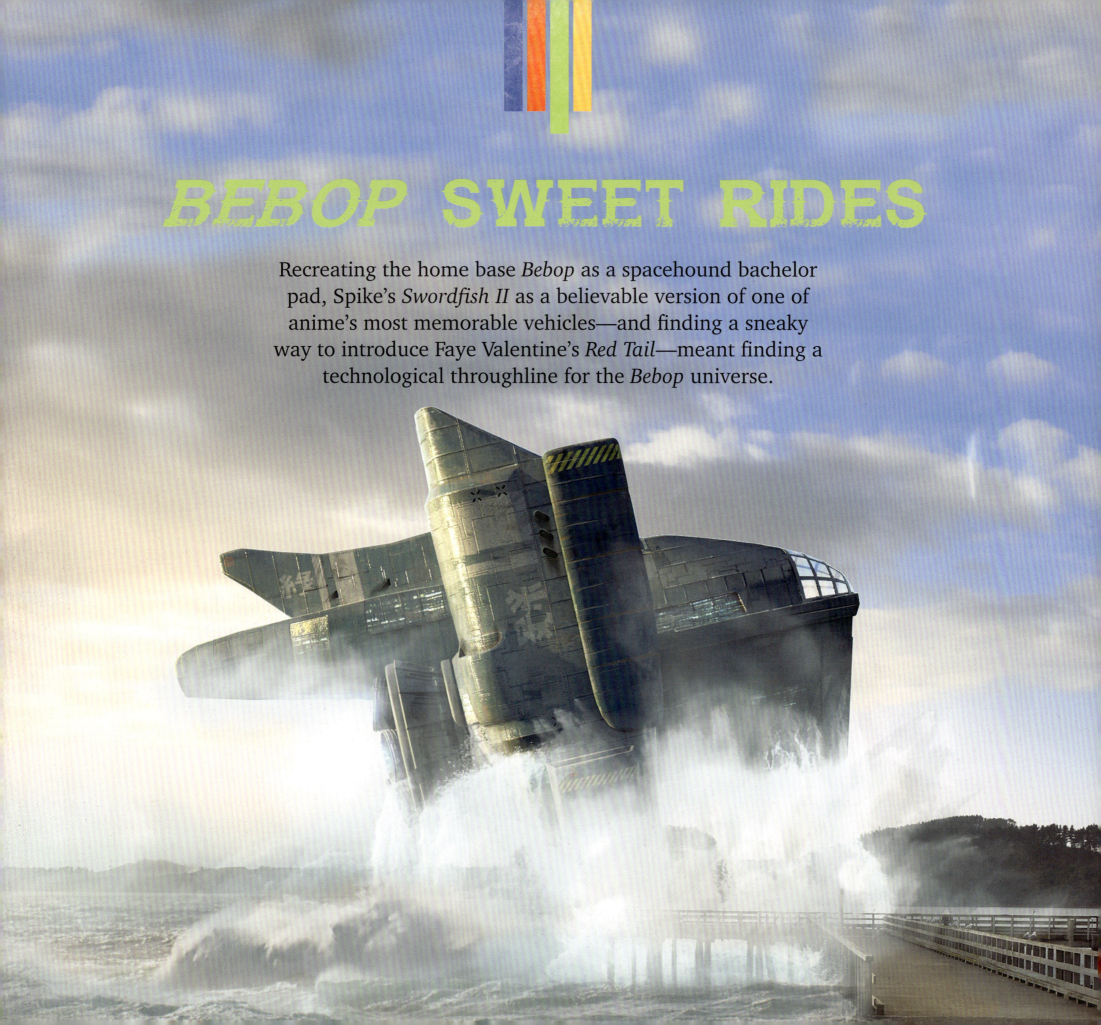

THE BEBOP

Spike Spiegel's and Jet Black's home, base of operations, and transportation around the solar system is the *Bebop*, a ramshackle spacecraft that is part tramp steamer, part yacht, part aircraft carrier. Sporting a boat-shaped prow with a helipad-like landing area and a streamlined, yacht-like bridge, two powerful propulsion engines and a pair of vertical stabilizer fins, the *Bebop* has an interior hangar bay for smaller craft—including Spike's *Swordfish II*—and it can enter planetary atmospheres and land, but only on water, where its lower vertical fins act as rudders, helping to guide and settle the vast bulk of the spacecraft into sufficiently large waterways much like a hydrofoil.

In the anime, the *Bebop* sports a central gravity ring that is visibly rotating and contains the ship's living area, including the familiar lounge where Spike and Jet kick back on facing couches to chat, drink and eat. A commonly seen part of the living area was a curved hallway with a spinning wall and airlock that the characters had to enter to transition between the artificial gravity of the wheel and the rest of the ship, which maintained zero-gravity conditions.

Recreating the feel of the anime *Bebop* was an early challenge for the live-action project. "There are lots of things that we like pulling from the anime," André Nemec says. "And obviously we take those as a core, and then make them ours. And everyone out here

◄◄ Very early concept for the Murdock gang's ship.

▼ Early concept art of the *Bebop*.

▼▼ Size and shape comparison between the various early versions of the *Bebop*.

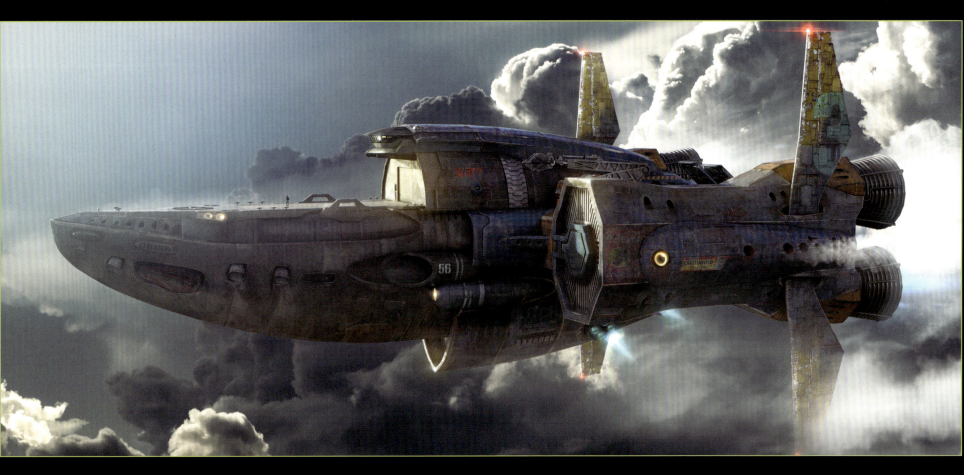

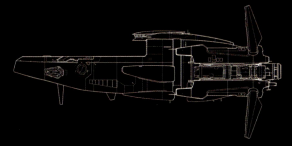
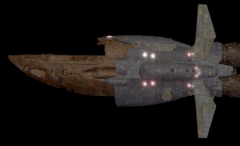

BEBOP SWEET RIDES

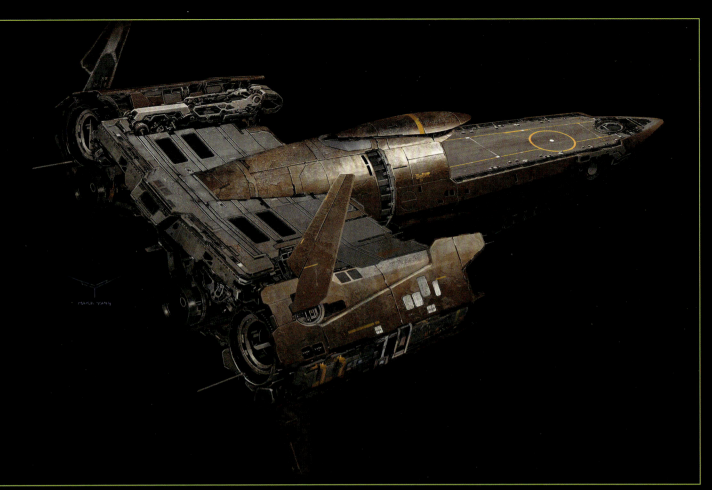
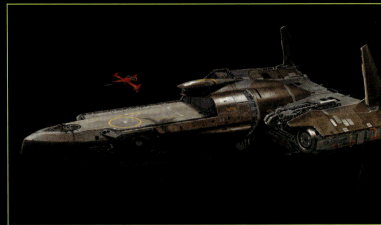
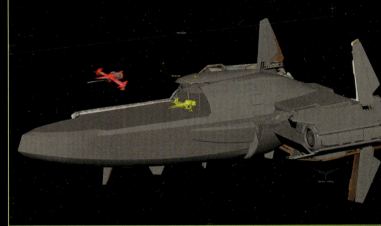

in every department [knows] how many different versions of the *Bebop* we've looked at; how big the belly on the ship was going to be: 'No, make it 4% more potbelly. No, no, no—streamline the nose a little bit. Wait, the gate on the ship should be wider.' On and on those conversations went until we felt we got it right."

"Obviously the *Bebop* is a very central character," Adelstein says. "The ship in the sea; the ratty *Bebop* was very important to us." In early preproduction work in New Zealand, concept artist Henry Fong (of *Star Trek Discovery* and *Pacific Rim*) developed a look for the *Bebop* that kept very close to the look of the anime ship, creating a greenish, hammered-together aesthetic with some curvy, piratical lines and the anime ship's distinctive engine intakes, which are almost crescent-shaped. It gave the impression of something made out of different pieces from several ships. The most important thing was maintaining the *Bebop*'s beat-up look, with Jet having done some cheap repairs. It is ultimately a trawler, a ship that goes on the water, flies in the air, and then goes into space."

The basic elements of the *Bebop* would be retained—the boat-like prow with its flat-top landing pad; the yacht-like but still retro-looking, swept-back bridge that sits atop the landing pad doorway into the hangar bay that holds the *Swordfish II* and other craft; the

> "OBVIOUSLY THE *BEBOP* IS A VERY CENTRAL CHARACTER. THE RATTY *BEBOP* WAS VERY IMPORTANT TO US."
>
> **MARTY ADELSTEIN, EXECUTIVE PRODUCER**

two big engines, and the vertical fins. Some of the early design sketches also showed a vertical elevator system inside the body of the ship that could raise the *Swordfish II* into position to move out onto the launch deck.

It was VFX company Rising Sun Pictures who were largely responsible for the final overall look of the *Bebop*. "The *Bebop* I believe stayed pretty true to the design that was set up a long

◀ Mark Yang came up with a more conventional engine/intake arrangement, while adding some exposed engine parts. The bow of the *Bebop* was revised to take down the sharp point. The lower 'scoop' was also deleted.

▼ Early concept art by Henry Fong. While the general shape adhered to the look of the anime, ultimately it was felt that the *Bebop* looked like it was assembled from a variety of different ships.

time ago," says VFX co-supervisor Victor Scalise. "RSP detailed the hell out of it. They did an amazing job of taking the concept and putting in all the fine details, all the nuances of knickknacks, engine pieces, stuff to give it scale, to make the 3D feel real, which is a very important part when you have a ship that's such a hero, that is a character of the show."

Concept designer Mark Yang began subtly reshaping the lines of the *Bebop*. "They had an original concept that was really a 3D model of the anime design. In anime, you want to exaggerate certain proportions, especially before 4K, there's certain things that need to just really pop out at you, like these really big shapes. And I think when you do that and don't take into consideration how it's going to look in a 3D environment, then it's going to look a little hokey, it's going to be difficult for that to be adaptive."

Yang experimented with a few ideas that took the design into even more extreme territory before dialing the look back. "I really looked at a lot of ships and how a lot of the proportions are broken up for this ship. I think that the *Bebop*, especially given that it has to land in water, has to be a certain shape. So I didn't feel the need to change some stuff. I did hollow out a lot of proportions, and there's actually quite a bit in the back section that we changed. But I think if you respect the original, the things that really stood out, like the vertical fins and a couple of big shapes, if you extrapolate them and update them to what quantum mechanics would look like, you can actually get away with a lot of the things that are recognizable. And once you put back the original colors and a lot of really recognizable iconic stuff, it's easier for you to make that connection."

Part of that connection lies in the less-than-pristine state of the *Bebop*'s exterior. "The *Bebop* is essentially a boat in space; it's a work ship," explains Victor Scalise. "It's not supposed to be overly stylish but functional. Its upkeep isn't the best. These guys don't have lots of money to make sure it's always running the best,

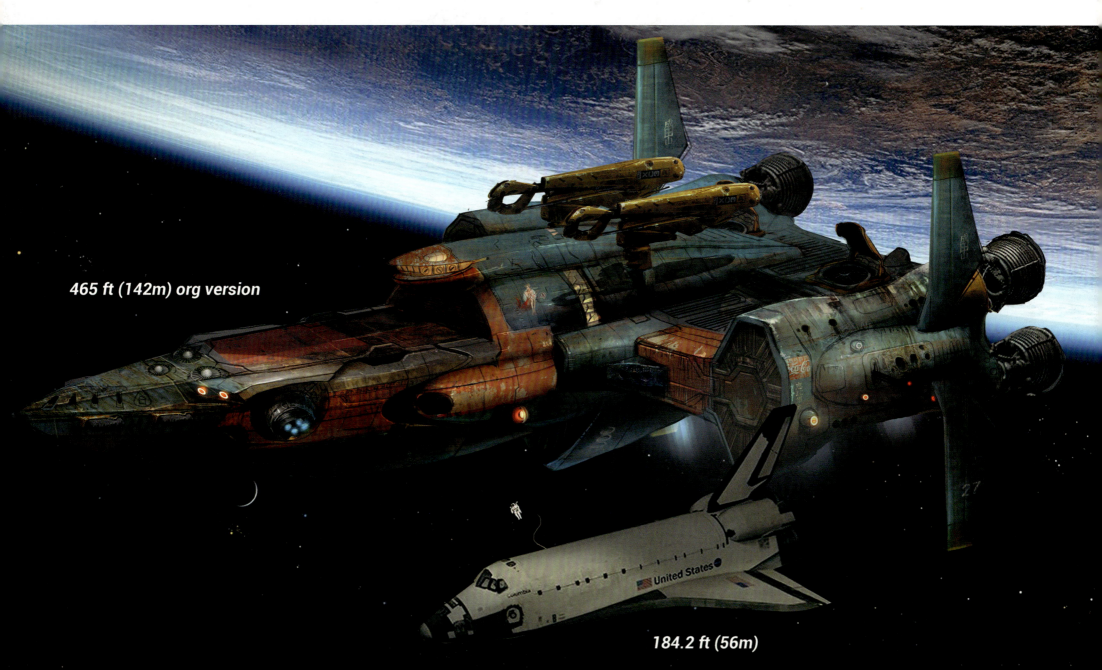

465 ft (142m) org version

184.2 ft (56m)

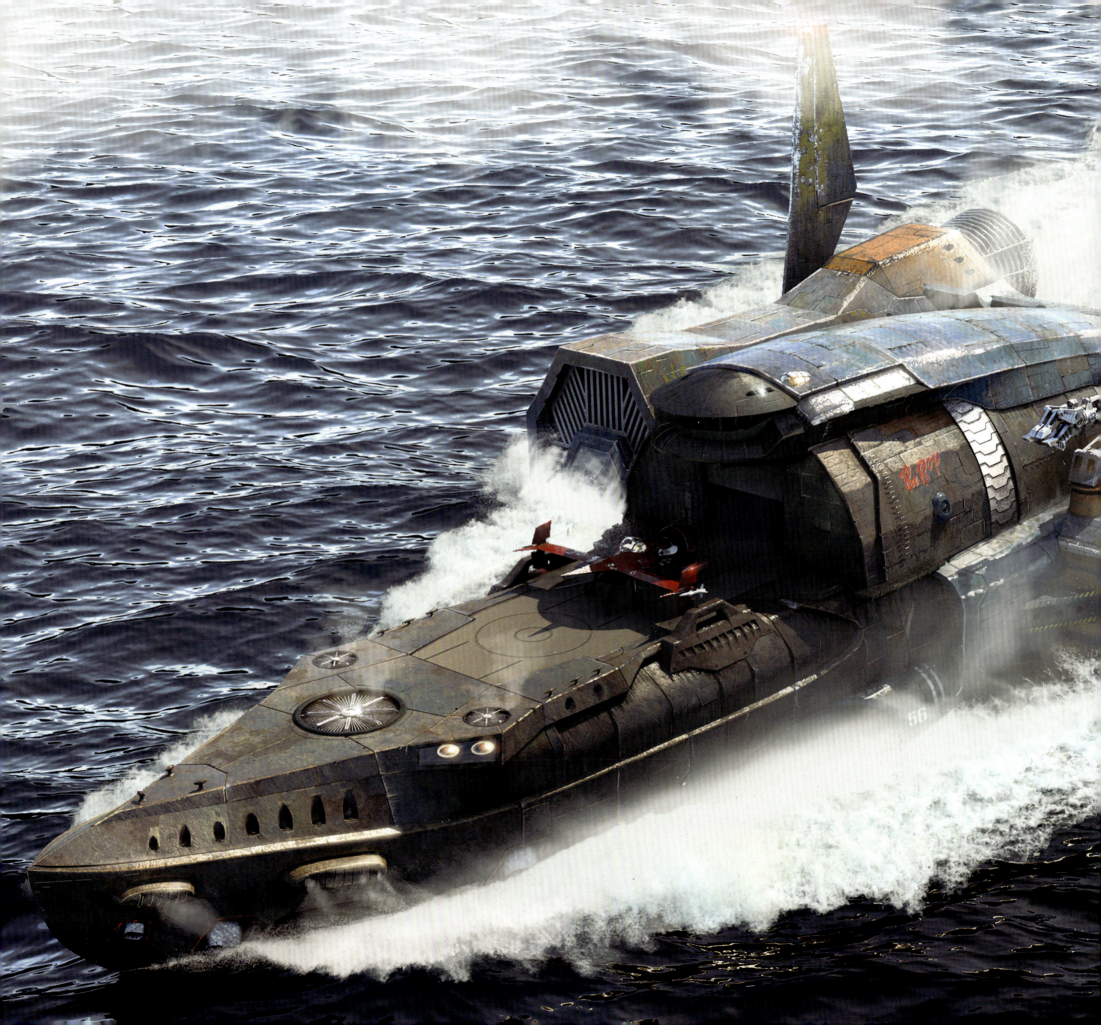

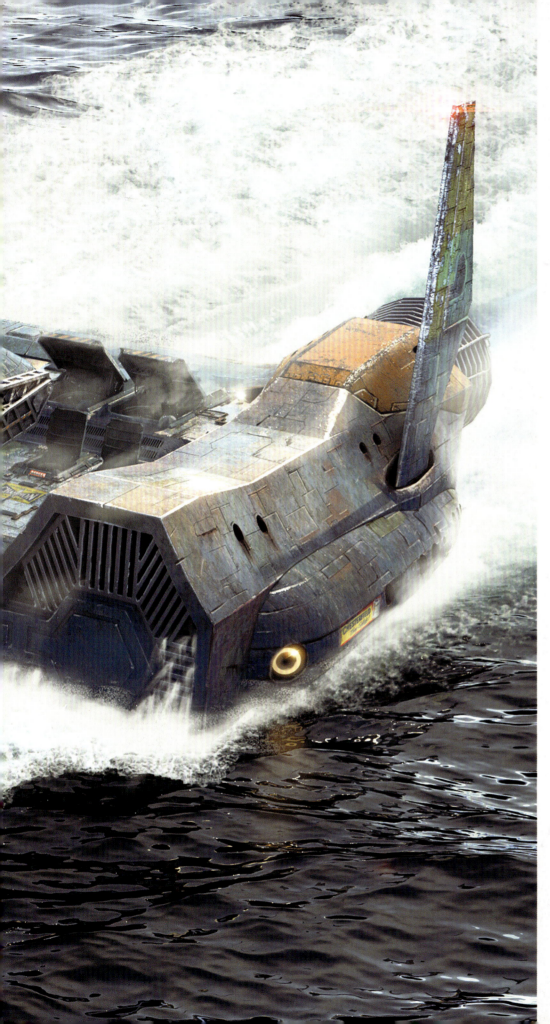

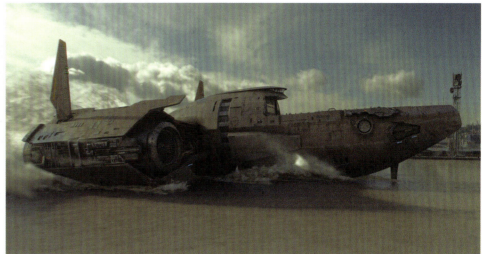

BEBOP LANDING CONCEPT
HENRY FONG 20190322

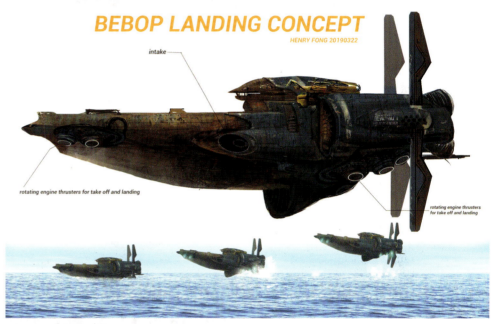

▲▲ The final approved model of the *Bebop* created by Rising Sun Pictures.

▲ While the rounded belly of the *Bebop* was favored, it was felt that the scoop at the rear looked awkward and was deleted in future revisions.

◄ Concept art using a very early CG model of the *Bebop* created by the art department.

Bebop Sweet Rides 49

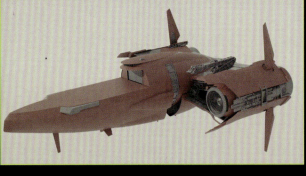

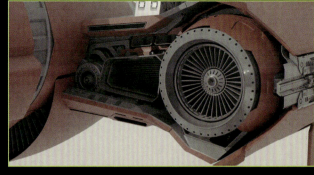
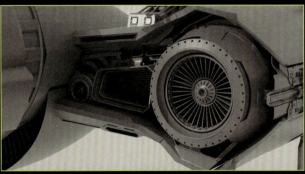
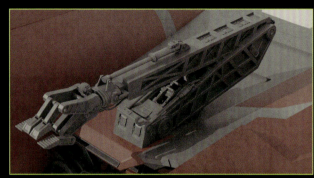
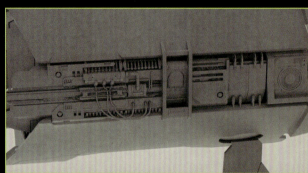
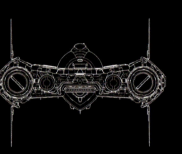
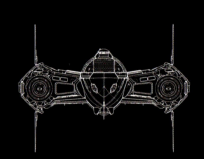
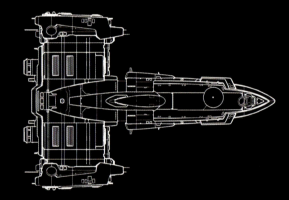
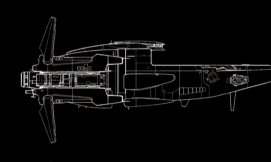

▶▲ The design work on the *Bebop* was continued by Rising Sun as they worked on the CG asset.

so we've put a lot of detail into it with RSP in terms of dirtying it up and getting the engine pieces worn. When we first got the model it was pretty clean, and we kept going in and dredging up the engine area, making all the parts feel like they're working parts, and I think Rising Sun Pictures did amazingly in terms of making this model so detailed that you can get right up against it and it still holds up."

One of the most important considerations when designing shots of the *Bebop* coming in to land on a planet was the fact that it is a ship designed to land not on the ground but on water. Victor Scalise explains: "For the water landings we were close to matching the shot designs from the anime. We used those as a basis, then changed perspective a bit and added some more camera movement. One thing that I always looked at when designing a shot was that in the anime there are a lot of 'locked' cameras—not a lot of perspective shifting. When bringing the show into a live-action world I would ask myself 'What would the traditional animators do if they were given the 3D tool set, and how would they design the shots?' We wanted to make sure that we had a lot of perspective shifting and moving camera because this also helps the 3D model feel more realistic."

"It's a big ship," Mark Yang says. "Even in the anime it's pretty massive. I think they had talked about scaling it down. But if you wanted to do certain things that they did in the anime, like having the two ships take off and come out of that hangar, that makes it kind of tricky if you size it down too much. Some of the trickier shots are when it interacts with physical environments—when it lands, and it deals with docks and all that stuff, and I think that worked out pretty well. But we've had a lot of discussions in terms of, like, sizing the bridge. Because there's a physical set that they pretty impressively built out."

Despite reinforcing the idea of the *Bebop* as being quite a large spacecraft, the 'gravity ring' concept quickly became a casualty of the realities of television production. While the rotating ring is incorporated as a part of the exterior design, it no longer represents a massive, moving section of the ship's interior. While the anime suggested that outside the gravity ring the characters used

50 COWBOY BEBOP MAKING THE NETFLIX SERIES

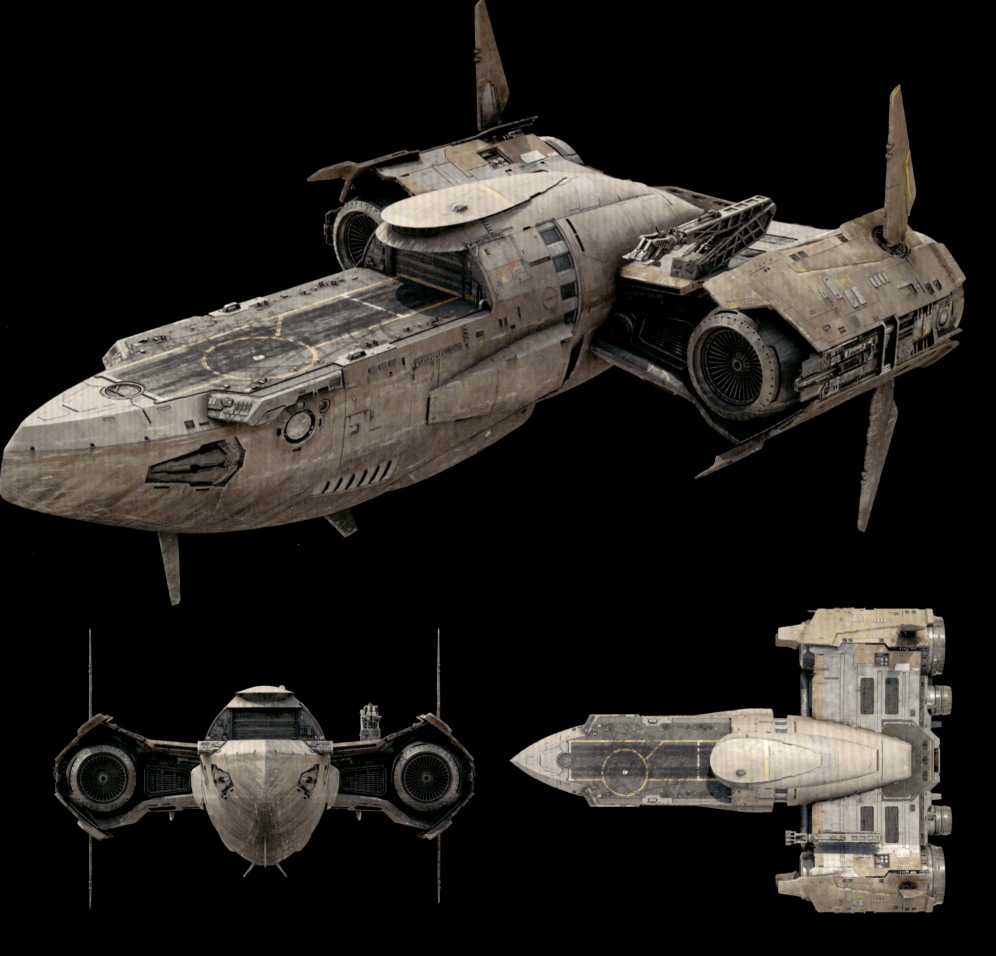

▼ Early concept art of the *Bebop* docked in Tharsis City.

magnetic shoes to stay upright, and food and liquids occasionally floated in air to indicate zero gravity, the live-action approach sees the *Bebop* fitted with some device that creates gravity and a right-side-up reality for the show's characters inside the ship. "I can't just have people floating everywhere," VFX co-producer Gene Kozicki says. "It's not feasible. So with that conceit, you go 'what's the gravity ring for?' Well, we don't know, but it's there. Maybe it helps generate the gravity."

> "THE *BEBOP* IS ESSENTIALLY A BOAT IN SPACE. IT'S A WORK SHIP. IT'S NOT SUPPOSED TO BE OVERLY STYLISH, BUT FUNCTIONAL."
>
> **VICTOR SCALISE,**
> **VISUAL-EFFECTS CO-SUPERVISOR**

"I think if you look at the anime, they selectively have gravity throughout the ship," Yang says. "I think the idea is that at one point the ship relied on the gravity ring to provide gravity, so they could experience a one-G environment, but the ship has evolved since then. It's like buying it for tourists and then really converting and adding all this technology to it. There's gravity in every deck, and that grounding ring, if it actually did do what it's supposed to do, wouldn't provide gravity for every single deck of the ship. So we wanted to keep that aspect of the ship because it was one of the things that was really visually interesting, and also provided mobility from one position to another. It's kind of a legacy of earlier space travel, matched with where they are today."

The *Bebop*'s main engines have been modified from the more fanciful crescent section designs seen in the anime to tubes with circular fan blades to suggest a more realistic turbine drive. While the anime ship sports two moveable cranes that can lift cargo or even the *Swordfish* from docks or the water onto the ship, for the live-action ship the crane component was reduced to one, adding an interesting asymmetry to the *Bebop*.

"We had talked somewhat about how the ships would fit in [the hangar], because in the anime they just kind of pile in one after another like it's a long garage," Mark Yang adds. "If you look at the volume of the ship, I think that makes a little less sense than if they were able to fit compactly into that space, because every inch on the ship is pretty precious." In the *Cowboy Bebop* anime, the *Swordfish*'s 'wings' fold so the ship can occupy a relatively small space.

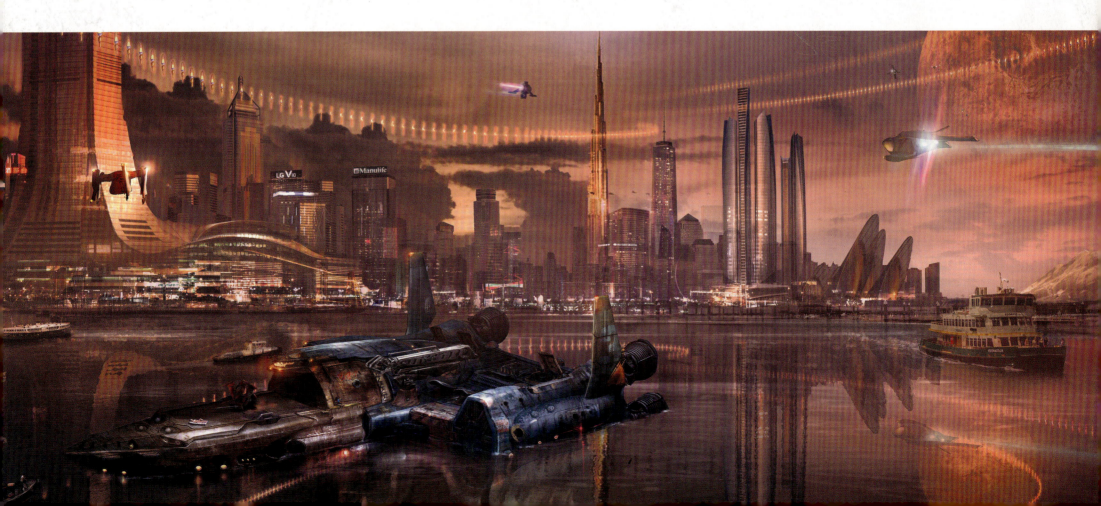

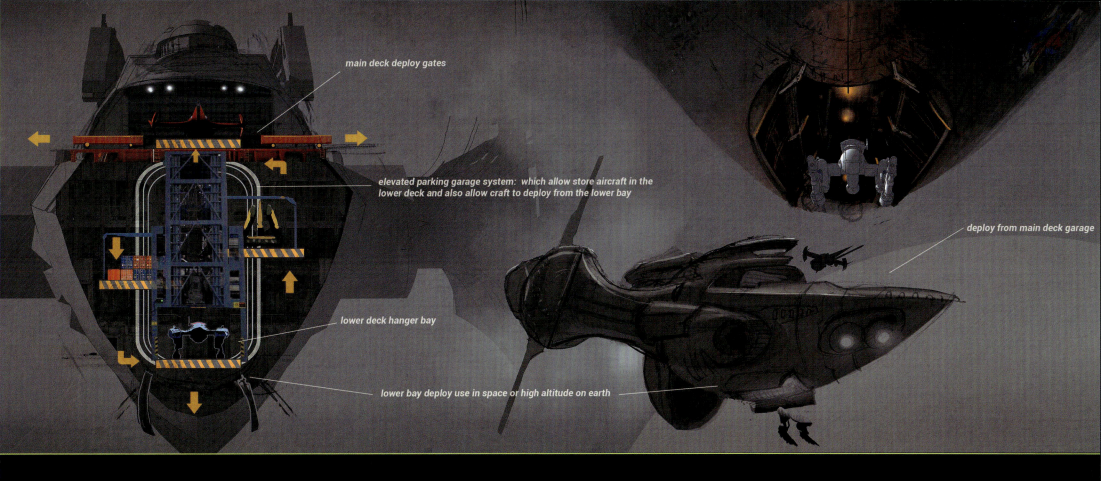

main deck deploy gates

elevated parking garage system: which allow store aircraft in the lower deck and also allow craft to deploy from the lower bay

deploy from main deck garage

lower deck hanger bay

lower bay deploy use in space or high altitude on earth

Kozicki notes that the layout of the hangar bays was redesigned from the standpoint of a 16:9 aspect ratio rather than the square, 4:3 TV ratio that the 1998 anime was designed for. "We made the doors more horizontal. So now the *Swordfish* can fit through the garage door with its wings up or its wings down; we've got that flexibility in there. We are not building this as a practical set—we will do it all as CG. The only time we really see it is when Spike is inside his cockpit and he's pushing buttons and he's getting ready to roll out the door. It's in the window that's behind him, so it's not really seen that much."

In addition to the main engine exhausts, the rear of the *Bebop* features a landing bay loading dock and the large vertical fins that extend above and below the ship. The fins retract and act as rudders when the *Bebop* is in the water, the idea being simply to have something happening to the ship as it's coming in to land. The *Bebop*'s loading dock also features illuminated graphics that light up to guide the *Swordfish* on takeoffs and landings, giving the area the look of an aircraft carrier.

Finding a color for the *Bebop* proved another challenge, with the hues shifting from browns to greens in the anime while early renderings of the ship in 3D featured metallic blues and greens. Mark Yang acknowledges that the color of the ship was initially a moving target. "I think given that it's probably largely affected by whatever planetary body is near, that's probably going to influence the look. The color I originally had was a lot more like a chemical rust color. But then I think I took it a little too far. And they brought it back to a little more of the brown color that you see most commonly [in] the anime. But it's hard—when I watched the show on Cartoon Network a lot of the colors were washed out, so I can't count on my memory discerning the color. But I picked a little more of a saturated brown color for it because it seemed like most seafaring ships had that."

▲▼ A practical hangar set was not needed—all the views of the interior would be handled through a digital asset. The art department did some early studies that had hatches on the flight deck and also some bomb-bay-like doors on the belly of the *Bebop*. Some of the artwork from the anime that came from the Sunrise/Bandai archive revealed that they had come up with an ingenious rotating canister storage system. A ship like the *Red Tail* or the *Swordfish* enters the hangar and another set of doors at the rear open up to reveal a storage canister. The ship is pushed into that canister and the canister rotates around and another one takes its place.

INSIDE THE *BEBOP*

While dispensing with the idea of the *Bebop*'s gravity ring eliminated some visual elements of the anime, it created the opportunity to open up and link the bridge and living area sets, which now exist as an arresting, multilevel space with a vaulted ceiling extending over the lounge and up through the bridge with its 180-degree windows. For staging and camera purposes on the show, the space needed sightlines so characters could be framed in the foreground on the bridge with the expanse of the living area in the background behind them, or vice versa.

"[The crew] would always talk about the Death Star and the *Millennium Falcon* and all those things, so to me it was the translation of the *Bebop* as a set and what that would look like, and they did an absolutely amazing job," Becky Clements says. "[The characters] were on it a lot, so you want to make sure there's scope and scale and it feels comfortable and not claustrophobic—but you also have to believe that this could actually fly through space."

▶▼ The main 'living room' of the *Bebop*.

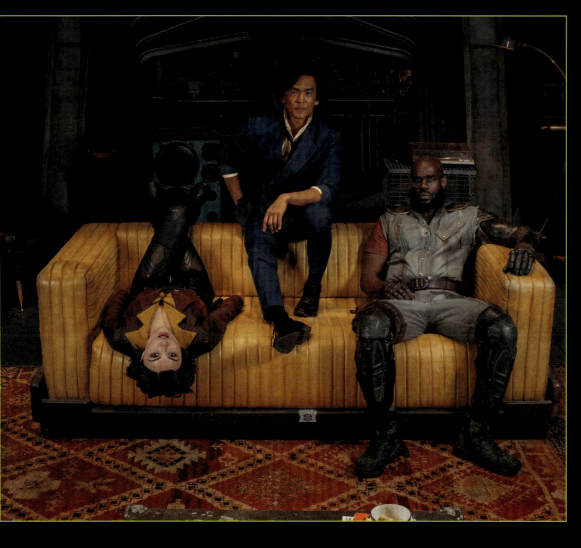

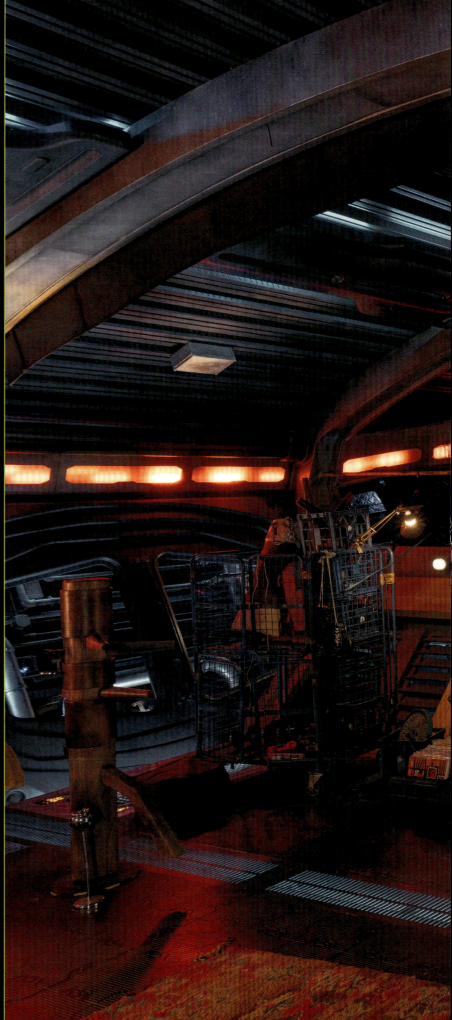

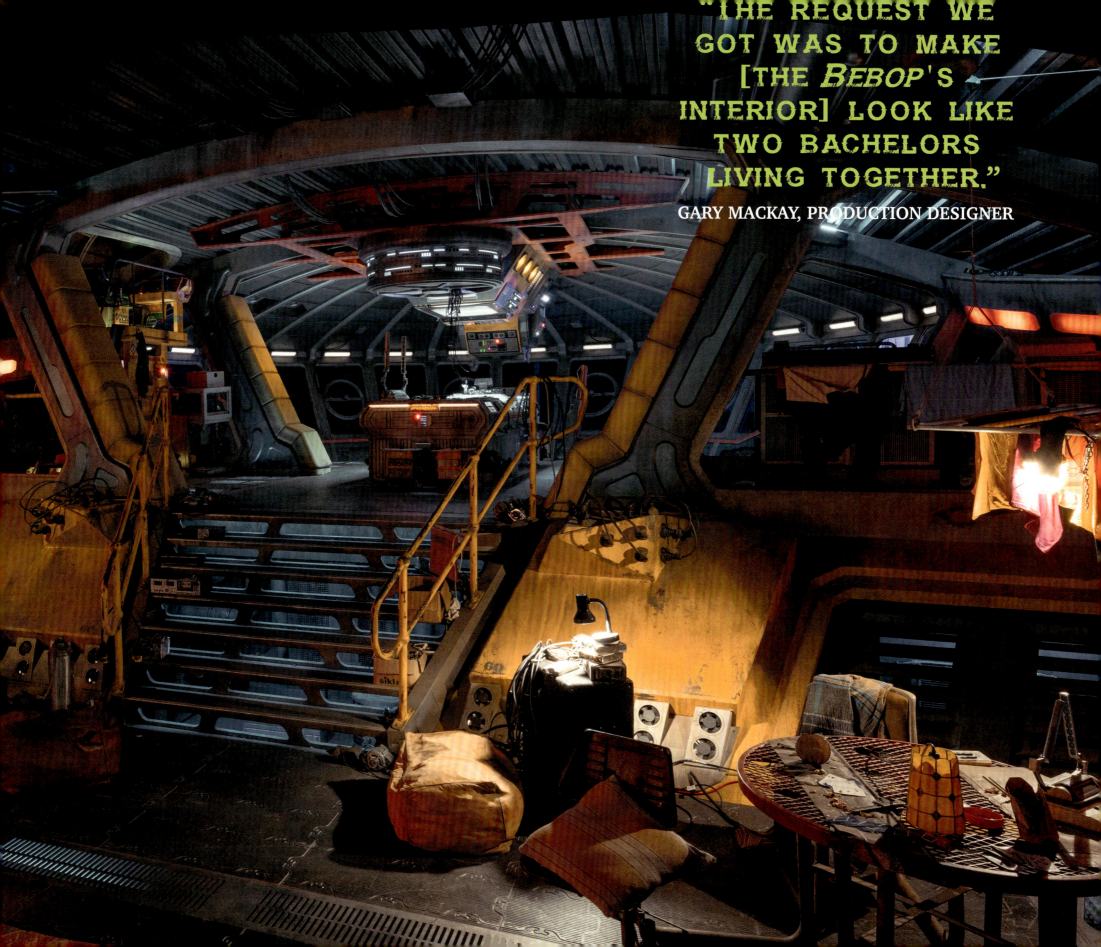

"THE REQUEST WE GOT WAS TO MAKE [THE *BEBOP*'S INTERIOR] LOOK LIKE TWO BACHELORS LIVING TOGETHER."

GARY MACKAY, PRODUCTION DESIGNER

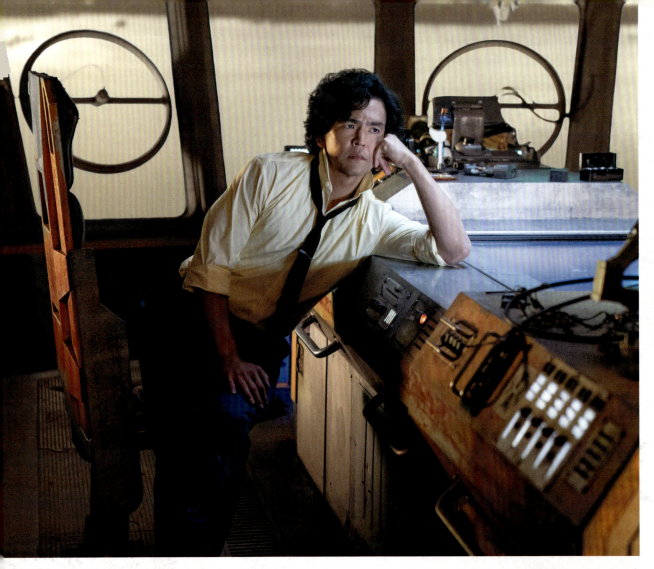

◀▲▼ The *Bebop*'s bridge under construction. The window panels were removable to allow access for lights and cameras.

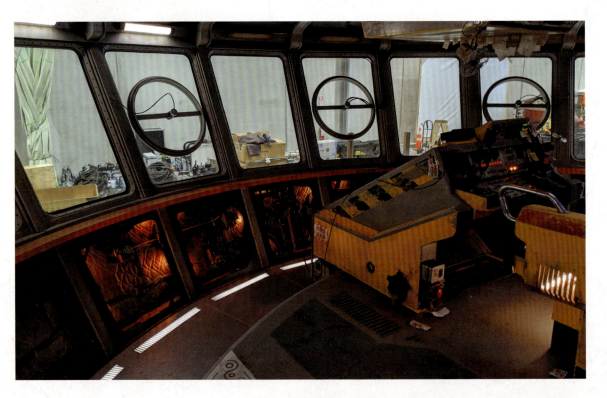

Gary Mackay notes the spaciousness of the multilevel bridge and living area. "[If you focus] up on the bridge, looking all the way back down through that, that's huge. I think it would have to be one of the biggest spaceships that has ever been built. Usually, people are doing something very small and contained and tight and claustrophobic because that's the story they want to tell, and so they are going for realism. They're traveling to Mars or they're going interstellar, and it's just little chambers joined together. We don't have to live in that world—this is much more fun and much more wide than that, so our reality is much looser. [The *Bebop*] is the size of two football fields. We have the living area and then we've got downstairs. So we've got another set built alongside this, which is with the bedrooms and the corridors and the bathroom and then the engine room, there's a whole series of other rooms that are alongside us on the stage."

Mackay and his crew studied key frames from the anime to design and detail the *Bebop* interior sets. "We took design cues from the anime down to things like the handrails and just key hatches or equipment on the walls. But obviously ours is a set and we make it much more lived in. The request we got was to make it like two bachelors living together, and the ship is just barely functioning. Jet

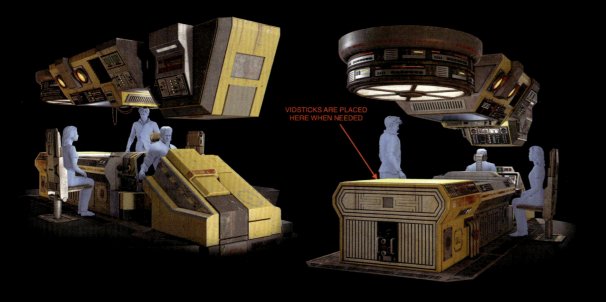
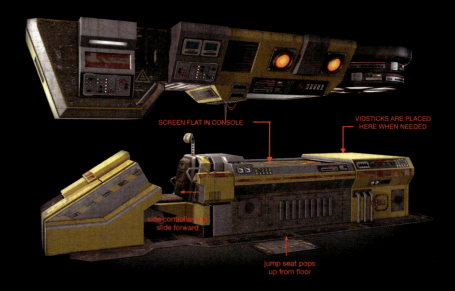

▲ Concept art for the *Bebop*'s helm area and map table.

▼ The final *Bebop* set details. Compare to the CG renderings by the art department on page 58.

just manages to keep it going with chewing gum and gaffer tape. He keeps it going, and he can make it go as fast as it'll ever go, partly hacking it like the *Millennium Falcon*, but it's just hanging on. And so we did a huge amount of texturing and aging on the set. And then even set dressing, like Jet's jazz collection and his turntable. We built the furniture from the anime and just stylized that up a bit, but the yellow couch is there, the armchair is there, the configuration is the same, and overhead you have the ceiling fan with the spinning blades and the lamp hanging underneath."

Set decorating fell to Anneke Botha and her crew, whose job was to take the basic architecture of the set and paint it, detail it and provide practical lighting. "I'd say decorating is like a cross between interior architect and interior designer," Botha says. "The set-decorating department works with the art department in creating layers on the screen. So construction would give you the set, and you'd fill it in. And you work closely with the designer, and obviously the director, and in this case the showrunner and [images from] the original anime."

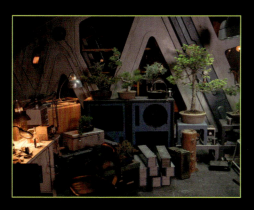
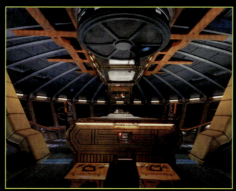
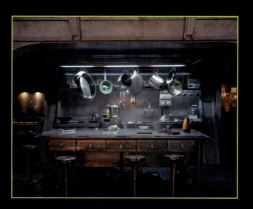
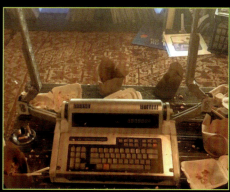
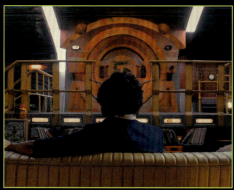
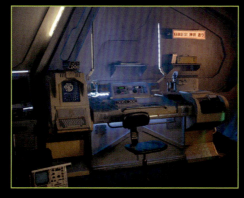

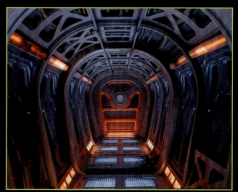

BEBOP SWEET RIDES

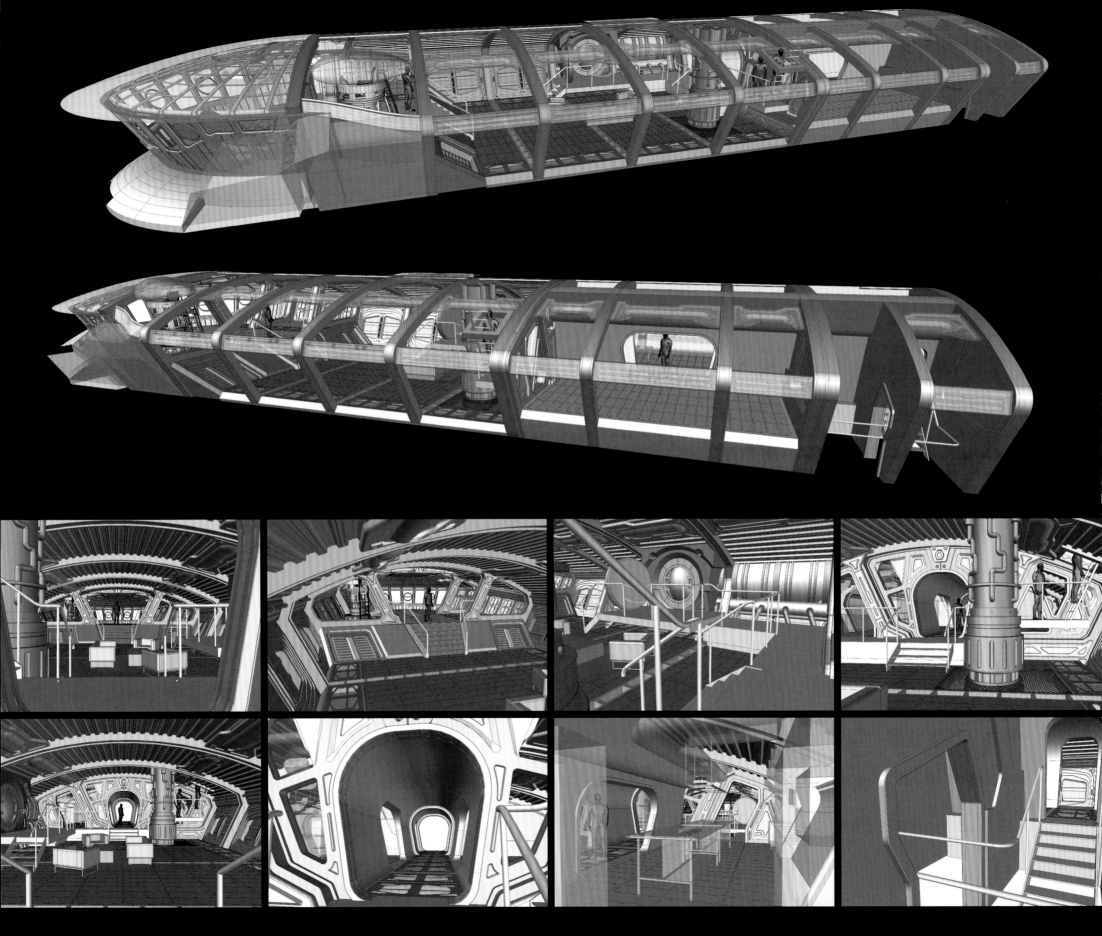

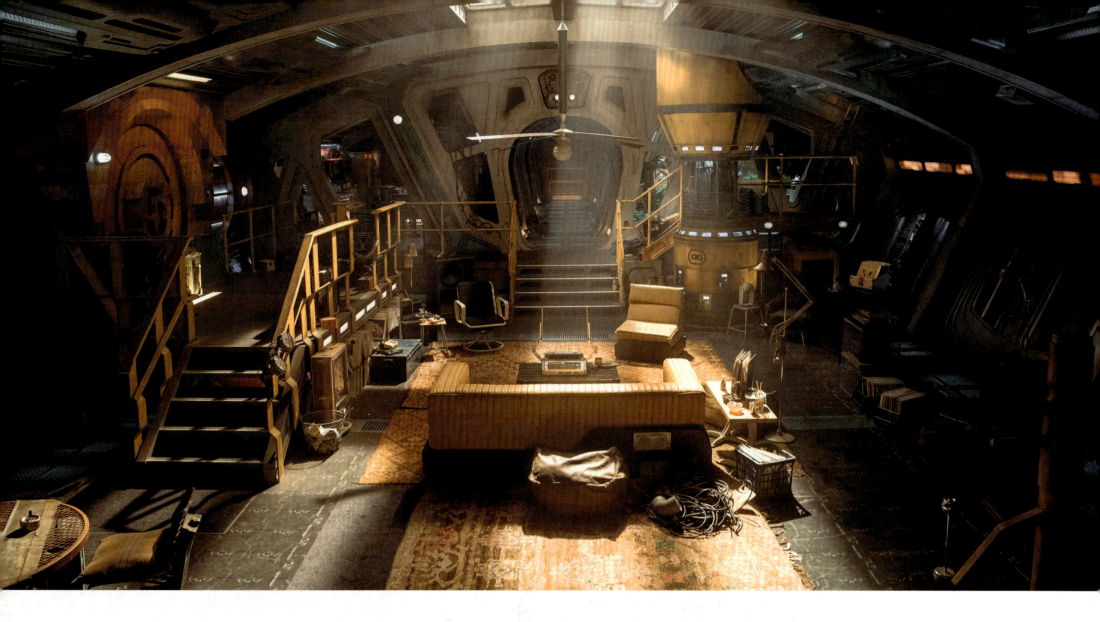

◀ CG renderings by the art department showing the change in layout of the *Bebop*'s key sets. The living room is now more accessible to the bridge area than it was in the anime.

▲ The final *Bebop* set.

Botha was part of the original design team with Grant Major, Sarah Cathie and Helen Strevens as the *Bebop* was still being conceptualized and eventually designed and built.

"I used to be there at a quarter past five in the morning because I couldn't sleep," she recalls. "And it was me and Sarah Cathie waiting in the parking lot until they actually gave us our key. But we had the design books of the original *Cowboy Bebop*, and the original sketches of the *Bebop*. The most important thing to me was that the *Bebop* was based on an old fishing trawler, and I wanted to find my own and strip out all the parts, a real fishing trawler. I gave my team a specific instruction to find me a fishing trawler that I can afford and that we're gonna go strip. And [set dresser] Rua Smith was like, 'No, no way. There's just no way.' Two weeks later, we were en route to strip our first fishing trawler. We bought the trawler for next to nothing, we stripped out the engines, we stripped out the pipes, we stripped out all the electrical boxes, we stripped out oil filters, we stripped out everything with blowtorches. The trawler that we stripped was called the BRAC 852, I think, and that BRAC number is embroidered on everything in the *Bebop*."

Botha's strong reaction to the original anime's characters informed the bulk of her work on the series. "The characters were so different, and there was a kind of tenderness and sadness to all of them. Spike was cool, and Jet was just like this big 'sigh' bear, and Faye—there was a sadness and a depth to all of them that I found very endearing. I couldn't stop watching it. The stories were fresh, but it's always a little bit nostalgically sad. And obviously the visuals—everything's got rounded edges. There's a lot of life, but there's a lot of genres incorporated in each one; they did a noir one, it's like they played with it and it looks like they had a lot of fun. But by stringing all these genres and pulling from all their visuals it's just like the love of filmmaking in this anime really comes to the fore, and you can see it."

For Botha, the key to the *Bebop* was Jet Black. "It really was very important to me to make it feel like Jet's home, and Faye and Spike were just visitors. They don't actually live there, they just kind of bounce in and out. And so Jet's monitor room was very layered, the lounge is very layered, and Jet's records are everywhere stacked in shelves and he's got his record player and his bonsai room, and the

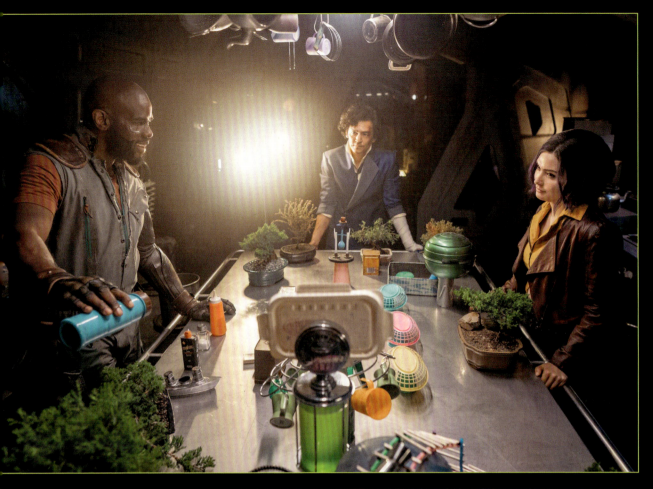

> "IT REALLY WAS VERY IMPORTANT TO ME TO MAKE [THE *BEBOP*] FEEL LIKE JET'S HOME, AND FAYE AND SPIKE WERE JUST VISITORS."
>
> ANNEKE BOTHA, SET DECORATOR

kitchen is quite messy. And on the bridge we painted his emblem, which was based off *The Crow*, and then there's 'Ware of the Dog' stickers and Charlie Parker records, and it's very Jet—it's his house. He doesn't have a home because he split up with his wife; the *Bebop* is his home."

Botha says she took the opposite approach where the presence of Spike Spiegel on the *Bebop* was concerned: "Everywhere you see Jet—there is no Spike anywhere, except for a little Post-it in the kitchen saying 'Jet, we're out of noodles. Jet, please fill up the miso. Jet, there's no bell peppers.' But Spike hasn't settled in yet, and I wanted to make that quite clear. Jet's quarters where he sleeps is very busy; there's his vinyl players and there's more junk that was actually built into the architecture of the ship, whereas Spike has nothing. It's very sparse, very clean. Spike's got his suits, that's it, because you don't know who he is; he doesn't have a history. And that was part of the visual storytelling that was very important to me. I did not want his quarters to be busy. That was part of the telling, like who is this guy? Where did he come from?"

And unlike Spike, Faye Valentine very much makes her presence known in the *Bebop* set dressing. "With Faye, when she moved in, it's just shit everywhere," Botha says. "She brings all this stuff and it's just a cluster. But it's all scattered. It's out of suitcases and out of boxes and on shelves, whereas it's Jet's home. We thought that had to be quite visually clear."

The *Bebop* living area is surrounded by catwalks and machinery to help create the illusion of a larger vessel with other rooms and machinery accessible from behind the bridge—augmenting not only the realism of the environment but also creating more visual interest and camera angle options. "That's creating something that's a mid-ground detail," Mackay says. "On film you don't just

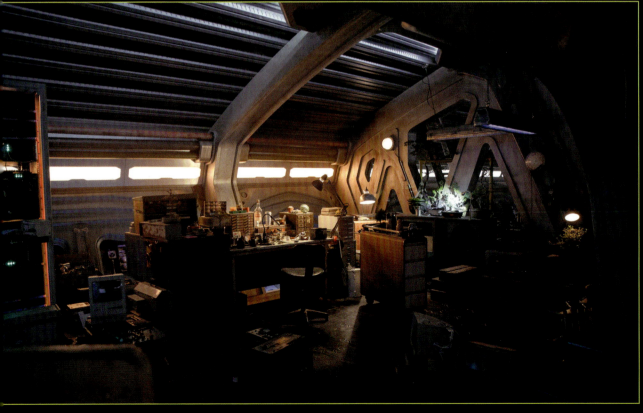

◀ The *Bebop*'s galley (top) and living room (bottom).

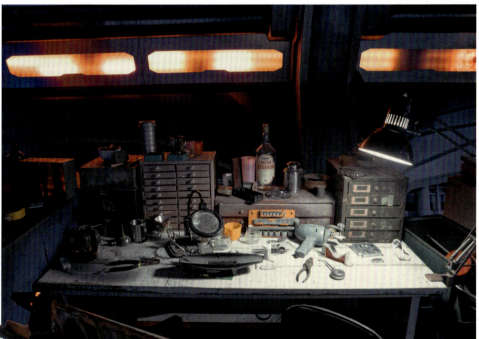
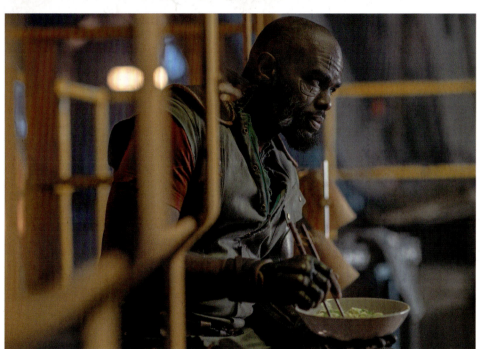
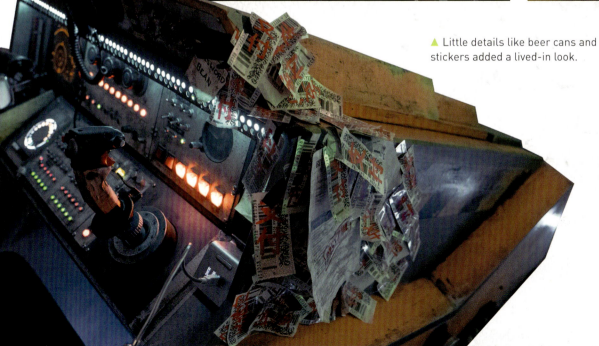

▲ Little details like beer cans and stickers added a lived-in look.

want walls, you want all these interesting rails and objects that give you something to look through and move around and come past. It's one of the huge goals and important things to achieve on a set, to create layers and elements to shoot through."

One eye-catching object, the yellow, illuminated 'tick tower' off to one side of the living area, ties the room in with the lower levels of the *Bebop*. "The tick tower is the cylinder that goes straight down to the engine room and propels the ship," Botha explains. "That's the power—the tick tower goes from the main cabin through to the engine room, and that's the source of power for the engines. It extends from the main cabin down to the engine room and then powers up from the engine back down to the top of the bridge."

Mackay and Botha worked to extend the fishing trawler design aesthetic all the way down to the *Bebop*'s engine room. "We all wanted the engine room to be bigger because it's the heart of

BEBOP SWEET RIDES 61

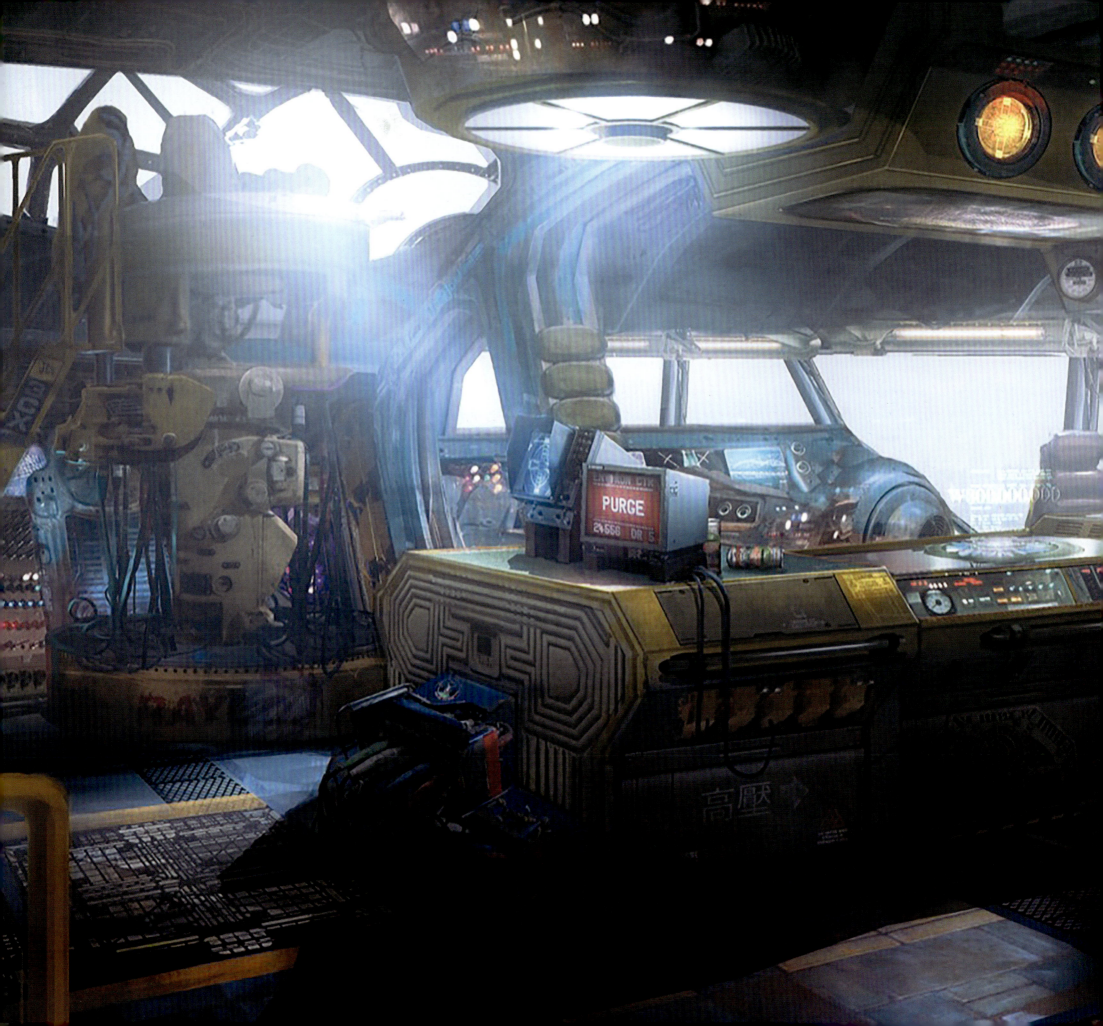

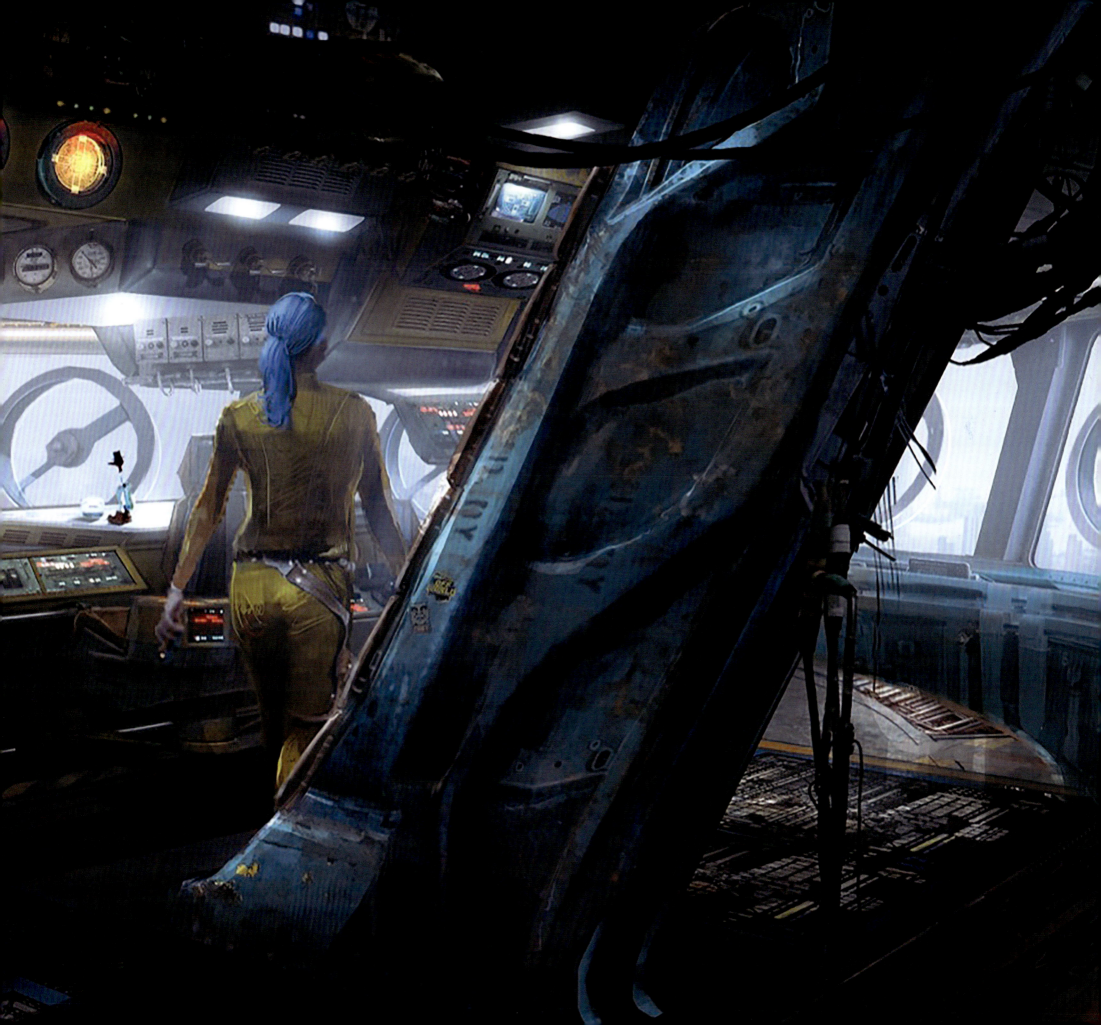

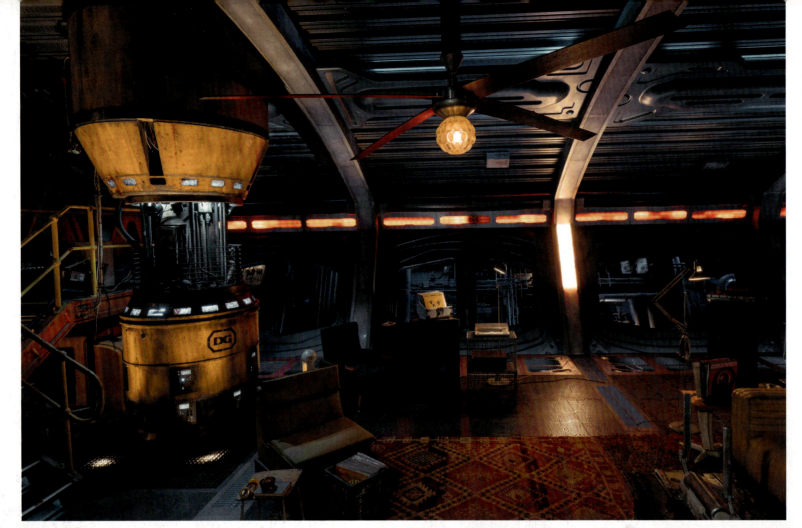

▶▼ It's never really explained what the power conduit tower that is off to one side of the living room does, but it was one of showrunner André Nemec's favourite features.

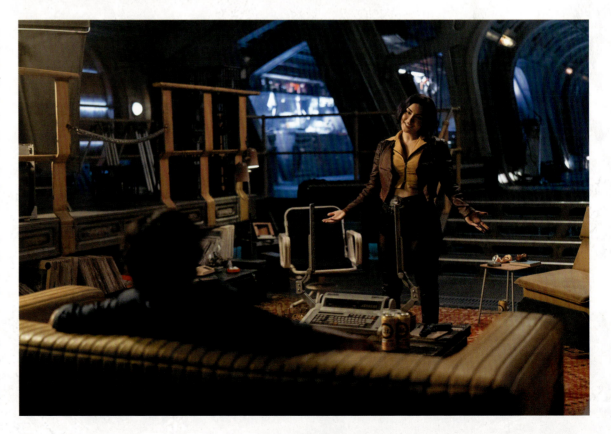

the ship, and it's the power of the ship, so it was important to have a lot of moving parts," Botha says. "But in the engine room itself we have the actual engines from the trawler; we have about three to four real engines in there mounted on the floor, all the trawler stuff from the ship. We kept that for the engine room because we knew the engine room was coming up. So there's a lot of pipework, busy cables everywhere that are basically broken, so when you look at it it's very chaotic. But it's like Jet's fixed it over and over and over again, and it's barely hanging on. But it's the heart of the ship, so it has this constant thundering through it, this constant thump, so even though the *Bebop* is a piece of shit it has a constant heartbeat, and through all the chaos it just keeps going."

Botha notes that viewers should assume that the *Bebop* has two engine rooms to match its two big, lateral engines. "The *Bebop* has got the two cylinders on either side of the ship, the two propellers. So that engine room that you can see, I always think that propels one of the cylinders, and there's another one on the other side. Because otherwise it doesn't make any sense—it's not big enough. So if you look at the profile of the *Bebop*, that one engine room is like the one propeller, and then there's another engine room set up for the other propeller. Otherwise, for me, it's still too small. It's very busy and there's a lot of walkway from the one wall to the end of the set, but it's still nothing like the *Millennium Falcon*."

"EVERYTHING IS WORN AND BEATEN AND DIRTY BECAUSE THIS THING COULD BE TWO OR THREE HUNDRED YEARS OLD. IT'S GONNA BE LIVED IN."

GARY MACKAY, PRODUCTION DESIGNER

The *Bebop* bridge tops the vessel, with the interior set boasting retro, push-button controls, wraparound windows and an illuminated map table. "We've made a huge effort here to go very analog and have a mixture—there are iPads recessed here, but we've got real gauges and all the switches that light up," Mackay says. "The flight controls are all taped up and dodgy, and all the toll gate tickets are hanging off the side and stacked on top of each other, and everything is worn and beaten and dirty because this thing time could be two or three hundred years old. It's gonna be lived in. And one of the things I've learned over the years is how far to push aging and distressing—a lot further than you'd think to the eye, and by the time it's lit and then graded, and whatever lenses [you] are using, you'll only ever see a tiny amount of it at a time. And if you haven't gone a long way with it, you will find everything just looks sparkly brand new. And that's one of my biggest fears is you don't see the history—you've got to see some time and some history in the object."

Enshrouding the bridge is the exterior, almost art deco superstructure of the *Bebop*, one of the ship's most distinctive features and one that gives viewers a clue to its scale as well as an eye to where the characters live and work onboard. The bridge area tops the *Bebop*'s landing pad and hangar entrance, and Grant Major, Gary Mackay, Mark Yang and others worked carefully to tie the shape of the exterior bridge structure to the layout of the interior set. "I think we could have just ignored it and did it *Star Trek* style, building all the shapes and dimensions so they can randomly be in every other part of the ship, but then you want to accommodate the actual shape of what they build, which worked out pretty well,"

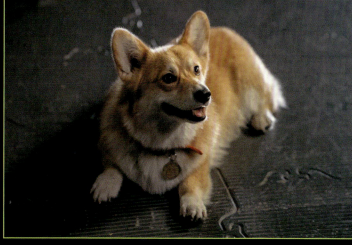

▼ The bridge set featured a lot of built-in lights and set-dressing details like unpaid bills and fines that Jet has never paid.

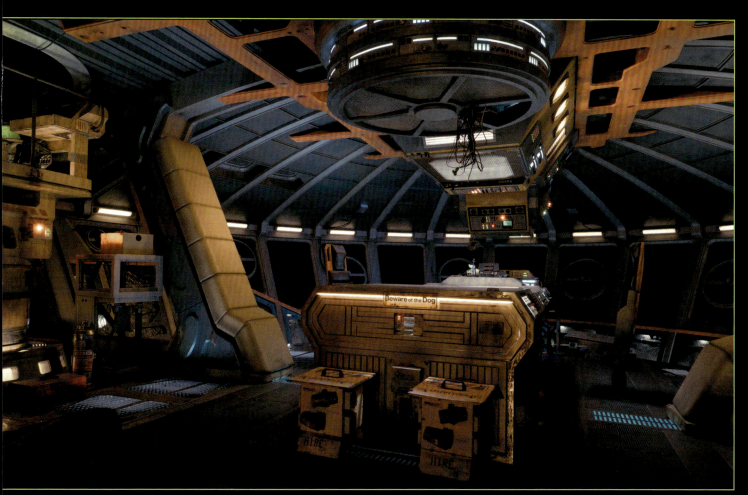

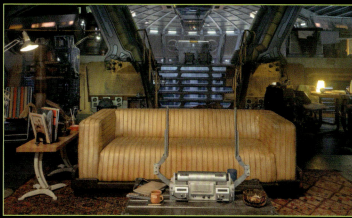

Bebop **Sweet Rides**

Yang says. "When you look at the bridge, and you turn around and you see how long the corridor is, that's how much room we're working within, from the bridge or the top section of the ship. So the rest of the ship we just size it to that proportion and try our best not to let that part overtake the rest of the design. I think overall it still maintains kind of the *Cowboy Bebop* look, but I modeled a lot of the sizing and also the aesthetics around what Russian submarines look like."

Yang found studies of Russian submarines particularly useful in the paint detail and aging of the bridge superstructure exterior, as well as the retro curvature of its shape. "I was looking at different ships that we have, and there's different types of paint decay on the walls. And to me, if the ship has experienced water environments, acidic environment damage, atmospheric environments, it would look kind of like a worn submarine."

While shots of the *Bebop* landing and docking in water have been planned and executed, depicting the characters outside the vessel while it's docked—something shown more than once on the anime series—remains a tantalizing possibility. "They looked into shooting a dog [on the deck] for certain scenes in Calgary," Yang says of early location work for the series. "A lot of things that we do now are based on CG, but there's definitely potential of [shooting the

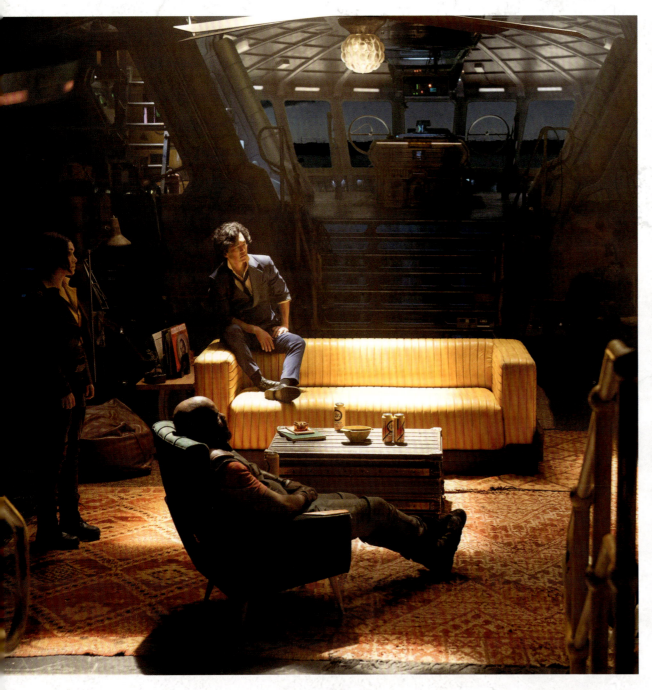

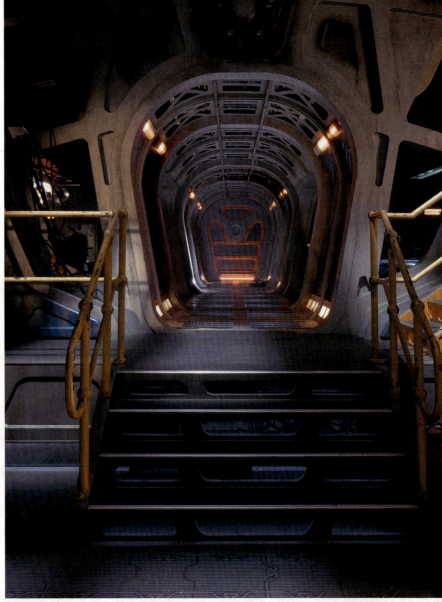

◀▲ The basic change in the set layout allowed for views of the living room area from the bridge.

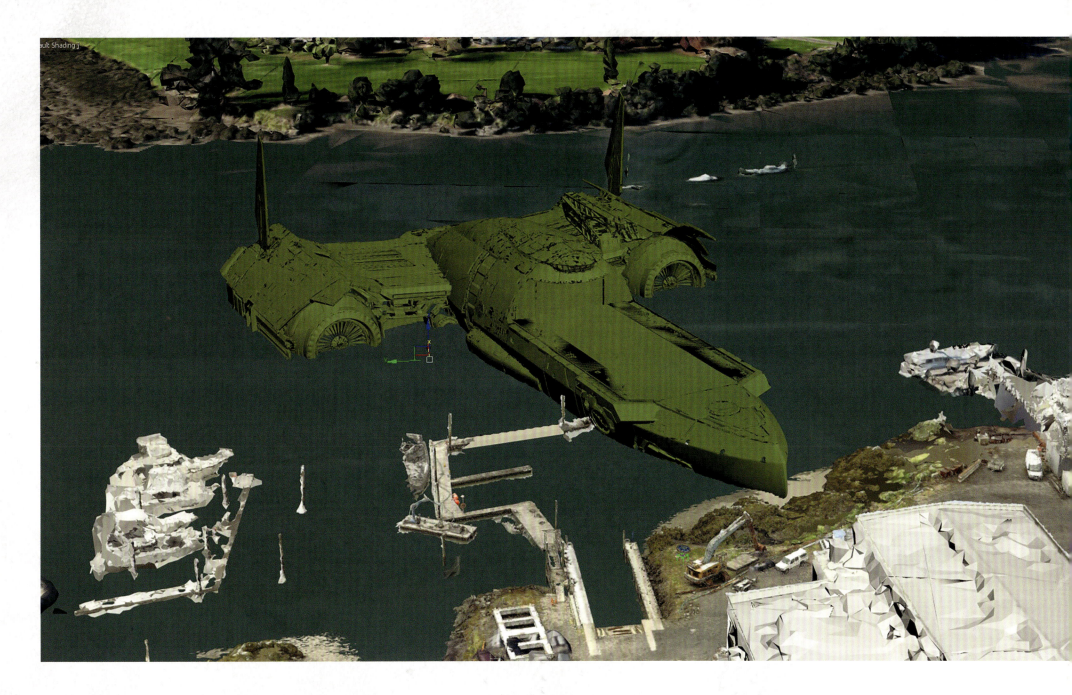

▲ On-set VFX supervisor Ben Colenso would fly a drone and survey locations where the *Bebop* might be placed. The digital model created by the drone, combined with the digital model of the *Bebop*, allowed the VFX team to adjust the scale of the *Bebop* and choose camera angles ahead of the shoot.

Bebop exterior against a water location]. I know that the set they built is flexible enough where a certain shot can be accommodated that way."

One iconic sequence from the anime required a compromise between constructing a full-size exterior deck for the *Bebop* and eliminating the sequence altogether, but Gary Mackay and his crew came up with a witty alternative. In the anime, Faye sunbathes on the landing deck of the *Bebop* while the ship is parked in a harbor, and Mackay came up with a way of getting the *Bebop* into the sunbathing shot without an expensive practical build. "There was a lot of debate about that," he acknowledges. "And in the end, what we did is we actually put Faye on the beach, with the *Bebop* in front of her in the harbor, so you get the *Bebop* in the shot rather than her being on it. And there was a beautiful reference we use—a Supertramp album of someone sunbathing under a yellow umbrella in the middle of an industrial junkyard. We find her with her picture and umbrella, and you pull back and you realize she's actually in the ugliest, shittiest industrial rusty yard of broken concrete. And then you kind of flip around to the other side and Spike's in a conversation with Jet. He's fishing off the end of the jetty that's got a big industrial boat winch on it, and the *Bebop* is out there in the water floating out beyond them. We had to do some very interesting jumping through hurdles and things like, 'How can we do this in a way that's still *Bebop*, that was funny, and not necessarily on the bridge?'"

THE *SWORDFISH II*

When Spike Spiegel needs to get outside the *Bebop* to land a bounty, his chosen mode of transport is the space fighter *Swordfish II*. In the anime lore the *Swordfish II* was based on a ground racing car body—the original *Swordfish*—that Spike purchased and that was then modified into a fast-pursuit space plane (by the character Doohan in the anime), capable of overtaking and disabling other spacecraft thanks to its powerful, variable-geometry engine mount (which gives the little ship Vertical/Short Takeoff and Landing or V/STOL capabilities), and its underslung plasma cannon, which in the anime design is almost the size of the *Swordfish II* itself.

Google *Cowboy Bebop* images and you're likely to see multiple hits of the familiar needle-nosed hull, dull red wings and bubble canopy of the *Swordfish*. The craft was an integral graphic element of the anime's high-energy main title sequence, shown launching from the *Bebop*'s front deck and screaming through space at tremendous speed, and it was involved in some of the anime's most exciting and memorable action sequences.

"The fans are gonna love the *Swordfish*," enthuses VFX co-producer Scott Ramsey. "There's a really great sequence where Spike launches the *Swordfish* off the bow of the *Bebop*. The *Swordfish* appears through smoke, crossing the flight deck. It lowers its wings and blasts off the *Bebop*. It's a really cool shot."

With the *Swordfish* being one of the most recognizable and iconic elements of the series, the live-action show's artists were determined to maintain the ship's distinctive appearance while

▼ Concept art of the *Swordfish II* in flight by Henry Fong.

▶ Color profile study by Henry Fong. Though the overall profile of the *Swordfish* changed significantly, the criss-cross stance of the stowed wings was retained.

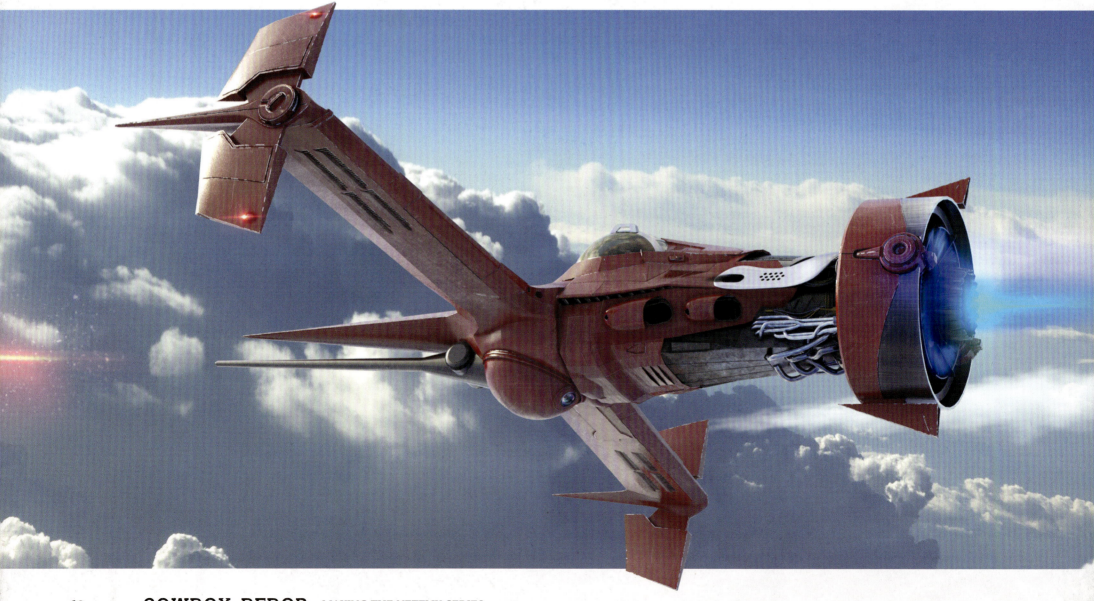

SWORDFISH II PROFILE STUDIES V01 HENRY FONG 2019 04 16

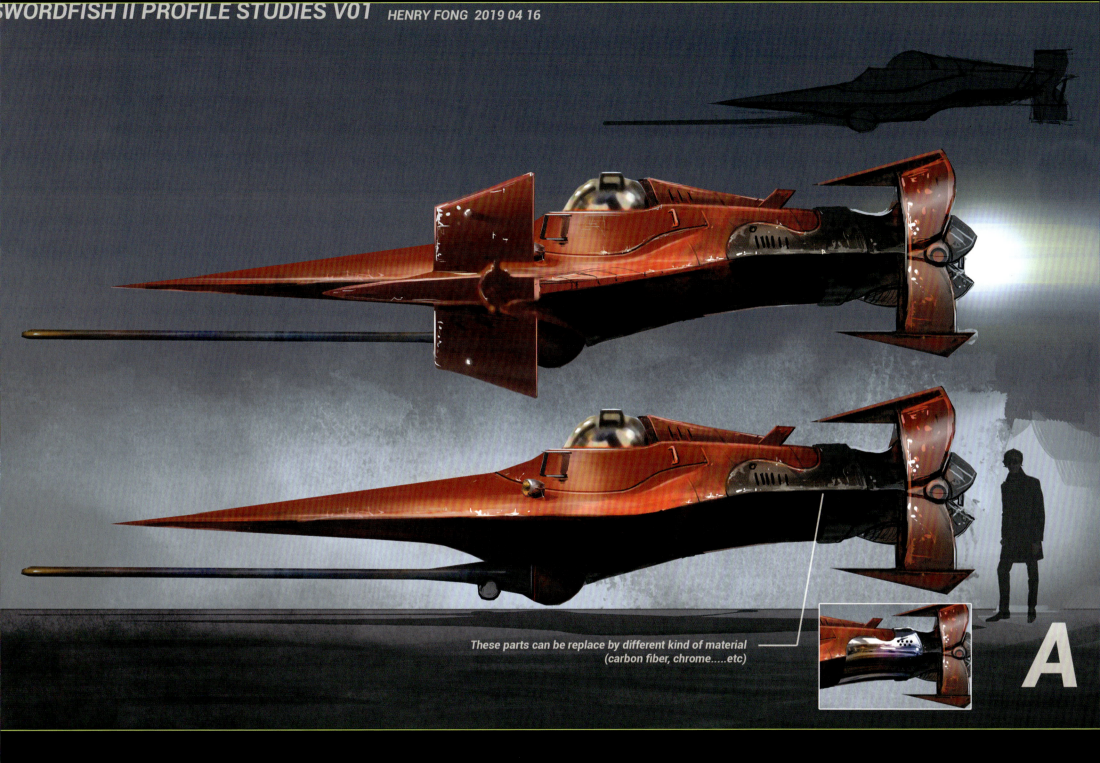

These parts can be replace by different kind of material (carbon fiber, chrome.....etc)

A

bringing some of its elements into a more realistic realm, as Victor Scalise explains: "The *Swordfish* is very cool—the model itself is very close to the ship from the anime. I feel like we hit the expectations of fans. There were some shot designs that were already very close to ones out of the anime, then there were other sequences where we went in and did our own designs and some nice cool camera moves to come around the *Swordfish*."

In the case of the *Swordfish*, achieving realism meant making some adjustments to the ship's surprising size. "The original *Swordfish* in the anime was actually quite a big ship," Mark Yang says. "From a distance it looked like a small pod because they were zooming in on shots of Spike, and he's driving it like a sports car. But it's pretty big—I think it's bigger than an F-15 [fighter jet]. If you look at that orb that he's sitting in, you would think that

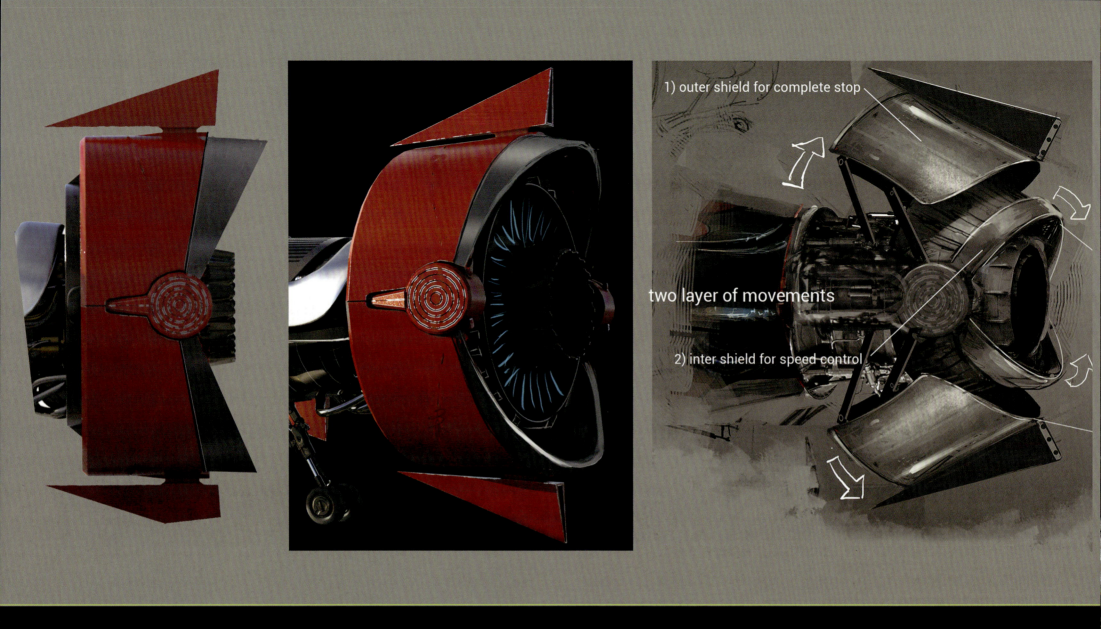

1) outer shield for complete stop

two layer of movements

2) inter shield for speed control

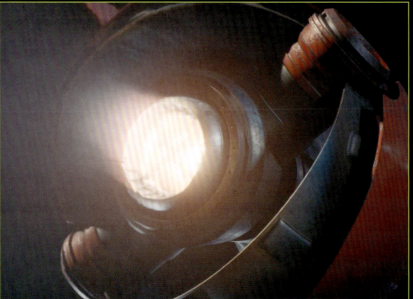

▲ The VFX team wanted to add some real-world believability to the main engine, referencing F-22 Raptors and F-35 Lightning jets.

◄ The anime was referenced and used as storyboards for the CGI shots of the *Swordfish* leaving the *Bebop*.

▼ Work-in-progress CG model by Rising Sun.

▼▼ Rising Sun duplicated the wing fold mechanism of the *Swordfish* for their CG model.

it's a really small part of the ship, but surprisingly the pilot's really small within the orb. We wanted to make the *Swordfish* a little more personal, so we size it down a lot more so that when he's interacting with the ship it's not [a] towering thing behind him where you only see the red panels."

One of the most distinctive elements of the *Swordfish* was also common to many of the small, one-man ships seen in the anime: the spherical pressure dome cockpit that Spike Spiegel sits in to pilot the craft. Also seen on the ISSP patrol ships and the *Red Tail*, the clear cockpit suggests a modular system around which various small spacecraft are built, which gave rise to discussions about

> "WE WANTED TO MAKE THE *SWORDFISH* A LITTLE MORE PERSONAL, SO WE SIZE IT DOWN A LOT MORE."
>
> **MARK YANG, CONCEPT ARTIST**

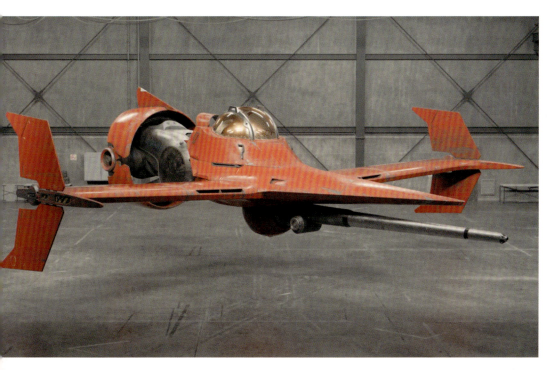
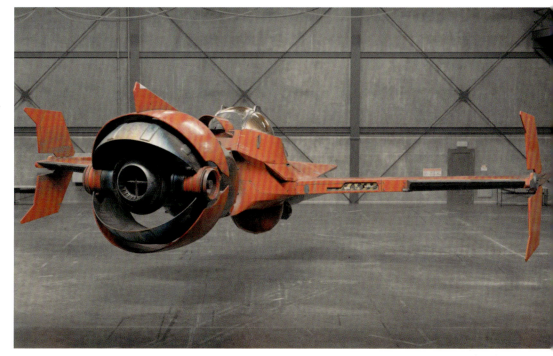
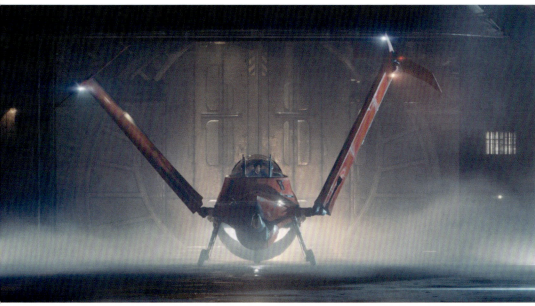
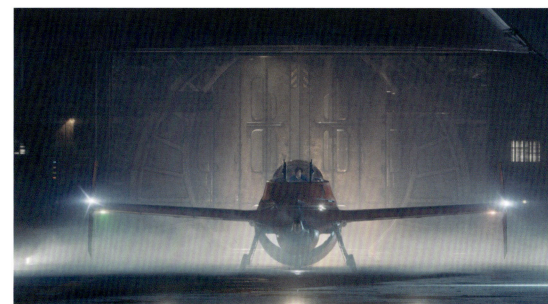

BEBOP SWEET RIDES

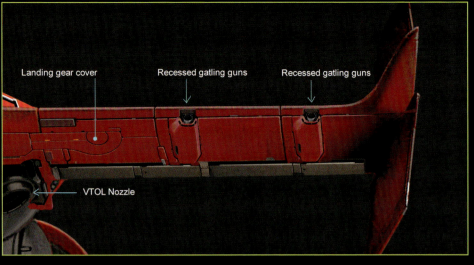

> "I THINK THE FANS ARE GONNA LOVE THE *SWORDFISH*. I THINK THERE'S DEFINITELY A LOT OF *SWORDFISH* PLAY IN THE SHOW THAT THE FANS WILL EAT UP."
>
> **SCOTT RAMSEY, VISUAL-EFFECTS CO-PRODUCER**

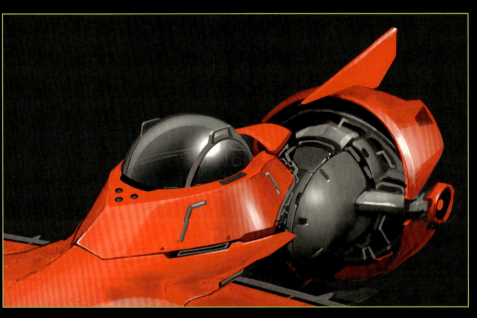
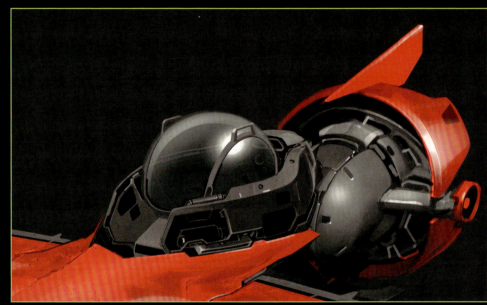
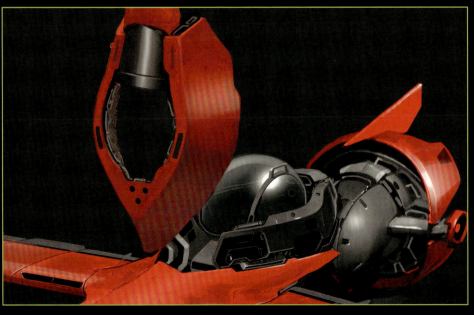
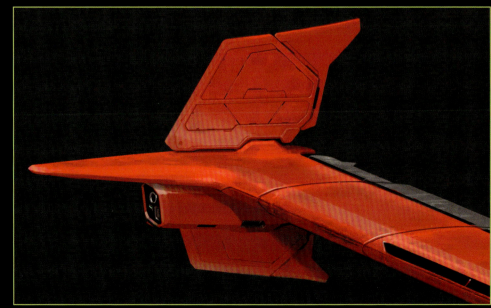

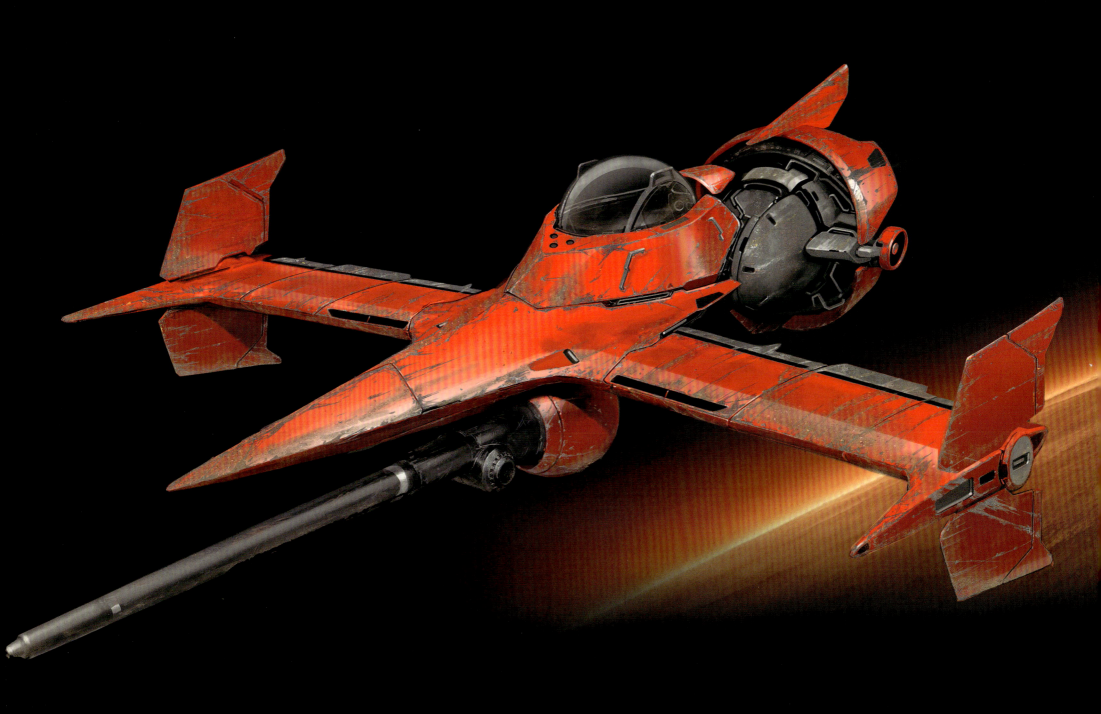

◄ VFX co-supervisor Greg McMurry felt it was important that the cockpit bubble mimic the look of the bubble in the anime.

▲ Final concept art of the *Swordfish*.

construction methods and a kind of military industrial complex within the solar system. "We came up the idea that spacecraft in the future and in the world of *Cowboy Bebop* are like a Humvee," says McMurry. "The military has a version of the Humvee, and there's a commercial version of a Humvee. There's a lot of different vehicles that are based on doing a Humvee. We decided that it was like Grumman, which designs all kinds of things for the military."

The fictional *Bebop* company was named Yang Industries after concept designer Mark Yang, and the name found its way into some graphic elements on the show. "So that company basically makes all those things, but they make it out of a basic model," McMurry explains.

Given the size of the *Swordfish* and other craft, and the fact that live actors need to interact with them and be seen piloting them from outside the craft, one might assume that all or part of these ships would be constructed as practical set pieces—or at the very least the bubble cockpit would be manufactured. But contemporary visual-effects capabilities have rendered a lot of these kinds of full-size props, and even many close-up shots, unnecessary. "In the *Swordfish* there are a bunch of shots that were shot with Spike in

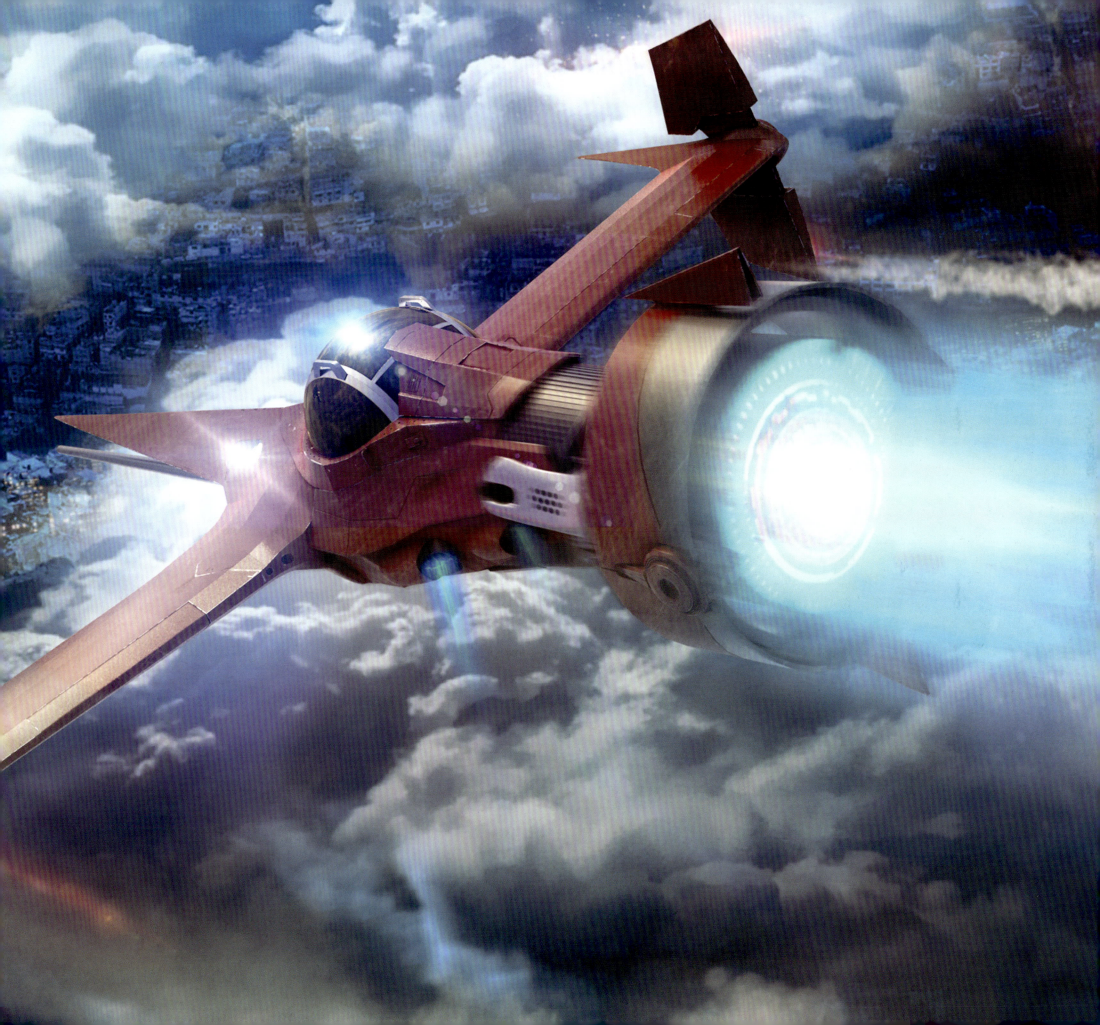

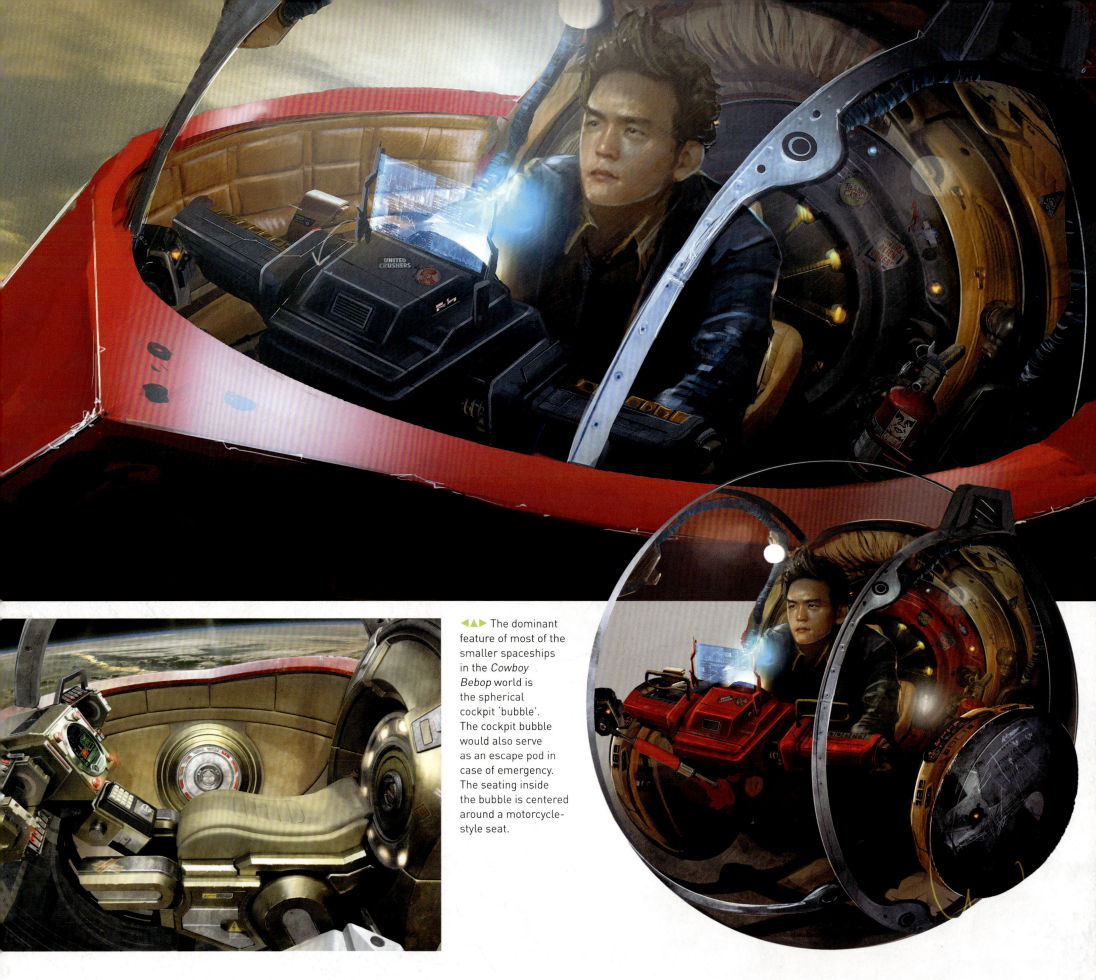

◀︎▲▶︎ The dominant feature of most of the smaller spaceships in the *Cowboy Bebop* world is the spherical cockpit 'bubble'. The cockpit bubble would also serve as an escape pod in case of emergency. The seating inside the bubble is centered around a motorcycle-style seat.

76 COWBOY BEBOP MAKING THE NETFLIX SERIES

the buck, as well as Faye in the buck, and a lot of those shots were used for the closeups," says Victor Scalise. "When you shoot the buck some of the shots were 'locked' like some of the designs of the [anime] moves. You were dictating a camera booth for the ship that we wanted to change, so we just opted to go full CG and change the shot a little bit, just to make it a little more exciting."

Theoretically, everything in an exterior shot involving the *Swordfish* could be digitally rendered, including the pilots, with actors recreated using face replacement and digital doubles, but McMurry prefers to start using live elements as a basis for lighting and texture. The cockpit and parts of the surrounding structure were built practically, and Gary Mackay hoped to build a full-size prop exterior of the ship. "We were gonna build one. And then as time went on and costs were updated, and in talking with the guys more and more [we asked ourselves] 'Do we actually really physically need it?'"

Anneke Botha also held back on detailing the *Swordfish* cockpit interior, albeit for character-related reasons. "You don't want to plaster the *Swordfish* like you did with the *Bebop* because Spike is [associated with] quite clean lines. He wears one suit all the time and it's quite stylish and he's quite fancy. And the *Swordfish* is swanky, man; that little ship is swanky."

Despite the change in scale and detail, the *Swordfish II* is still very much the iconic vehicle anime fans love. "I wanted to stick as close as I can to the original *Swordfish*," Mark Yang says. "I just finished, a couple years ago, working on *Transformers: Bumblebee*, and I remember when I first saw Optimus Prime in the original movie, I thought that it was similar, but it wasn't what you

▲ Magazine cover by the art department.

▼ *Swordfish* seating configuration studies.

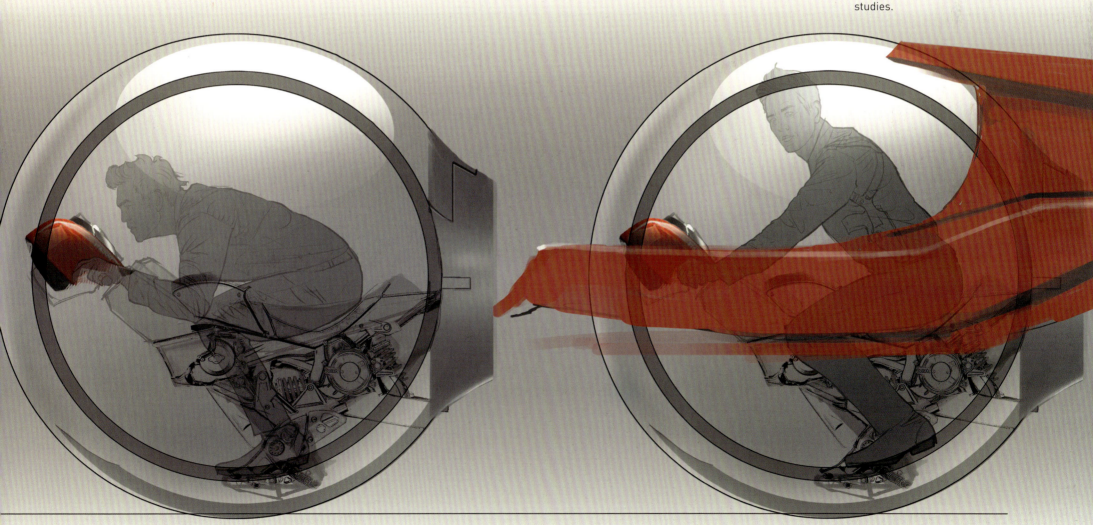

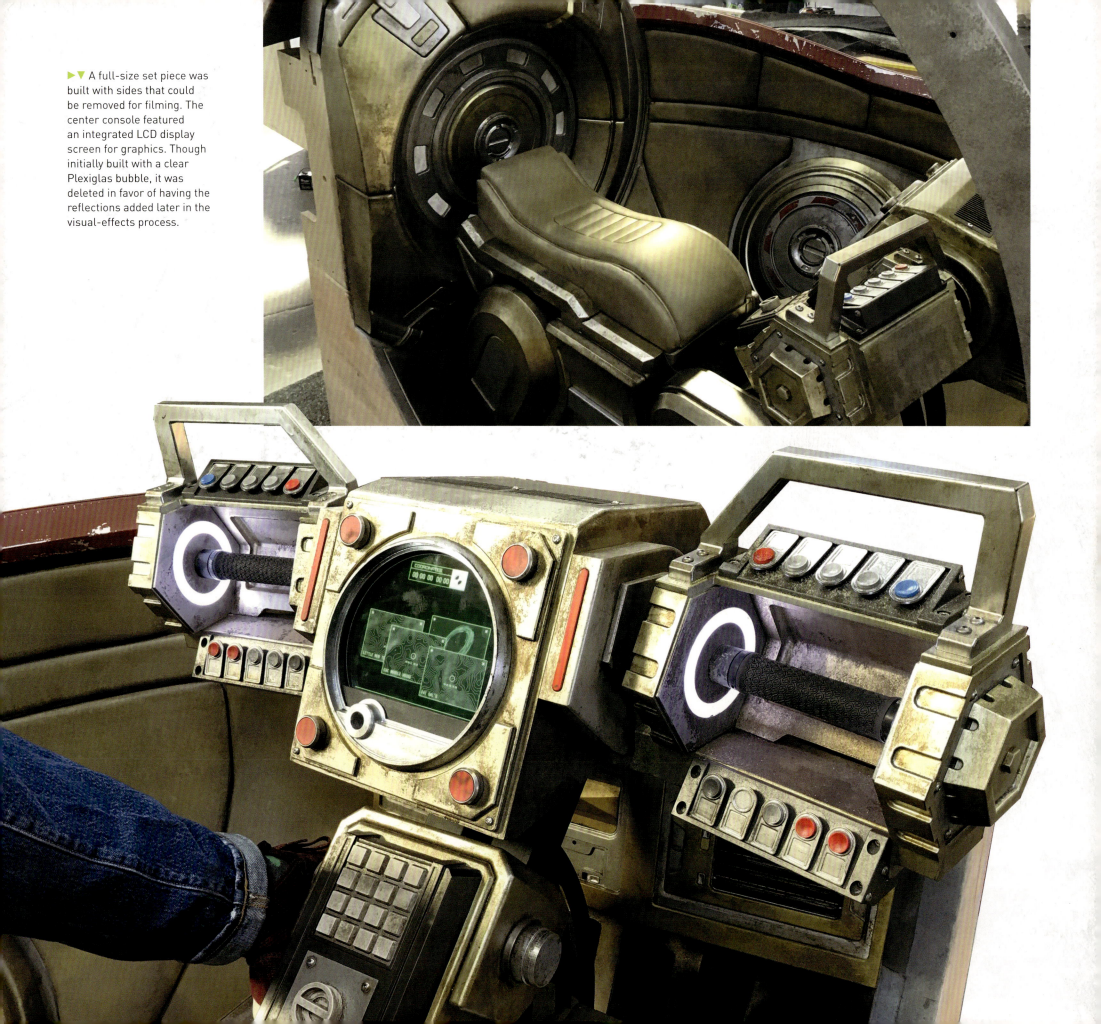

▶▼ A full-size set piece was built with sides that could be removed for filming. The center console featured an integrated LCD display screen for graphics. Though initially built with a clear Plexiglas bubble, it was deleted in favor of having the reflections added later in the visual-effects process.

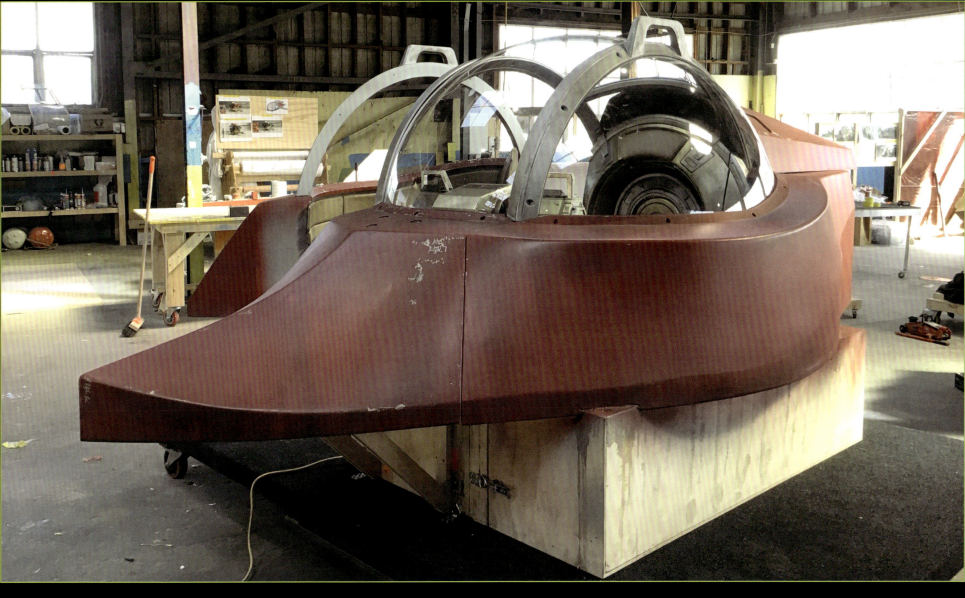
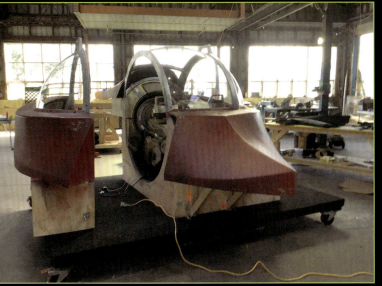
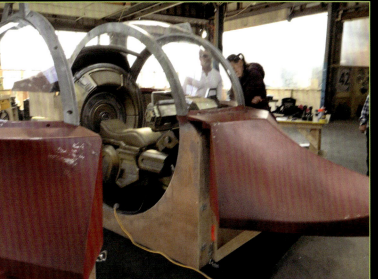

▲◄ As the scripts developed, it became clear that a full-size *Swordfish* prop would not be needed—there simply weren't that many scenes that would require something other than seeing Spike or Faye inside the cockpit bubble. It was decided that a full-size cockpit buck would be built to film the actors in, but the rest of the *Swordfish* would be integrated with the CG *Swordfish* being developed by the VFX team.

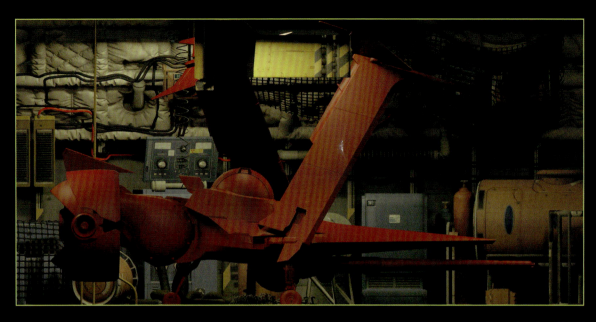

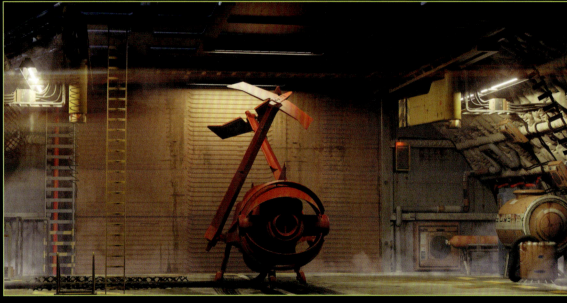

▲▶ Interior *Bebop* hangar/garage design studies by Rising Sun's art department, headed by Nick Pill.

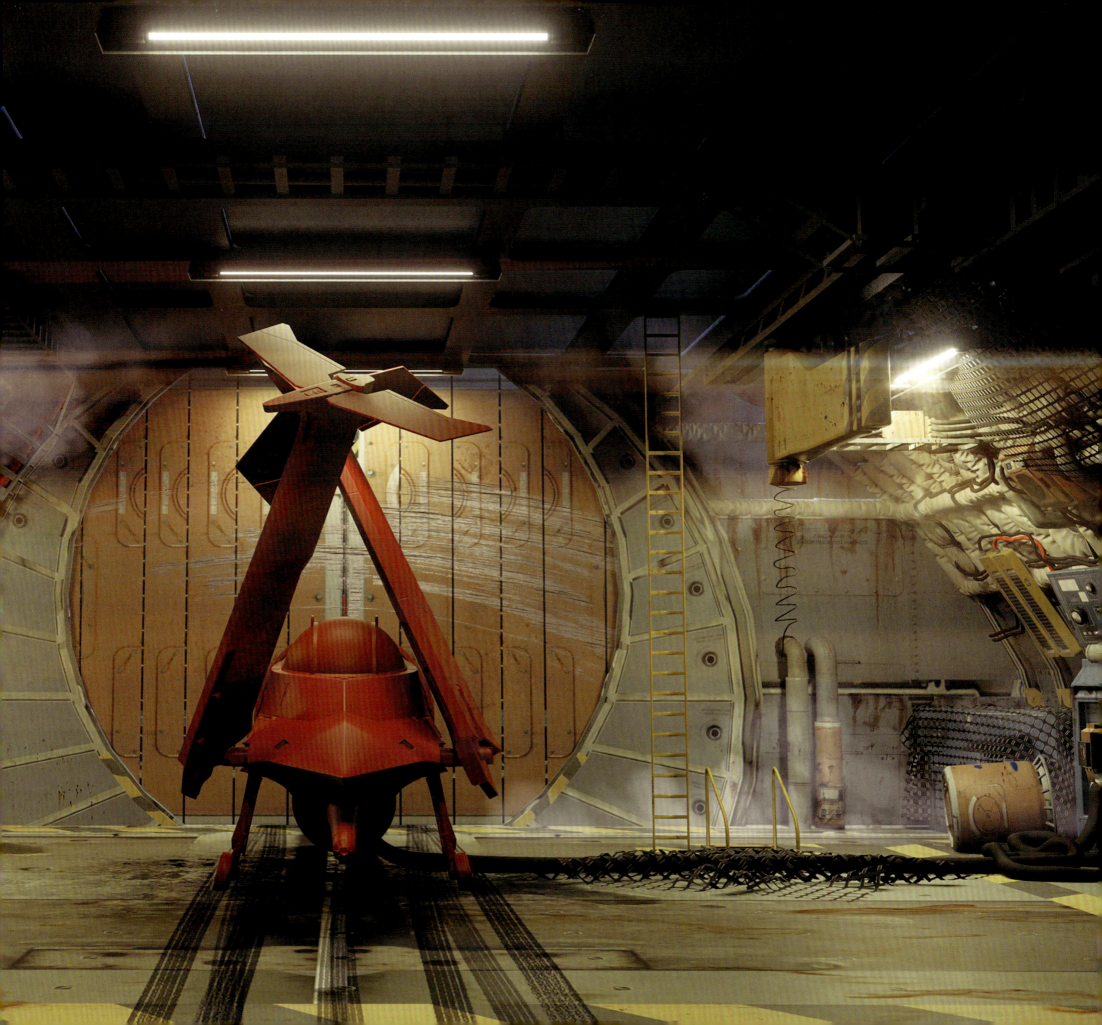

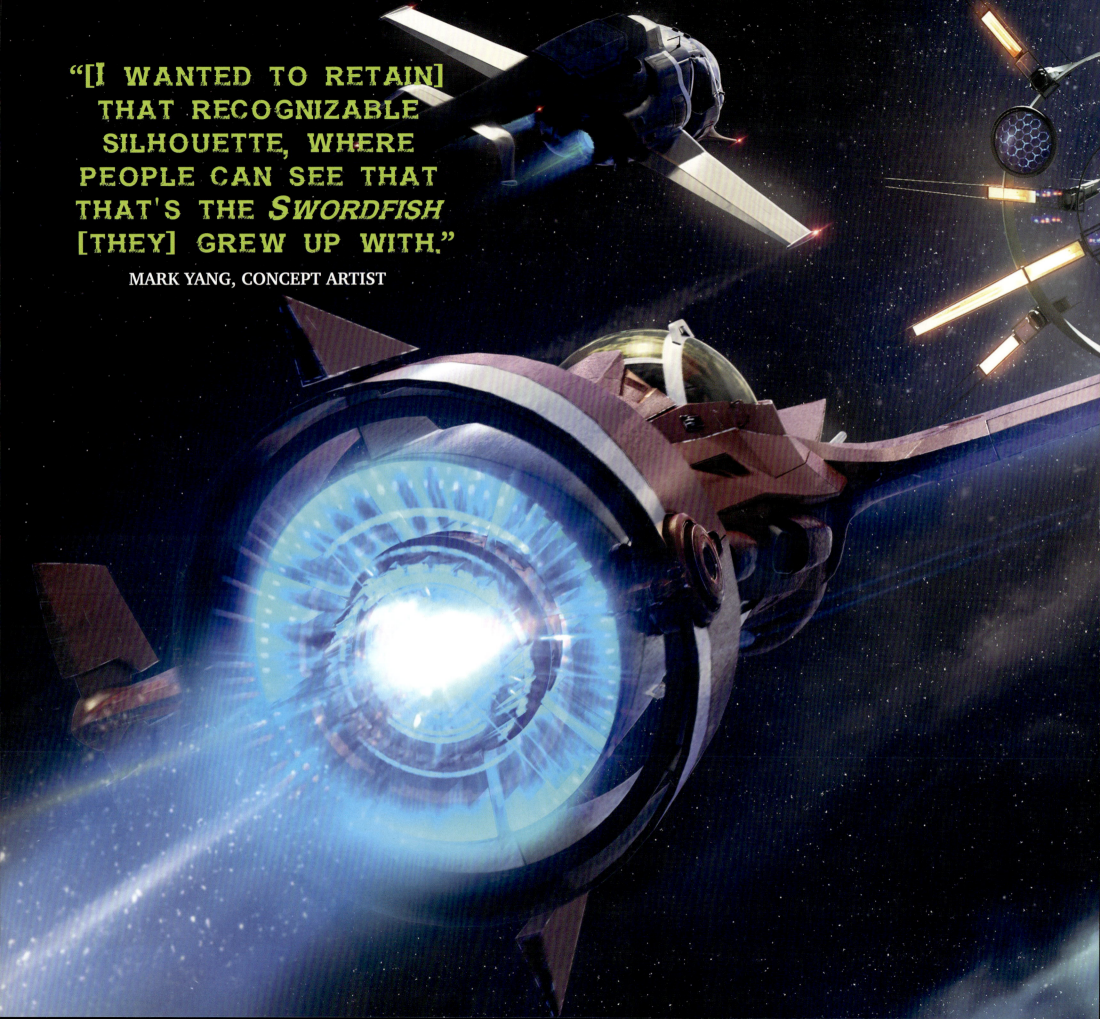

"[I WANTED TO RETAIN] THAT RECOGNIZABLE SILHOUETTE, WHERE PEOPLE CAN SEE THAT THAT'S THE *SWORDFISH* [THEY] GREW UP WITH."

MARK YANG, CONCEPT ARTIST

◀▼ Early concept art depicting Spike chasing Katerina as she heads to the Astral Gate.

saw in the anime, necessarily. And I've worked on Optimus Prime for the new movie, and one of the things I wanted to do was, I had a toy and I wanted that toy to be represented on screen, but in a modern way, where it was a physical thing with good industrial design that felt tangible. And so that's kind of what I really wanted to bring to this *Swordfish*. First and foremost, that recognizable silhouette, where people can see that that's the *Swordfish* [they] grew up with. But then at the same time, we get closer to this Lego-esque toy: you can actually open hatches, there's actually fuel doors and electrical panels and things that behave like a modern aircraft. Given how big the original ship was, there was a lot more room for the *Swordfish* nose cone to be essentially this big classic Lotus-like 1950s sports car idea of just how long that thing is. There was a lot more room to kind of elongate the cannon for it too and still maintain that silhouette."

"We just trimmed it out a little bit and we didn't change it," Greg McMurry says. "It looks pretty much like the *Swordfish*—and the *Swordfish* looks pretty cool to begin with."

BEBOP SWEET RIDES

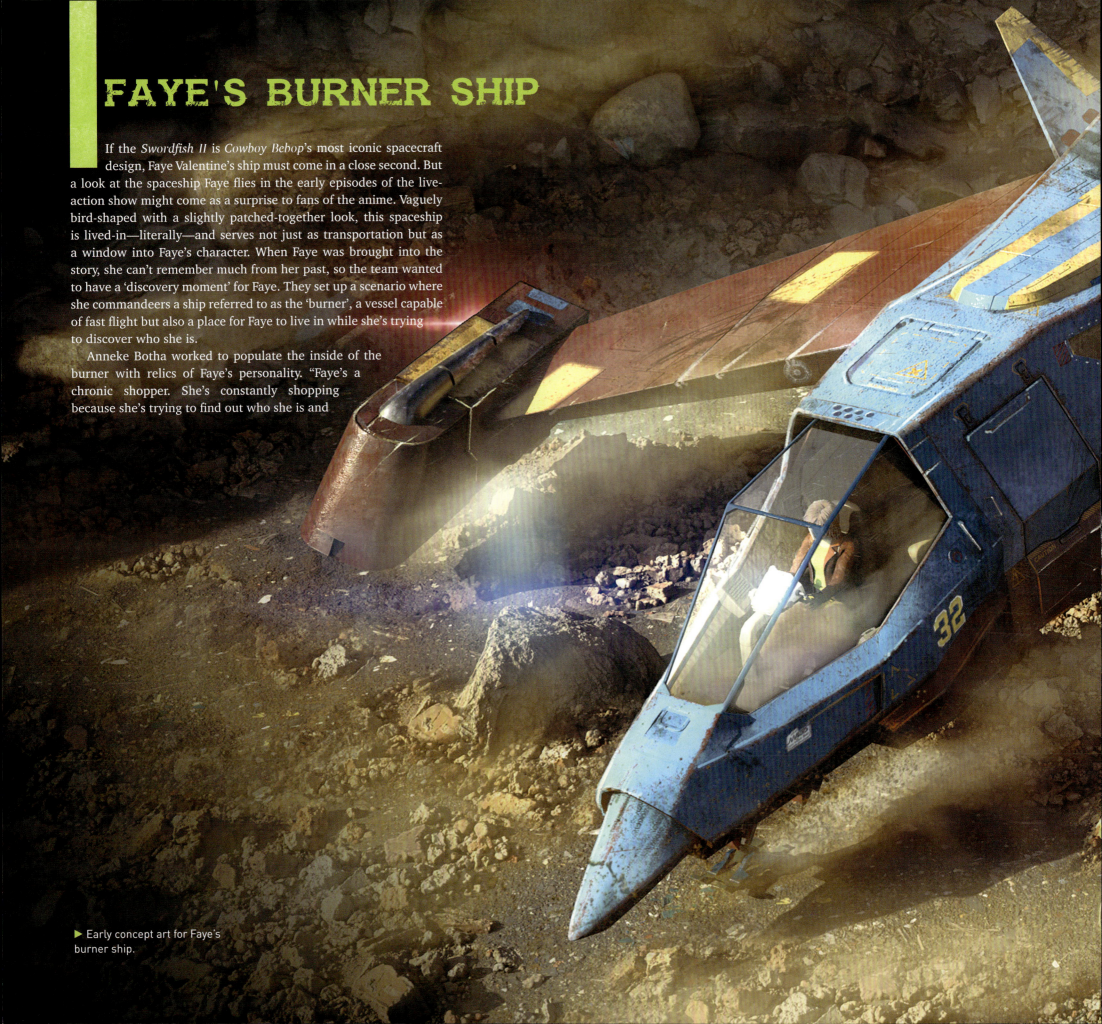

FAYE'S BURNER SHIP

If the *Swordfish II* is *Cowboy Bebop*'s most iconic spacecraft design, Faye Valentine's ship must come in a close second. But a look at the spaceship Faye flies in the early episodes of the live-action show might come as a surprise to fans of the anime. Vaguely bird-shaped with a slightly patched-together look, this spaceship is lived-in—literally—and serves not just as transportation but as a window into Faye's character. When Faye was brought into the story, she can't remember much from her past, so the team wanted to have a 'discovery moment' for Faye. They set up a scenario where she commandeers a ship referred to as the 'burner', a vessel capable of fast flight but also a place for Faye to live in while she's trying to discover who she is.

Anneke Botha worked to populate the inside of the burner with relics of Faye's personality. "Faye's a chronic shopper. She's constantly shopping because she's trying to find out who she is and

▶ Early concept art for Faye's burner ship.

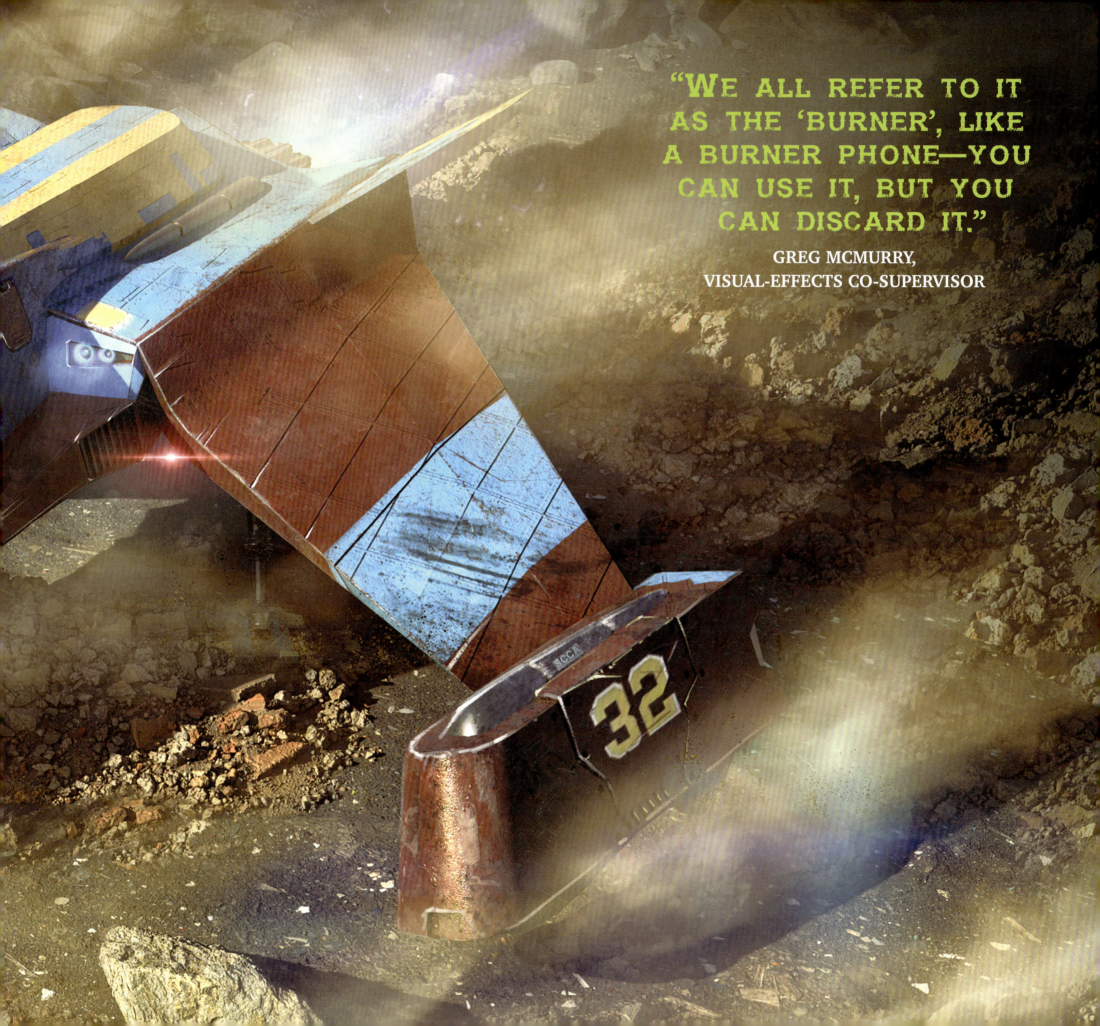

"We all refer to it as the 'burner', like a burner phone—you can use it, but you can discard it."

GREG MCMURRY,
VISUAL-EFFECTS CO-SUPERVISOR

what she likes. Is she into overalls, or is she into fancy clothes? Is she into discount? She's trying to fill the void by shopping, and in her burner we had all these little tag cards of different people, like she stole little identity cards from a banker or lawyer, those lanyards that you wear on your neck. I had hundreds of them made and she still doesn't know [who] she is. Was she a teacher? Was she a cop? Was she a security guard? Was she a banker? I had all these postcards in her burner that she stole from people's postboxes. It's like, 'Hey, we're in a family on Mars and we are having a good time. We hope to see you soon,' because she really doesn't know who she is, but she does shop a lot. And in the anime she's always sitting there with a book, trying to find out who she is, what does she like. We had this big stack of online magazines: *The New Gun*, *New Clothes*, *New Food*—It's like she's constantly searching for who she is because she doesn't know."

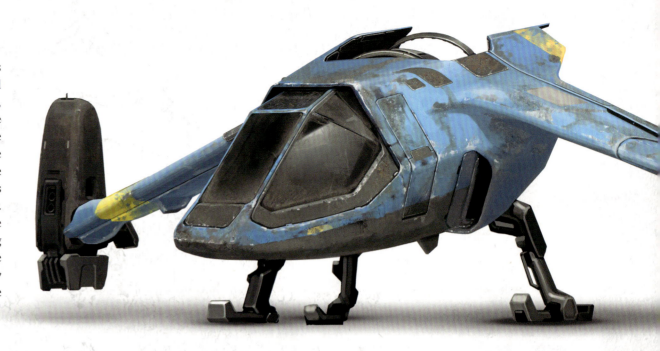

Jumping in and out of the first few episodes of the live-action series as she encounters—and annoys—Spike and Jet, Faye reappears in Episode Four in the burner, and her fragile psyche leads to the destruction of the ship. "The burner sequence was something that we had Framestore take on for the whole Callisto sequence," Victor Scalise elaborates. "The original concept for the sequence was [Faye] was just going to clip the missile with her wing. We were going over it with John Kilshaw, our visual-effects supervisor at Framestore, and he said 'Well, what if the missile hit the ship, like she was doing a pit maneuver on the missile with her wing?' And it then rips off the wing, which then creates the whole chaos of her spinning and flipping and all the debris raining down, which was a lot of fun."

The look of the burner ship was dictated by an actual practical prop scrounged from a real aircraft. Mark Yang was then asked to

> "[THE BURNER SHIP] IS LIKE LIVING IN A VOLKSWAGEN VAN. YOU HAVE ALL YOUR STUFF PILED IN THERE, AND YOU JUST LIVE IN IT."
>
> GREG MCMURRY,
> VISUAL-EFFECTS CO-SUPERVISOR

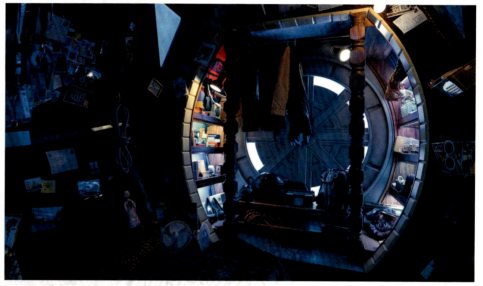
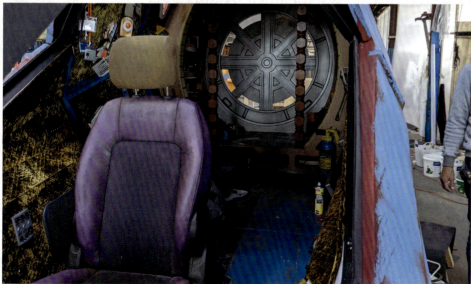
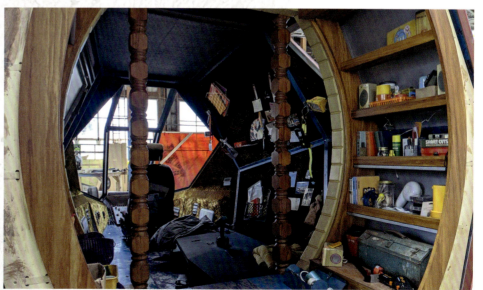

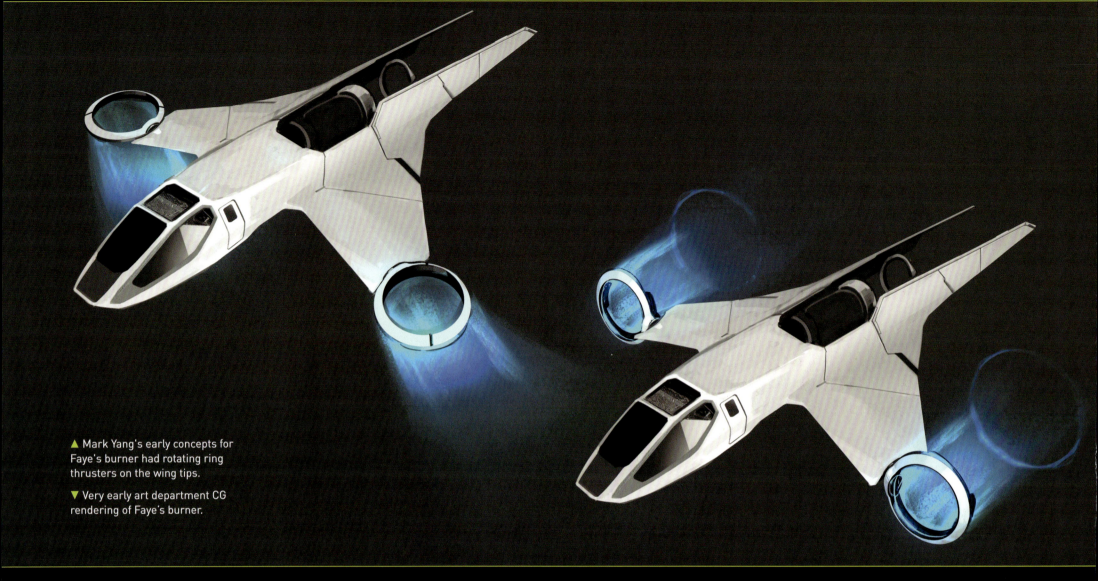

▲ Mark Yang's early concepts for Faye's burner had rotating ring thrusters on the wing tips.

▼ Very early art department CG rendering of Faye's burner.

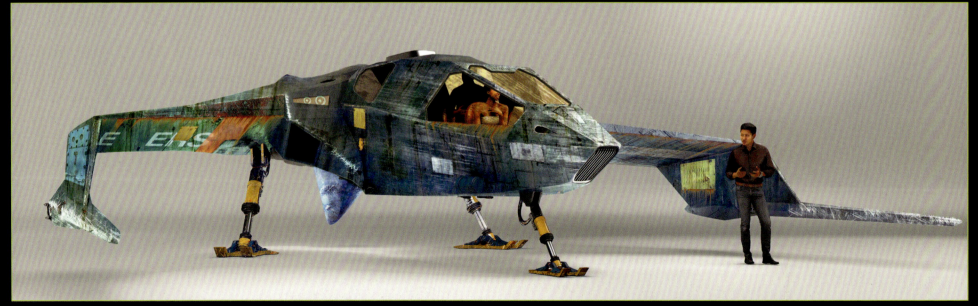

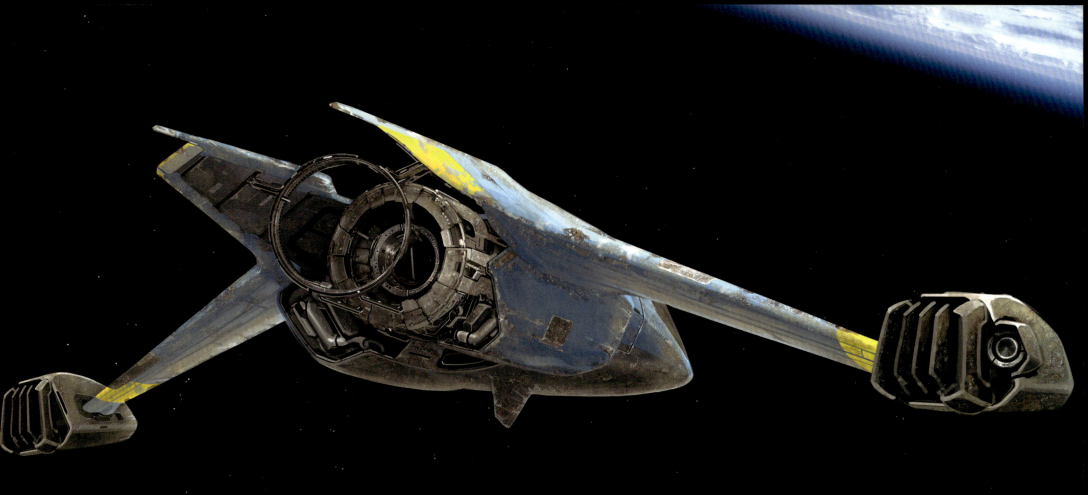

use it as a starting point and see what he could come up with. The burner ship actually gets a fair amount of screen time in Episode Four—it needs to fit in some very tight spaces, so the decision was made to make it a vertical takeoff and landing. Engines were put on the wing tips that could rotate, and there was a bigger engine in the back that propels the burner ship, breaks gravity and goes into space.

"I gave it somewhat of a makeover based on the evolving design aesthetics that they wanted," Yang says. "And [an] analysis of the ship that was a pretty interesting concept is essentially it's a ship that wasn't exactly designed to be lived in. It started off with a pretty classic sci-fi layout, with the big wings and the pylons, and then when I got hold of it I remembered that a lot of the *Cowboy Bebop* engines that I saw had elliptical aspects to them, so I hollowed out the middle of the ship to give it that feeling."

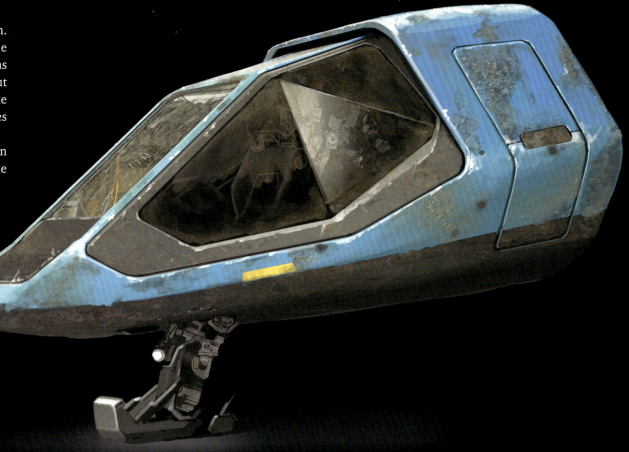

▲▶ Since only the front portion of the ship needed to match the practical set, Mark Yang added a larger engine at the rear, as well as manouverable jets on the ends of the wings.

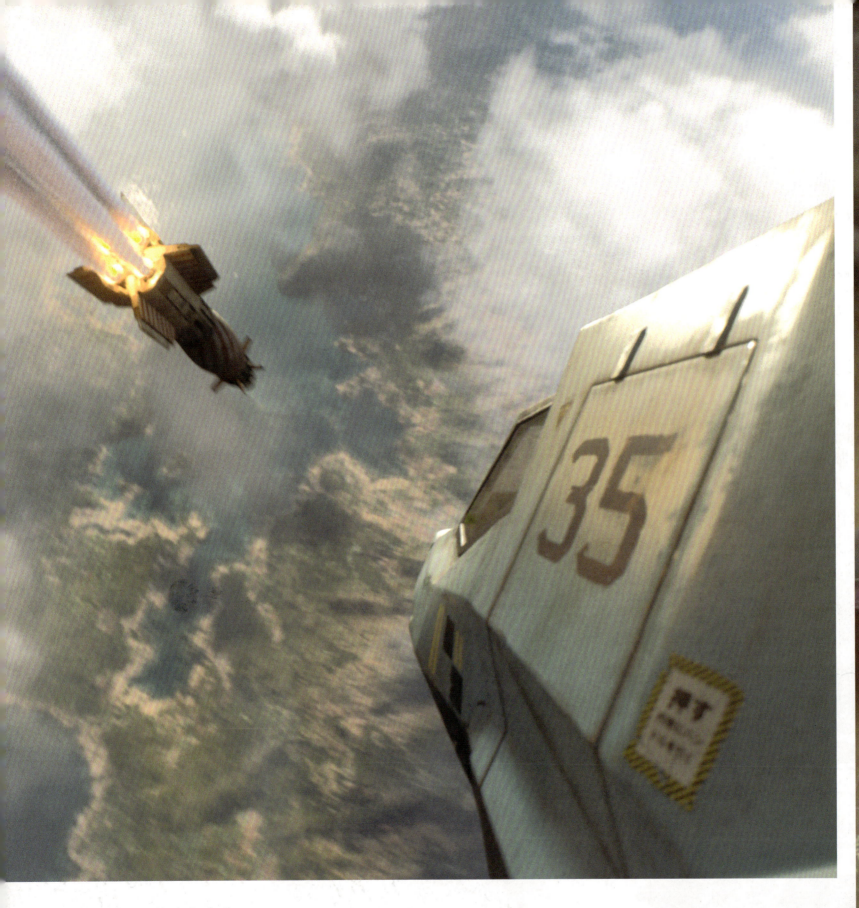

▶ Final burner ship design by Framestore.

▲ Early concept art of Faye as she chases down a missile fired by the Murdock gang.

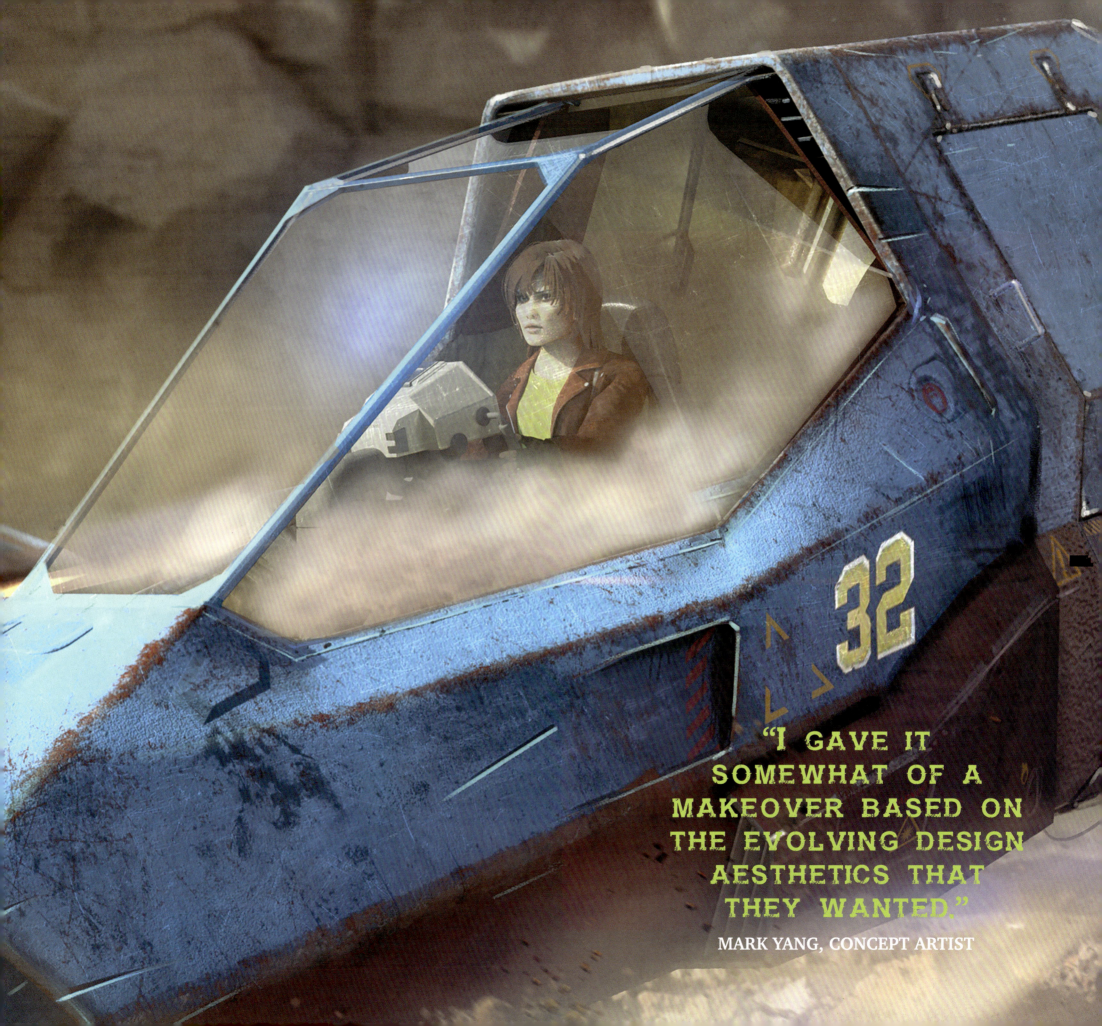

"I GAVE IT SOMEWHAT OF A MAKEOVER BASED ON THE EVOLVING DESIGN AESTHETICS THAT THEY WANTED."

MARK YANG, CONCEPT ARTIST

In the chronology of the series, the burner ship is a bit of a bait and switch—fans may assume that they'll see Faye Valentine in her familiar *Red Tail* ship and wonder what they're getting with the burner. "I think the expectation most people have when they see Faye is to see the *Red Tail*," Yang acknowledges. "So to not have that ship definitely is gonna be very shocking for a lot of people. I've worked on the recent *Star Trek: Picard* series, and all the *Transformers* series, and the one thing that you definitely get from interacting with people who are big fans of this stuff is that they're gonna have something to say about it, whether or not they like it."

▲▶ Concept art of the burner's dashboard by Mark Yang (right) and the finished set piece (above), inspired by the dashboard console of the 1970 Vauxhall SRV concept car.

▶ The cockpit filming 'buck' under construction (right) and on set (above).

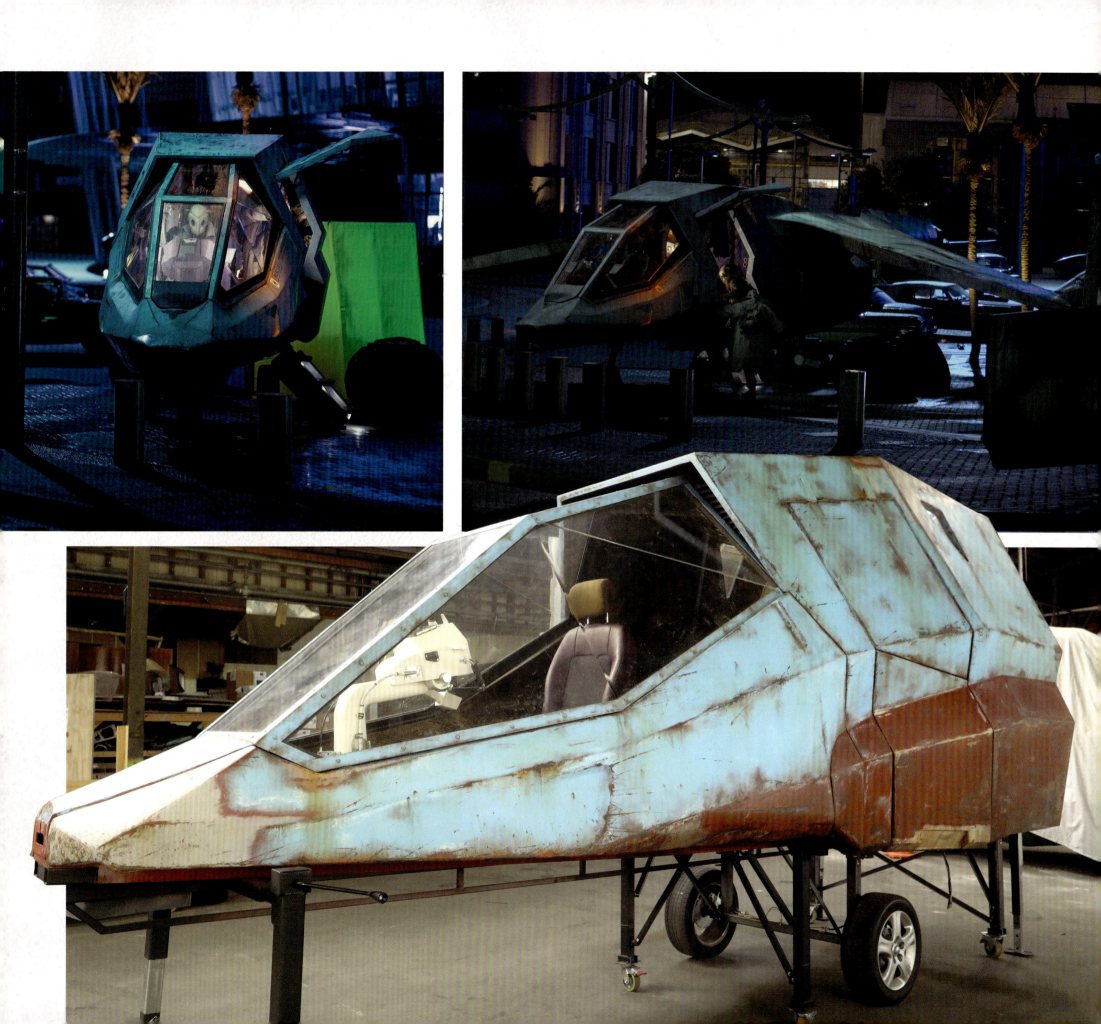

THE *RED TAIL*

Perhaps the second most familiar vehicle from the *Cowboy Bebop* anime, Faye Valentine's highly maneuverable *Red Tail* figures in some of the animated series' most exciting space action sequences. As a result, it was clearly important that the live-action production got its details right. "The *Red Tail* is another ship that we kept very true to the anime," says Victor Scalise. "Goodbye Kansas took on the task of building the *Red Tail* and doing all of the *Red Tail* shots in the series. They really added a lot of detail to the ship. The *Red Tail* is another ship that is very maneuverable, as well as having some big guns, which we were able to take advantage of for the cathedral fight."

There was initially no budget for including the *Red Tail* in the series, but Becky Clements, with her family aviation background, had a particular affinity for the ship. "The *Red Tail* in many ways is much more flight-appropriate than the *Bebop* or some of the other ships," she says. "But we definitely had [budgetary] conversations as well. The one thing I would say about the ships is they are pretty true to the anime. We definitely got them as close as we could;

> "THE *RED TAIL* IS ANOTHER SHIP THAT IS VERY MANEUVERABLE, AS WELL AS HAVING SOME BIG GUNS."
>
> **VICTOR SCALISE,**
> **VISUAL-EFFECTS CO-SUPERVISOR**

▼▶ *Red Tail* concept art by Mark Yang.

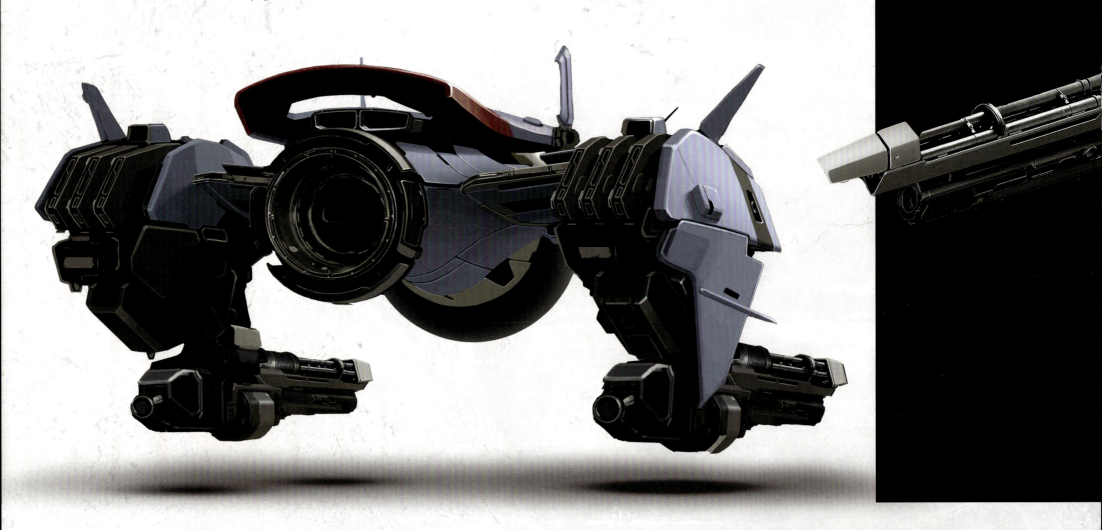

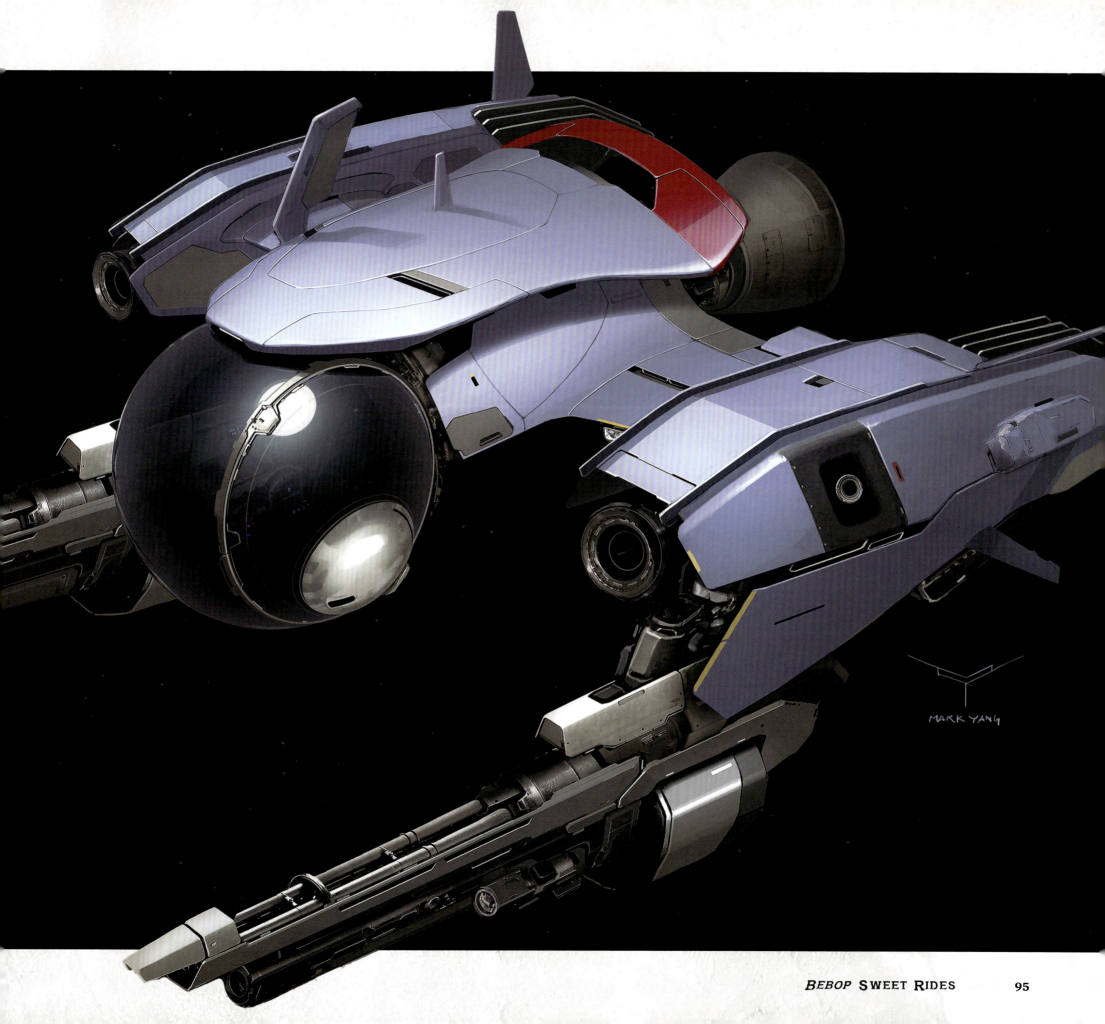

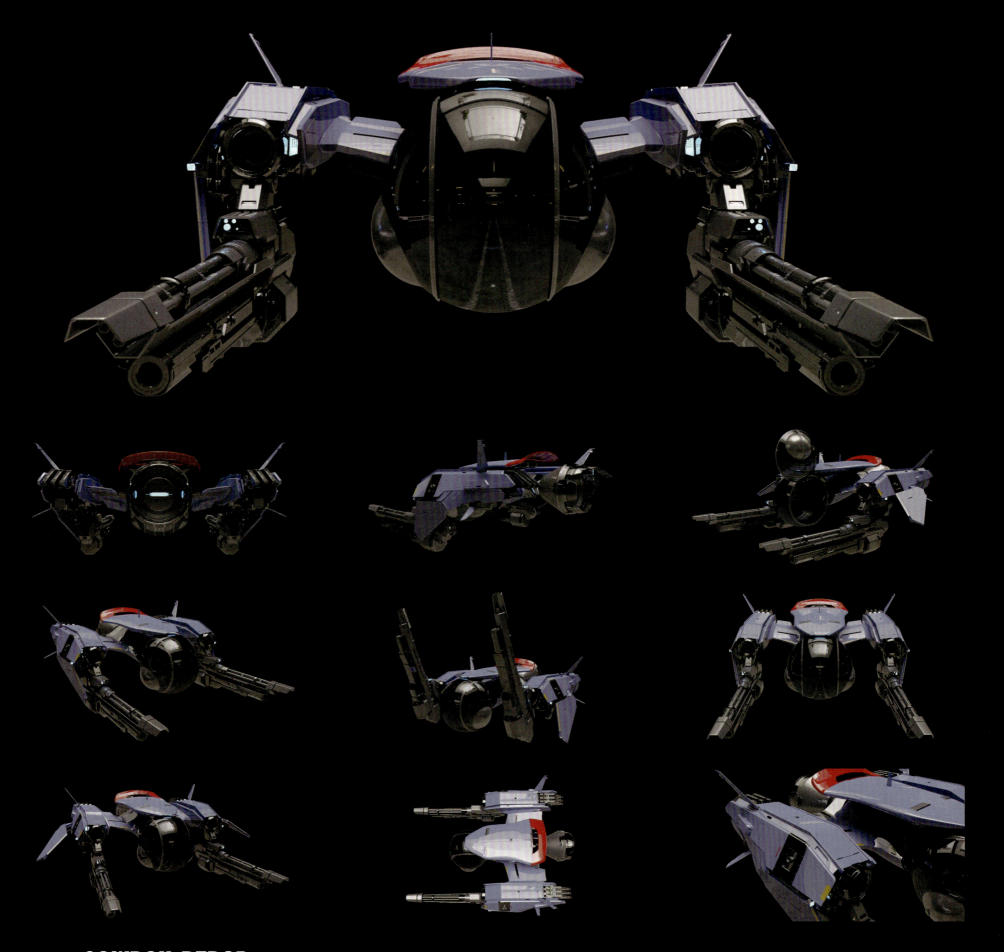

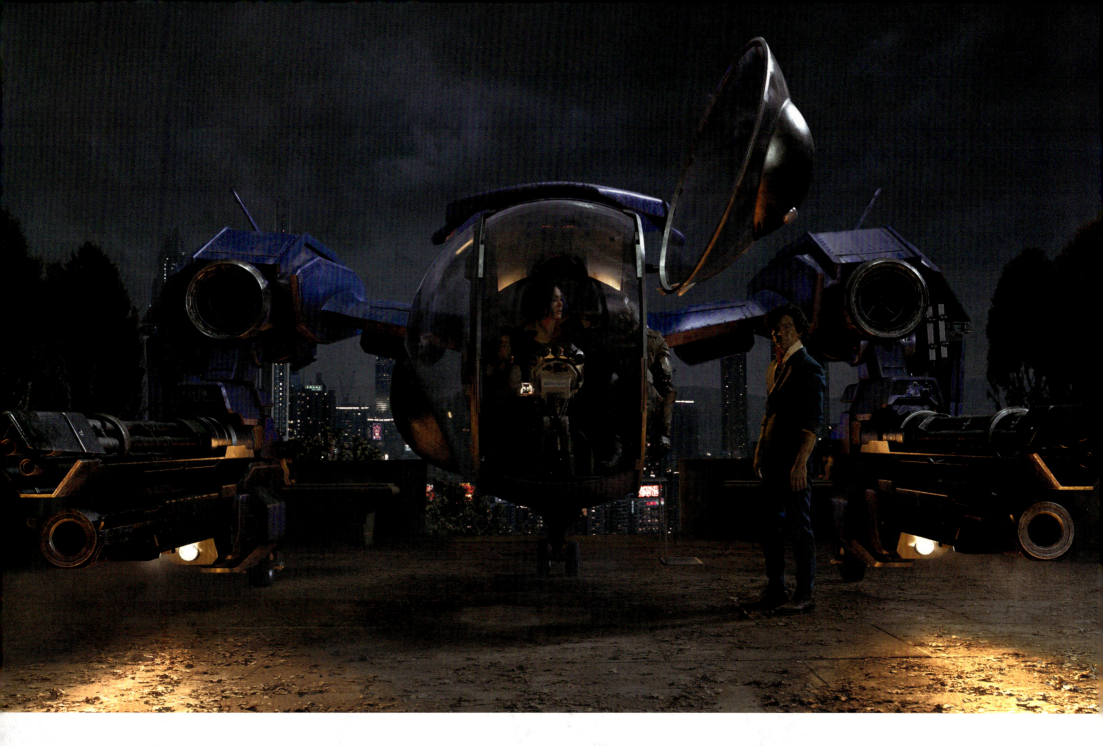

◂▴ Rising Sun Pictures started the early build of the *Red Tail* (left). It was then taken over by Goodbye Kansas to add final details, rigging and textures (above).

maybe expanded a little bit on some of the exterior VFX shots of them, but for the most part we built them to look pretty true."

While the anime introduced Faye flying the *Red Tail*, the burner ship is her transportation in a couple of early episodes before it's destroyed, leaving her stranded without spaceflight capability until Spike and Jet reluctantly agree to take her onboard the *Bebop*. But con artist—and Faye's would-be mother—Whitney happens to have a small storage facility full of absconded objects, and one of them, hidden under a tarp, is the *Red Tail*, which Faye decides will function nicely as payback for Whitney's manipulation.

In keeping with the Grumman Aircraft/Yang Industries concept, as well as the anime's characteristic design element of having modular pressure-bubble cockpits, the *Red Tail* became a kind of utility craft—a platform that could lend itself to multiple variations and assignments. The familiar bubble cockpit sits between two equipment pods that can be swapped out to contain cargo manipulator arms, heavy weapons or additional thrust engines; a streamlined cowl over the cockpit contains sensor and navigational equipment, and there's a central rear engine that can move to direct thrust just like the *Swordfish*'s turbine.

The *Red Tail* resembles a highly customized version of a loader, something that was moving cargo around, but with big Gatling guns on it. "I was very happy when they hit me up, and they're just like, 'I think we're going to have the *Red Tail* in this series', and I would

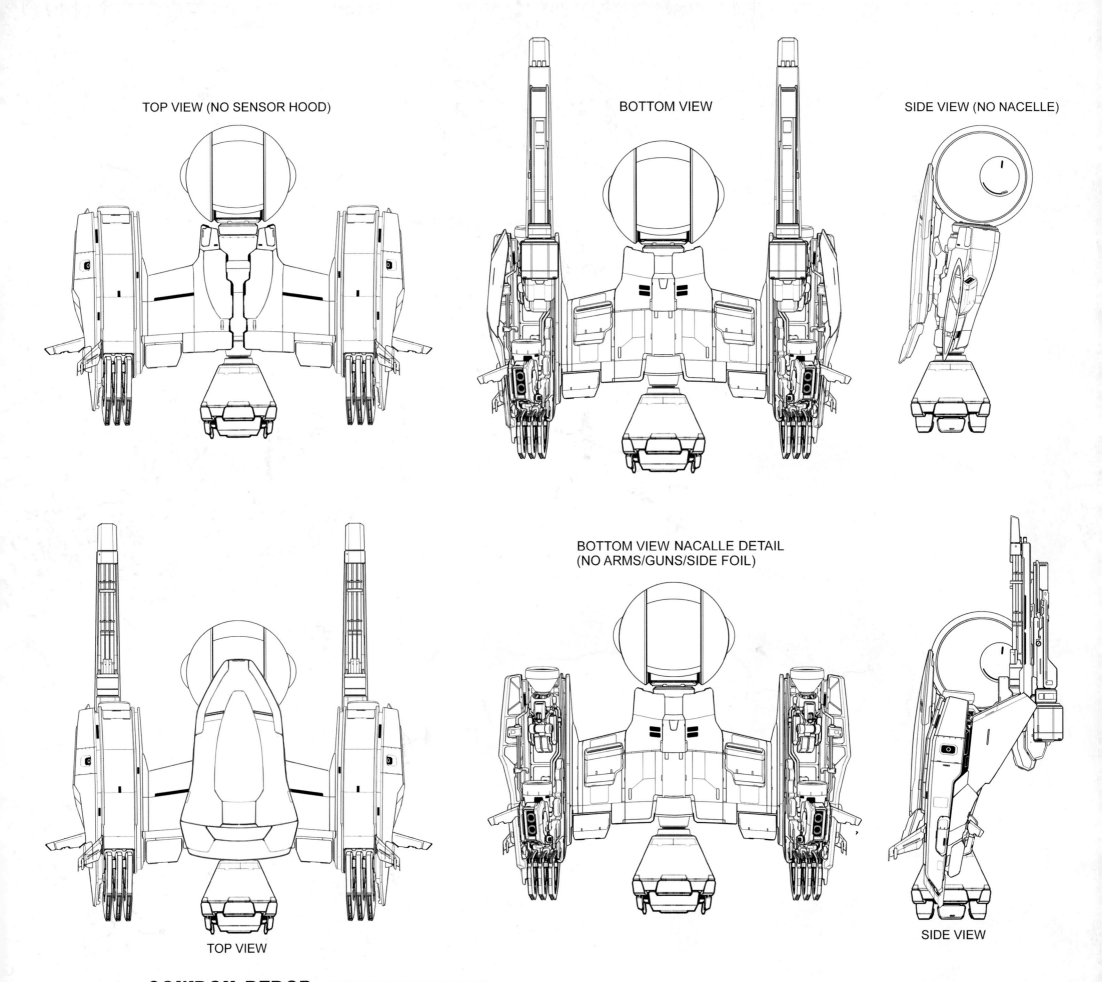

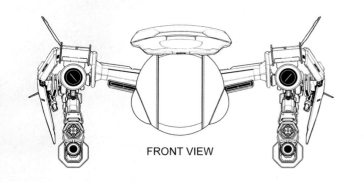
FRONT VIEW

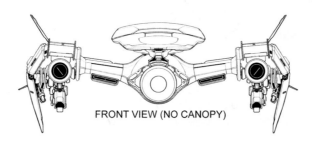
FRONT VIEW (NO CANOPY)

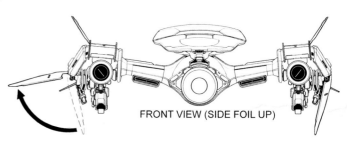
FRONT VIEW (SIDE FOIL UP)

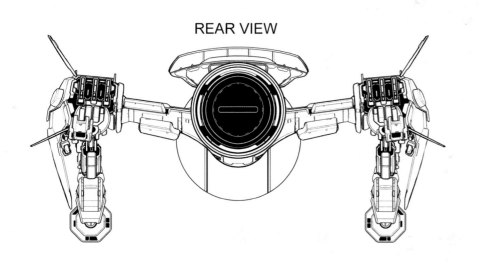
REAR VIEW

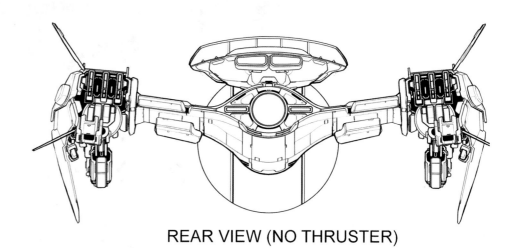
REAR VIEW (NO THRUSTER)

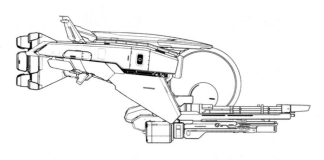
SIDE VIEW (GUNS DOWN)

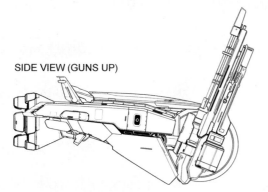
SIDE VIEW (GUNS UP)

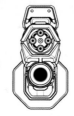
GUN FRONT VIEW

GUN BACK VIEW

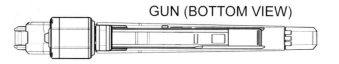
GUN (BOTTOM VIEW)

GUN (SIDE VIEW)

GUN (TOP VIEW)

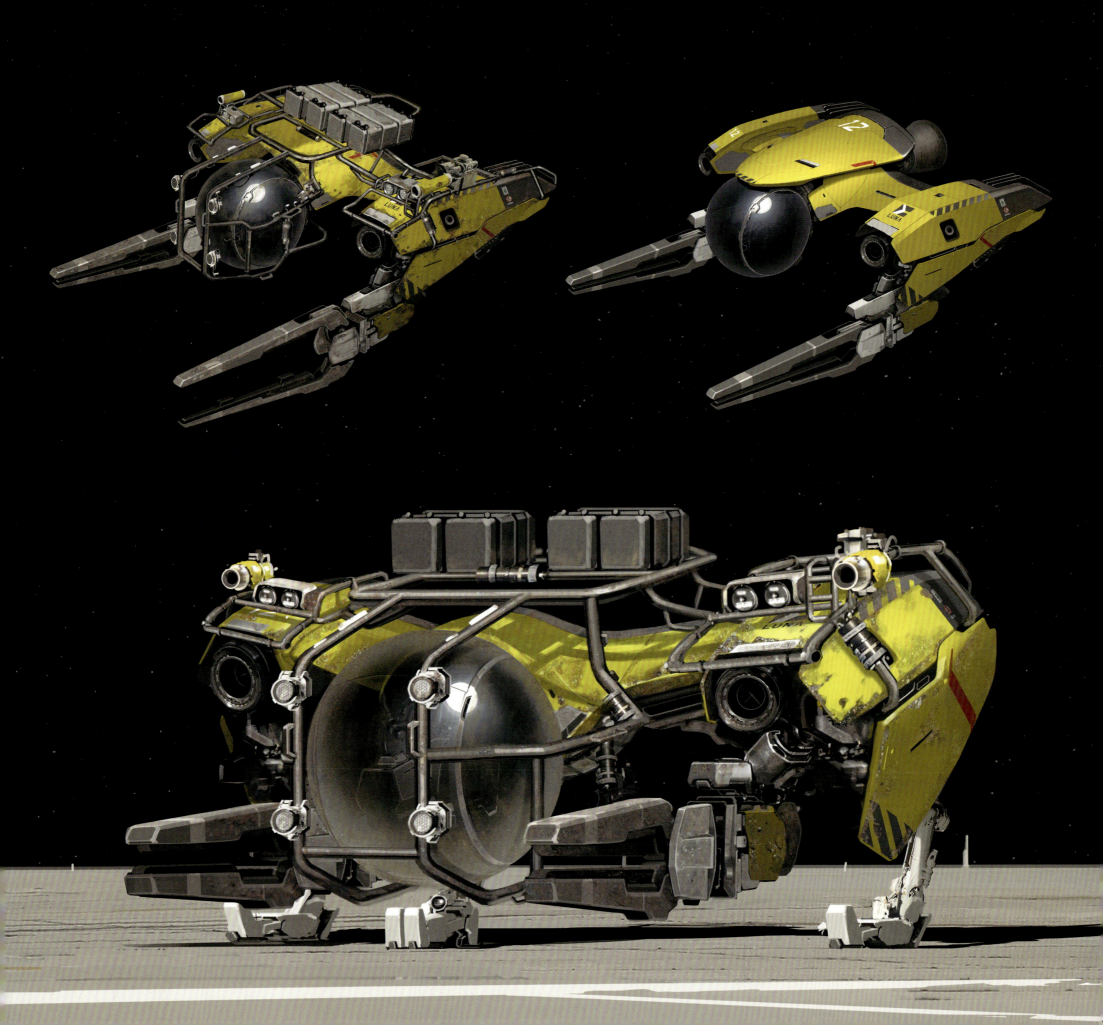

◄ At one point it was thought that a cargo loader version of the *Red Tail* would be seen near Vicious' synth fish factory.

▼► The first version of the *Red Tail*'s guns was rejected as being too big.

▼ Early rendering to lay out the basic proportions of the cockpit bubble and body.

"In the Bebop universe, [the Red Tail] is kind of like the electric car, the Prius of its day."

MARK YANG, CONCEPT ARTIST

get a pass at it," Mark Yang says. "I thought that was one of the more interesting assignments that designers can get because when you see that ship in the anime, you immediately think, 'Dude, there's a ton of possibilities. There is a really interesting looking ship.' When you were watching the anime, I think they built up a good chunk of the mechanics around how these bubbles are modular, and they can be used on different ships," Mark Yang says. "I kind of think of it as a drone aesthetic, and that's kind of how the proportions work. In the *Bebop* universe, it's kind of like the electric car, the Prius of their day. There's a certain set, basic, fundamental configuration that they all have, and they all

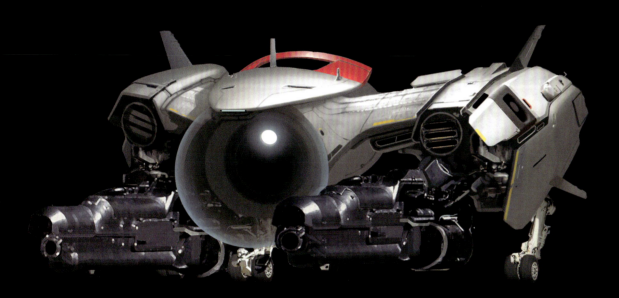

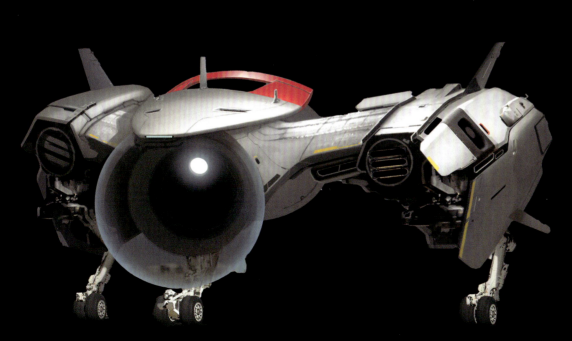

BEBOP SWEET RIDES

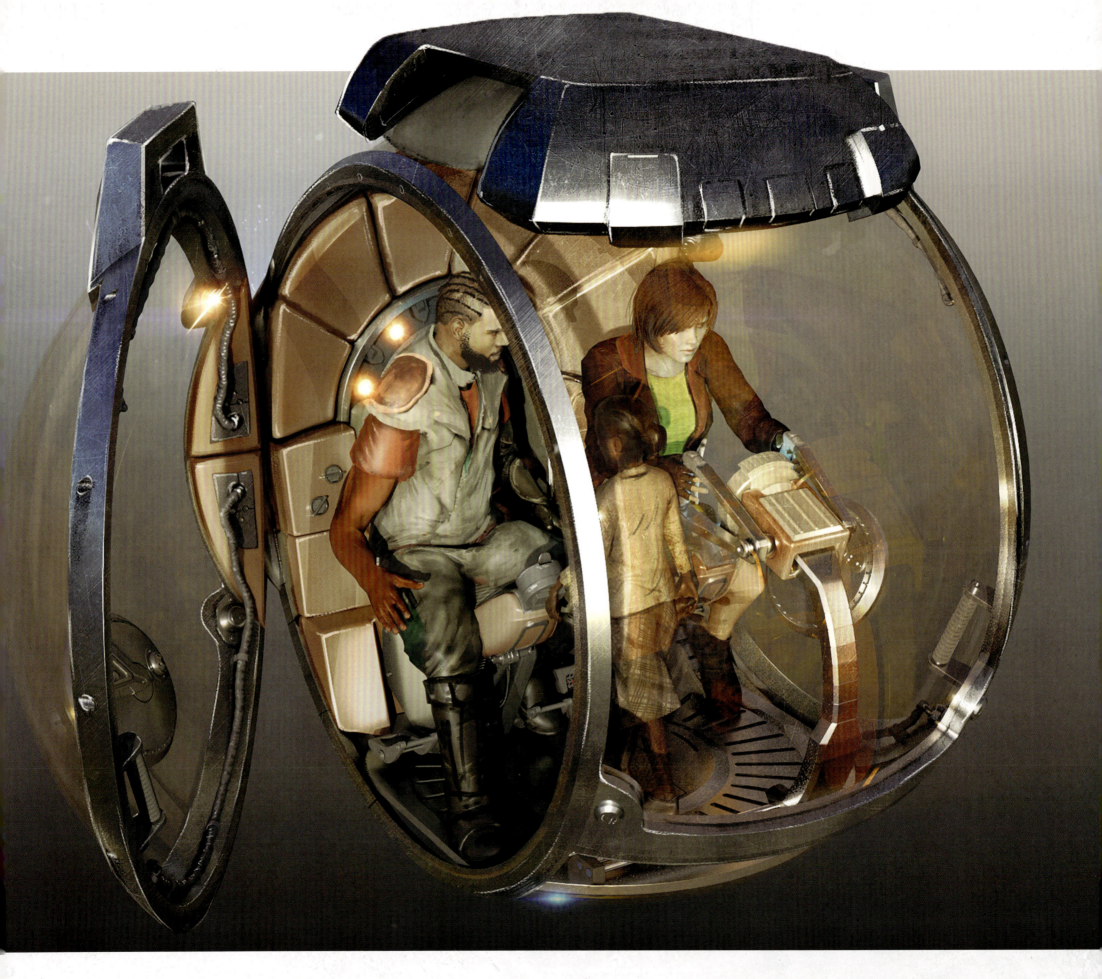

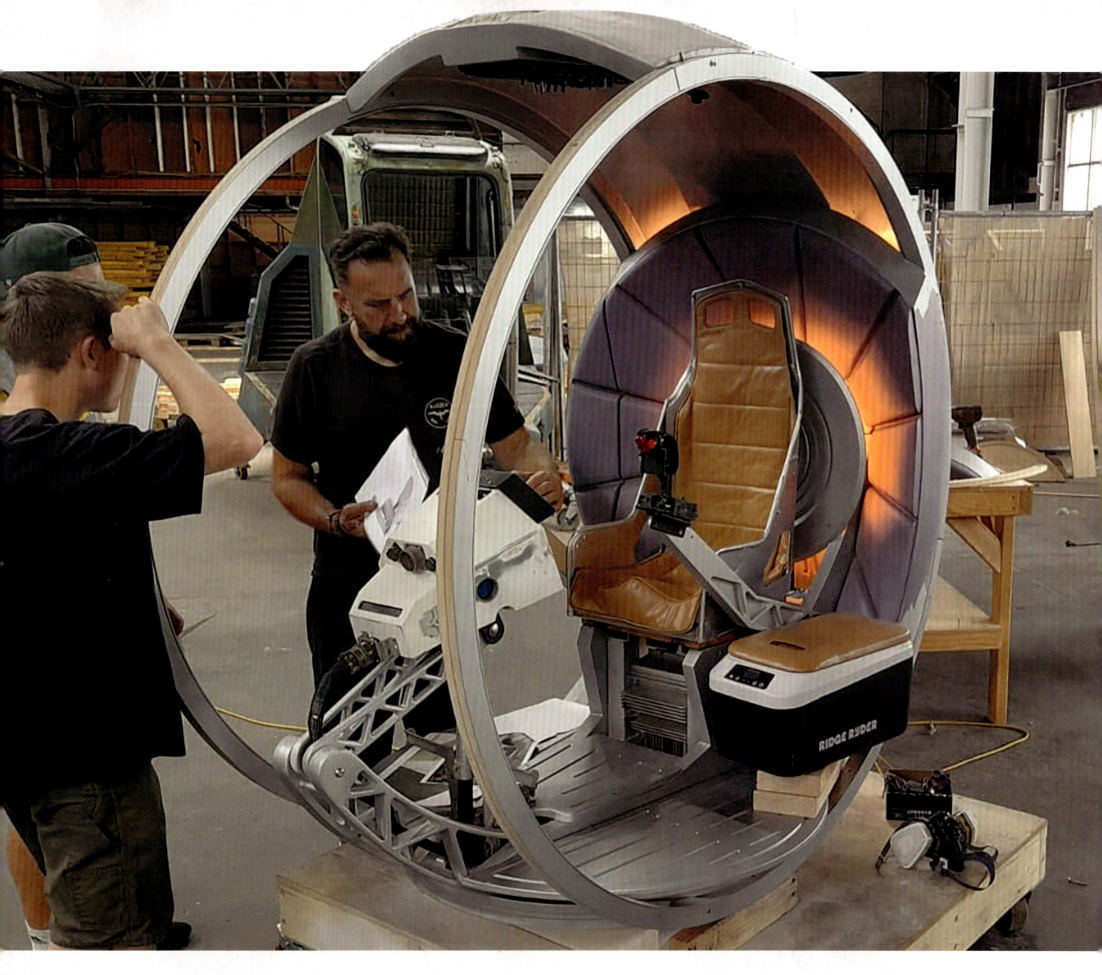

▶ Though the *Red Tail* is depicted as a single-seater in the anime, the story requirements dictated a cockpit bubble that could seat Faye, Jet and Jet's daughter Kimmie. Early concept art explored having two anime-style motorcycle seats inside the bubble.

▼ Concept model used to work out the basic size and layout of the new *Red Tail* cockpit bubble. At this point it was decided that the cockpit 'buck' would have no practical glass. The mullion 'hoops' would be included for the safety of the actors, but they would be replaced with CG mullions in the VFX process.

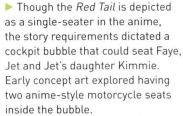

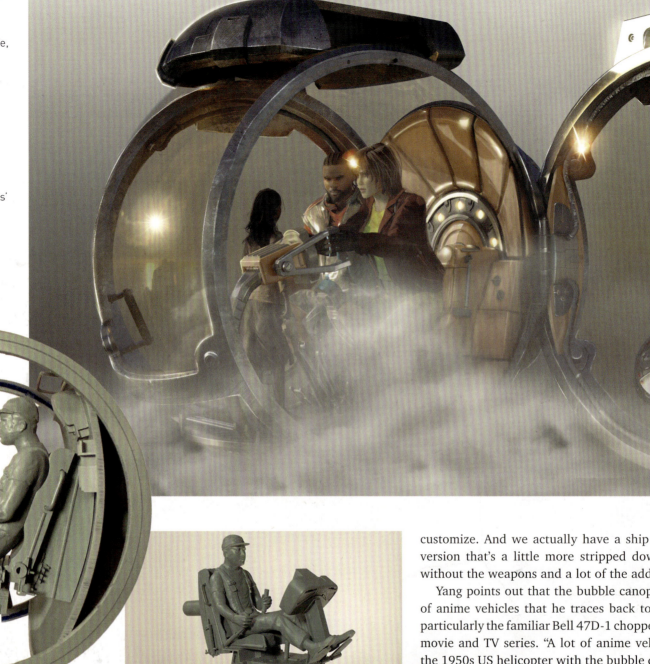

customize. And we actually have a ship where it's a construction version that's a little more stripped down, where you can see it without the weapons and a lot of the add-ons."

Yang points out that the bubble canopy is a traditional element of anime vehicles that he traces back to early helicopter designs, particularly the familiar Bell 47D-1 chopper seen in the old *M*A*S*H* movie and TV series. "A lot of anime vehicles have that look, like the 1950s US helicopter with the bubble dome. They just went nuts with it, like *Megazone 23* has a couple of VTOLs that didn't have the bubble dome but that have a very similar aesthetic, where you had the really vulnerable open pilot with mechanical gadgets like skis, or legs or arms or manipulators. They had one in *Orguss* and it had that slight bubble shape, and then they had a rescue ship, and then of course they have the same version of the ship as a walker in the '80s as well. That's the nice thing about animation; they have the liberty of going as far as they can and try a lot of interesting things."

To give the *Red Tail* a helicopter's maneuverability, the rear engine was mounted on a gimbal so that it would have the same kind of F-35 swivel capabilities that the *Swordfish* boasts. The VFX team were working out the stance and the basic proportions, and

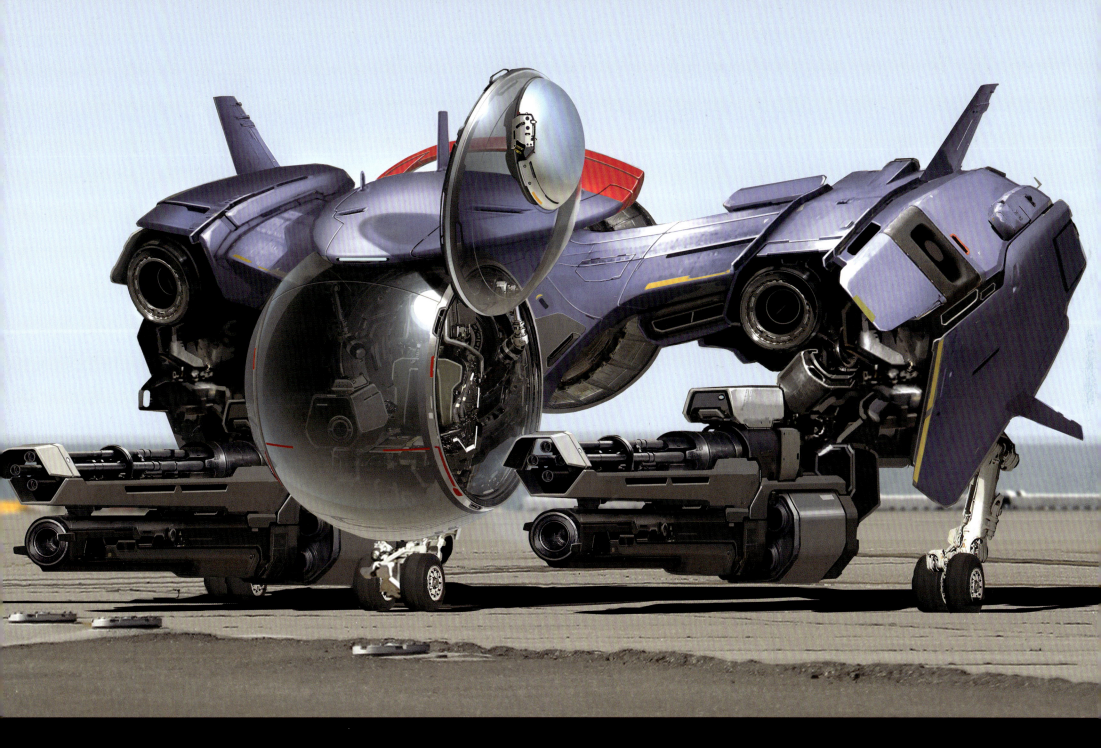

▲ Final concept artwork of the *Red Tail* by Mark Yang.

decided to scale the bubble to be a six-foot-diameter dome. Then they had Mark Yang do a series of studies of different types of guns. Ultimately, they settled on having a Gatling gun, a grenade launcher, small headlights, and one engine in the back of the vehicle, while maintaining a certain amount of swivel on the foils."

The design team also worked out the details of the *Red Tail* cockpit, and made the decision to change up the stance that Faye Valentine would be taking as she sits at the controls, moving away from the motorcycle position that Spike leans into in the *Swordfish*. The controls were redesigned with two handles on each armrest so that Faye could carefully maneuver herself around while sitting in a race car-style seat.

McMurry refers to the *Red Tail* as a "muscle car"—as distinctive and full of attitude as Faye Valentine herself.

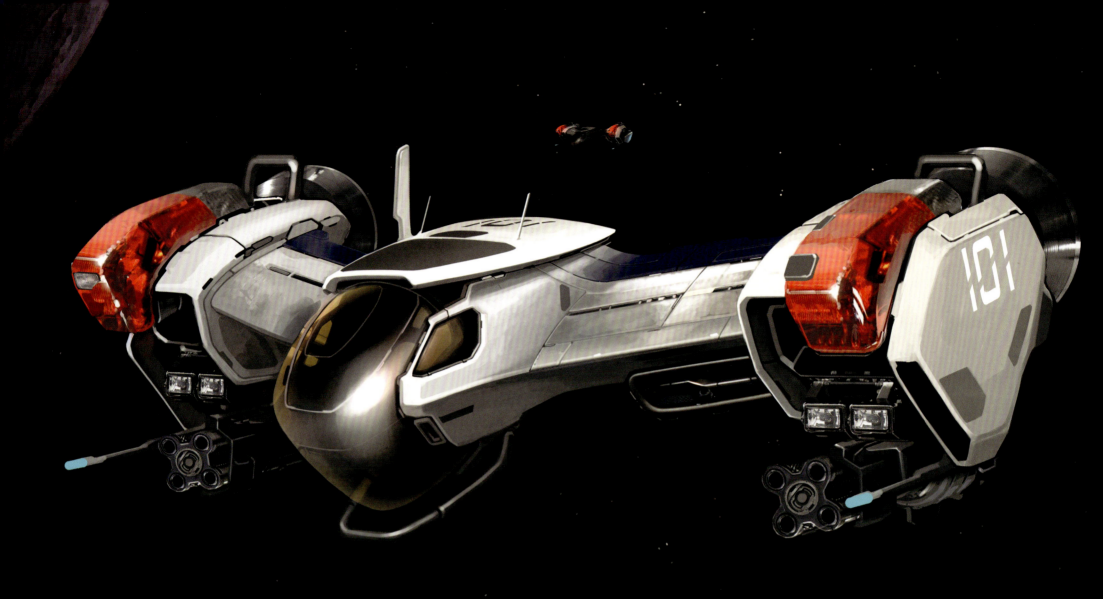

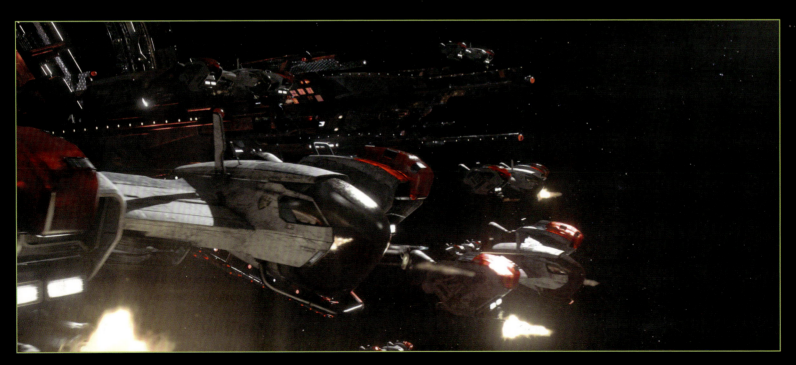

◀▲ Ultimately, the creative team thought the ISSP cruiser looked a little too close to the *Red Tail* and didn't want viewers to think that any of the ISSP ships featured in Episode 101 was the *Red Tail*. Mark Yang reworked his design by changing the shape of the cockpit bubble and integrating it with the wing. These changes actually moved the ISSP ship closer to the look of the ships from the anime; (left) guns extended, (above) guns partially retracted.

ISSP SHIPS

There are iterations of the *Red Tail* design seen in the series even before Faye's trademark ship makes its appearance. One is the show's 'space police cruisers', the ISSP patrol ships that create a blockade around the Astral Gate in "Cowboy Gospel" and represent Jet Black's past dogging the *Bebop* and its crew. The ISSP ships are very much like the *Red Tail* in shape, but with a black-and-white color scheme.

Once the debut of the *Red Tail* was pushed to late in the first season, the whole concept of abundant variations of the design required another look. "The ISSP ship also has guns, but it also has these bubblegum lights to flash red," Gene Kozicki says, noting the thought process that eventually resulted in modifying the design. "We said, 'For the ISSP ship, we'll do the most basic of variations and put some guns on there.'"

"The ISSP ships are also very close to the design from the anime," adds Victor Scalise. "And I think you can get a sense of that kind of short, stocky ship like the *Red Tail*, [but] the ISSP ships are [more focused on] those little shoulders with the guns, very much like something out of *Robocop*."

> "THE ISSP SHIPS ARE [MORE FOCUSED ON] THOSE LITTLE SHOULDERS WITH THE GUNS, VERY MUCH LIKE SOMETHING OUT OF *ROBOCOP*."
>
> **VICTOR SCALISE, VISUAL-EFFECTS CO-SUPERVISOR**

▼ The initial concept for the ISSP police cruiser was to base it on the same general shape and layout as the *Red Tail*, the idea being that the same company built both ships using the same components. The ISSP was to feature two engines, big red police lights, and drop-down guns.

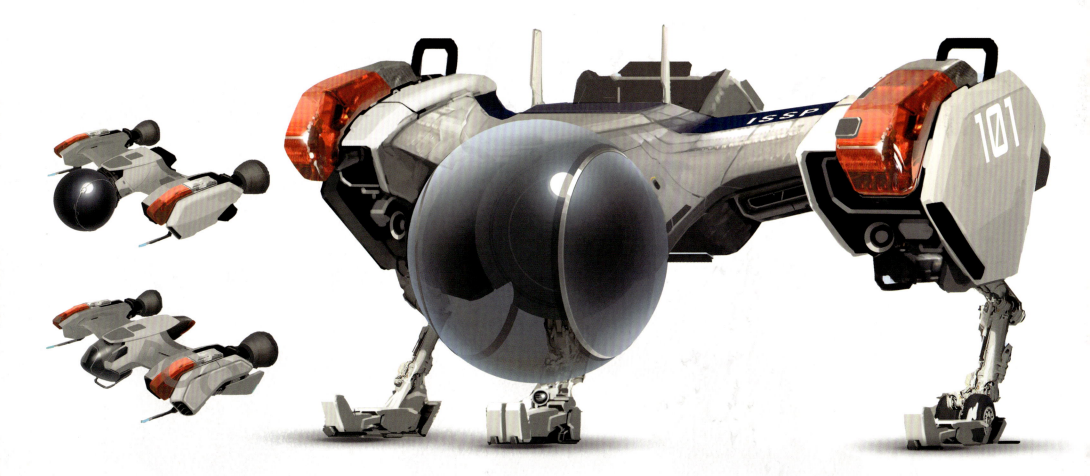

Bebop SWEET RIDES 107

SPACE FREIGHTER

The original *Cowboy Bebop* anime episode "Heavy Metal Queen" featured a space trucker in a plot inspired by a Deep Purple song called "Space Truckin'". While that storyline hasn't been adapted for live action, the visual idea of long-haul space freighters that look very much like the tractor trailer semi-trucks driving along American highways was an idea built into the second episode of the live-action series, "Venus Pop", which involved a mad 'Teddy Bomber' terrorizing Venus.

In "Venus Pop" the Teddy Bomber turns out to be a space trucker hiding out in his rig. The design crew experimented with a number of approaches to the freighter, beginning with a quite literal interpretation of a stylized semi-truck cab with a long, rectangular cargo pod attached at the rear.

Various iterations of this concept, including one with a futuristic ring around the cab, were subsequently explored. Another version featured three right-angled, thruster-like structures that project

▼ Early concept art for the Teddy Bomber's freighter by Henry Fong. Ultimately, it was felt that this version was too big a vehicle.

"THE MAIN THING I WAS CONCERNED WITH WAS NOT ONLY TO WORK OUT HOW COOL IT COULD LOOK IN SPACE, BUT ALSO HOW THE PROPULSION WOULD WORK."

MARK YANG, CONCEPT ARTIST

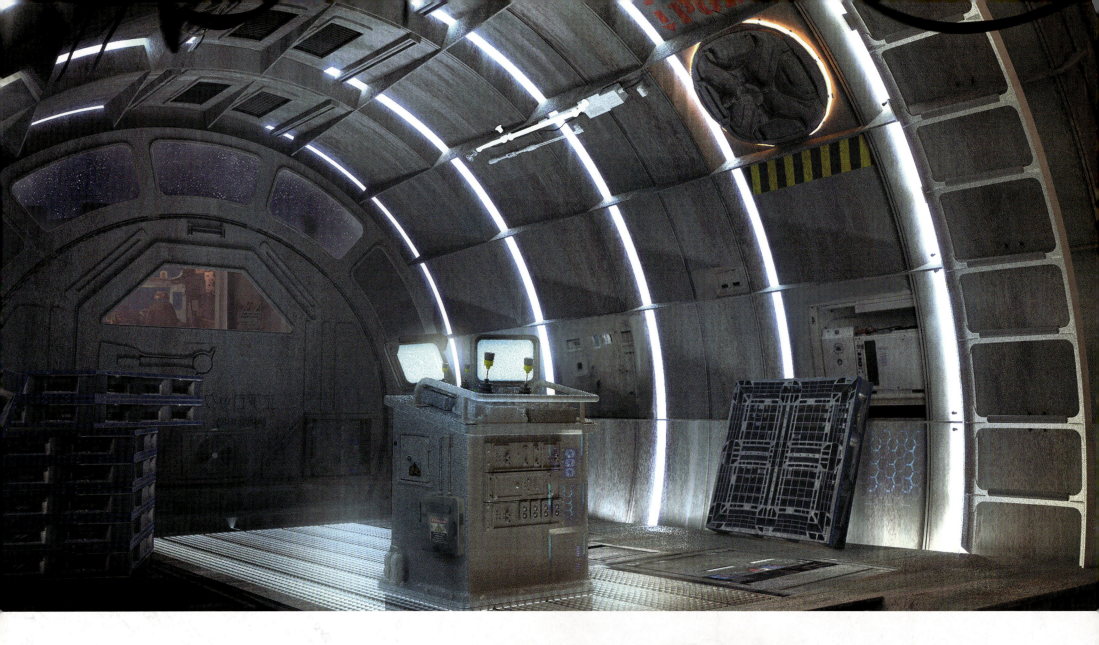

backward and run parallel to the central cargo pod. "I wanted to work on a kind of a spaceship transport where it was kind of like the modern version of a semi-truck, but a space version where you can swap out the cargo," Yang says. "The main thing that I was concerned with was not only to work out how cool it could look in space, but also how the propulsion would work. I think the common thing people would do was attach the propulsion onto the front cab, which is how we have trucks nowadays. But I thought it'd be interesting if they attach the pod onto the physical cargo itself to help drive the thing."

Visual-effects vendor Rising Sun took a crack at the design that evolved it closer to its eventual onscreen appearance, but it was Ingenuity Studios who designed the final version, which stars in one of the series' most intricate sequences. "We had the whole freighter getting hit by an asteroid and breaking off the front of the cab," Victor Scalise explains. "The amount of detail [Ingenuity] put into the model was phenomenal. You're coming along the ship and then you swing around, the cab explodes, and you're looking right into the cab as you come around, and then you swing back in to see Jet and Spike, and that was a fun little sequence to play with.

"Also we had to build the environment for when it's parked on the ground. Ingenuity did a phenomenal job of doing a 3D set extension there, and adding in life and people and the construction yard, which is great."

▲ Concept art for the interior of the Teddy Bomber's freighter.

◀ Concept art for the teddy bomb.

◀▶ Additional freighter concept art by Mark Yang.

▶ The final design by Ingenuity Studios.

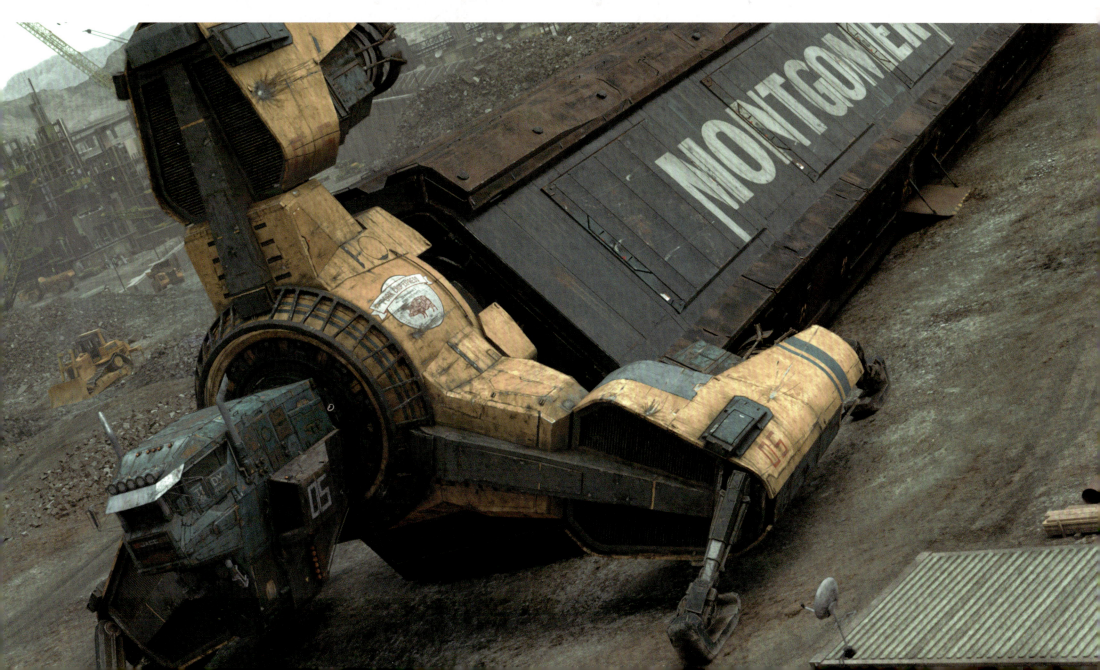

ECOTERRORIST SHIP

In the fourth episode, "Callisto Soul", the trio runs afoul of Maria Murdock (Adrienne Barbeau) and her cult of 'Eco Warriors' plotting to transform the ugliness of civilization that has spread across the solar system in the form of human colonies back into raw nature via 'pollen grenades' that use the same terraforming technology used to transform worlds like Mars and Europa into Earth-like environments. Unfortunately, when humans are in the path of the bombs they tend to get turned into trees and shrubs.

Various designs for the Eco Warriors' transport ship were devised, many incorporating the idea of a visible, glass-domed arboretum to reflect the environmental theme. A nose for the ship had also been constructed early on in production so that actors could be seen inside it as part of the Eco Warrior crew. One idea involved where the Murdocks would have acquired this ship, with the VFX crew considering the possibility of the ecoterrorists obtaining a trawler or a tug and adapting it for their own needs. Various sketches were produced, but the team didn't want to contradict the already-built

▲ Maria Murdock (Adrienne Barbeau).

▼ Concept for the Murdock gang's ship.

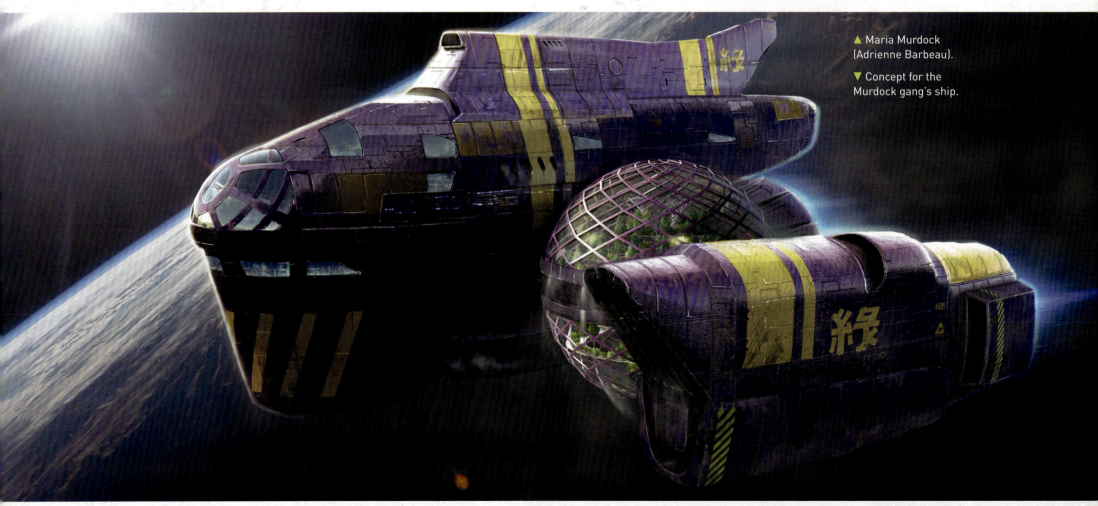

▼ Because the live-action Murdock schooner bridge set was going to be a reuse of the Teddy Bomber's freighter set with a new window that was already built, the VFX team were committed to a certain shape. They also needed to incorporate the greenhouse—the Murdock gang are ecoterrorists after all—and some form of bomb bay from which Maria could drop her missile.

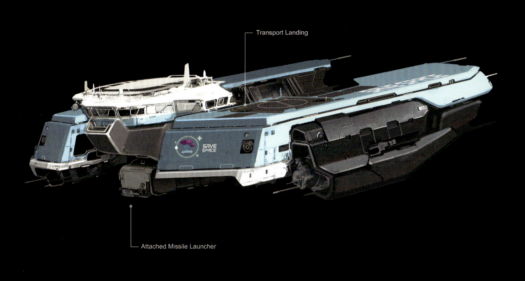

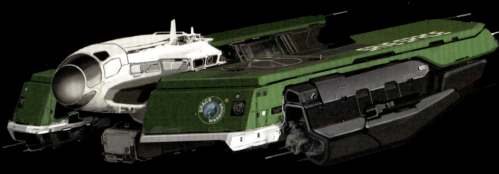

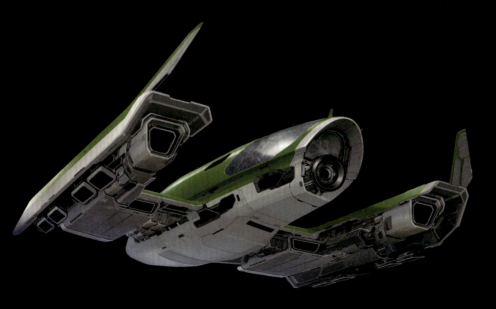

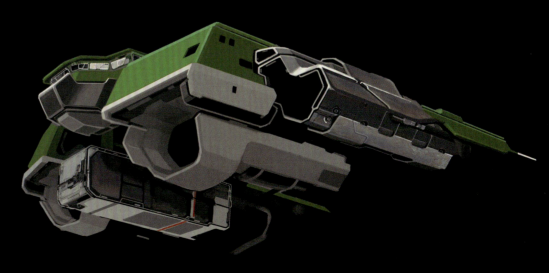

BEBOP SWEET RIDES

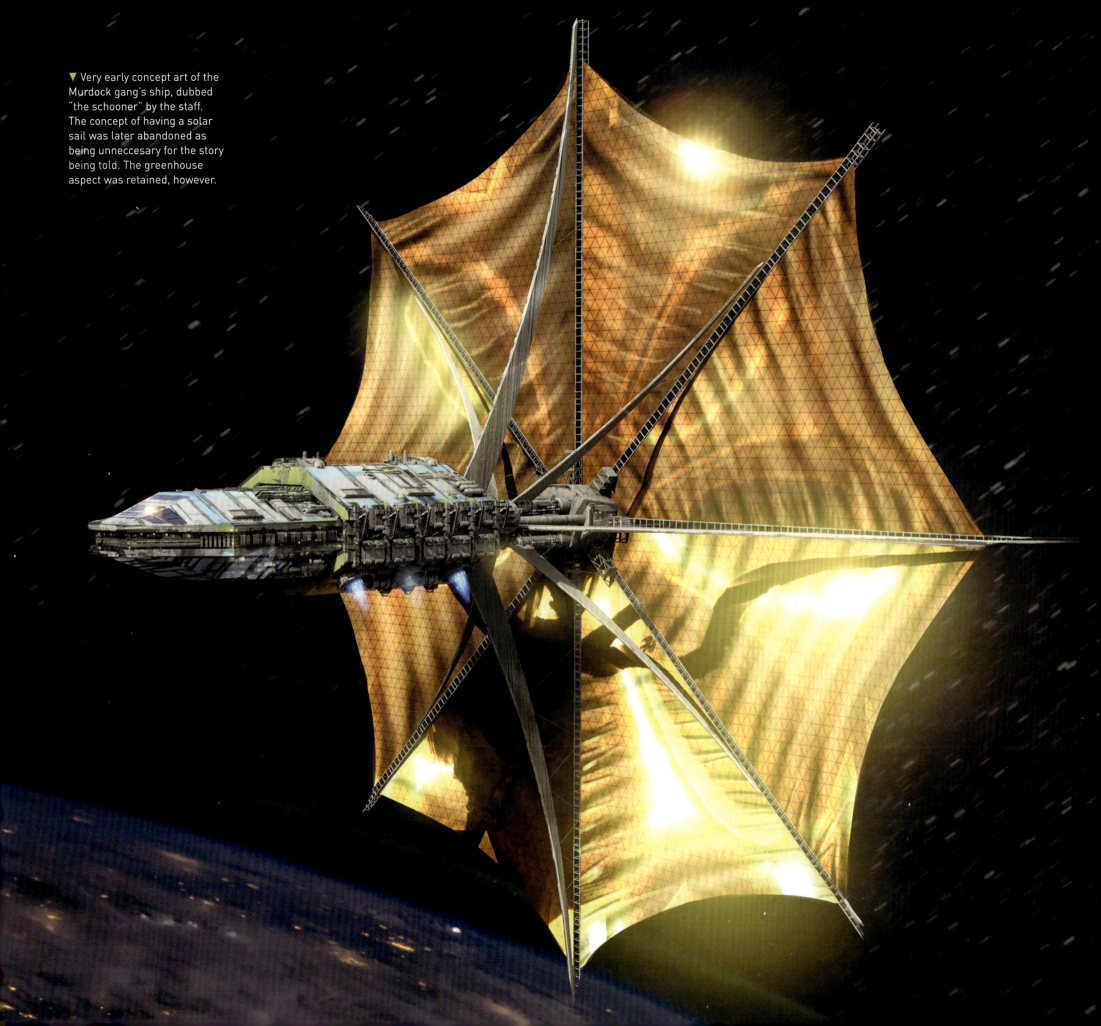

▼ Very early concept art of the Murdock gang's ship, dubbed "the schooner" by the staff. The concept of having a solar sail was later abandoned as being unneccesary for the story being told. The greenhouse aspect was retained, however.

▲ Concept art for the Murdock gang's shuttle. In the initial script, the Murdocks were to be involved in a shootout with Faye in which their shuttle was disabled. As the story evolved, this plot point was dropped.

▲▶ Most of the big ships in *Cowboy Bebop* had to have a water landing capability. The Murdock gang would have their ship tied up dockside before lifting off to space.

"WE STARTED WITH SOMETHING THAT'S ACTUALLY VERY NAUTICAL, AND I THINK WE PULLED IT BACK INTO SOMETHING A LITTLE MORE SPACEY."

MARK YANG, CONCEPT ARTIST

set piece. The nose of a Russian ground-effect ship was grafted onto the vessel and the decision was made to put the greenhouse area in the back so that various plants could be seen coming through."

In the episode, the ship is seen docked next to a coastal missile platform intended to launch a spore attack on a colony. "We looked at a lot of different Greenpeace ships," Yang says. "We didn't want to go too far with that and make any references to ecoterrorism or anything like that. But I think we ended up looking at different ships where there's a lot of surface, because there's a ship that lands on that ship, and they wanted to give it flexibility to do different things. So we started with something that's actually very nautical, and I think we pulled it back into something a little more spacey. Which is always how I like to work, because I feel like if you take it too far in the cosmic direction then you lose that tangibility, the ability to be able to feel like you can actually hold on to something."

BEBOP SWEET RIDES

ECOTERRORIST POLLEN GRENADES

The Eco Warriors' weapons technology is demonstrated in an early hostage-taking scene in which Murdock threatens patrons at an opera house and one of her minions accidentally drops a 'pollen grenade' and turns a hapless female victim into a tree. "What the pollen grenades do is take something and cause it to spawn major green growth," Greg McMurry explains. "It converts any cellular structure to something organic that generates oxygen. It's not particularly that it turns a person into a tree, but it's the mishap of a person getting exposed to that gas that turns them into a tree."

McMurry explains that the pollen grenades fit into the terraforming technology that has allowed for the rapid colonization of the solar system. "The whole world of *Cowboy Bebop* is because we were eco-terraforming, but within a structure, and it's done through some chemical process. My rationale is, it's just like when we go to Mars you say, 'Is there any chance we're gonna find something that could have been the essence of life, like a molecule that could have hydrogen in it or something?' So that's what I think this eco-gas is: it seeks out anything that it could instantly start converting into life. But if it gets on a person, of course, that's a very complicated organism, and it just takes it over and feeds off of it. So a person becomes the food for this instant ecosystem that can be used to terraform a planet."

As McMurry describes it, the transformation process is graphic. "The first thing that would happen is she would inhale the gas and it would go into her system, and then tree branches would start growing out of her mouth very quickly, and then other ones would start ripping out of her skin and coming out from underneath her skin. You might look at her arm and see a raised section of her arm, and then all [of a] sudden a branch comes out and leaves pop out. Because in in order to terraform a planet, it's got to happen pretty fast—otherwise we'd be sitting around for about a year. So it happens very quickly. And the fact that the host in this case is a human as opposed to some molecular structure that they found on the surface of Europa, it's supercharged with nutrients. So it happens very quickly right in the audience's face."

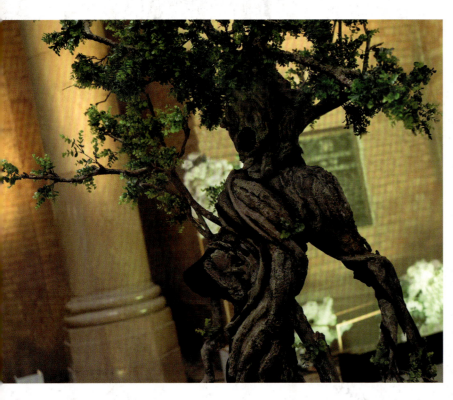

▲▶ Practical prop trees of the Murdocks' victims being sculpted in the prop shop in New Zealand.

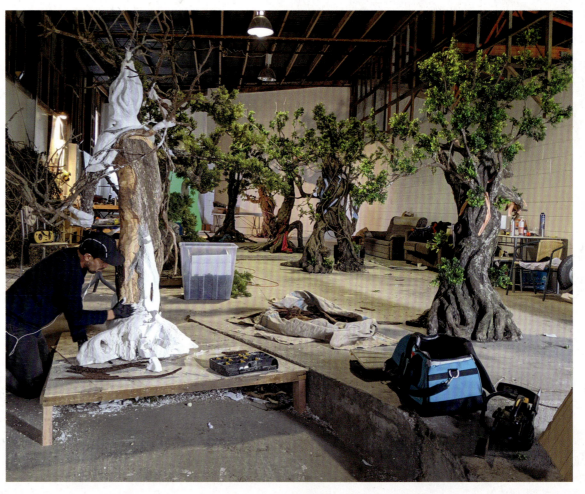

116 COWBOY BEBOP MAKING THE NETFLIX SERIES

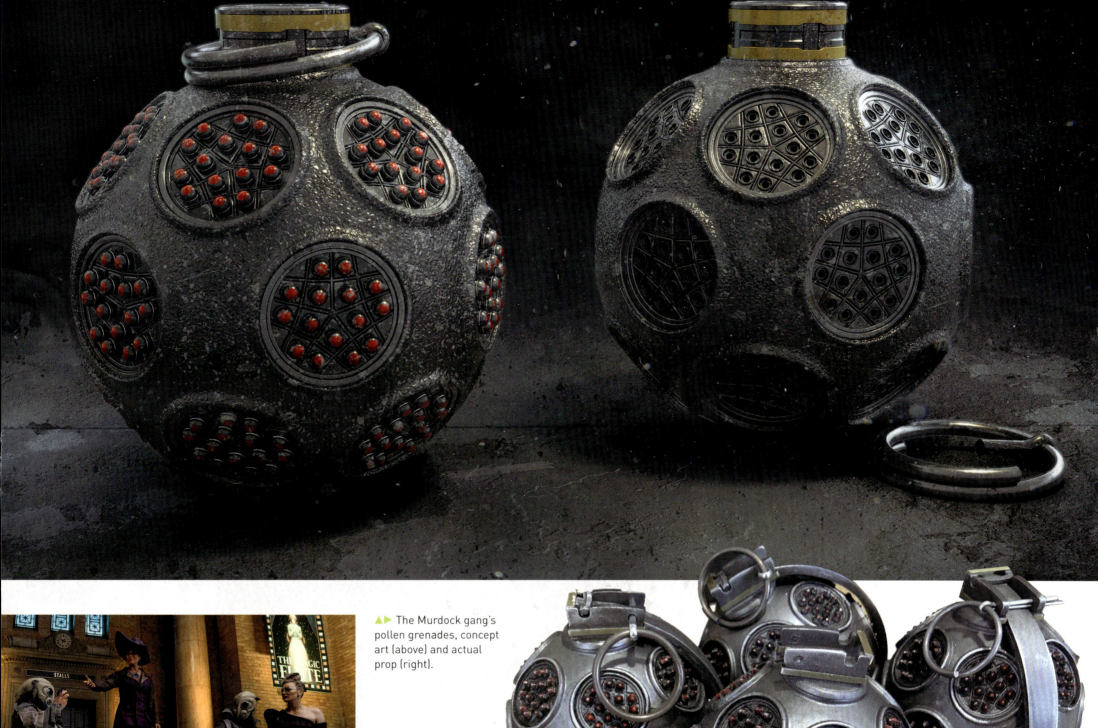

▲▶ The Murdock gang's pollen grenades, concept art (above) and actual prop (right).

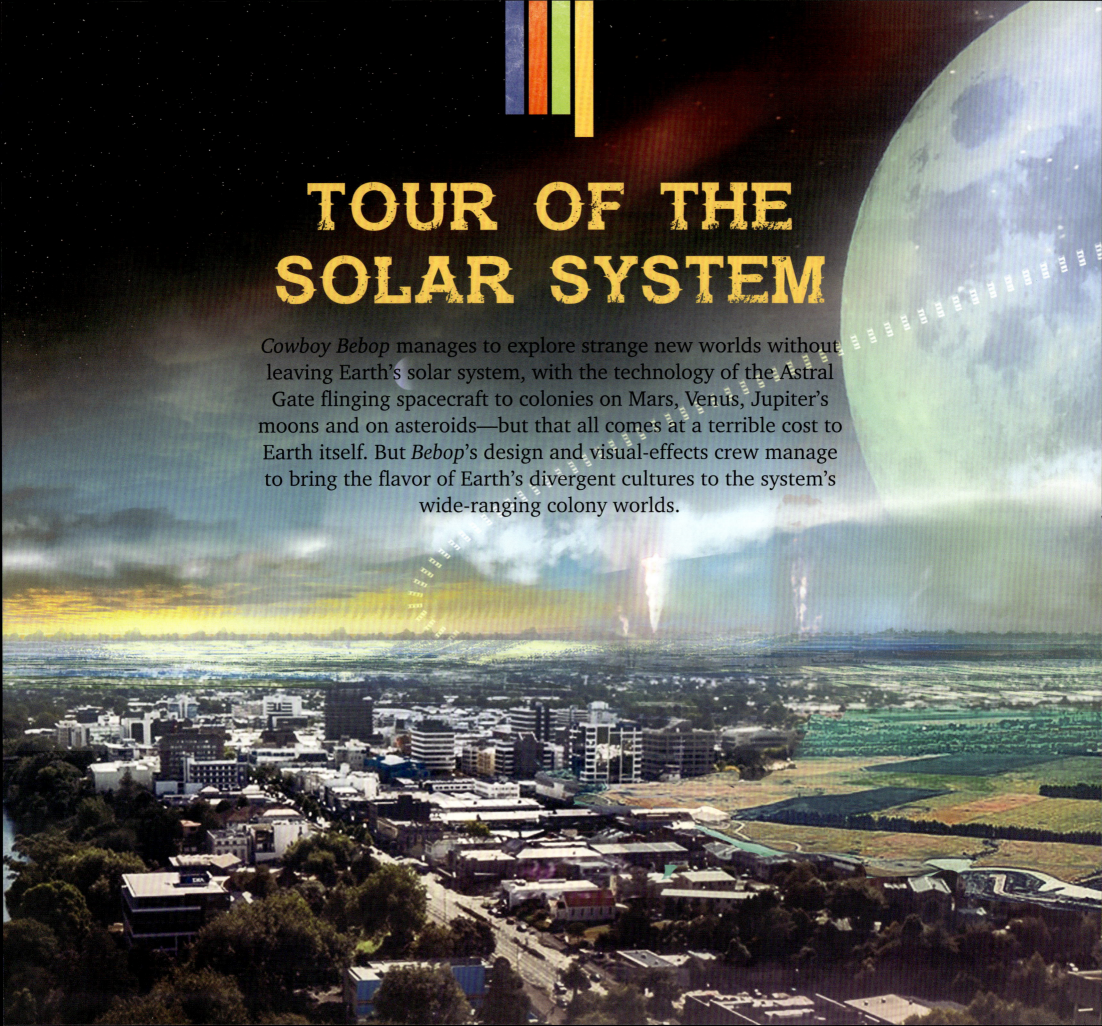

TOUR OF THE SOLAR SYSTEM

Cowboy Bebop manages to explore strange new worlds without leaving Earth's solar system, with the technology of the Astral Gate flinging spacecraft to colonies on Mars, Venus, Jupiter's moons and on asteroids—but that all comes at a terrible cost to Earth itself. But *Bebop*'s design and visual-effects crew manage to bring the flavor of Earth's divergent cultures to the system's wide-ranging colony worlds.

ASTRAL GATE

In science fiction space opera there's a tradition of 'jump gate' ideas to explain how spacecraft can travel quickly across the galaxy from solar system to solar system, violating the laws of physics by traveling faster than light. In *Cowboy Bebop*'s future, the idea is applied to a more achievable and believable goal: populating the solar system and making travel between the planets, moons and asteroids commonplace.

The Astral Gate is in effect a solar-system-wide toll road that helps propel spacecraft at the speeds necessary to cut interplanetary travel time down from months to hours or days. But that technology does come at a cost: an Astral Gate accident winds up devastating the Earth's surface and rendering humanity's home world a barren wasteland. "The Astral Gate is the convenient plot device that allows us to get from point A to point B in a reasonable amount

▼ Rising Sun Pictures render of the *Bebop* exiting the Astral Gate.

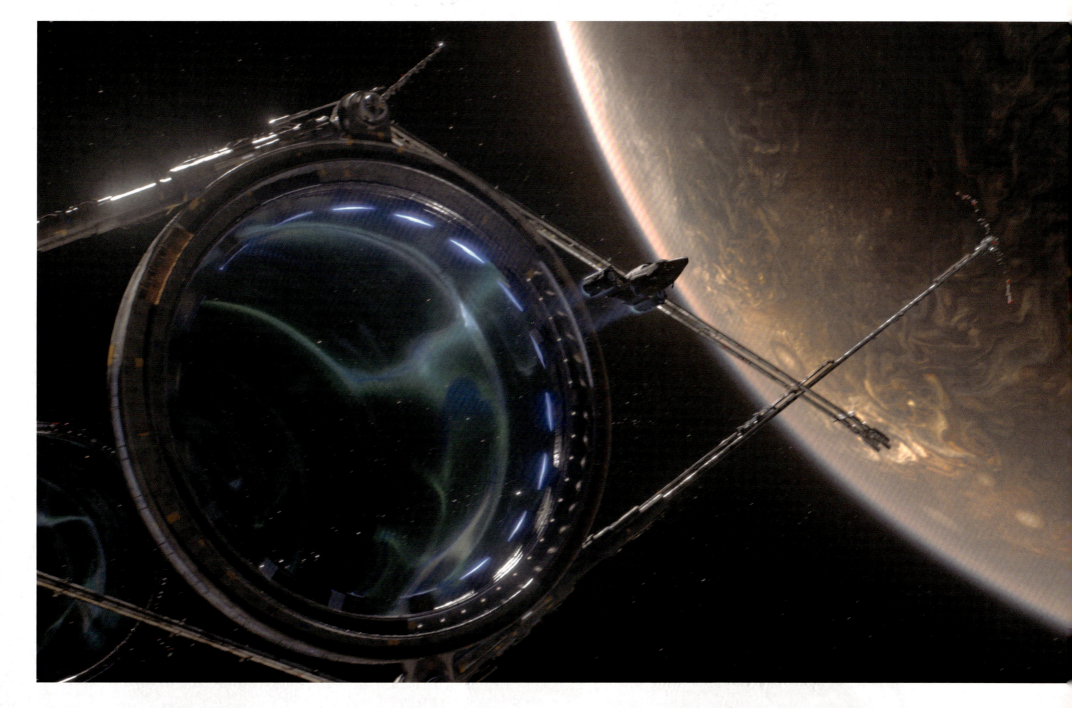

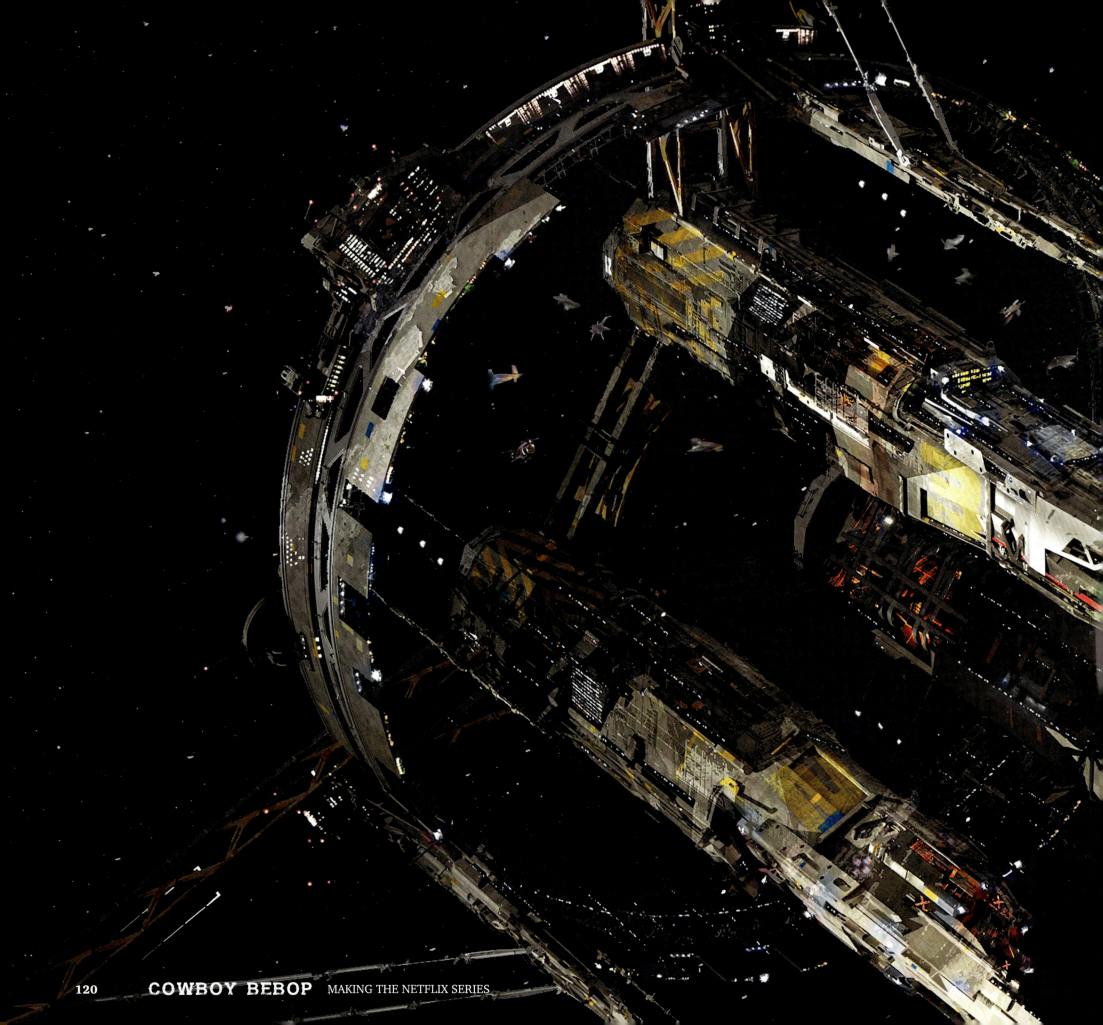

◀ The idea behind the Astral Gate is that besides the obvious technological device to enable ships to travel great distances, it would also be a hub for people to meet or even live.

of time," Gene Kozicki says. "They wanted to have a fair degree of sophistication and complexity to it so that there's a little bit of peril involved, and so that it could possibly be used in future seasons, where something goes wrong."

A production assistant researched all the references to the science behind the Gate in the original *Cowboy Bebop* anime, and one of the first documents found from the original creators was a line drawing of the Astral Gate. This was then sent off to one of the producers to see if they had anybody from the original creators that could translate it. They sent it back with a plethora of Japanese writing on it, translated to what they thought the Astral Gate actually did.

It was determined that the Gate was a series of 'accelerator rings' that propel spacecraft between the planets, with various ring stations interspersed throughout the solar system so that ships can be gradually accelerated to incredible speeds without putting their crew in danger from rapid inertial changes. When a pilot wants to go into inter-solar-system travel, they fly into a ring that accelerates them to the next ring that accelerates into another, and at the other end the gate fine-tunes the ship's speed and its phase

> "[THE PRODUCERS] WANTED TO HAVE A FAIR DEGREE OF SOPHISTICATION AND COMPLEXITY TO [AN ASTRAL GATE] SO THAT THERE'S A LITTLE BIT OF PERIL INVOLVED."
>
> **GENE KOZICKI, VISUAL-EFFECTS CO-PRODUCER**

TOUR OF THE SOLAR SYSTEM

with relationship to the speed of light to slip it into the astral flow. The ship comes out of it the same way—it hits a big ring, which is a decelerator. A funnel brings the ship in, and at the other end of the funnel there is a converter, which takes the ship out of this phase shift that had the pilot traveling at such an incredible speed.

In the series, the Astral Gates are run by a corporation that has a monopoly on travel throughout the solar system. As established by the anime, there has been an accident with one of the gates, which has all but wiped out the Earth, but all the Astral Gates are still owned by this corporation. So it's safe to say that travelling through an Astral Gate is a somewhat risky business.

The toll tickets seen on the bridge of the *Bebop* reflect the bureaucracy of Astral Gate travel; there is a 'toll plaza' with an inspection that all ships have to undergo, and upon departure to go to another planet pilots have to check in and be registered.

The idea comes into play in the first episode with Red-Eye drug dealer (and addict) Asimov and his wife Katarina, when a grieving and desperate Katarina, with the mortally wounded Asimov at her side, attempts to fly into the Astral Gate and its ISSP blockade. And, in a moment reminiscent of the movie *Thelma and Louise*, she realizes she has no way to get away and instead uses it as their suicide moment.

▲▶ Rising Sun's art department explored a wide variety of looks for the ships travelling inside the Astral Flow. The anime sessions had a fairly simple look when the ships were inside the Astral Flow, and André Nemec and Michael Katleman wanted to steer away from the current look of 'warp speed' seen in the current *Star Trek* and *Star Wars* films, so the mandate to Rising Sun was to just let their imagination run wild and come up with a wide variety of concepts.

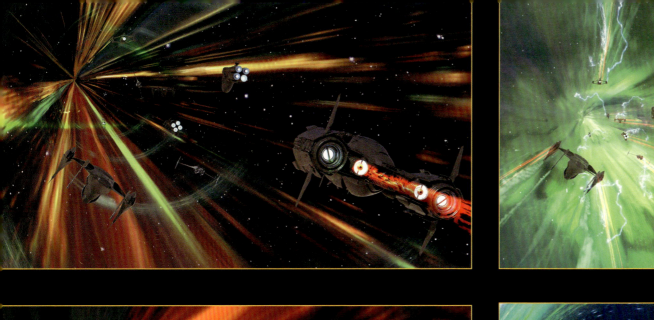
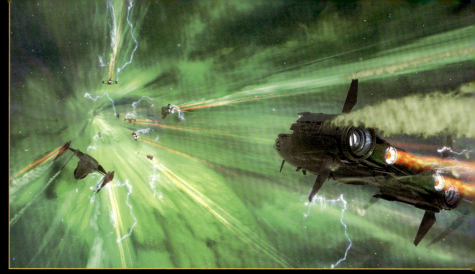
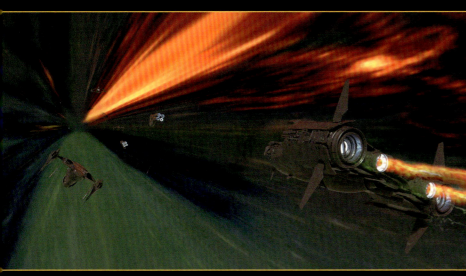
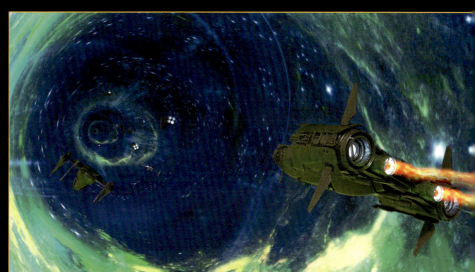
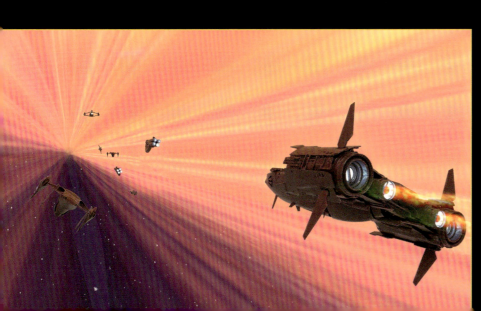
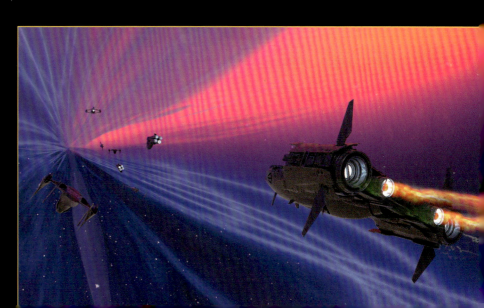

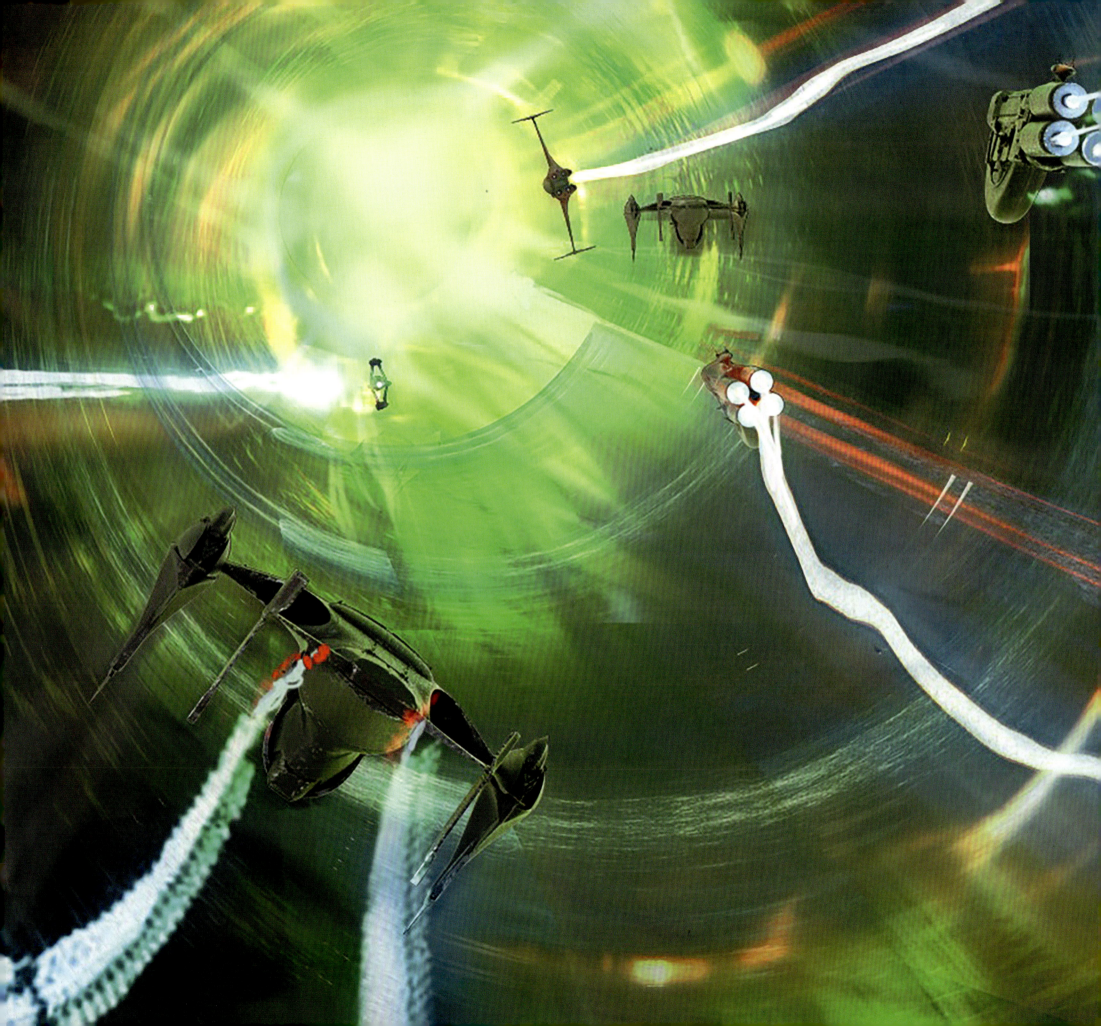

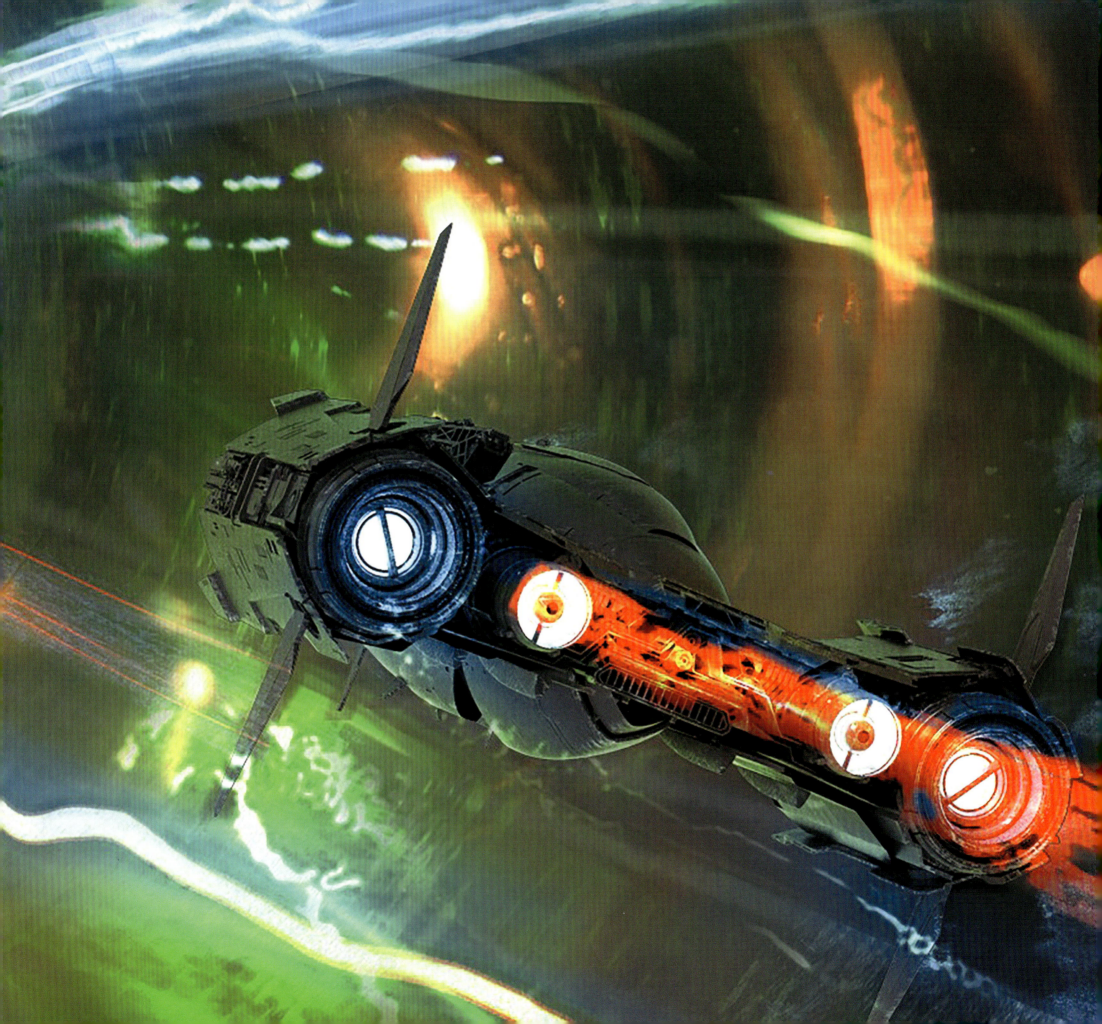

▲▶ Travelling down one of the Astral Gate's tunnels.

Astral Gates in planetary orbit are depicted as colonies and communities unto themselves; not only are they very complicated places, but there are people living in them as they are also effectively massive space stations. The treatment of travel through the Astral Gate onboard the *Bebop* also serves to help delineate character. "Jet goes to the Astral Gate all the time—he's very relaxed," McMurry points out. "He's looking around, and I even tried to do a little scene where some people in a nightclub that has a big day window looking out see him go by."

Victor Scalise explains the challenges of making the Astral Gates look suitably impressive. "I think one of the challenges of the Astral Gates is how do you get scale out of them and give them weight in space. I think that a lot of the camera moves that we designed for those shots helped it out because I know originally a lot of the moves when we came in were locked-off, stationary ones. [We decided to] move the camera so you get some perspective shifting on these objects, so that all the details in 3D that are put into these models are paying off."

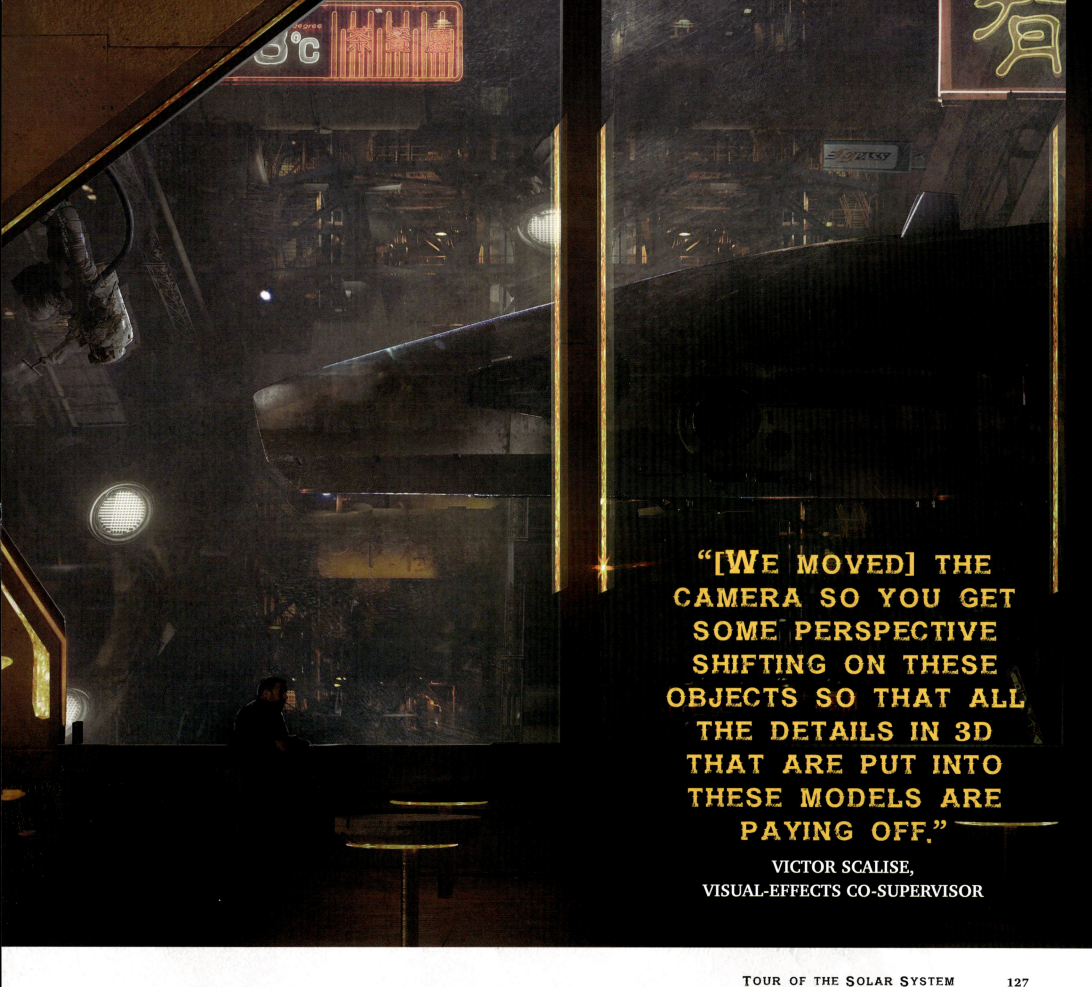

"[WE MOVED] THE CAMERA SO YOU GET SOME PERSPECTIVE SHIFTING ON THESE OBJECTS SO THAT ALL THE DETAILS IN 3D THAT ARE PUT INTO THESE MODELS ARE PAYING OFF."

VICTOR SCALISE,
VISUAL-EFFECTS CO-SUPERVISOR

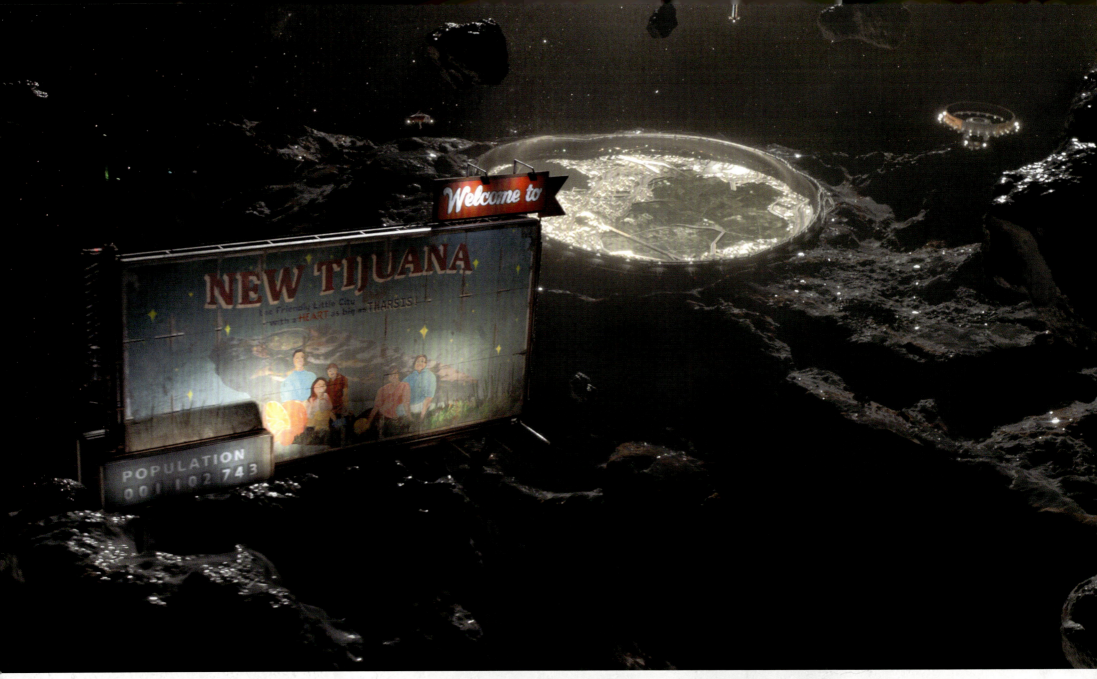

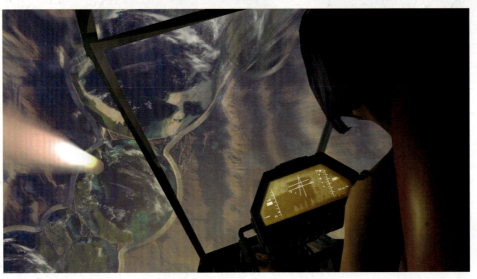

▲ New Tijuana on the asteroid.

◄ Storyboards/pre-viz for Faye chasing the Murdocks' missile in order to save Spike and Jet.

THE COLONIES

The Astral Gate provides a doorway to the far corners of the solar system and *Cowboy Bebop*'s colony worlds. The original anime managed to use the idea of colony environments to play with different genres, with some colonies looking more futuristic and spacey while many overtly pay homage to Earth cities and environments of the past. "André said, 'I want it to feel like it's a world that we would have created if we had a choice,'" McMurry explains. "So when, for example, you go to Chinatown, or you go to Tijuana, we go there because there's a certain thing about going to Tijuana we like. That's great, but there's a lot of stuff we don't like. But let's say we go build another Tijuana that had everything in it that we liked: On *Bebop*, every world that is created is a world created by the characters. It's created by all the people that have had to leave Earth."

The idea of tailor-made colony environments and architecture allowed the production to utilize location work in New Zealand, as well as a constructed backlot with facades and street environments that could be swapped out and changed from episode to episode. "I think that of all the things that we're doing live-action, this one is almost the easiest because it's a space Western," Becky Clements says. "We always talk about the fact that it's almost more Western than space. All of the plates of the *Bebop* landing, we're actually shooting footage in New Zealand of places where we scouted and

▼ Concept art had to take into account some of the practical locations in and around Auckland, New Zealand, where *Bebop* would be filming.

TOUR OF THE SOLAR SYSTEM

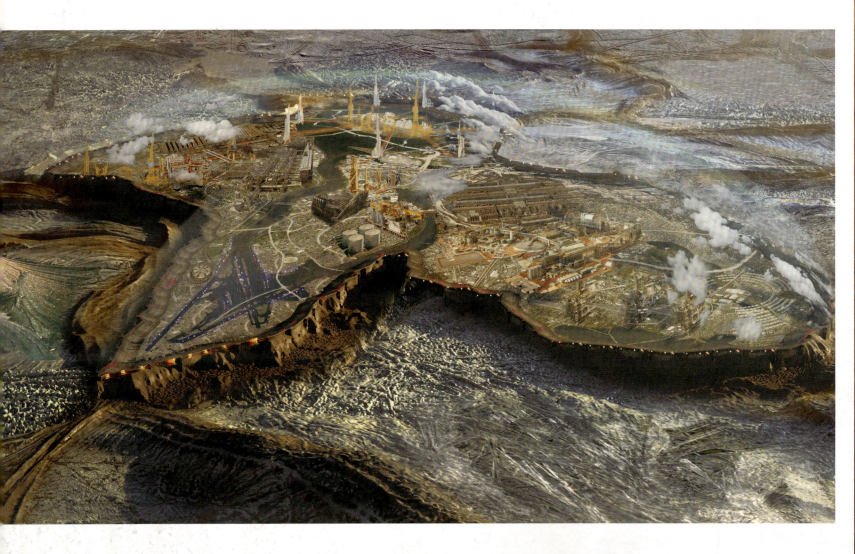

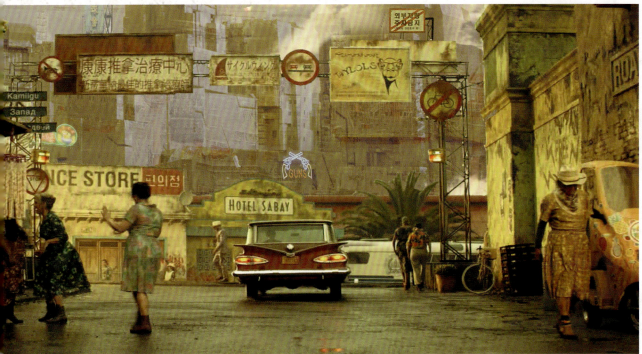

▲ The layout of cities in the *Bebop* world would take advantage of the natural terrain of the planets and moons they were set on.

◄ Visual effects would extend the backgrounds of the sets beyond what was built on the backlot.

► High above a moon of Jupiter. Ultimately it was decided that this look felt too busy, and the scale of the cities didn't look realistic.

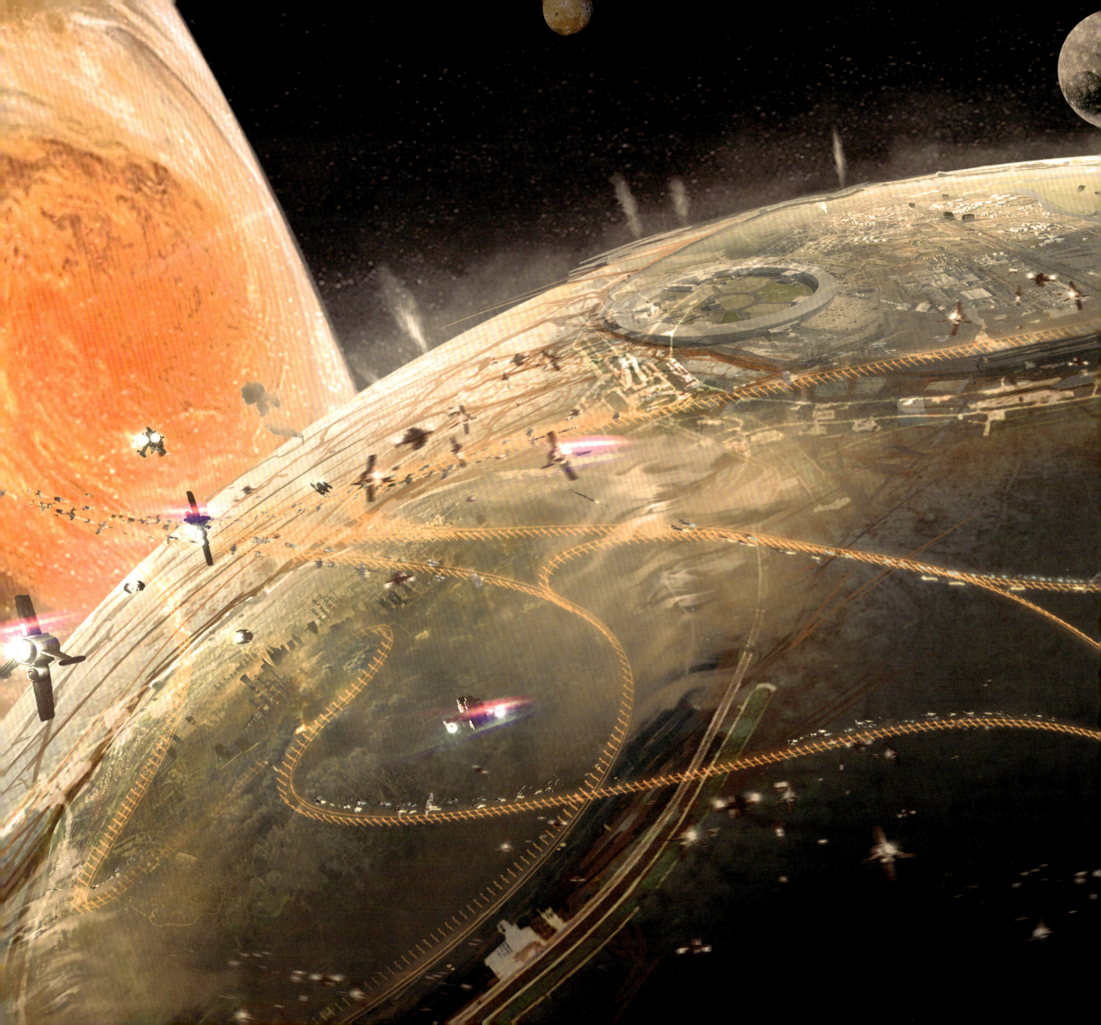

◀ Another concept that was ultimately rejected was the 'highway markers' denoting traffic lanes between an Astral Gate and planet surface.

▼ The Murdock gang's shuttle awaits their getaway.

then we're just having the *Bebop* drop into frames, so it truly is our world with VFX on top of it. There's an analog feeling or a texture to it—the restaurants look like restaurants. When we go into an astral port you'll see advertisements on the wall. Every image has a planetary touchstone that just feels like something we've seen before."

Concept artist Mark Yang worked on some of the environments alongside his vehicle design work. "We have a lot of people working on the different environments for the show, but the stuff that I got my hands on was the city that was based on a space Chicago. All these places start as sci-fi, industrial places, but then you live in these places for a while and most places become kind of Disneyland-ish. If you lived somewhere long enough, you would probably bring in a certain culture and aesthetic that you're used to, so I think underneath a lot of these cities it is like a space station,

but then this is paved over with these façades of Neo Chicago, or New Tijuana. One of our sets is based on a very classic 20th-century aesthetic, and we've got cities that look like modern versions of medieval cities, so you get a little of the old clashing with the new."

For colonies mounted on asteroids or on floating island cities in the atmosphere of Venus, 'atmo-wall' barriers provide energy that encloses a breathable atmosphere for the colony inhabitants, with circular gateways that allow spacecraft to enter and leave without allowing the pressurized air to escape. Yang was one of several designers to take a pass at the massive gateways and the constructed supports built up at the perimeters of some of the colony worlds. "I looked at refineries and water infrastructures that people have around the world where they utilize hydro power, and how that affects the environment. That's kind of what I was pitching and selling."

◄ Concept art for Spike's VR-induced hallucination that he is involved in a shootout with the Syndicate, with the *Bebop* in the background.

▼ The atmo-wall for Europa was designed using the original anime as a reference.

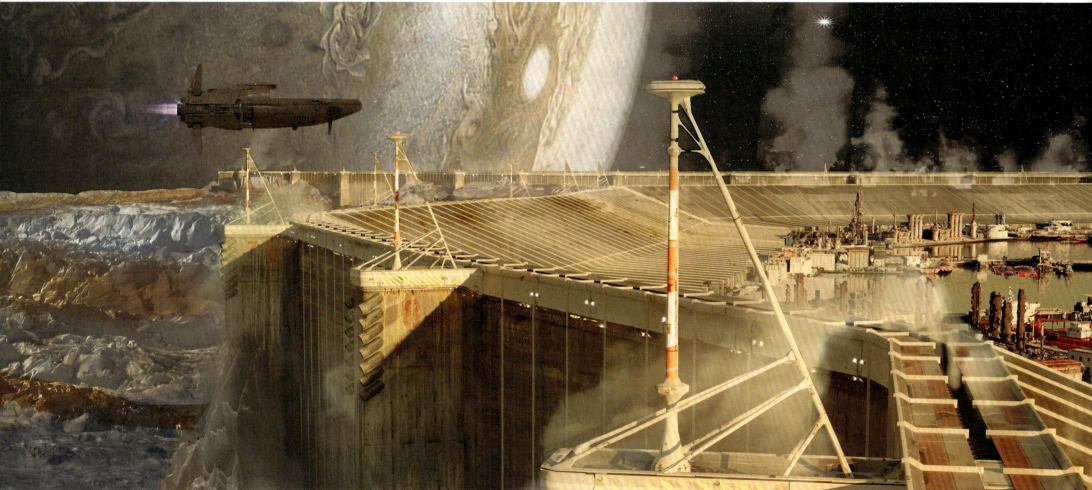

TOUR OF THE SOLAR SYSTEM

VENUS

Because the surface of Venus is far too hot to sustain human life, locations like the El Ray Bar and a church in Ishtar City are set on disc-shaped, floating cities with dome-like 'atmo-walls' that render the interior indistinguishable from environments on Earth. A sequence of some Syndicate heavies plotting their next move takes place in a vineyard shot in New Zealand, with the possibility of some of the other island dome habitats seen floating in the distant sky background. The way the show is edited means on Venus, for example, there is often no traditional cut to an establishing shot of the ground level and then a cut to an establishing shot of the amazing floating islands. It was hoped that people will get where they are, so the mindset of the creatives was to not spend a lot of time belaboring the spectacle of visual effects for every one of these locations that takes place on a planet.

▶ Concept art of one of the floating islands by Rising Sun.

▼ The dominant features of Venus' Ishtar City are the floating islands.

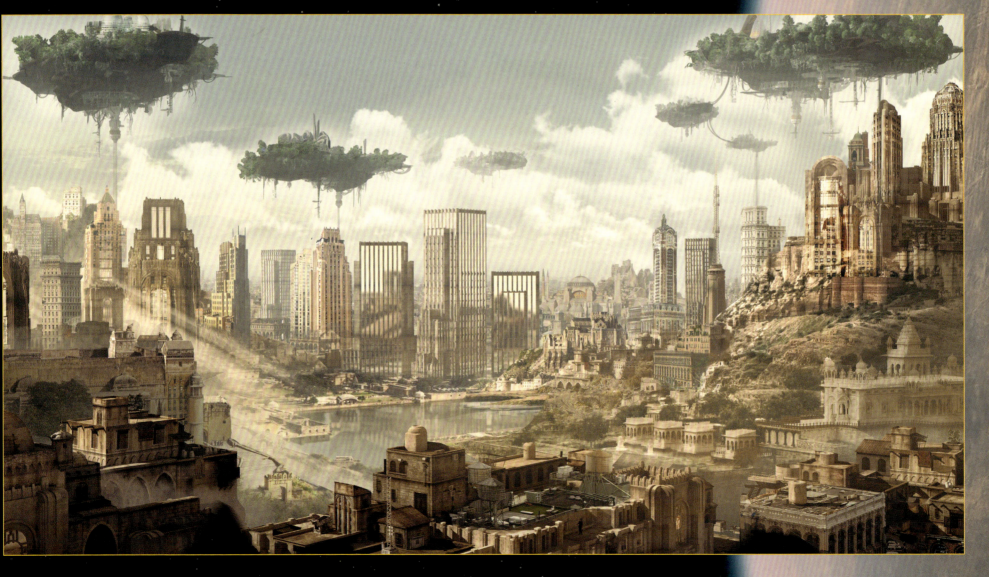

▲ In general, the concept art coming out of the art department did not really represent the scale of a city when viewed from space. Studies were done to calculate the relative size of different cities and then figure out what they would look like when viewed from 200–400 miles in orbit. Ultimately, the sizes were cheated larger than they actually would be—but not as large as the original concept art.

Contemporary automobiles mix with small ultralight flyers and zipcraft to populate the streets of the various colonies. "Each world has got its own car generation," Gary Mackay says. "If we're on Mars it's muscle cars. If we're on Europa it's '50s fin cars. If you're in Tharsis City everything's small and bubbly, so we've got Fiat Unos and Volkswagen Beetles, and everything's little and round and funny. So we've kind of specifically given the coolest cars we can to each world, but in a specific way."

While it might sound easy to cut and paste digital assets as background vehicles, Mackay was adamant about constructing as many street vehicles practically as possible. "My philosophy is to get as much on camera as we can—we're always pushing for in-camera. It's just more comfortable having more control of it. And also it means it's in the edit; there are entire scenes we shoot on our backlot with no digital additions to them. It's just faster, more efficient for everyone. And I know the VFX team have got enough on their plate building spaceships and planets without having to add too many vehicles and buildings all the time."

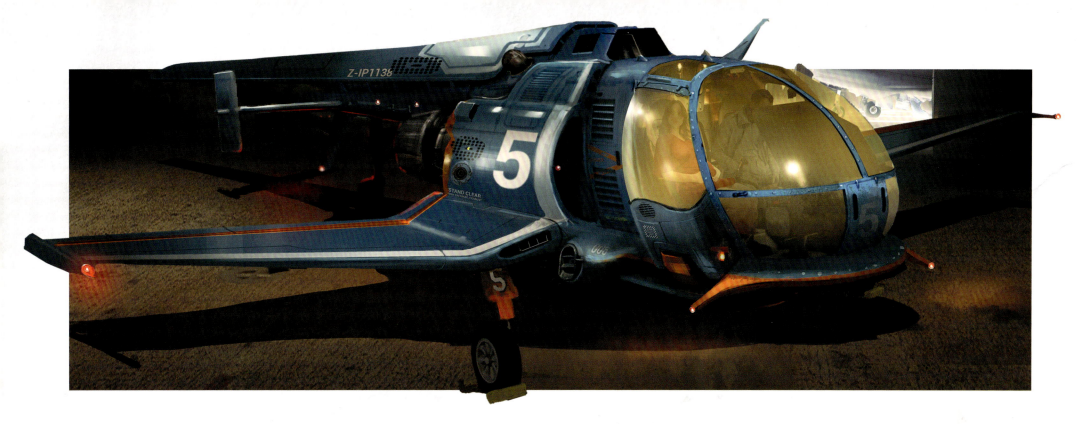

▲ Katerina's zipcraft, which she steals from a spaceport on New Tijuana, was based on a helicopter that the art department procured. Concept designer Henry Fong added wings, jet engine exhausts, and details like intake grills from old cars to disguise the origins.

▼▶ Different designs and color schemes for various zipcraft.

A zipcraft commandeered by drug dealer Asimov and his wife Katarina in the pilot was based on a small, decommissioned helicopter purchased by the production. "This is us buying a helicopter and giving it a workover for our generic zipcraft," Mackay says. "We probably made three or four different versions that we would change and recolor and redo, and we decided that these are the Toyota Corolla of *Bebop*, and I say it's okay to see them in different places at different times."

Anneke Botha found an aeronautical company and raided it for equipment to detail the zipcraft interior. "We had a certain leather upholstery in it that you use for Ferraris, and we just did a clear vinyl over that. And then all the control consoles are stripped out of original planes that we bought. So every zipcraft we upholstered differently, and we do little control panels—we take actual aeronautical equipment and just rebuild it and repurpose it."

For two white Syndicate vans that arrive to intercept Asimov and Katarina, Mackay and his crew modified standard street vans. "We took basically a Volkswagen van and pulled the front off, and I got the crew to fill and get rid of every crease and make it fluid. So we've rebuilt that entire van out of fiberglass, and we've cleared all the guards and put a wonderful scoop on it. I actually got a really interesting young international vehicle designer who's worked for Volkswagen to come and work with me for two weeks on this, because he has all the perfect design cues, he's just immersed in it, and he knew how to make it fit and function."

TOUR OF THE SOLAR SYSTEM

EARTH

In the episode "Binary Two-Step", the *Bebop* travels to Earth, and it's not a very inviting place. Off-world colonization is well under way by the time the Astral Gate disaster happens, and that event only hastens the process of abandoning the planet. Faye Valentine's history as a child of Earth abandoned in cryo-sleep ties in to the Astral Gate disaster and its aftermath; after the Astral Gate disaster happens, migration is massively stepped up. The rich people managed to cut in line and get a ticket on some of the first evacuation ships and get to their colonies, but other people were left behind to die, or decided to put themselves or put their families in cryo-sleep.

Greg McMurry's desire to avoid referencing the look of *Blade Runner* came into play in sequences set on the abandoned Earth. But Gary Mackay notes that avoiding the *Blade Runner* look has been easier than it sounds. "[*Bebop* has] a lot more humor. I think it's a lot poppier, both in its color palette and the [locations] because maybe we're on a planet, on the moon Europa, and there's the orange glow of Jupiter and everybody's inspired to use that orange glow and immediately you think *Blade Runner*. We still use orange, but we use it very judiciously and not in that context. We've got a wasteland that we're shooting and we've got characters on Earth heading towards an abandoned military base, and we've gone with charcoal black and dusky gray, a scorched Earth, and stayed away from orange because it was so easy to lean into the 'orange apocalypse', and we just made sure we absolutely didn't."

▼▶ Different concepts of the military base that the *Bebop* crash-lands near.

▶▶ View of the Earth after it has been ravaged by the Astral Gate disaster. These enviroments were created by The Mill.

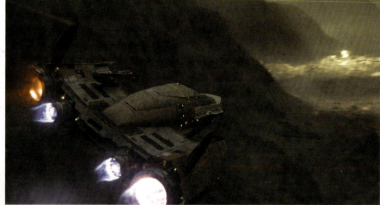
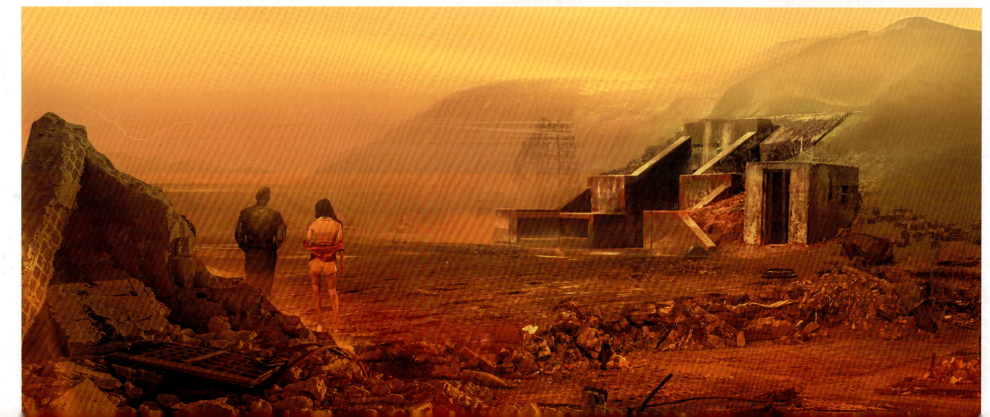

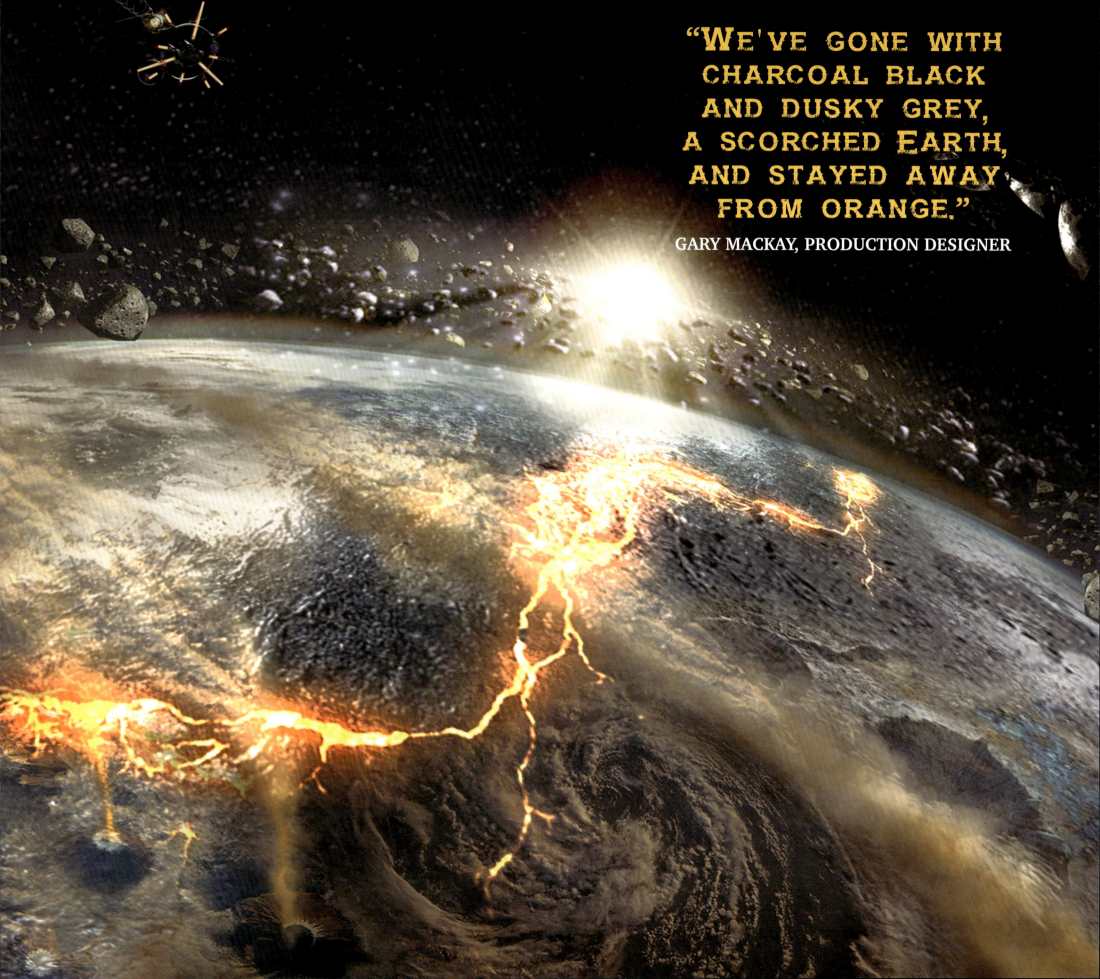

"We've gone with charcoal black and dusky grey, a scorched Earth, and stayed away from orange."

GARY MACKAY, PRODUCTION DESIGNER

MARS: ANA'S BAR

Mars has been one of the first and most successful terraforming experiments in the solar system, allowing it to support a time-tested and sprawling colony and Earth-like metropolises. As Spike Spiegel's birthplace, the red planet also hosts a number of critical and oft-visited locations where some of the show's key dramatic moments play out.

One of the most important—and most notably revised from the anime—is Anastasia's Bar in Tharsis City. Massively upgraded from the humble convenience store the character owned in the anime, Ana's is now the best jazz club in the solar system and a key location for conversations between Ana, Vicious and Julia, as well as flashback scenes of Spike's time as a Syndicate enforcer. "In the anime, Ana just owns a little shop, a little Hong Kong store," Gary Mackay says. "Our design for the bar is based on a military underground bunker in Moscow, and the style of the bunker is a jumping-off point because she was Russian, Anastasia, in our story. My thought was that she took over this place up on the street—when you're on the street, all you see is the entrance to an old power substation. There's a substation with just a number eight on the outside of it, and it's on a street where there's not lots of other businesses or it's not in the nightclub district—it's only people like the gangsters, the corrupt police, the celebrities, the movie stars that go there, because they know no one's going to hassle them. That's where you go and everyone minds their own business."

The 'vaulted bomb shelter' look of the bar is dominated by a central, ceiling-mounted hopper. "I had a lot of fun with this," says Mackay. "Huge amount of copper work, and both sides of this whole set all roll away, as they do on the *Bebop* interior; all the side panels just roll away on wheels. So this is where we meet Julia in the nightclub—that's where her story starts."

Set decorator Anneke Botha worked overtime to get the underground bar set camera-ready. "Ana's bar broke me," she chuckles. "Everything

◀ Concept art for Tharsis City, with Mars' Olympus Mons in the background. In reality, Olympus Mons is so massive it would totally fill the frame, so a certain artistic license trumped scientific reality.

▼ While Ana's Bar (interior, below right) is neutral territory, Ana (left, with Gren behind the bar) will not tolerate any shenanigans.

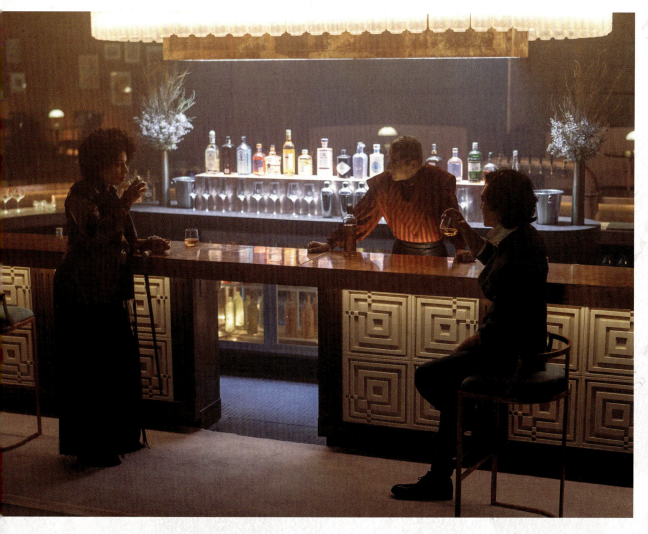

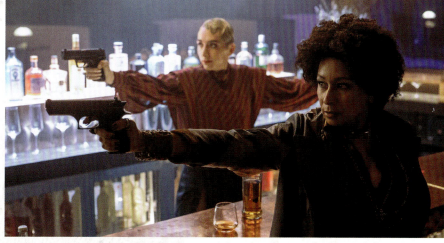

TOUR OF THE SOLAR SYSTEM

was made—we had the bar chairs made and upholstered, we had the booths made, woodgrain painted, upholstered, we had the bar screens cut out, plexi painted. We had paintings made especially for that by Katie Theunisen; it was a massive, massive set."

Tamara Tunie's casting as Ana also affected the look of the set. "Originally, Anastasia was obviously a Russian, and then in the story, as the script progressed, she became African American with the history of protest and activism," Botha says. "When she was still Russian, we ordered from the Hermitage Museum in Russia this double-crested eagle, glossy glassware and bar decanters, which we still put in because she retains an element of Russia in her, but then it was important to also bring in the protest elements. So we had the jazz musicians—jazz is protest music in itself, according to me—and we had several historical African-American protest activists framed behind her desk as well. We had a coffee table book made for her, which was a 'Free Titan' book, and we made that on African American females, which was quite important to me to bring that aspect out as well. For everything else in the office we upholstered chairs, we made the furniture, we took an old candle holder and made that electrical and put Edison bulbs in. Obviously the monitor wall as well, we made that. We found interesting bottles and we relabeled them. The bar trolley was made—that big, beautiful bar trolley we made out of acrylic rods and steel that moves in and out, and then put it on wheels."

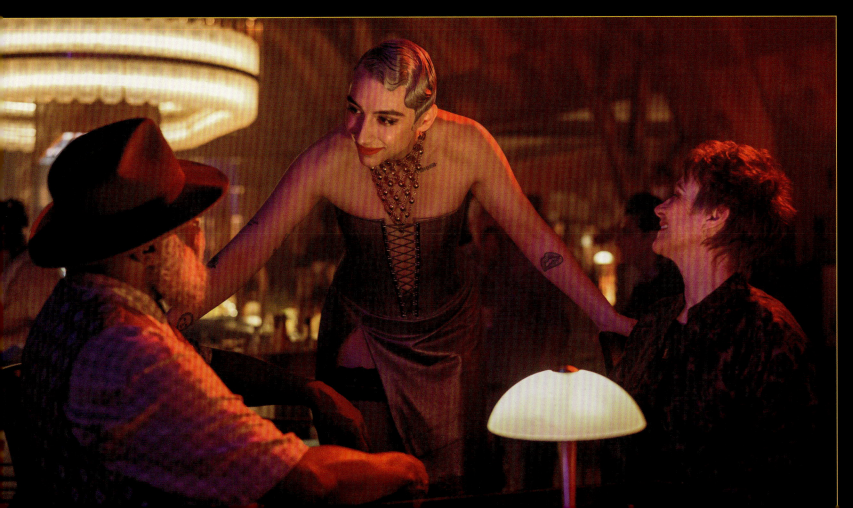

◀ Gren (Mason Alexander Park).

▲ Julia's dressing room at Ana's Bar.

▶ Ana (Tamara Tunie).

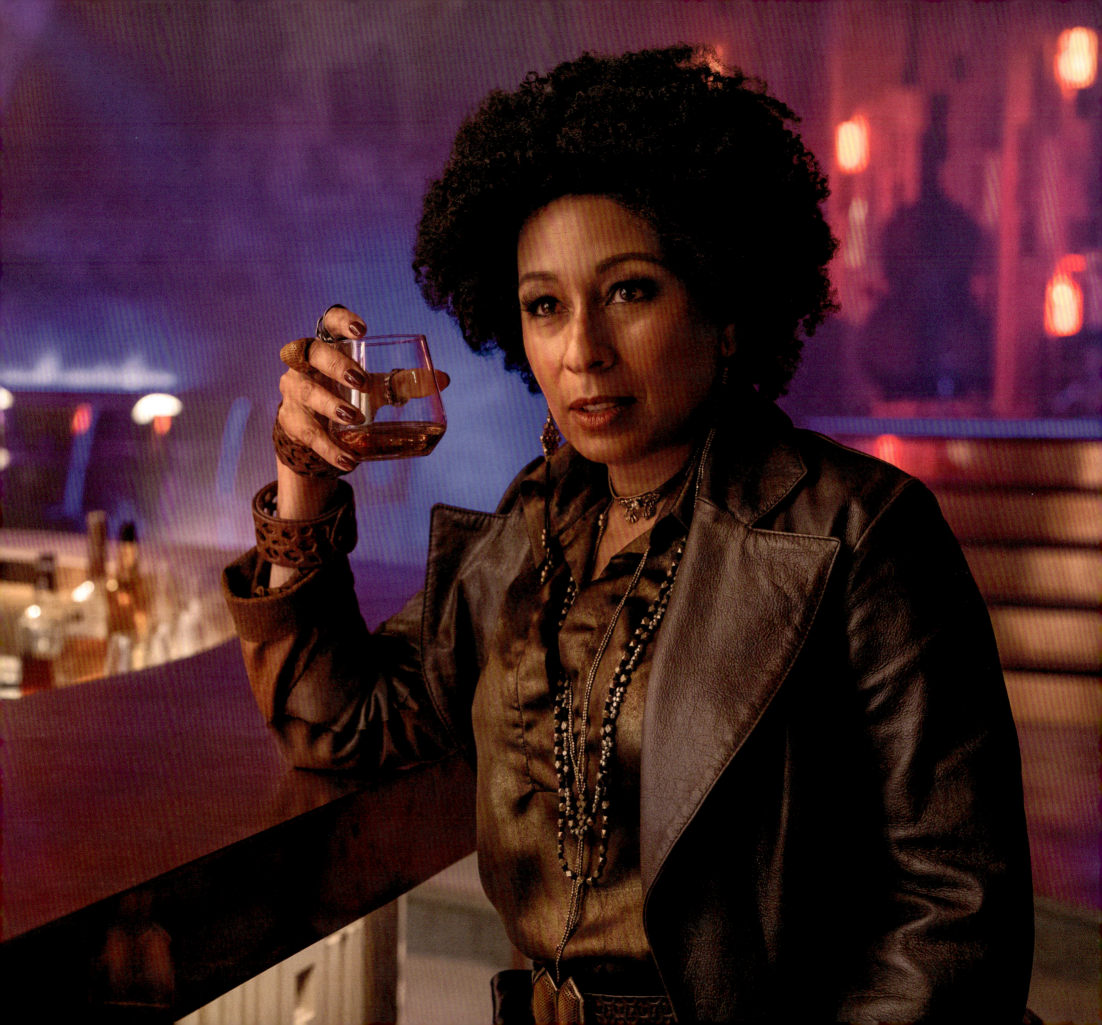

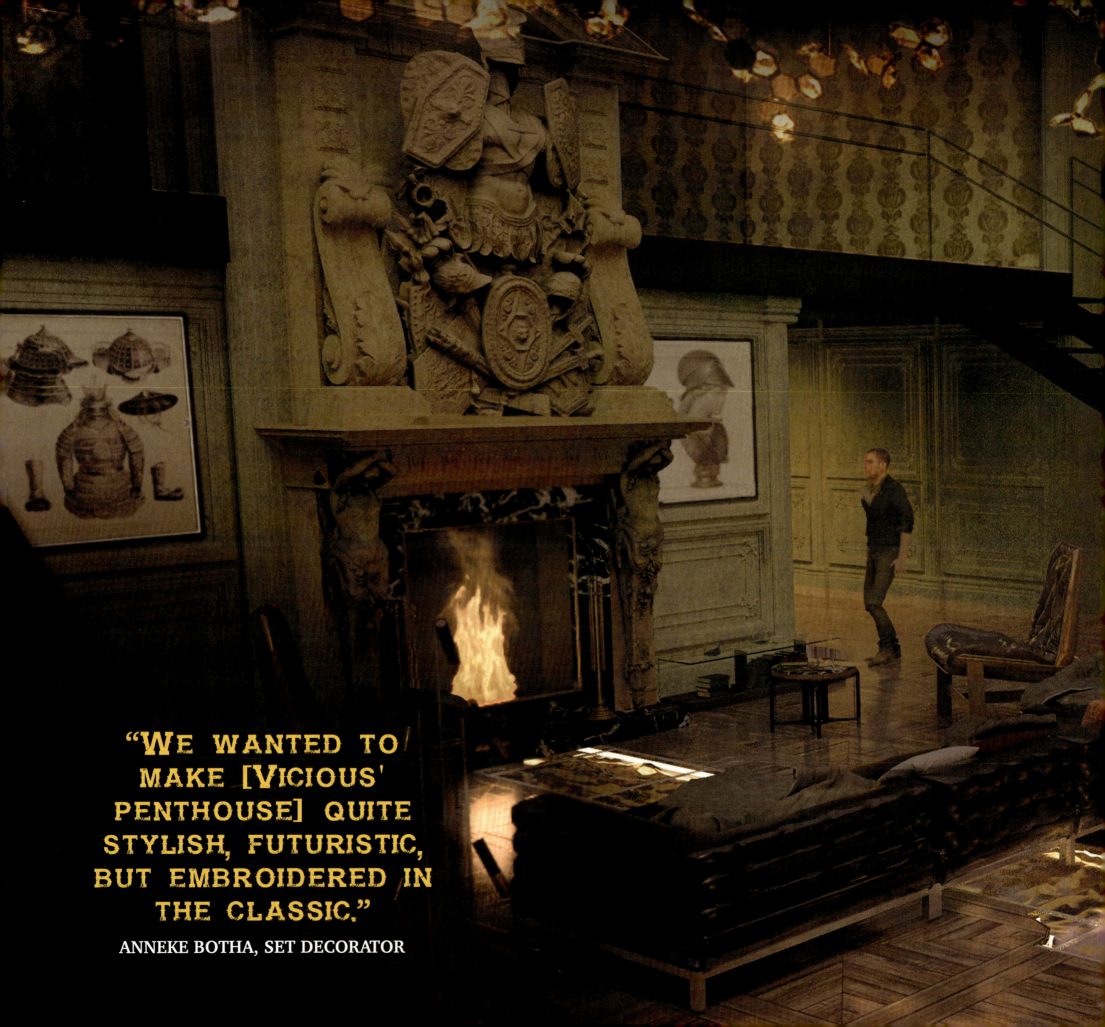

"WE WANTED TO MAKE [VICIOUS' PENTHOUSE] QUITE STYLISH, FUTURISTIC, BUT EMBROIDERED IN THE CLASSIC."

ANNEKE BOTHA, SET DECORATOR

MARS: VICIOUS' PENTHOUSE

Dominated by classical columns and elegant, almost Louis XVI furniture and detailing, the luxurious penthouse Vicious dwells in with Julia on Mars called for an undercurrent of tension built into the set design and decoration. "With Vicious, he obviously comes from old money," Botha says. "We wanted to make it quite stylish, futuristic, but embroidered in the classic. And every sculpture in Vicious's penthouse we wanted to make quite violent, so all the sculpture and all the art are of colonialization or fighting for the frontier. I wanted it to be like the Conqueror, Ivan the Great—if you look closely, it's quite dark. And we wanted to always have a little hint of orange on the set, because Vicious' tone is orange. We had the chairs reupholstered in orange seats except the Le Corbusier chairs, they were fine. The architecture is classical with a mid-century modern twist, classical busts (mostly featuring Hercules). All the reprinted artworks were war-like, colonial, like Rubens' Battle of the Amazons. We also did an oriental print of a cormorant bird—as per the anime, Vicious always had one on his shoulder. The double-crested cormorant bird has an orange beak, that is why I favored tones of orange in his penthouse."

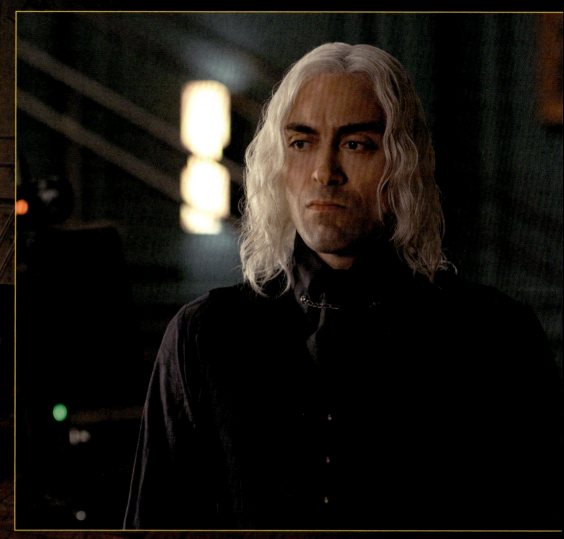

◀▲ Vicious' penthouse was a set built entirely on stage, requiring considerable traditional plaster and sculpting skills.

TOUR OF THE SOLAR SYSTEM

MARS: VIRTUAL REALITY LONDES CENTER

In "Binary Two-Step", Spike takes a virtual reality vacation that sends him on a journey back to the past. To detail out the virtual reality Londes Center in Alba City, Anneke Botha worked to make her own trip to the past, specifically 1970s Earth. "The Londes Center we wanted to really route to the '70s look. We wanted to do Ernest Igl desks, and to buy one is $25,000. So we made those desks—we built them and we sprayed them, and I remember John Cho walking up to them and he goes like, 'Oh, these desks are so cool!' And trying to open the drawer and it didn't open. And he was like, 'They're fake!' And it was like 'Yes, they're fakes—good fakes!'"

Botha wanted to add to the feeling that everything in the Londes Center might not be exactly what it seemed. "If you walk into the Londes Center, it almost looks perfect. But I didn't want any layering in there. It needed to be perfect lamps, perfect desks, everything quite in chronological order. But if you look closely, you'll see there's almost nothing on the desks; there's almost nothing in the place and people work there, so why is it so empty? And it was also

▶▼ The initial concept for the Londes Center had multiple victims hanging (in a homage to the 1978 Michael Crichton film *Coma*), adding the twist of the victims being trapped in a virtual-reality hallucination.

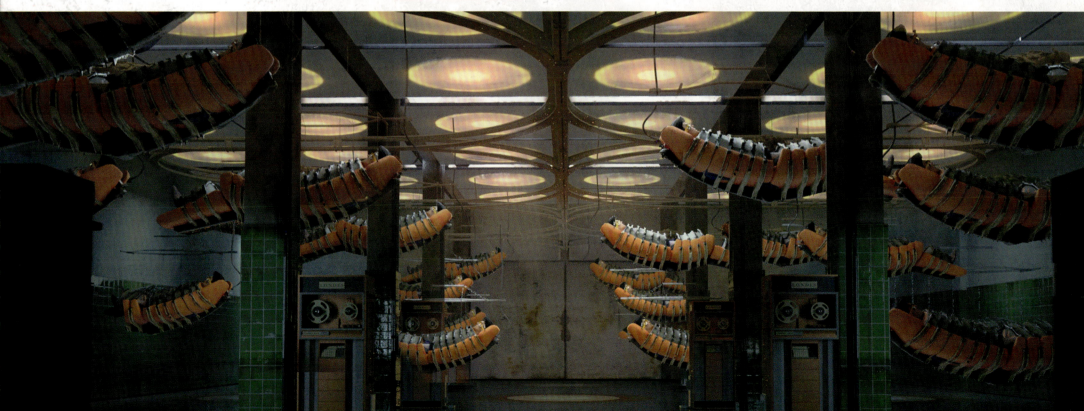

◀ Practical prop of the Londes Center monitor 'tree' featuring graphics and readouts of Spike's vital signs.

▼ Concept artwork of the mainframe computer, buried in a secret military bunker on Earth.

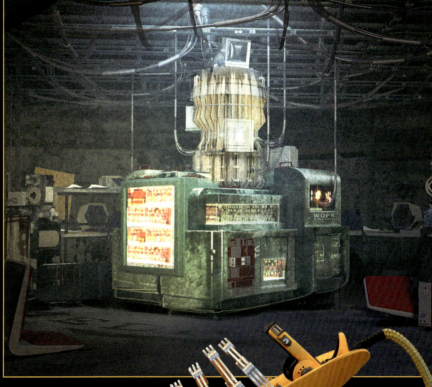

part of telling the story that it's fake—it's just a virtual reality fake like the rest of that town. Everything's just façade dressing; there's no layering. We had a mannequin in the back of a counter, so it's like *The Truman Show* almost. It's like if you're in a bad loop and you start picking up that the whole town is fake. But the style was very '70s retro and very clean; nothing out of sync or out of place: Perfect. Too perfect. Picture perfect."

Botha literally pulled the reel-to-reel machines featured in the Londes Center set out of a fire. "Those big reel-to-reel machines, we found them in this guy's house that had almost burned down—we went down to his basement and there they were, these perfect reel-to-reels just covered in soot." She says that the set decorator's job becomes like that of a detective or a muckraking reporter. "It's like you're little hungry journalists hunting and you get a lead from here, someone knows a guy who knows a cousin who had an uncle down south, and then you just find it, but it takes time. But it's very rewarding when you do, especially in New Zealand, which is like an island in the middle of nowhere."

▲ The Londes Center chair 'captures' Spike and traps him. The chair would be a practical prop as well as a CG asset used by Scanline VFX.

MARS: LE FOU MEDICAL FACILITY

One of the show's pivotal episodes is "Sad Clown A-Go-Go," based on the infamous "Pierrot Le Fou" episode of the anime series in which a killer clown, Pierrot Le Fou, who was part of a weapon experiment gone wrong and now lives simply to take joy in killing, sets his deadly sights on Spike Spiegel. With the legendary status of the "Le Fou" storyline, the live-action series creative team faced a huge challenge in bringing one of *Cowboy Bebop*'s most vivid heavies to life. "The Pierrot Le Fou episode is a very beloved one," André Nemec acknowledges. "Very dynamic. But not a lot of dialogue in that one. And not a lot of a deeper understanding of the Le Fou character."

Nemec, writer Javier Grillo-Marxuach and the rest of the *Bebop* team dug into the character in an attempt to humanize Le Fou. "Part of what we thought was, 'Let's see who Pierrot Le Fou is.' There are hints of it in the anime, and once we felt satisfied that we [had] come up with a story that legitimized Le Fou as a character that could exist in our world, we then crafted that character into the overall storytelling."

The Le Fou character is revealed in the episode's opening, which takes place in a high-tech research facility invaded by Vicious and his minions. An experiment takes place with Le Fou, which results in the creation of a real monster of a man who ends up having a mental connection with Ein because they were both developed in the same lab."

As with the Londes Center, Anneke Botha worked to lend a surreal atmosphere to the experimental medical facility's set dressing. "In the design concept it was based on a prominent American artist, Matthew Barney; he was quite graphic," Botha says. "For that set, Alex Garcia Lopez was also heavily influenced by Alejandro Jodorowsky, the Chilean director, so Gary Mackay combined both influences. And we wanted to do everything with a bit of a twist. So we took Victorian furniture, and we sprayed it in a color we call

◀▼ Concept art for the Cherious Medical Lab. Hexagons were a recurring design theme throughout the series.

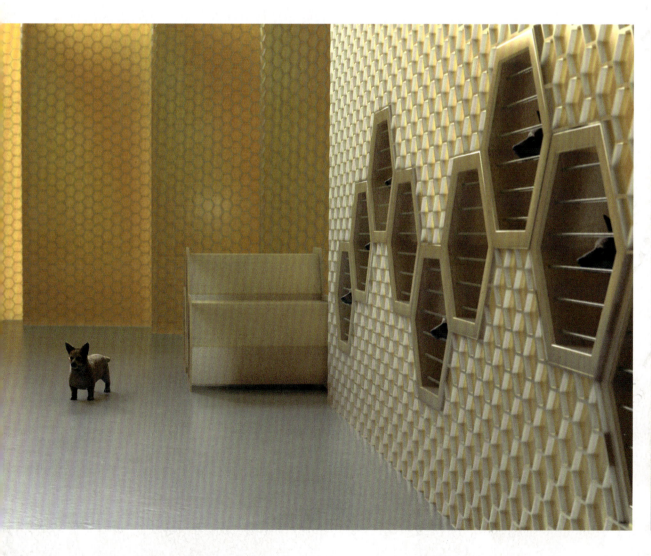

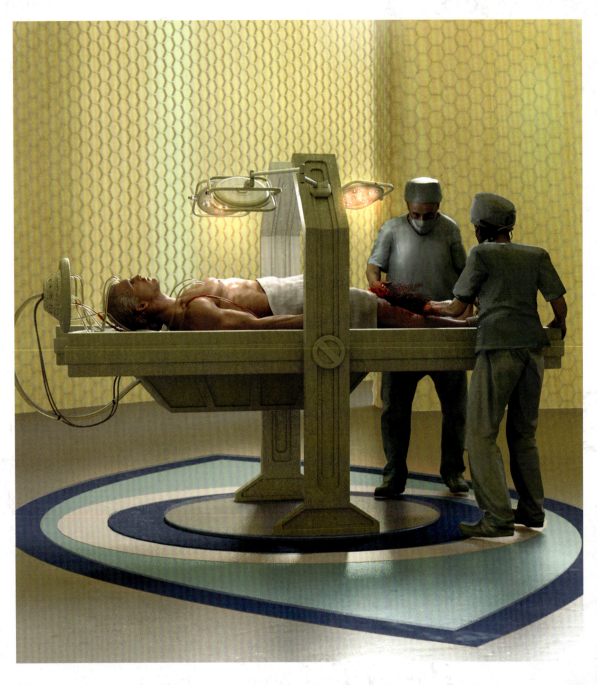

▲▶ Since most of the scenes of Le Fou being operated on were going to be seen in a series of close-up flashbacks, it was decided to keep the lab set relatively simple and unlike a hospital operating room.

French butter. So it looks like a medical facility, but it has a quiet otherworldliness about it, almost as if it's a dream, because it's not your standard medical bed; it's not a standard medical table; it's not your standard operation facility. We wanted to make it almost surreal, with objects that you can recognize but with a slight twist to it. It took forever, but we made the medical lamp ourselves that had all these mirrors and even retrofitted bulbs. And the furniture for that was all Victorian. I was so fussy about that furniture; if we had four pieces I probably vetoed 70. I was like, 'No, no, no,' it had to be perfect. It has to be like, 'That looks like a cabinet, but is it a cabinet?' It's the same function, but different shapes, different color. Because that whole sequence is quite surreal."

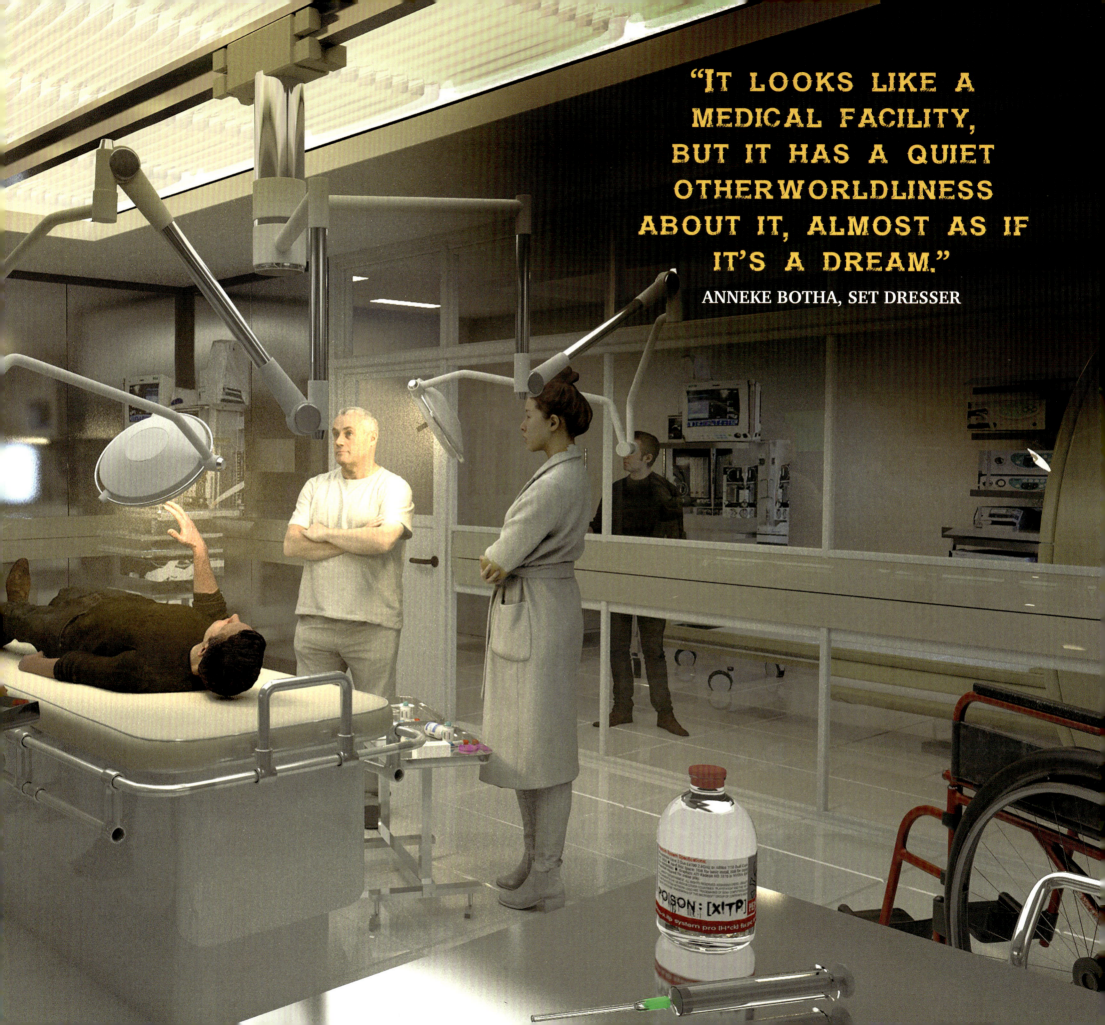

"IT LOOKS LIKE A MEDICAL FACILITY, BUT IT HAS A QUIET OTHERWORLDLINESS ABOUT IT, ALMOST AS IF IT'S A DREAM."

ANNEKE BOTHA, SET DRESSER

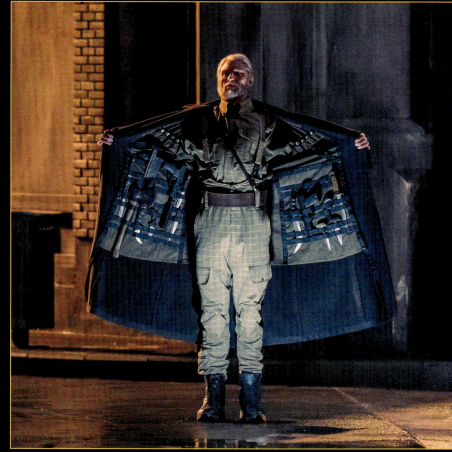

▲ Pierrot Le Fou (Josh Randall).

◀ Because of Le Fou's ability to fly, and the desire to mimic the fight between Spike and Le Fou seen in the anime, considerable wire stuntwork was required.

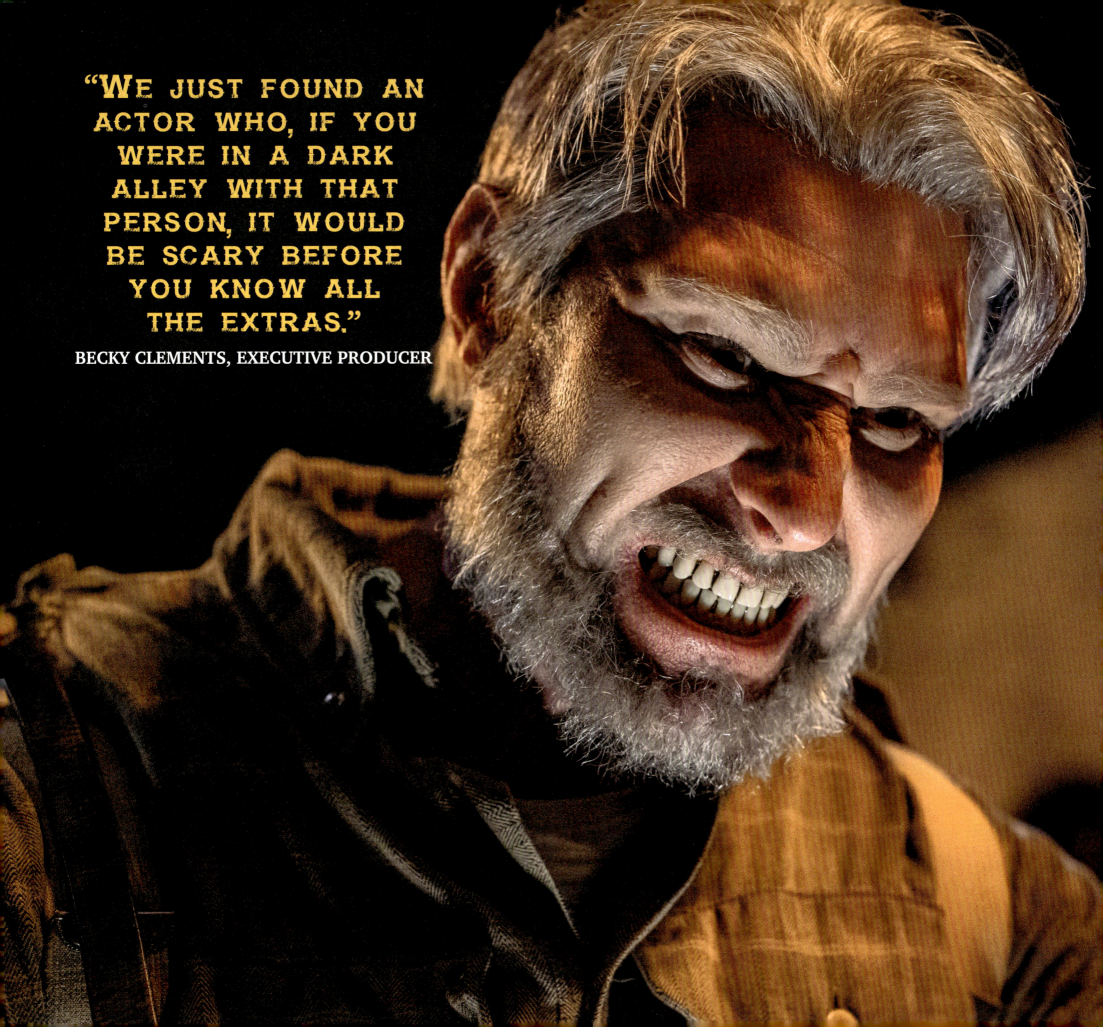

"WE JUST FOUND AN ACTOR WHO, IF YOU WERE IN A DARK ALLEY WITH THAT PERSON, IT WOULD BE SCARY BEFORE YOU KNOW ALL THE EXTRAS."

BECKY CLEMENTS, EXECUTIVE PRODUCER

MARS: THARSIS CITY FISH FACTORY

Tharsis City on Mars is one of the biggest metropolises in the solar system, the equivalent to New York City for the United States, and one of the most developed places in the system of Earth colonies. Mars has a relatively easy atmosphere to process and so it was colonized first. Tharsis was made to look somewhat like New York, with a hint of Hong Kong added in, and the city's skyline is dominated by Mount Olympus, a shield volcano remnant two and a half times the size of Earth's Mount Everest—so large, in fact, that the object's scale had to be cheated to prevent it from making Tharsis City seem puny by comparison. The visual-effects team planned to create the show's cityscapes by employing New Zealand city locations and a kit of random, futuristic buildings (many based directly on buildings seen in the anime series) that could be digitally integrated into location footage.

A key location for the series is the fish factory, where Vicious is secretly running an operation to manufacture the hallucinogenic drug Red-Eye (which provides inhuman strength—and aggression—to Asimov in the "Cowboy Gospel" pilot episode). Enslaved workers,

▼ Set dressing in the warehouse of Vicious' hideout.

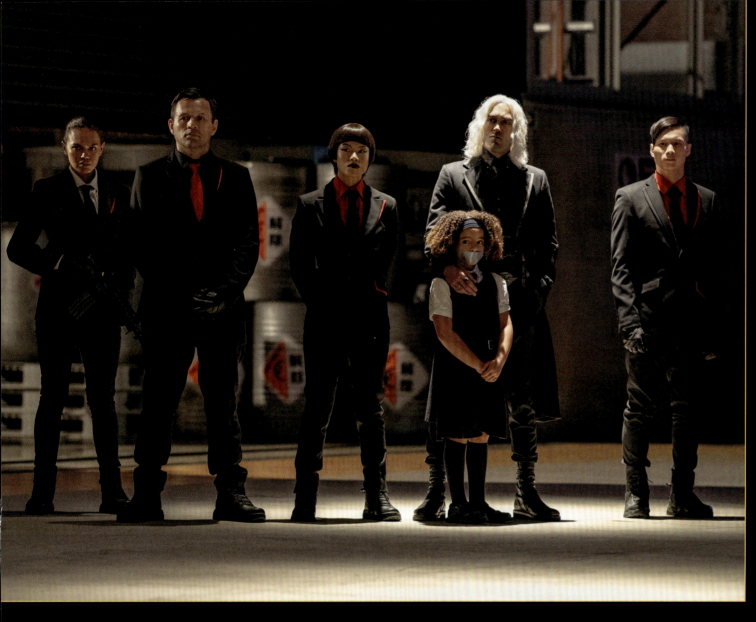

▲ In the *Bebop* world, fish and meat is all synthetic and genetically grown.

◄ Vicious kidnaps Jet's daughter Kimmie, setting up the climactic battle in the season's finale.

stripped naked and with their eyes sewn shut to prevent them from being used as witnesses, toil away packaging the dangerous narcotic until Vicious orders them mowed down in a bloody massacre.

While it has a perfectly seedy, industrial appearance in its exterior, Gary Mackay notes that the location is actually an educational facility. "Almost like a college where they teach construction and plumbing and drain laying, and that's where we ended up filming. Everything up to the roof line will end up being real, and everything above the roofline will [be created with visual effects]. But we've been through many, many versions of the fish factory. We just shot, last week, Spike on a sniper position on the roof, and then we built a set that [acts] as the interior of the fish factory, and processing room—we walk through and meet Vicious, and I think it is going to be the first time we meet him on the set. We ended up making 80 or 90 fake dead tuna, which was a thing in itself."

► Concept art for Vicious' fish factory interior—the cover for his Syndicate operation.

TOUR OF THE SOLAR SYSTEM

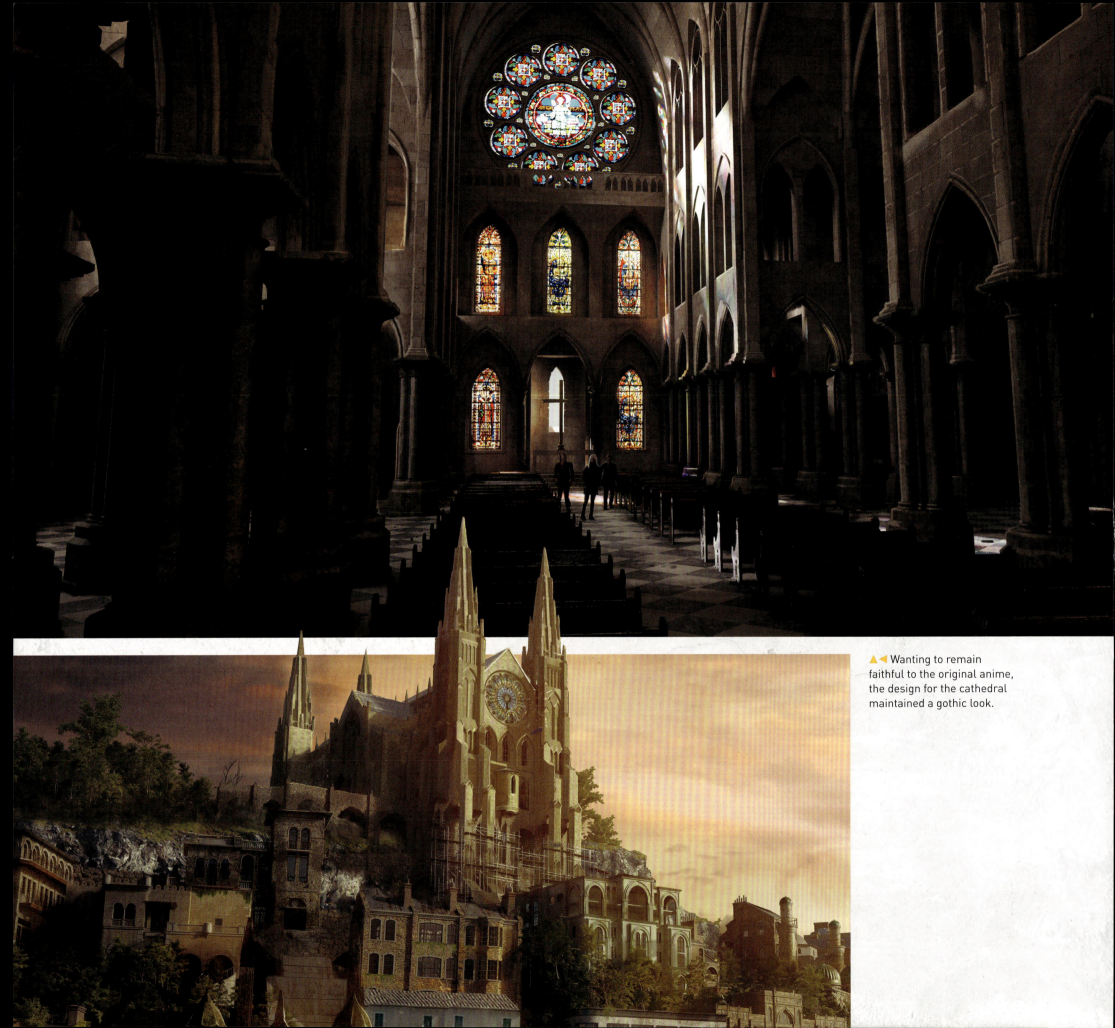

▲◄ Wanting to remain faithful to the original anime, the design for the cathedral maintained a gothic look.

MARS: CATHEDRAL

Cowboy Bebop's anime episode, "Ballad of the Fallen Angel", features a showdown between Spike and Vicious that takes place around their old Syndicate stomping grounds and winds up in the dramatic setting of a cathedral, an immense, shadowy space complete with stained-glass windows to provide stark shadows and color. The live-action episode "Supernova Symphony" recreates the collision between Spike and Vicious. Gary Mackay knew the episode would require a loving tribute to the anime's moody lighting and stylized action. "We duplicated some key moments of Spike walking back in the doors of the cathedral in this huge shaft of light, going straight up the cathedral as his shadow appears, and then he appears—we've done exactly that shot. And we've tried to do that with a cross that's on the altar that's the same cross that's in the anime. And I use red and black tiles on the floor because that's what's in the anime."

Mackay sees the live-action *Cowboy Bebop* coming full circle as it acknowledges the influences from American and worldwide pop culture and sci-fi that the original anime makers were so excited about incorporating into their show. "They just were mining everything from all the decades before that were all their favorites. And then we get to mine what they did, plus their references, so we can reference the cathedral from *The Crow* or something like that, which they were inspired by, into their domain, and then we take that and amplify it and cross it. They mix Notre Dame Cathedral with the cathedral from *The Crow* and so we can do that as well, and even add *The Matrix*. We can take what we liked from movies we love and the movies they loved, and meld it into the best of everything that we can, or what works for us."

▼ The gothic cathedral set under construction and after the gunfight with Vicious' goons (bottom right).

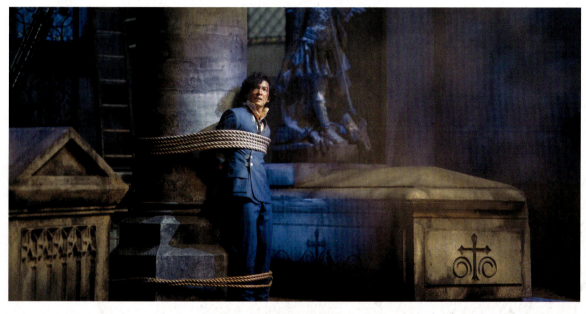

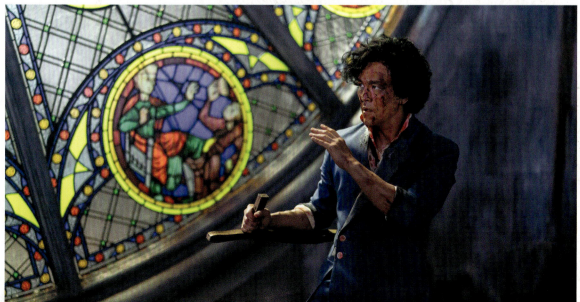

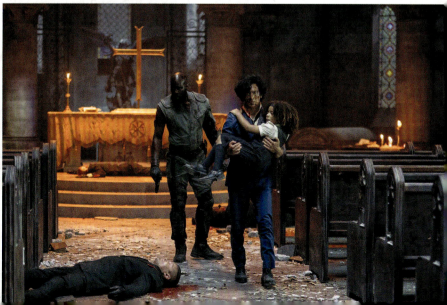

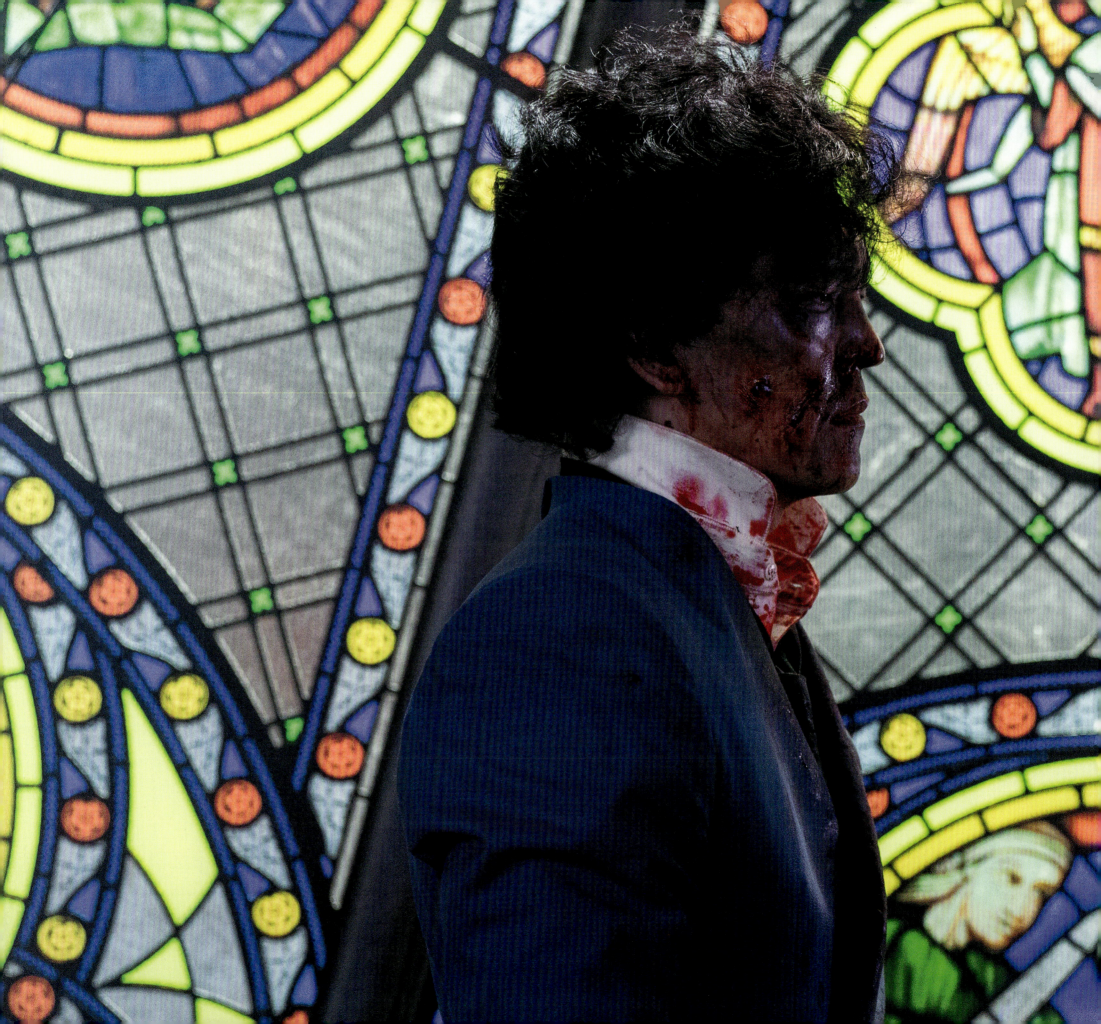

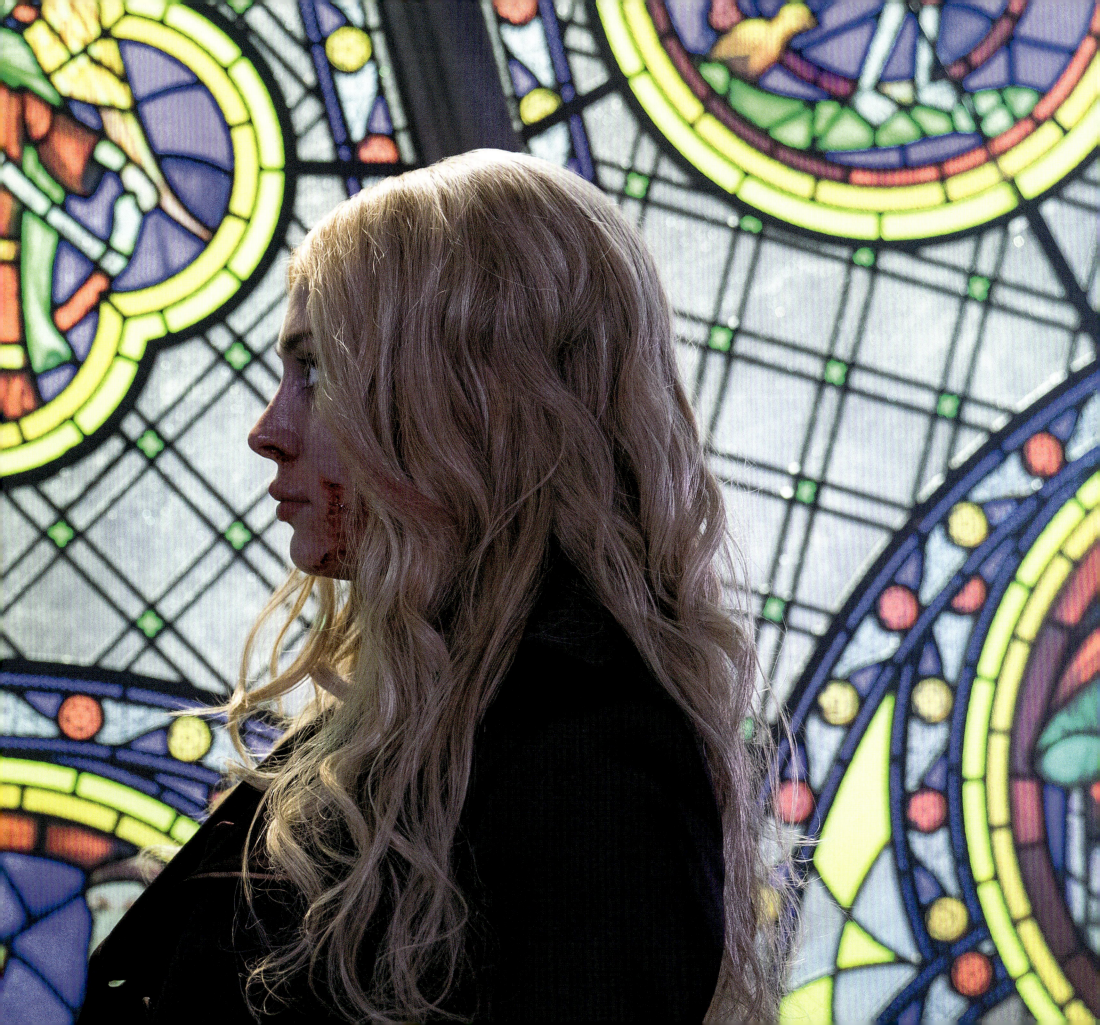

ELDERS' TEMPLE

Just as Ana takes care to locate her bar off the beaten path to avoid the eyes of the law and other unwanted scrutiny, the Elders of the three crime syndicates that dominate the solar system tuck their temple away on an unremarkable asteroid, where Vicious must go to pay his respects and maneuver for his own power and influence. With its stark color palette and circular ceiling design, the Elders' Temple set has a hint of Ken Adam and a James Bond villain lair, although Gary Mackay explains that his influences were more artistic than film-oriented. "I was into James Turrell, the amazing American artist who does the Roden Crater, and all these beautiful artworks that are all about light. Cross that with Tadao Ando, who's a famous Japanese architect, and mesh those two together along with a Russian artist's work I saw when I was a teenager that was like a matrix of black pipes resting in beds of black oil. So for the set we did black water; we built the whole set on a tank—we flooded the set and had stone walkways that go across the black pools of water, and made an octagonal room and had a moon gate on two sides. And we put bamboo outside that, and did an aurora lighting effect through the bamboo that's making all the Shoji screens move and wobble and be very unusual. From concept to actually making it we wound up using a light and color in here that was almost like Coca-Cola in the end; it was a really lovely tarry brown."

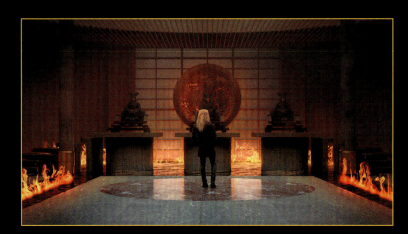

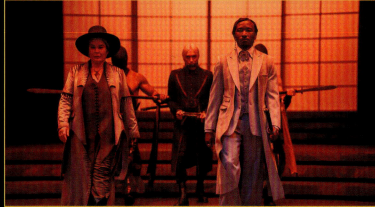

▶▼ Production designer Gary Mackay mixed in oriental influences, as well as design elements from the original anime, to create the interior sets of the Elders' Temple.

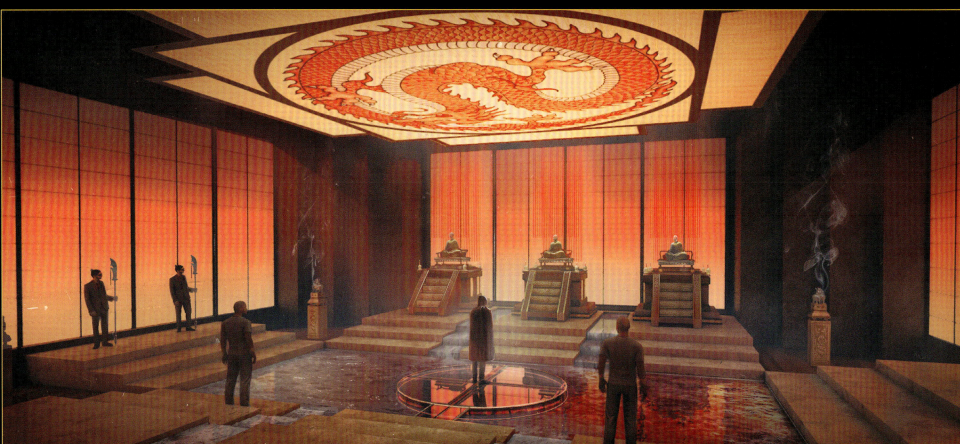

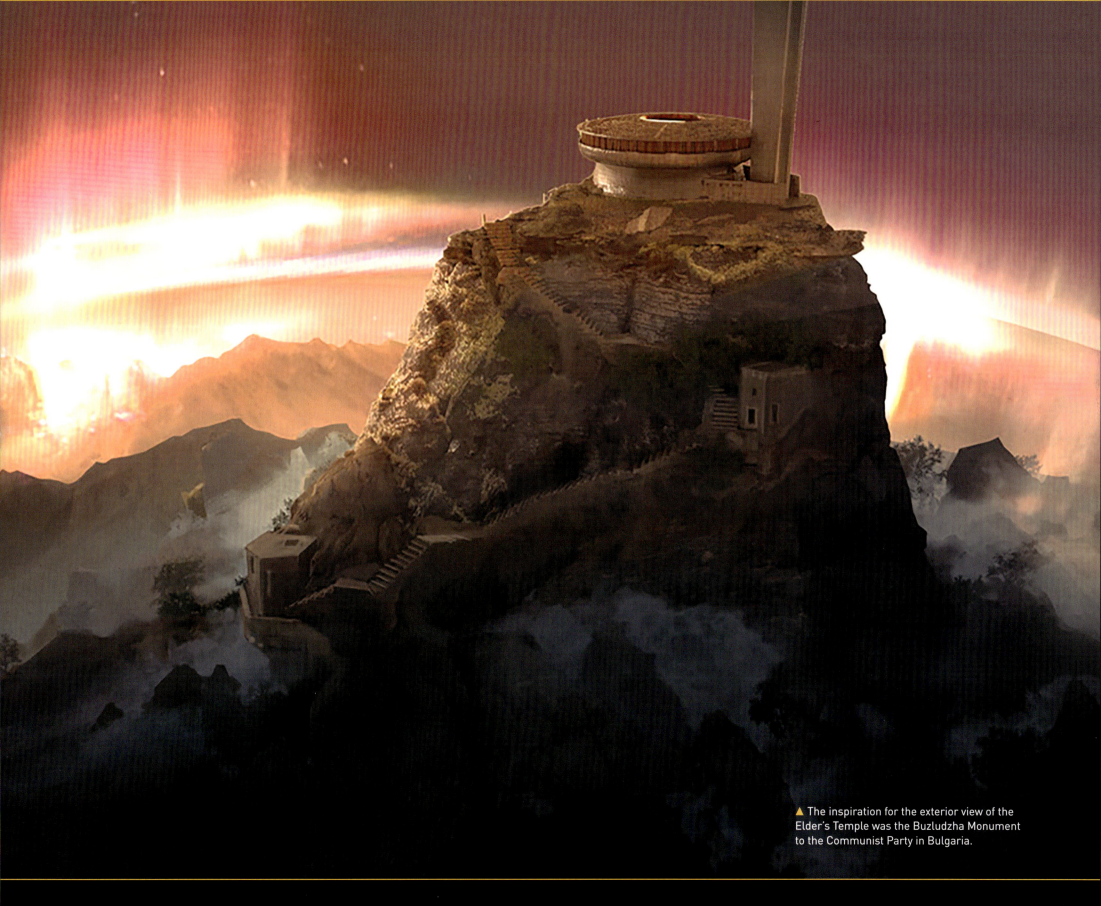

▲ The inspiration for the exterior view of the Elder's Temple was the Buzludzha Monument to the Communist Party in Bulgaria.

NEW TIJUANA AND OTHER COLONIES

With a new colony—sometimes several—to visit in every episode, the production needed a way of shooting exteriors while limiting location travel. Auckland, and New Zealand in general, provides some of the most spectacular scenery and varied location opportunities in the world, but while taking advantage of that the art design team also worked to create a traditional studio backlot for *Cowboy Bebop*, with streets and facades that could be redressed and switched up to provide the look of a dozen or more different worlds, including New Tijuana, cited as the oldest and most established colony in the solar system, in existence for over a century. "We wanted to make sure each of the colonies had a different look and feel," Victor Scalise says. "Some of this was done with color palettes in production that we matched with the VFX, but some of the look was also defined in VFX by types of buildings and [the] amount of nature in the environments."

And not just the *Bebop*—the production itself needed some maneuvering room. "We've got a big crew; we've got 300, and the onset crew is probably 160 and a whole bunch of technical gear, so

◀ Rising Sun Picture created Salt City from a modified stock footage plate (top) and Atmo Wall (bottom).

▶ Ultimately it was decided that there would be no physical structure above New Tijuana and the energy field would be subtle, with the clouds actually forming a boundary layer that ships would pass through to get to space.

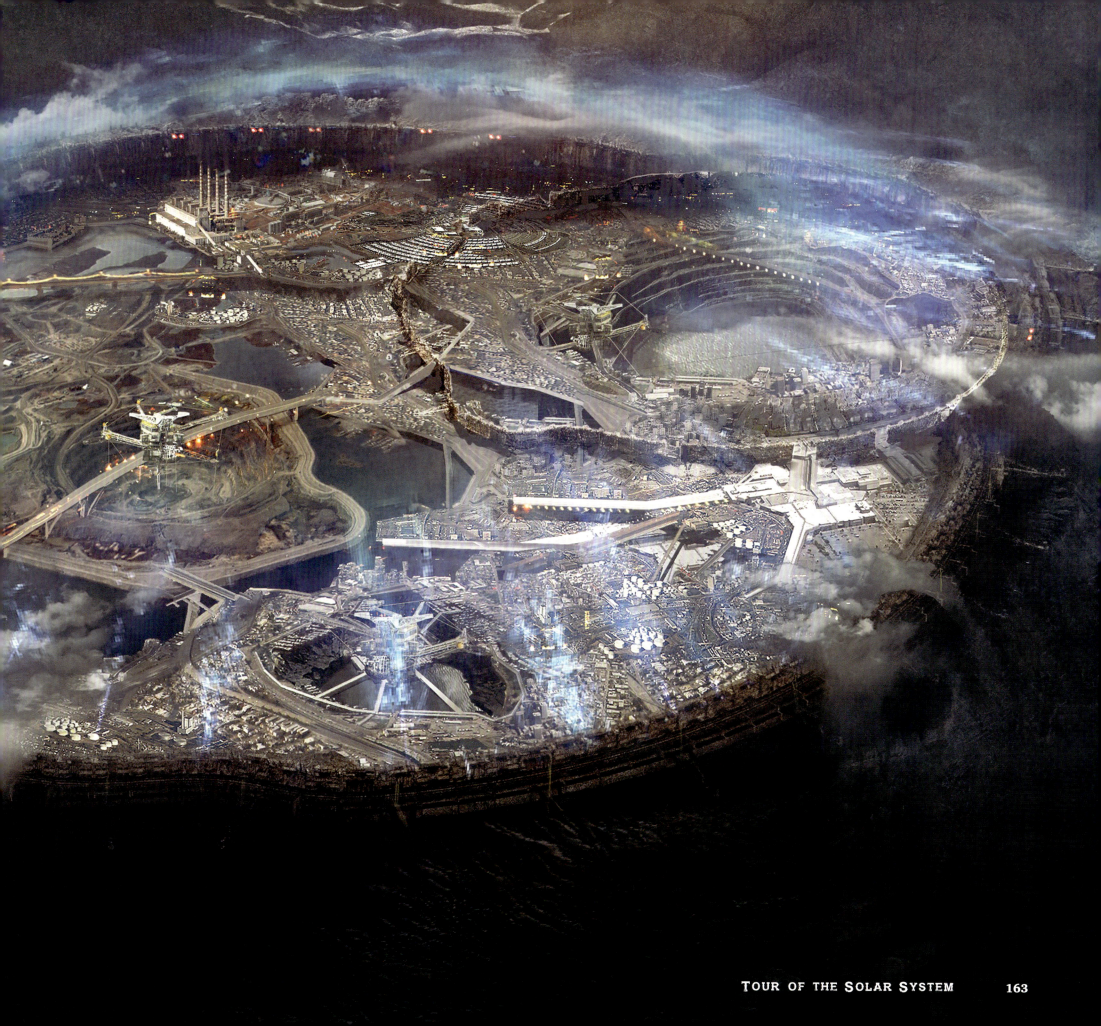

TOUR OF THE SOLAR SYSTEM

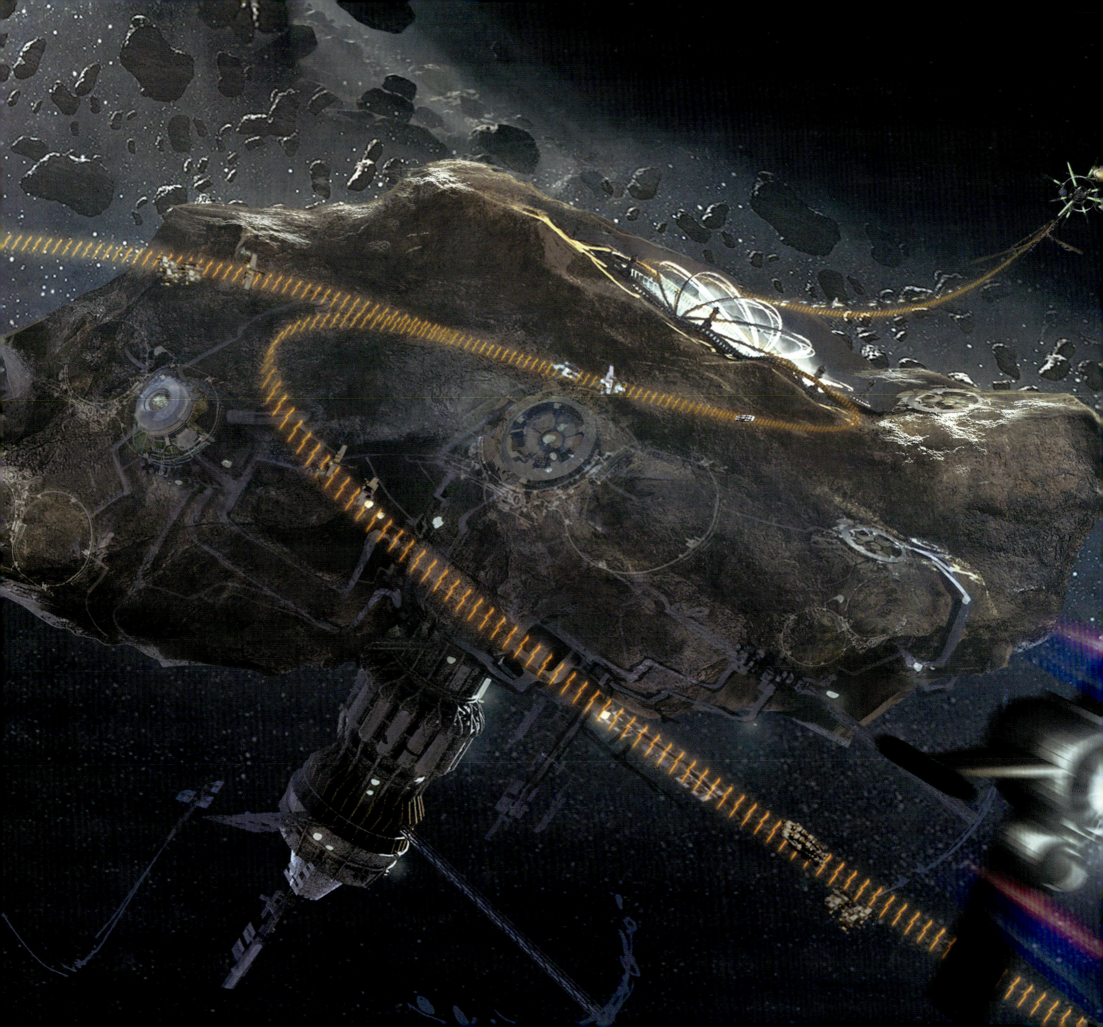

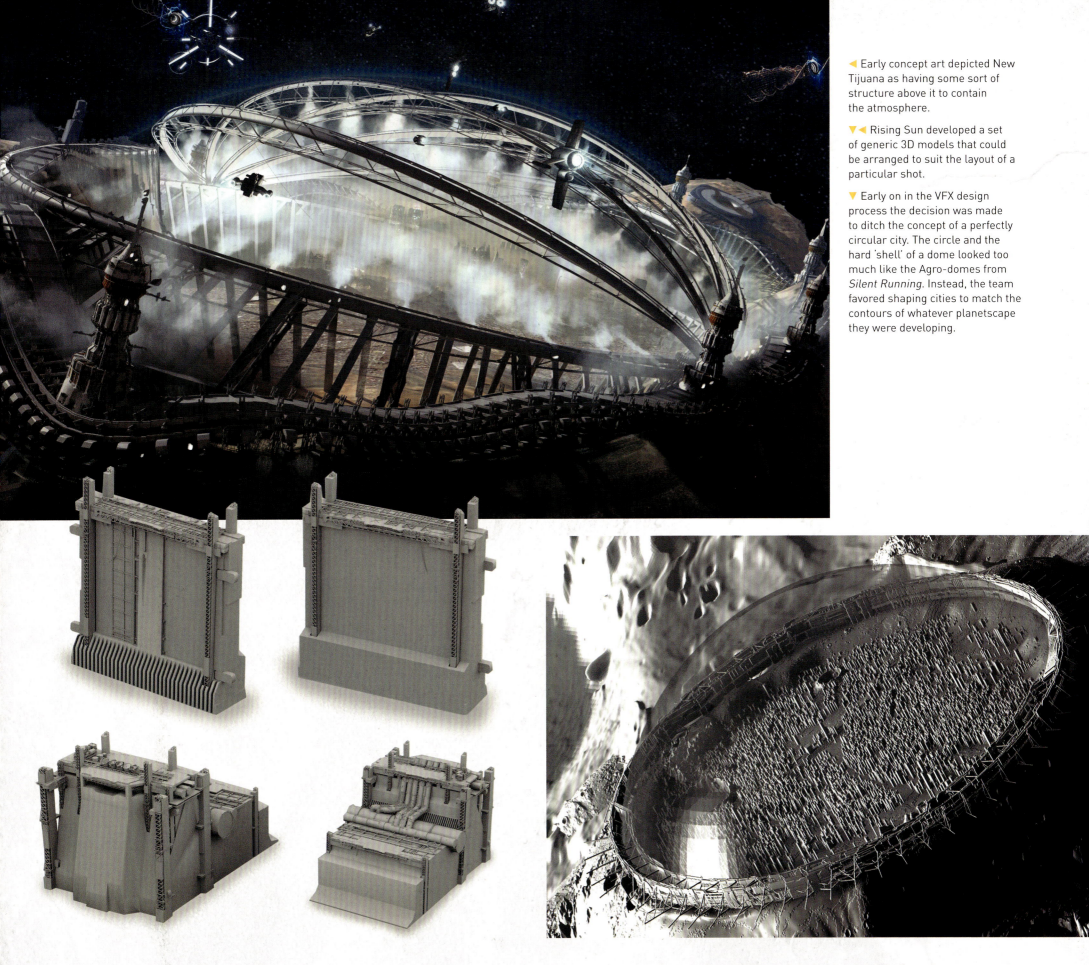

◀ Early concept art depicted New Tijuana as having some sort of structure above it to contain the atmosphere.

▼◀ Rising Sun developed a set of generic 3D models that could be arranged to suit the layout of a particular shot.

▼ Early on in the VFX design process the decision was made to ditch the concept of a perfectly circular city. The circle and the hard 'shell' of a dome looked too much like the Agro-domes from *Silent Running*. Instead, the team favored shaping cities to match the contours of whatever planetscape they were developing.

TOUR OF THE SOLAR SYSTEM

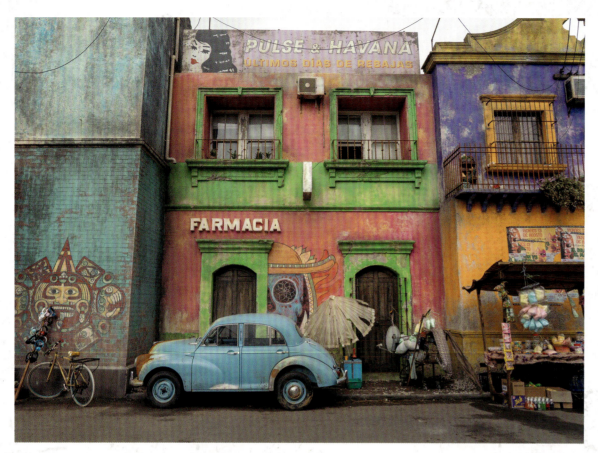

it can be problematic sometimes to go into the city," Gary Mackay explains. "When John Cho had his knee injury, we had been at an old psychiatric hospital—we'd redressed it and built over the top of it and created an exterior out on the edges of the city, and we had made our own New Tijuana there. It was a long way to travel; it had its own issues and problems with permissions, and just getting out there and what time of night you can film because people lived in that complex. And we talked to the producers in between our starting up again about finding some land closer to our studio and building a backlot on it. And they were into it. We found a great lot that's five minutes from our stages, and I designed a set of streets that I could rework or redress—initially three different city streets. And then we ended up actually doing a fourth and a fifth, and different locations."

Bebop's set-decoration crew worked to not only provide a lot of the flavor of New Tijuana, but to suggest the larger *Bebop* world and preview stories and characters that would show up in future episodes. "There are a lot of Easter eggs in New Tijuana if you know where to look for them," Botha says. "There was a T-shirt seller that had a shirt with Maria Murdock's dolphin on it, so he was selling those T-shirts as the Eco Warriors' T-shirts. So we try to put Easter eggs in as much as we can to tease what's coming up for the next episode, based on the anime. We had the fortune teller in that dress specifically as the fortune teller out of the anime, with his little mat and his little cage."

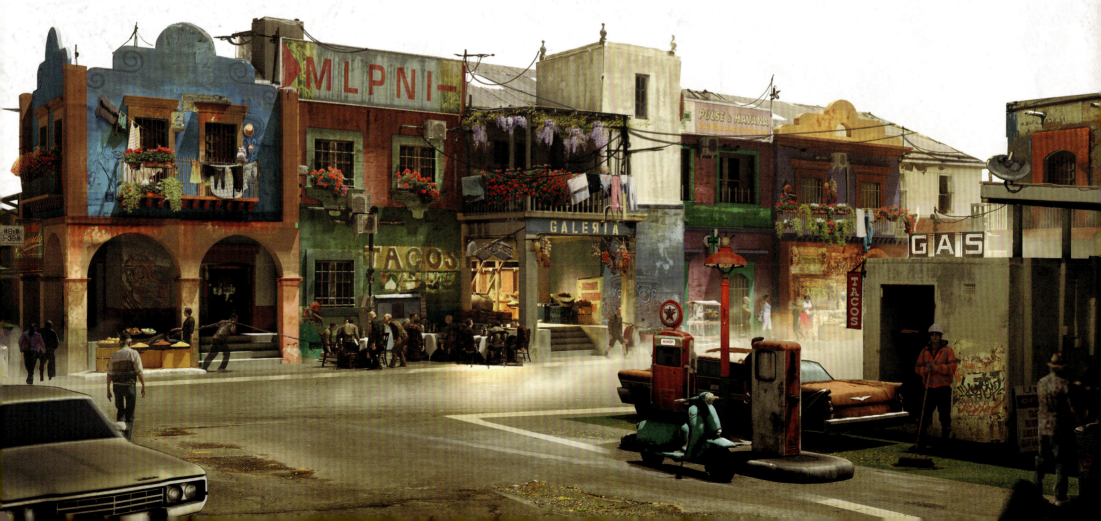

▲▶ Concept art for the 'girlie sign' that would adorn the side of Betty's Bottom. To give it a distinct look, this district was lit heavily with pink and purple hues (actual sets, right).

◀ New Tijuana concept art and final backlot set (top left).

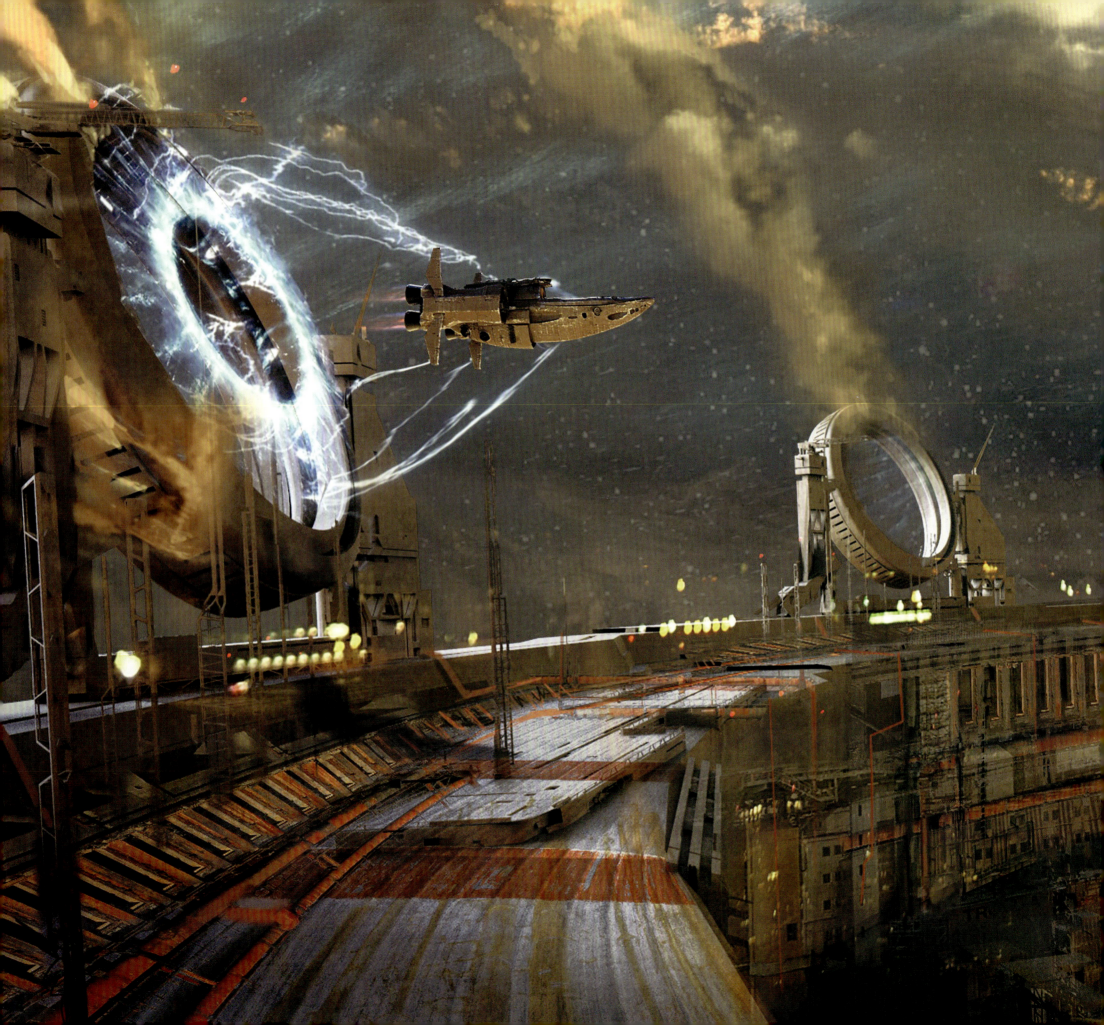

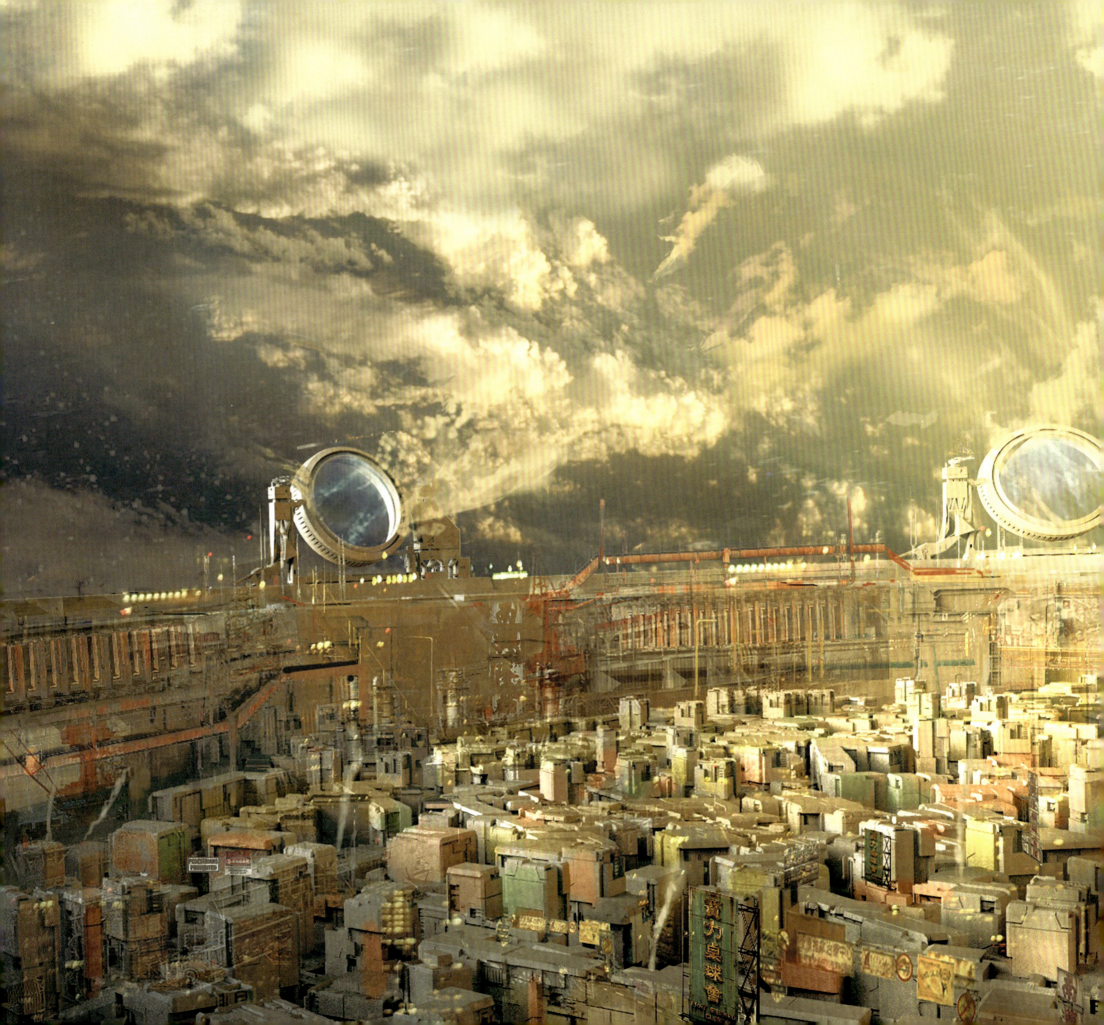

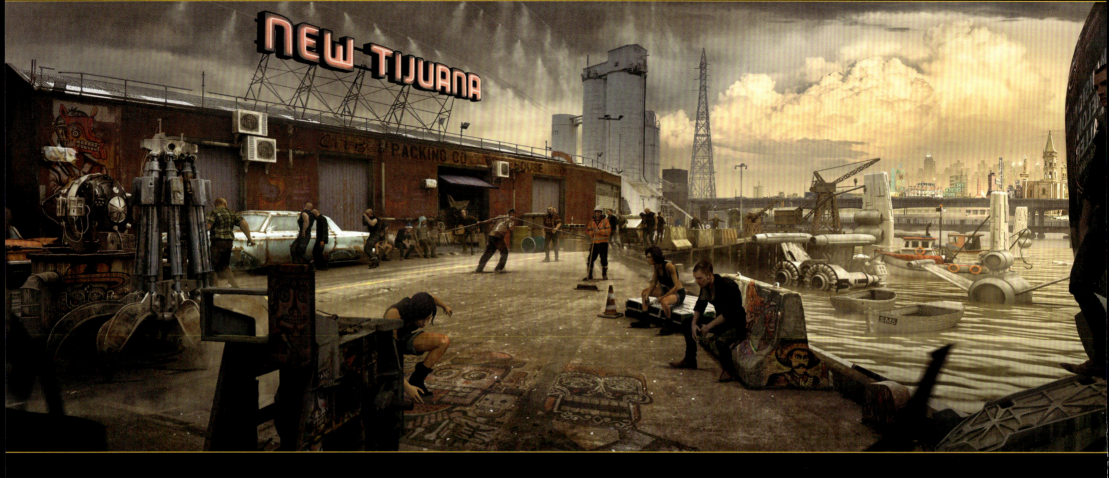

Over the course of the first season the production's backlot was dressed and redressed to create locations across the solar system, from cities on Mars to asteroid colonies and hubs of civilization on the moons of Jupiter. "We like using the backlot for the five streets for different times and different paint jobs, different dressing," Mackay says. "And even for the first iteration, which was Santos City (on Jupiter's moon Io), we ended up basically building that—the reference we had initially for that was Georgetown, Middle America with a *Bebop* flavor, and a limited palette like we do with everything. And then once we made that, we completely covered that to build joinery out and put arches [up] and [we] plastered the whole set in lime-green plaster and turned it into a lime-green Morocco, North African city, and shrouded it in all that knowing that the other stuff was all underneath, and we can tear it all away and reveal the one we needed two weeks later. And so we did the Morocco set, we filled the streets, all the extras were very different. We dressed it with huge swathes of dyed fabric and little tiny scooters, and three-wheelers buzzing around the streets and amongst all the people."

Since Anneke Botha was from North Africa, tackling the look of Santos City came naturally. "That dressing for me was like, 'Great, let's work it.' It's a lot of chaos, but very stylized chaos. So we had to rig a lot of cabling, there were carpets, there was a tea house, there

▲ The running joke in *Bebop* is that New Tijuana is a place that Spike hates to go.

◄ The *Bebop* graphics department came up with a billboard for New Tijuana, complete with bullet holes, as well as other graphics.

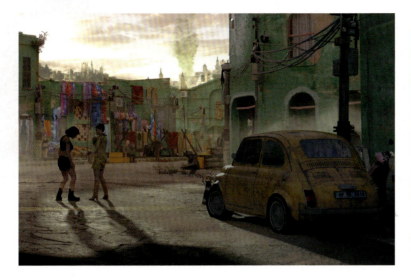

▲▼ Concept art for Santo City (above) and the final set (below). The basic structures were the same backlot, but with a heavy retexturing and repainting, along with new set dressing.

was a liner on the floor. We did a bodega which was not a bodega—it was like a North African shop, which was quite challenging because then you had to turn that around in a picture-perfect town. So you're creating North African chaos, fuzziness, like crap everywhere, and then going to Alba City: pristine lines, the perfect picture look that was based off Georgetown, so it's like picture-perfect fakeness and then going back to Proteus, which was just, like, derelict. It was Hillbrow [Johannesburg] on a bad day with just barbed wire and braziers; you have hobo braziers everywhere. There's crap on the floor and burned-out cars, and we turned Santos around into Alba and then into Proteus, which was hard—we were tired. We like to be tired."

And the change-ups didn't end there. "We just flipped it into a Gotham-like night city for Pierrot Le Fou," Mackay says. "And then we flipped it again into the middle-American town that we use for the long days, the Londes exteriors and the streets of Alba City (on Mars). And then we've since reworked it two more times, just part of it into other sets. So fingers crossed that nobody will know that and nobody will see that—that's the gamble you take. But I think we've done a pretty great job, and I think you'd have to be pretty clued in to pick any of that up."

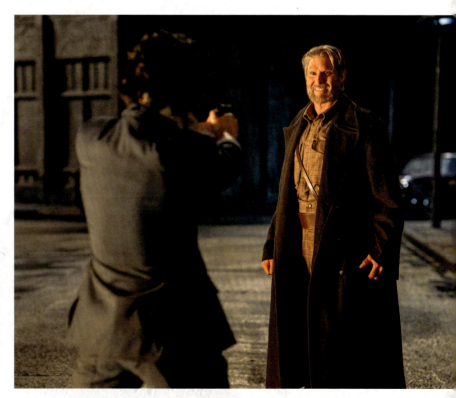

TOUR OF THE SOLAR SYSTEM 171

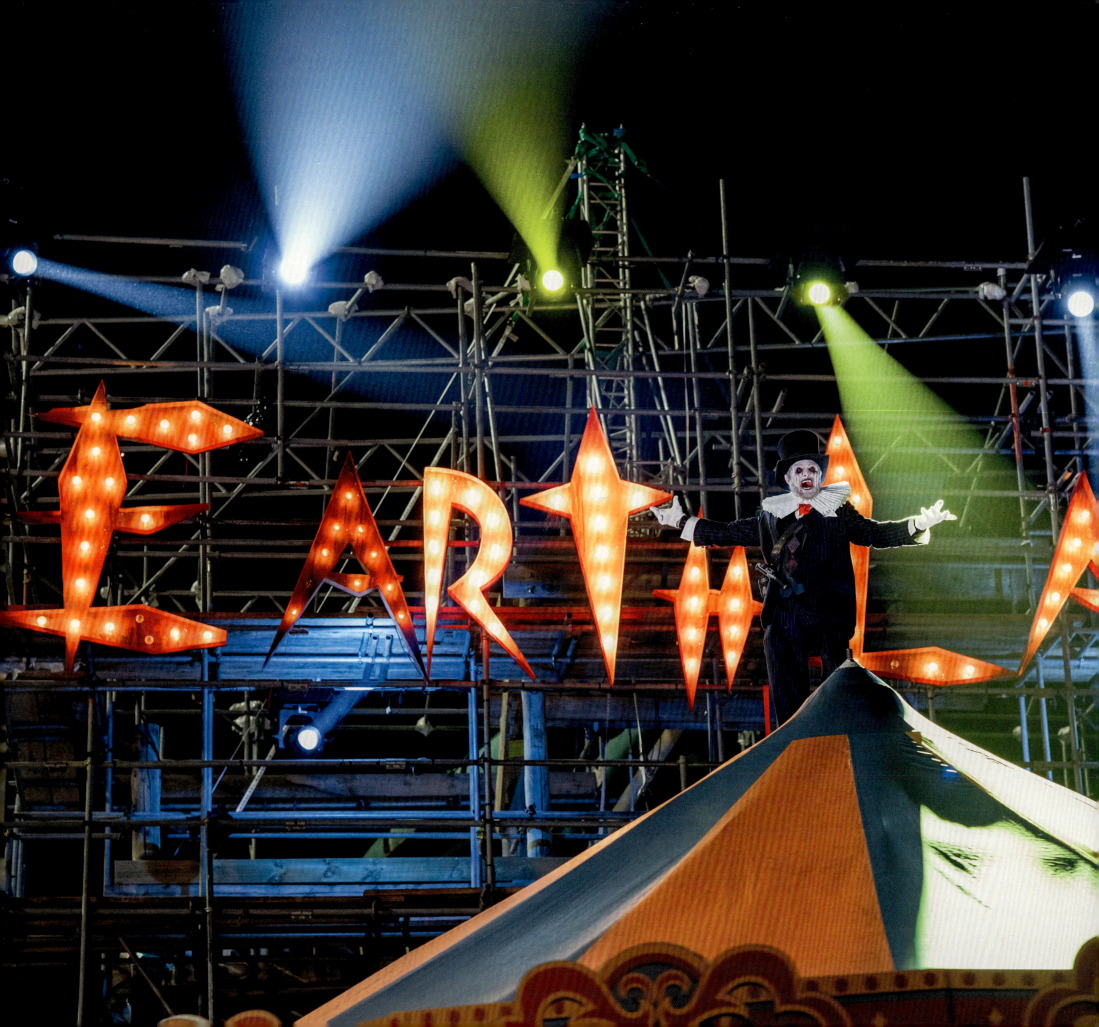

EARTHLAND AMUSEMENT PARK

In "Sad Clown A-Go-Go", Pierrot Le Fou lures Spike and the gang to the Earthland amusement park, a relic housed on a small asteroid, for a final showdown. Le Fou has made Earthland his home and hiding place because the place has a special meaning for the assassin. He has happy memories of being a child at the amusement park, and he attracts Spike to Earthland by sending a message through Ein that lures the *Bebop* crew there.

McMurry, Gary Mackay and the art design team took inspiration from some real, abandoned amusement parks, and filmed the episode's climax at a decommissioned water park in New Zealand.

"There's a Six Flags amusement park in New Orleans that got flooded during Hurricane Katrina," McMurry says of his original inspiration for the look of Earthland. "During the flood the whole park was just destroyed, completely flooded, and they never really cleaned it out. Decades later, it's just this weird place, completely abandoned, and you can just walk into it. I took all these photos—I remember the strangest was this swing ride, where you sit in a chair and the thing goes around, you're swinging: the chairs are all in half, and they're still hanging out. So that's the premise for this amusement park: It's an amusement park that is closed down, a lot of the stuff is still there, and Le Fou's there because it reminds him when he was there as a kid before they started doing all the experimentation. But it's really scary and horrible, and they have a big gun fight there."

Art director Gary Mackay located an equivalent location near Auckland. "We have a big water park that was abandoned about four years ago, and it's surprising how overgrown and falling apart it is already. We went and hired that and built our Earthland in it and added to it. We probably spent three weeks in there preparing it and building sets and building sideshows and building a ghost train and

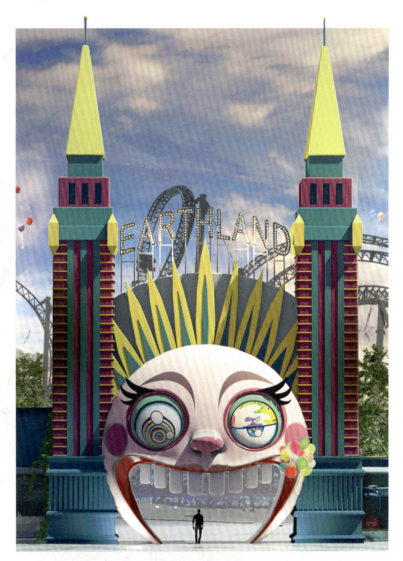

▲▶ The entrance gate for Earthland was modeled after the gigantic face of Luna Park in Melbourne. The production shot the Earthland Park scenes at an unused water park outside Auckland. The entrance tower would be a combination of a practical set and CGI by Scanline VFX.

putting a carousel with the horses on it in there and a big Earthland sign. And then that's up to VFX to help us from the skyline up. They're going to put in the rollercoasters, and the huge Ferris wheel in the distance like in the anime."

Anneke Botha and her team aged and detailed the location for the night shoot. "We bought so much for that; all the stalls obviously we wanted to make like the original from the anime. I was very adamant about that hippo, so we had the hippo polycut, brought it into the workshop, painted [it] so that it looks exactly like the anime. The Earthland sign I wanted to be the same as the anime, so we had that made and we had those bulbs made. We brought in a carousel from a vendor that usually does festivals, and he brought in the pony carousel. And we took a local graffiti artist, Misery—she's incredible. She did all the graffiti panels for us on the side of the store. Her work is very dark, but very beautiful. So she'll have this carnival-esque theme [where] everyone's heads are cut off."

For André Nemec, the episode not only pushed the production's filmmaking capacities, it also provided a key contribution to the

"WE WERE ABLE TO USE LE FOU AS A DRAMATIC DEVICE TO BRING OUR CORE CHARACTERS TOGETHER."

ANDRÉ NEMEC, SHOWRUNNER

show's character dynamics. "When we write them, we always want to get to a place where we understand the reason this episode exists in our season; why this one is important for us to tell. And I think we were not only able to expand upon the canon regarding 'Who is Le Fou really?', but also use Le Fou as a dramatic device to bring our core characters together—to bond Spike, Jet and Faye into a family. That's why Pierrot Le Fou comes into their world."

▲ Pierrot Le Fou had fond memories of Earthland as a child, but returns to find it abandoned and dilapidated.

▶ The setting of Earthland, like the anime, was to be on an asteroid. The VFX team came across imagery of a real asteroid called Psyche 16 that had wild metallic colors, and decided it would be the perfect setting for an abandoned theme park. While the park would be in one crater, the supporting infrastructure would be in the other craters.

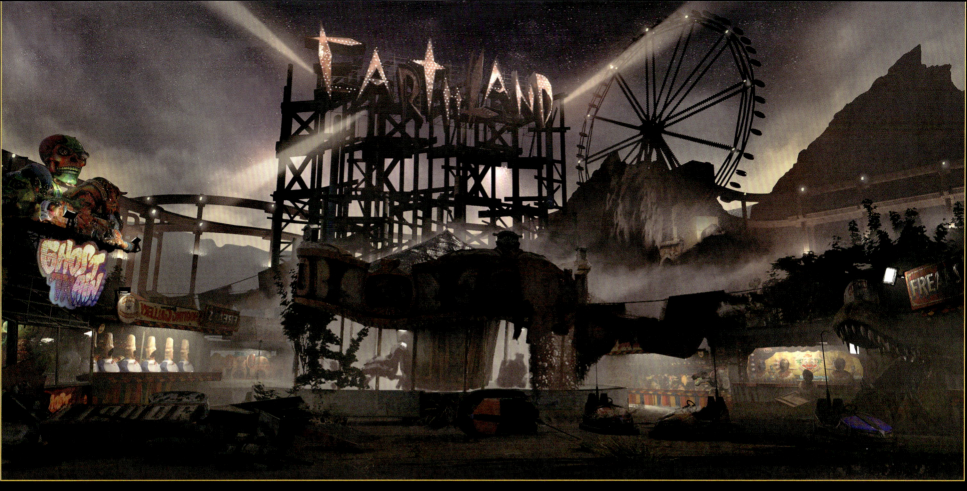

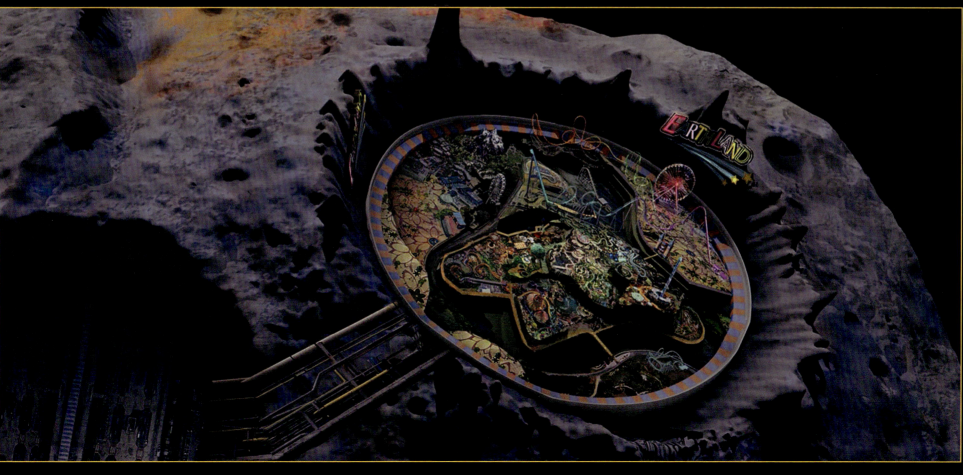

TOUR OF THE SOLAR SYSTEM

COWBOY BEBOP
MAKING THE NETFLIX SERIES

ACKNOWLEDGMENTS

There's a reason why the end credits of a movie or TV show are so long—it's because it takes a lot of people to pull it off. *Cowboy Bebop* was no exception. We tried to touch on the team aspect of this in the book and how the design work would affect—and be affected by—different departments. Of course, we could only scratch the surface of all those who had a role to play, big or small. Yeoman's work (the *Bebop* is a ship after all) was done by the art and production teams in New Zealand, as well as the VFX teams of Rising Sun, Scanline, Barnstorm, Framestore, Ingenuity Studios, Goodbye Kansas, The Mill, Refuge, Outpost, Mr. Wolf, Mr. X, The Product Factory, Incessant Rain, and NetFx, who were scattered literally around the world. We'd also like to acknowledge the contributions of Nic Louie (our oracle of all things *Bebop*) at Tomorrow Studios, Andy Jones and William Robinson from Titan Books, and Joe Lawson, George Tew, and Claire Starkey from Netflix.

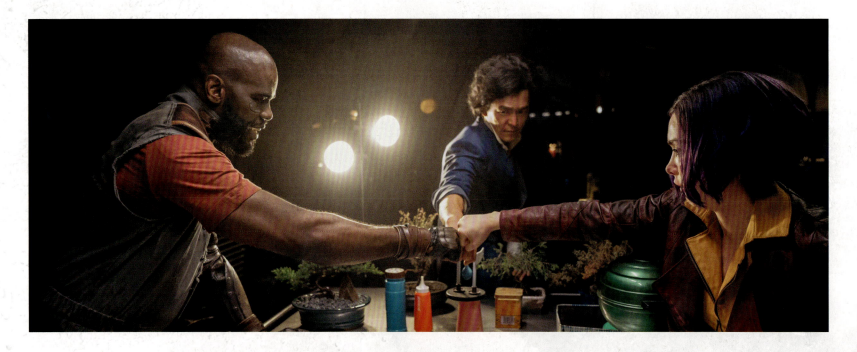

SEE YOU, SPACE COWBOY...